JENNY HOLZER

제니 홀저

당신을 위하여

FOR YOU

전시총괄
강수정

전시기획·진행
이현주

국립현대미술관 커미션 프로젝트
당신을 위하여 : 제니 홀저

국립현대미술관
서울 서울박스 및 로비, 과천 야외공간

2019. 11. 23. – 2020. 7. 5.

전시진행보조
최혜윤
송현주

전시디자인
이민희

그래픽디자인
김동수

설치·운영
박양규
정재환
최상호
주창하

공간조성
윤해리

작품보존
범대건
권인철
조인애

홍보
소통홍보팀

교육
교육문화과

사진·영상
이미지줌

번역
서울셀렉션
백한나

Robotic LED 설치·운영
지엘 어소시에이츠

텍스트
김혜순
한강
에밀리 정민 윤
스베틀라나 알렉시예비치
호진 아지즈

고마운 분
국립현대미술관 후원회,
바르토메우 마리 리바스,
가이 레써, 강이룬, 국제갤러리, 김태윤,
닉 모건, 로버트 허먼, 레아 하트만,
스프루스 매거스, 아니카 베리,
아리엘 로젠블럼, 안상수,
알라나 게드과다스, 에릭 섬션,
에이미 실버, 이안 코스텔로,
제이크 포르니, 지나 씨랄리,
지엘 어소시에이츠, 클라우디아 뮐러,
콜린 라플레체, 패트릭 휴벤탈,
패티 테인터, 폴 카뮈프,
하나 트랜, 하우저 앤 워스

Supervised by
Kang Soojung

Curated by
Lee Hyunju

Curatorial Assistants
Choi Hyeyoun
Song Hyunju

Exhibition Design
Lee Minhee

Graphic Design
Kim Dongsu

Technical Coordination
Park Yang-gyu
Jeong Jaehwan
Choi Sangho
Ju Changha

Space Construction
Yun Haeri

Conservation
Beom Daegeon
Kwon Incheol
Cho Inae

Public Relations
Communication and
Media Team

Education
Department of Education

Photography & Film
Image Joom

Translation
Seoul Selection
Peck Hannah

Robotic LED Installation
GL Associates

Text
Kim Hyesoon
Han Kang
Emily Jungmin Yoon
Svetlana Alexievich
Hawzhin Azeez

MMCA Commissioned Project
FOR YOU: Jenny Holzer

National Museum of
Modern and Contemporary Art,
Seoul, Seoul Box and Lobby,
Gwacheon Outdoor Space

November 23, 2019 – July 5, 2020

Acknowledgments
Ahn Sangsoo, Annika Berry,
Gina Ciralli, Ian Costello,
Jake Forney, Alanna Gedgaudas,
GL Associates, Leah Hartman,
Hauser & Wirth, Robert P. Herman,
Patrick Hubenthal, Paul Kamuf,
E Roon Kang, Kim Taiyun,
Kukje Gallery, Collin LaFleche,
Guy Lesser, Bartomeu Marí Ribas,
MMCA Director's Council,
Nick Morgan, Claudia Müller,
Ariel Rosenblum, Amy Silver,
Sprueth Magers, Erik Sumption,
Patty Tainter, Hana Tran

A LITTLE KNOWLEDGE CAN GO A LONG WAY
A LOT OF PROFESSIONALS ARE CRACKPOTS
A MAN CAN'T KNOW WHAT IT'S LIKE TO BE A MOTHER
A POSITIVE ATTITUDE MEANS ALL THE DIFFERENCE IN THE WORLD
A RELAXED MAN IS NOT NECESSARILY A BETTER MAN
A POSITIVE ATTITUDE MEANS ALL THE DIFFERENCE IN THE WORLD
A SINGLE EVENT CAN HAVE INFINITELY MANY INTERPRETATIONS

AT TIMES YOUR UNCONSCIOUS IS TRUER THAN YOUR CONSCIOUS MIND
AUTOMATION IS DEADLY
BEING HAPPY IS MORE IMPORTANT THAN ANYTHING ELSE
CHANGE IS THE BASIS OF ALL HISTORY
CALM IS MORE CONDUCIVE TO CREATIVITY THAN IS ANXIETY
FEAR IS CALMING
DISGUST IS THE APPROPRIATE RESPONSE TO MOST SITUATIONS
DISGUST IS THE BEGINNING OF ANESTHESIA
DYING AND COMING ARE A LOT ALIKE
EMOTIONAL RESPONSES ARE AS VALUABLE AS INTELLECTUAL RESPONSES
EXTREME BEHAVIOR HAS ITS BASIS IN PATHOLOGICAL PSYCHOLOGY
GO ALL OUT IN ROMANCE AND LET THE CHIPS FALL WHERE THEY MAY
GO ALL OUT
SOOTHING BUT RISKY
IF YOU AREN'T POLITICAL YOUR PERSONAL LIFE SHOULD BE EXEMPLARY
IF YOU AREN'T POLITICAL YOUR LIFE WILL BE INTERESTING

PEOPLE ARE RESPONSIBLE FOR WHAT THEY DO UNLESS THEY ARE INSANE
WITH THEIR HANDS ARE PARASITES
PLAYING IT SAFE CAN CAUSE A LOT OF DAMAGE IN THE LONG RUN
FOR PERSONAL GAIN
RANDOM MATING IS GOOD FOR DEBUNKING SEX MYTHS
MATURITY RECLUSES ALWAYS GET WEAK
ROUTINE SMALL EXCESSES ARE WORSE THAN THE OCCASIONAL DEBAUCH
NOT A MORAL ACT SALVATION CAN'T BE BOUGHT AND SOLD
SYMBOLS ARE MORE MEANINGFUL THAN THINGS THEMSELVES
TO HIDE ONE'S INABILITY TO ACT
WE MUST MAKE SACRIFICES TO MAINTAIN OUR QUALITY OF LIFE
VIOLENCE IS PERMISSIBLE EVEN DESIRABLE OCCASIONALLY
PURIFICATION RITE
YOU MUST KNOW WHERE YOU STOP AND THE WORLD BEGINS
YOU DON'T KNOW WHAT'S WHAT UNTIL YOU SUPPORT YOURSELF
YOU ONLY CAN UNDERSTAND SOMEONE OF YOUR OWN SEX
OTHERS TO BE EXTRAORDINARY
YOUR ACTIONS ARE POINTLESS IF NO ONE NOTICES
YOUR OLDEST FEARS ARE THE WORST ONES

Jenny Holzer (b. 1950) is a leading contemporary artist who has explored personal, social, and political subjects through language for over forty years. She communicates with the public through a wide array of media, including posters, projections, electronic signs, stonework, and everyday objects. Three years in the making, her commissioned project for the MMCA reimagines the Seoul Box and lobby at MMCA Seoul and the outdoor space at MMCA Gwacheon, giving visitors an opportunity to experience the essence of her artistic practice.

At MMCA Seoul, posters featuring Holzer's *Truisms* (1977–79) — the renowned series that marked the beginning of her use of language — and *Inflammatory Essays* (1979–82) cover the entire wall of the lobby, providing a connection to her early practice and the philosophy that formed the basis of her oeuvre. Outdoors at MMCA Gwacheon, visitors can experience Holzer's language in a different medium and spatial context through *Selections from Truisms*, an installation of eleven texts chosen by the artist to be engraved on a stone bridge overlooking the museum and its surrounding landscape.

Another new work, a monumental roboticized LED sign titled *FOR YOU*, was specifically designed for the Seoul Box. This striking work features the words of five contemporary women writers who give voice to our times — Kim Hyesoon, Han Kang, Emily Jungmin Yoon, Svetlana Alexievich, and Hawzhin Azeez. Rooted in the artist's practice over the past four decades, this work speaks to the suffering, lives, and deaths of those lost and left behind amid political conflicts and historical tragedies such as wars and societal disasters.

This exhibition is made especially significant by the fact that *FOR YOU* and *Selections from Truisms* will become part of the museum's permanent collection, thanks to the support and financial sponsorship of the MMCA Director's Council (MDC).

In closing, I would like to extend my sincere appreciation to Jenny Holzer for her dedication and to the MDC for its generous support. I would also like to thank curator Lee Hyunju and the museum staff for helping to make this project a reality.

Youn Bummo
Director, National Museum of
Modern and Contemporary Art, Korea

제니 홀저(Jenny Holzer, 1950–)는 40여 년간 언어를 매개로 사회와 개인, 정치적 주제를 다뤄 온 세계적인 작가입니다. 홀저는 포스터, 프로젝션, 전광판, 석조물, 일상용품 등 다양한 매체를 활용한 독창적인 방식의 작품들로 대중과 소통해왔습니다. 지난 2017년부터 약 3년 간 추진된 이번 커미션 프로젝트는 서울관 내 서울박스와 로비, 과천관의 야외 공간을 새롭게 해석한 신작으로 제니 홀저 작품의 정수를 만날 기회를 제공합니다.

전시에서는 언어를 매개로 작업을 시작했던 홀저의 대표작 〈경구들(Truisms)〉(1977–79)과 〈선동적 에세이 (Inflammatory Essays)〉(1979–82) 포스터를 서울관 로비에 대규모로 구현하여 작업 세계의 근간을 이룬 초기 작품 활동과 철학을 유추하게 합니다. 또한 과천관 야외 공간에서는 미술관과 주변 풍경을 함께 조망할 수 있는 석조 다리 위에 작가가 선정한 11개의 텍스트를 새긴 영구설치 작업 〈경구들에서 선정된 문구들(Selections from Truisms)〉을 통해 홀저의 언어를 서로 다른 매체와 장소적 맥락에서 이해하고 감상할 수 있습니다.

이와 함께 프로젝트를 위해 새롭게 기획·제작된 기념비적 로봇 LED 〈당신을 위하여(FOR YOU)〉가 서울관 서울박스에 설치되어 관람객을 맞이합니다. 특히 이 작품은 김혜순, 한강, 에밀리 정민 윤, 스베틀라나 알렉시예비치, 호진 아지즈 등 시대의 목소리를 담은 현대 여성 문학 작가들의 글을 함께 선보이며 더욱 주목을 받고 있습니다. 지난 사십여 년간 작가의 작품 활동을 바탕으로 제작된 이번 신작은 정치적 갈등, 전쟁과 같은 역사적 비극 혹은 사회적 참상 속에서 희생된 이들과 남겨진 사람들의 아픔, 삶과 죽음에 관한 이야기를 들려줍니다.

이번 프로젝트는 국립현대미술관후원회(MMCA Director's Council, MDC)의 후원과 기증을 통해 작가의 LED 신작 〈당신을 위하여(FOR YOU)〉와 과천관의 영구설치작품 〈경구들에서 선정된 문구들(Selections from Truisms)〉 두 점을 미술관의 컬렉션으로 소장하게 된다는 점에서 더욱 의의가 있습니다.

마지막으로 이번 프로젝트를 위하여 헌신적으로 노력해주신 제니 홀저 작가와 지원을 아끼지 않은 국립현대미술관 후원회, 그리고 프로젝트를 위해 애써주신 이현주 학예연구사를 비롯한 미술관 가족들께도 감사드립니다.

윤범모
국립현대미술관장

FOR YOU: JENNY HOLZER

당신을 위하여 : 제니 홀저

JENNY HOLZER

FOR YOU

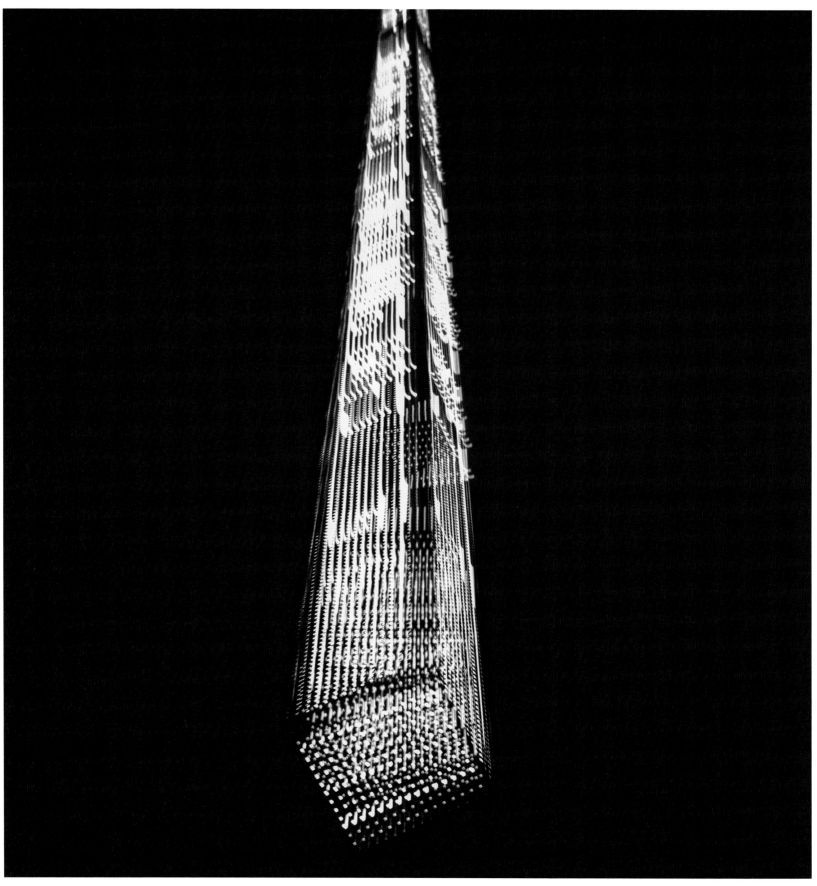

 8

DEAD YOU'RE FREE! YOU CAN
CHANGE THE RADIANT CHILD IN
YOU TO A REFLECTION OF THE
SHIT YOU WERE MEANT TO SERVE.

CAUSE THERE IS NO GOD SOMEONE
ST TAKE RESPONSIBILITY FOR MEN.
HARISMATIC LEADER IS IMPERATIVE.
CAN SUBORDINATE THE SMALL WILLS
THE GREAT ONE. HIS STRENGTH
HIS VISION REDEEM MEN. HIS
FECTION MAKES THEM GRATEFUL.
ITSELF IS NOT SACRED, THERE
O DIGNITY IN THE FLESH.
IRECTED MEN ARE CONTENT WITH
NDOM, SQUALID, POINTLESS LIVES.
LEADER GIVES DIRECTION
PURPOSE. THE LEADER FORCES

SCORN RELEASE, SCORN
SWEETNESS, SCORN LIGH
QUESTION OF FORM AS M
IT IS A MATTER OF REVUL

RS.

THE
E
HE
L
GET

P
BS,
RN

나쁜 사람들에게는 끔찍

나쁜 의도가 좋은 결과를

남자는 어머니가 된다는

낭만적 사랑은 여성을 조

낮은 기대치는 좋은 보호

내 부모가 내 부모인 것은

너무 많은 생각은 문제를

노고에는 그 어떤 보상도

노동은 삶을 파괴하는 핵

FOR YOU

Lee Hyunju
Curator, National Museum of
Modern and Contemporary Art, Korea

1
Claire Bishop, *Radical Museology*
(London: Koenig Books, 2014), 6.
클레어 비숍, 『래디컬 뮤지엄』
(서울: 현실문화, 2016), 구정연 외 옮김,
11–12.

A Commissioned Project by the Museum of Modern and Contemporary Art (MMCA), *FOR YOU: Jenny Holzer* uses the language of art to expand the public space and enhance the communal spirit of the museum. For more than forty years, Jenny Holzer has been producing text-based artworks in diverse media, all of which seek to engage the public on an endless array of personal, social, and political issues. But in these turbulent times, can art offer any real solutions to life's problems? What role should public museums play in guiding contemporary discourse? In response to such questions, Claire Bishop suggests that "museums … attempt to represent the interests and histories of those constituencies that are (or have been) marginalized, sidelined and oppressed. This doesn't mean that they subordinate art to history in general, but that they mobilize the world of visual production to inspire the necessity of standing on the right side of history."[1] Embodying this spirit, Holzer has consistently maximized the public capacity of art by directly addressing the "realities of life" with her works. Through her innovative sculptural and media experiments, Holzer draws upon language to stimulate interdisciplinary discussion and dispute, thus serving as an effective catalyst for social change.

Born in Ohio in 1950, Holzer received her BFA in painting and printmaking from Ohio University and her MFA in painting from the Rhode Island School of Design (RISD). During her final year at RISD, while also enrolled in the Independent Study Program at the Whitney Museum of American Art in New York, she began producing text-based artwork in the form of anonymous street posters, using written language to draw attention to historical and political discourse and current social issues. Her messages appear in a multitude of surprising formats and public spaces, being printed on postcards, coffee cups, and T-shirts, and even projected on buildings and bodies of water. In 1990, Holzer became the first woman to represent the United States at the Venice Biennale and then proceeded to win the Golden Lion grand prize for best pavilion. Over the past three decades, her works have been shown at some of the world's most prestigious museums (e.g., the Guggenheim Museums in New York and Bilbao, the Whitney Museum, the Louvre Abu Dhabi, Tate Modern, etc.), but she also continues to install her text-based artworks directly in the public sphere in order to engage the wider populace on various sociopolitical topics.

In addition to *Truisms* (1977–79) and *Inflammatory Essays* (1979–82), which were written by the artist herself, this exhibition also includes the monumental new work *FOR YOU*, featuring texts by five contemporary women writers: Kim Hyesoon, Han Kang, Emily Jungmin Yoon, Svetlana Alexievich, and Hawzhin Azeez. Printed on posters, carved in stone, or illuminated as LED signs, messages are emblazoned throughout the MMCA's public areas (i.e., the MMCA Seoul Box and lobby and the outdoor space of MMCA Gwacheon), transforming every visitor into an active participant in the project.

당신을 위하여

이현주
국립현대미술관 학예연구사

MMCA 커미션 프로젝트 《당신을 위하여: 제니 홀저》는 예술의 언어를 통해 보다 확장된 공공의 장소이자 공론의 장으로 미술관을 위치시키고자 마련되었다. 제니 홀저는 지난 40여 년간 텍스트를 매개로 사회와 개인, 정치적 이슈를 다루며 지속적으로 공적 영역에 관여하여 예술의 가능성을 실천해온 예술가이다. 혼돈의 시대 속에서 예술은 실질적인 삶의 문제에 어떻게 개입할 수 있는가? 공공의 미술관은 동시대의 사회문화적 담론 형성에 어떠한 역할을 할 수 있는가? 우리는 이러한 질문들 속에서 답을 찾기 위한 여정을 시작한다. "동시대 미술관은 주변화되고 열외되었던 구성원들의 관심사와 역사를 현재로 가져와 시각 생산물의 세계를 동원하여 예술이 역사의 바른편에 서야 하는 필연성을 이끌어 내는 공공의 장소가 되어야 한다"는 클레어 비숍(Claire Bishop)[1]의 제안은 하나의 대안이 될 수 있을 것이다. 마찬가지로 홀저는 급진적인 예술의 최전방에서 언어를 통해 다성적인 지식과 생각을 공유하고 토론과 논쟁으로 사회 변화를 추동하는 조형적 실험을 지속해왔다. 우리가 직면한 '삶의 문제'를 용기 있게 다루고 현실에 개입함으로써 예술의 공공성을 극대화해 온 홀저와의 만남은 필연적이다.

1950년 미국 오하이오 주에서 태어난 홀저는 오하이오 대학에서 회화 및 판화(BFA)를 공부했으며 1977년 로드아일랜드 디자인학교(RISD)에서 회화로 석사학위를 받았다. RISD에서의 마지막 해, 휘트니 미술관의 독립연구프로그램에 참여한 것을 계기로 작가는 역사적이고 정치적인 담론과 현재의 사회 문제에 관심을 끌기 위해 언어를 사용하여 익명의 거리 포스터 형태로 텍스트 기반의 작품을 제작하기 시작했다. 그는 종이컵, 엽서, 티셔츠와 같은 일상 사물에서부터 건물의 파사드나 강, 바다와 같은 자연 풍경에 언어를 투사하는 초대형 프로젝션에 이르기까지 일상 삶의 다양한 공간에서 대중에게 메시지를 전달하였다. 홀저는 1990년 제44회 베니스 비엔날레에서 미국을 대표하는 첫 여성 작가로 선정되어, 당해 최고의 국가관에 수여되는 황금사자상을 수상하였으며 지난 30년간 뉴욕과 빌바오의 구겐하임 미술관, 휘트니 미술관, 루브르 아부다비, 런던의 테이트 모던 등 세계 유수 미술관의 전시는 물론 공공 영역에서 사회·정치적 이슈들에 적극적으로 발언하는 텍스트 작업을 통해 거리 미술가로서의 실천을 지속해왔다.

이번 프로젝트를 위해 홀저는 본인이 저작한 대표적인 텍스트 작품 〈경구들(Truisms)〉(1977-79)과 〈선동적 에세이(Inflammatory Essays)〉(1979-82)를 비롯하여 기념비적 LED 신작 〈당신을 위하여(FOR YOU)〉을 통해 김혜순, 한강, 에밀리 정민 윤(Emily Jungmin Yoon), 스베틀라나 알렉시에비치(Svetlana Alexievich), 호진 아지즈(Hawzhin Azeez) 등 다섯 명의 현대 여성 문학 작가의 글을 함께 선보인다. 텍스트들은 포스터, LED 사인, 돌 조각과 같이 작가가 사용했던 주요한 매체를 통해 구현되었으며 국립현대미술관 서울관의 서울박스와 로비, 과천관의 야외 공간 등 미술관을 방문하는 모든 이에게 개방되어 있는 공공의 장소가 프로젝트를 위한 무대가 되었다. 각각의 작품을 마주하게 될 공적 공간(public space)은 다양한 관객들을 능동적 참여자로 프로젝트에 초대하며 협업자가 될 모두에게 당신을 위한 '자리'를 마련한다.

from *Truisms* (1977–79), 2019
from *Inflammatory Essays* (1979–82), 2019

Entering MMCA Seoul, visitors are immediately greeted by posters of Holzer's *Truisms* and *Inflammatory Essays*, which combine to cover one giant wall of the lobby. From a distance, the eye-catching colors of the posters resemble the elaborate patchwork of a decorative graphic wall. Stepping closer, visitors begin to perceive the stark black letters printed on the posters, inexorably enticing them to read every sentence.

Serving as a new type of public square, the first-floor lobby of MMCA Seoul is open to everyone, whether they are meeting friends, visiting an exhibition, or simply taking a break. One side of the lobby consists of a massive white wall, 9.4 meters tall and 45 meters wide. Although it has occasionally provided a backdrop for paintings, performances, or projections, this wall usually fades invisibly into the ambience of the museum. But now, covered with 1,600 new posters in a diagonal layout, this empty void has come to life as a dynamic interactive space. Gazing up at the wall, dozens of curious onlookers mill around, some nodding in agreement and others tilting their head in confusion. Everyone engages in their own type of conversation, either chatting with someone nearby or snapping photos to post online.

Holzer's *Truisms* are her first and best-known text-based work, comprising over 250 statements that borrow the form of maxims or clichés. The work was partially inspired by a list of recommended books that Holzer received from Ron Clark while at the Whitney program in 1977. Each sentence takes a complex (and often controversial) idea related to social beliefs, traditions, and truths and compresses it into a short statement, without endorsing any particular stance. At first, Holzer anonymously posted the statements alphabetically on the streets of New York.[fig. 1] In the ensuing years, they have been replicated on T-shirts, baseball hats, electronic signs, sidewalks, and stone benches, among other things. Now, thanks to the efforts of four translators, 240 of Holzer's original statements are being presented in Korean for the first time, encouraging interpretation and participation among viewers.[2]

The brightly colored posters on the wall are the latest incarnation of *Inflammatory Essays*, a collection of one-hundred-word texts that constitute Holzer's second text-based work. Inspired by various treatises and manifestos, Holzer initially printed the texts on sheets of colored paper and pasted them around Manhattan.[fig. 2] Employing the decisive tone of a manifesto, each text in the series promotes a particular opinion. But by presenting the texts anonymously, Holzer detached herself from those opinions, thus encouraging people to focus solely on language and ideology, while also contemplating the need for social change, the possibility of public manipulation, and the conditions of revolution.

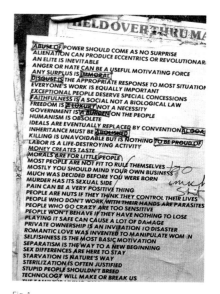

Fig. 1
from *Truisms* (1977–79), 1977
Offset poster
34.75 × 22.9 in. / 88.3 × 58.1 cm
Installation: New York, 1977
©1977 Jenny Holzer,
member Artists Rights Society (ARS), NY / SACK, Seoul
Photo: Jenny Holzer
〈경구들〉로부터 (1977–79), 1977
오프셋 인쇄 포스터
34.75 × 22.9 in. / 88.3 × 58.1 cm
설치장소: 뉴욕, 1977
©1977 제니 홀저, 뉴욕예술가권익협회 / 한국미술저작권관리협회
사진: 제니 홀저

Fig. 2
from *Inflammatory Essays*, (1979–82), 1982
Offset posters
17 × 17 in. / 43.2 × 43.2 cm, each
Installation: *Toronto Poster Project*, Toronto, 1982
©1982 Jenny Holzer,
member Artists Rights Society (ARS), NY / SACK, Seoul
Photo: Peter Greyson
〈선동적 에세이〉로부터 (1979–82), 1982
오프셋 인쇄 포스터
각 17 × 17 in. / 43.2 × 43.2 cm
설치장소: 토론토 포스터 프로젝트, 토론토, 1982
©1982 제니 홀저, 뉴욕예술가권익협회 / 한국미술저작권관리협회
사진: 피터 그레이슨

〈경구들〉로부터(1977-79), 2019
〈선동적 에세이〉로부터(1979-82), 2019

〈경구들〉과 〈선동적 에세이〉는 관람객이
미술관에서 가장 먼저 마주하게 되는 1층 로비의
거대한 벽면을 가득 채우고 있다. 강렬한 색상의
패턴으로 먼저 눈길을 끄는 이 작업은 멀리서
보았을 때 마치 컬러 패치워크로 화려하게 장식된
대형 그래픽월처럼 보인다. 하지만 로비에
진입하여 가까이 다가갈수록 각각의 색 면 위에,
혹은 하단의 흰 종이 위에 검정색의 단호한
글자들로 선명하게 인쇄된 텍스트를 인지하게
되면서 우리는 각각의 문장들을 읽기 위해 벽면
앞에 바짝 붙어 멈춰 서게 된다.

로비는 미술관 외부에서 내부로, 다시 전시실로
이동하기 전, 전시를 관람하기 위해서가
아니더라도 미술관을 휴식과 만남의 장소로
이용하는 이들의 열린 광장이 된다. 로비 정면에
위치한 이 거대한 벽은 누구도 주목하지 않았던
그저 비워진 흰 여백이었다. 몇 차례 회화 작품이
걸리거나 퍼포먼스의 배경이 되거나 혹은
프로젝션을 위한 스크린으로 활용되었던 때를
제외하면 대부분의 시간 동안 존재가 지워진
장소였다. 이러한 공허의 장소는 홀저의 포스터가
벽면을 가득 채우고 난 뒤 생동하는 공간으로
변모한다. 공감의 제스처로 고개를 끄덕이거나,
도무지 알 수 없다는 듯 고개를 갸웃거리는
사람들, 마음에 들어온 문장을 스마트폰으로
촬영하거나 자신의 SNS 계정에 포스팅하는
이들까지. 모두 각자의 방식으로 누군가와 대화를
나눈다.

높이 약 9.4m, 너비 45m에 이르는 광활한 로비의
현장 설치를 위해 약 1600장 이상의 포스터를
새롭게 제작·설치하였고, 두 작품이 대각선을
이루며 사선으로 겹쳐지는 레이아웃을 적용하여
시각적으로도 매우 역동적인 풍경이 연출되었다.
특히 이번 전시를 위해 240개의 문구로
이루어진 작가의 〈경구들〉시리즈는 4인의 공동
번역자와 협업으로 번역하여 국문으로 처음
선보이게 되었으며 관람객의 적극적인 해석과
참여를 가능하게 하였다.[2]

홀저의 첫 번째 텍스트 작업이자 가장 잘 알려진
〈경구들〉시리즈는 250여 개가 넘는 문장으로
이루어진 작품으로, 현존하는 경구(aphorisms),
격언(maxims), 그리고 상투적인 문구(clichés)의
형식을 차용한다. 이 시리즈는 특히 1977년
홀저가 참여했던 휘트니 미술관 독립연구프로그램
(Independent Study Program)에서 론 클락
(Ron Clark)이 제공한 추천 도서 목록으로부터
영향을 받았다. 각각의 문장은 복잡하고
어려운, 논란의 소지가 있는 아이디어를 간결하고
직접적인 발언으로 정제하여 표현하고, 그 어떤
입장도 고수하지 않은 채 사회적 믿음, 관습,
그리고 진실을 탐구한다. 알파벳 순으로 나열된
〈경구들〉의 문구들은 맨하탄 거리에 익명의
포스터 형식으로 처음 배포되었으며(fig. 1)
이후 티셔츠, 모자, 전광판, 보도, 돌 벤치 등에
새겨졌다.

이와 함께 화려한 색상의 패턴으로 시선을 끄는
포스터 작품은 작가가 직접 저술한 두 번째
텍스트 작업 〈선동적 에세이〉로 각각 100개의
단어로 이루어진 텍스트 컬렉션이다.(fig. 2)
색지에 인쇄되어 맨하튼 도심에 부착되었던
이 글들은 홀저가 접한 정치, 유토피아,
예술, 종교에 관한 글과 선언문 등에 영감을 받아
제작되었다. 각 글의 어조는 선언문의 형식을
차용해 단호하며 특정한 입장을 지지하는 것이
특징이다. 홀저는 독자가 개인의 성격으로부터
분리된 이데올로기만을 가늠할 수 있도록
자신의 목소리를 배제하고 주어가 생략된 익명의
문장을 제시하고 있다. 이 글들을 통해 우리는
사회 변화의 필요성, 대중조작의 가능성, 그리고
혁명에 따르는 조건들에 대해 고민하게 된다.

2
Whenever the *Truisms* are exhibited,
the statements are arranged in
alphabetical order. If they have been
translated from the original English,
they are rearranged to be in alphabetical
order in the new language. In this
exhibition, 240 *Truisms* are presented
on eight posters, each containing
thirty statements that are arranged in
order of Hangeul, the Korean alphabet.
'경구들(Truisms)'은 그동안의 전시,
프로젝트, 출판 등을 통해 여러 국가의
언어로 번역되었다. 영문의 경우
A-Z까지 알파벳 순으로 배열된 것과 달리
번역된 경우에는 고유의 언어가 갖는
표기 순서에 따라 재배치되는 특성이 있다.
이번 프로젝트를 위해 국문으로 번역된
한글 포스터의 경우에도 240개의
경구들이 '가나다' 순으로 배치되어 있다.
각 포스터에는 30개의 경구들이
포함되어 있으며 총 8장의 포스터가 모여
전체를 이룬다.

3
Hal Foster, "Subversive Signs,"
in *Recodings : Art, Spectacle,
Cultural Politics* (Seattle : Bay Press,
1985), 100.

4
Byung-Chul Han, *Psychopolitics :
Neoliberalism and New Technologies of
Power*, trans. Erik Butler (London :
Verso, 2017), v, 11.
한병철 (Han Byung-chul),
『심리정치』 (서울 : 문학과 지성사, 2015),
김태환 옮김, 24.

As an unknown artist starting out, Holzer sought to differentiate herself from previous generations by posting text-based works directly in the public sphere, rather than trying to produce elaborate objects or images. This strategy reflects Hal Foster's theory of the new conceptual artist as a "manipulator of signs," rather than a "producer of art objects." For Foster, artists such as Holzer who "treat the public space, social representation or artistic language ... as both a target and a weapon" elevate the viewer's role from "passive contemplator" to "active reader."[3] Rather than simply looking at a traditional painting or sculpture, viewers of Holzer's posters are compelled to spend extra time reading and deciphering the text. By enacting the reading process, Holzer's works become interactive mechanisms prompting conversation within and among viewers, each of whom assigns his or her own meaning. Pondering the possible implications of the text — both overt and latent — viewers become active subjects rather than passive spectators.

This transition becomes evident when looking at the original *Truisms* that Holzer posted in New York, which were aggressively underlined, edited, scribbled and written on by anonymous passersby. For instance, a photograph taken during the 1990 Venice Biennale shows a *Truisms* poster on a Venice street with the words "PROPAGANDA IS NOT A FORM OF ART" scrawled on it in large letters.(fig. 3) The image is a stark representation of the shock, anger, or anxiety that Holzer's unconventional work evidently stirred in someone.

As mentioned, since their original presentation as street posters, Holzer's *Truisms* have proliferated in various forms. In 1982 and 1985, through the support of the Public Art Fund, various Holzer texts, including "ABUSE OF POWER COMES AS NO SURPRISE" and "PROTECT ME FROM WHAT I WANT," were displayed on a large electronic sign in Times Square.(fig. 4) Puzzling pedestrians with such unexpected messages, the Times Square displays exemplify Holzer's strategy of artistic intervention, in which she appropriates public space to raise questions about excessive consumerism, false advertising, media distortions, and other social issues.

In his book *Psychopolitics*, philosopher Byung-Chul Han cites "PROTECT ME FROM WHAT I WANT" as a concise summation of the tragedy of contemporary neoliberalism. According to Han, we are now living in the "age of digital psychopolitics," wherein people are coerced by the illusion of freedom to voluntarily expose themselves on the internet and social media, allowing their data to be quantified, analyzed, and exploited.[4] Written more than forty years ago, the *Truisms* are remarkably apt in their discernment of our current dystopian times, in which human desire is routinely hijacked by unseen others equipped with advanced technology. Indeed, the ongoing relevance of *Truisms* signals that our "rapidly changing" world might actually be more static than it seems, and that we must never stop questioning the verities of contemporary life.

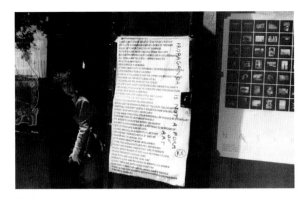

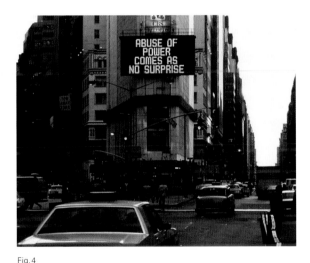

홀저는 소수의 특별한 계층만이 소유하거나 감상할 수 있는 값비싼 오브제와 이미지의 예술품을 제작하는 대신 다수의 대중이 마주하는 거리에 포스터를 붙이는 텍스트 작업을 통해 익명의 거리 미술가로 활동을 시작했다. 할 포스터 (Hal Foster)가 홀저를 비롯한 당시 후기 개념미술 작가들에 대해 '오브제의 제작자'가 아닌 '기호의 조정자'가 되었다고 정의한 바와 같이 그는 이전 세대의 미술과 차별화 되는 전략을 펼치고자 했다. 이들이 공적 공간을 대상으로 자신들이 조정하고자 하는 사회적 표상 체계, 혹은 예술적 언어를 표적이자 무기로 삼고, 관객을 '수동적 관조자(passive contemplator)'가 아닌 메시지를 읽는 '능동적 독자(active reader)'로 전환시킨 것처럼3 홀저의 텍스트 작업은 관람자의 역할을 확장하는데 기여하였다. 관객이 그림이나 조각과 같은 전통적인 조형적 오브제를 시각적으로 감상하는 것과 달리 텍스트를 도입한 작품은 주어진 텍스트는 물론 그 행간 까지를 읽어 내기 위해 꽤 오랜 시간 집중해야 한다. 또한 이 과정에서 관람자는 텍스트를 스스로 독해하는 의미 생산의 주체자로 작품에 개입한다. 홀저의 작업은 이러한 읽기의 과정을 통해 작가가 제시한 텍스트에 대해 각자의 의미를 부여하게 된 관람객 스스로, 혹은 그들 사이에 대화를 유발하는 상호작용의 매개로 작동한다.

본래 거리에 부착된 포스터에서 출발한 〈경구들〉 의 설치 전경에서 우리는 '능동적 독자' 혹은 '참여자'로서의 관객들을 보다 명확히 확인할 수 있다. 당시 포스터 위에 제시된 문장들에 대해 현장의 관객들(행인들)은 일부 구절에 밑줄을 치거나 본인의 의견을 밝히는 낙서, 단어의 수정, 변형, 혹은 새로운 제안 등을 표시했다. 1990년 베니스 비엔날레를 위한 미국관의 전시와 함께 거리에 부착되었던 〈경구들〉 포스터의 사진(fig.3) 속에는 "PROPAGANDA IS NOT A FORM OF ART"라는 문장이 포스터 위에 세로로 커다랗게 쓰여 있다. 이 장면 속에는 당시 홀저의 작업이 기존의 미술과 다르다는 것에 대해 누군가 느낀 충격, 분노 혹은 불안감이 그대로 표출되어 있다.

앞서 거리의 포스터로 선보였던 홀저의 경구들은 이후 더욱 다양한 형태로 확장되어 왔다. 특히 대중예술기금(Public Arts Fund)의 후원을 통해 1982년과 1985년 뉴욕 타임스퀘어의 거대한 전광판 위에 노출된 "내가 원하는 것으로부터 나를 지켜줘(PROTECT ME FROM WHAT I WANT)", "권력의 남용이 놀라운 일은 아니다 (ABUSE OF POWER COMES AS NO SURPRISE)"와 같이 예기치 않은 문구들은 행인들의 이목을 끄는데 성공했다.(fig.4) 번쩍이는 빛으로 끊임없이 발화하던 전광판 속 홀저의 텍스트들은 당시 과도한 소비문화의 확산, 광고와 대중매체로 인한 진실의 왜곡 등 사회적 문제들에 의문을 제기하고, 예술적으로 개입하고자 했던 작가의 공간적 전략에 일치하는 것이었다.

철학자 한병철은 그의 책『심리정치 Psychopolitik』에서 1982년 타임스퀘어에 투사되었던 홀저의 경구 "내가 원하는 것으로부터 나를 지켜줘(PROTECT ME FROM WHAT I WANT)"를 오늘날 신자유주의 체제의 비극을 통찰하는 문장으로 인용하였다. 그가 '디지털 심리정치의 시대'라 명명한 현대 사회의 자유 (라는 착각) 속에서 개인은 소셜미디어를 통해 누군가의 강압적 명령 없이도 스스로를 노출하게 되고 이는 끊임없이 데이터로 측정, 분석되어 결국 착취의 자원으로 전환된다.4 첨예한 기술의 발달 속에서 인간의 욕망이 누군가의 조작에 의해 조종되고 있는 디스토피아적 시대상을 40여 년 전에 쓰여진 홀저의 텍스트는 더욱 명징하게 드러낸다. 그의 문장들이 시대를 초월해 현재까지 유효한 것은 변화했다고 여기는 세상이 그다지 변하지 않았음을, 혹은 불변함을 증명함과 동시에 우리가 믿고있는 세상의 진실과 진리에 관한 질문을 멈추지 않아야 함을 다시금 일깨운다.

Selections from Truisms, 2019

In 1986, Holzer began carving her messages on stone benches, conveying a certain solemnity and permanence.(fig. 5) Taking the form of everyday objects commonly found in parks or cemeteries, these works achieve Holzer's goal of making art more accessible, while opening new spaces for discussion and contemplation. Unlike her colorful posters or glowing signs, the marble and granite objects convert ephemeral language into permanent sculptures, suggesting new possibilities for interpretation. As the artist herself stated in the press release for her 2019 exhibition at the Guggenheim Museum in Bilbao, "When words are carved in stone, they can be touched, they can be read with the hand; they might be perceived differently than when on the page."

On her first visit to MMCA Gwacheon in 2017, in preparation for this project, Holzer expressed her wish to make a new carving in the natural environment around the museum, preferably in a secluded cave or natural outcropping of rock. Unfortunately, no such area of natural rock could be found, since most of the surrounding space has been extensively landscaped and developed to create the museum's sculpture garden. After some discussion, Holzer's conception of "natural space" was expanded to include the architectural elements of the museum itself, many of which (e.g., the main building, the walls and pavement leading to the building, and the bridge over the lake) are made from natural granite.

Although granite is Korea's cheapest and most common type of stone, many architects working here prefer to use Italian marble or some other imported stone with a higher pedigree. In his design for MMCA Gwacheon, however, Kim Taesu (b. 1936) consciously sought to integrate the building with the surrounding natural space, and was thus inspired to use granite while looking at nearby Cheonggyesan Mountain. Considered a bold choice at the time, Kim's decision to use granite greatly enhanced the museum's harmony with the environment, which is why his superb design has stood the test of time for more than thirty years.[5]

For this exhibition, Holzer produced a permanent installation of *Truisms* at MMCA Gwacheon by having eleven statements engraved (in both Korean and English) on the railing of the stone bridge that traverses the pond near the main entrance.[6] Designed as a type of portal between the museum and the outer world, this bridge (which also serves as a dam) offers a comprehensive view of the museum, mountains, and surrounding landscape.[7] From now on, people who come to this spot seeking respite from the clamor of city life will inadvertently come across Holzer's provocative statements:

지나친 의무감은 당신을 구속한다
(A STRONG SENSE OF DUTY IMPRISONS YOU)
YOU ARE GUILELESS IN YOUR DREAMS
따분함은 미친 짓을 하게 만든다
(BOREDOM MAKES YOU DO CRAZY THINGS)
SOLITUDE IS ENRICHING
선택의 자유가 있다는 것을 늘 기억하라
(REMEMBER YOU ALWAYS HAVE FREEDOM OF CHOICE)
YOU ARE THE PAST PRESENT AND FUTURE
가질 수 없는 것은 언제나 매력적이다
(THE UNATTAINABLE IS INVARIABLY ATTRACTIVE)
LISTEN WHEN YOUR BODY TALKS
모든 것은 미묘하게 서로 연결되어 있다
(ALL THINGS ARE DELICATELY INTERCONNECTED)
RAISE BOYS AND GIRLS THE SAME WAY
당신의 모든 행동이 당신을 결정한다
(THE SUM OF YOUR ACTIONS DETERMINES WHAT YOU ARE)

Each of these statements was delicately carved into the railing, making them impossible to see from any distance. Indeed, many people will surely walk right over the bridge without realizing that they are in the presence of a work by one of the world's foremost artists. Significantly, Holzer also dissuaded the museum from promoting the work or even mentioning it in museum guides, staying true to the original intention of *Truisms*, which avoided association with a unified author. No longer bound by alphabetical order, the statements on the bridge are rearranged to suggest "delicately interconnected" sentences. Encountering these mysterious words, people will doubtless pause to ruminate and question the statements, pricking up their ears to the sounds that resound within them. By eliciting such reflections, the bridge truly becomes a space of transference.

5
Kim Taesu, interview in *MMCA 1986: Gwacheongwan-ui gaegwan* (Seoul: MMCA, 2016), 46.
김태수 인터뷰, 『국립현대미술관 1986 과천관의 개관』, 2016, 46.

6
According to Kim Taesu, both the bridge and pond were inspired by the pathways to Korean Buddhist temples, which often feature bridges across reflecting pools or descending streams. Kim, interview in *MMCA 1986*, 50.
김태수는 인터뷰를 통해 우리나라의 절에 진입하는 공간에 '반사되는 연못(reflecting pool)'이 포함되고, 물이 흘러내려가면서 다리를 건너 접근하도록 하는 것이 매우 좋은 배치(real nice sequence)라 생각했다고 언급하였다. 또한 물이 있는 공간을 만들면 자연스럽게 다리가 생길 수 있기 때문에 미술관으로 들어가는 입구에 댐을 만들어 물을 담는 공간을 기획했다고 밝혔다. 위의 책, 50.

7
The bridge is approximately 2.1 meters wide and 51 meters long; each statement is carved into a block (90 cm × 60 cm) forming the parapet. The engraved blocks are separated by four blank blocks, allowing people to easily read and absorb each text.
다리의 총 길이는 약 51 m, 폭은 2.1 m이며 경구들이 새겨진 난간은 각각 가로 90 cm, 세로 60 cm의 블록 53개로 이루어져 있다. 각각의 경구가 새겨진 블록 사이마다 4개의 블록은 비워진 상태로 두어 관람객이 텍스트를 온전히 감상할 수 있는 여백의 공간을 남겨 두었다.

홀저는 1986년부터 대리석, 화강암과 같은
자연석으로 제작된 석재 벤치에 글자를 조각하는
작업을 선보이기 시작했다. 도시의 공원이나
공동 묘지에서 찾아볼 수 있는 구조물과 비슷한
석재에 새겨진 그녀의 작품은 일종의 근엄성과
영구성을 내재하며 논의의 공간을 제공한다.(fig. 5)
일상의 사물 혹은 환경적 요소로 그의 작품이
존재하는 것은 관객에게 글을 읽고 사유할 수 있는
기회를 제공하고자 한 작가의 의도와 더불어
예술의 일상화를 실천하는 작업 방식이다.
형형색색의 포스터, 빛과 색으로 눈길을 사로잡는
LED 사인이나 초대형 라이트 프로젝션과 달리
석조물에 새겨진 홀저의 작품은 부유하는 언어를
영구적인 조각의 형태로 변형시킴으로써
작가의 텍스트를 새로운 방식으로 이해할 수 있는
대안을 제시한다. 2019년에 개최된 빌바오
구겐하임 미술관 회고전에서 작가가 언급한 바와
같이, "돌에 새겨진 글자는 만질 수 있고,
차갑고 단단한 촉감을 느끼며 읽을 수 있으며,
인쇄 매체로 구현된 텍스트와는 전혀 다른 감각을
전달할 수 있다."

Fig. 5
Truisms : A relaxed man…, 1987
Danby Royal marble bench
17 × 54 × 25 in. / 43.2 × 137.2 × 63.5 cm
Text : *Truisms*, 1977–79
Installation : *Benches*, Doris C. Freedman Plaza, New York, 1989
©1989 Jenny Holzer,
member Artists Rights Society (ARS), NY / SACK, Seoul
Photo : David Regen
〈경구들 : 느긋한 남자가…〉, 1987
댄비 로열 대리석 벤치
17 × 54 × 25 in. / 43.2 × 137.2 × 63.5 cm
텍스트 : 〈경구들〉, 1977–79
설치 : 벤치들, 뉴욕 도리스 C. 프리드먼 플라자, 1989
©1982 제니 홀저, 뉴욕예술가권익협회 / 한국미술저작권관리협회
사진 : 데이빗 베겐

홀저가 지난 2017년 이번 프로젝트를 위해
처음으로 과천관을 방문하였을 당시 염두에 둔
곳은 미술관 주변의 숲이었다. 정확히 말하자면
깊은 숲 속에 숨겨져 있을 법한 동굴이나 너른
돌로 이루어진 어떤 지형이었다. 하지만 아쉽게도
과천관은 개관 당시 광대한 야외조각장을
겸비한 현대미술관의 건립을 추진하기 위해 해당
부지를 대규모로 개간하여 공간을 조성한 곳으로
미술관 주변의 진정한 자연석 지대를 찾아낸다는
것은 불가능한 일이었다. 수 차례의 논의를
거쳐 우리는 홀저가 제시한 공간의 의미를
좀 더 확장하여 과천관을 구성하는 석조 건축물
자체가 하나의 자연 경관을 조성하는 '환경'적
요소에 가깝다는 것. 특히 미술관 본관
건물을 비롯하여 진입로의 성벽, 보도, 호수와
연결된 다리 등 모든 건축적 요소가 자연석
(화강암)을 이용하여 자연스럽게 주변 환경과
어우러지고 있음에 주목했다.

과천관의 건축가인 김태수(1936–)는
과거 인터뷰를 통해 건물의 재료를 선택하기
위해 과천관 부지를 방문하였을 때 이 곳을 감싸고
있는 청계산에서 보여지는 화강암의 색상과
질감으로부터 아이디어를 얻었다고 밝혔다. 당시
이태리산 대리석과 같이 고급 재료로 여겨졌던
수입 석재 대신 "한국에서 가장 값싸고 흔한
돌"이라 여겨 당시 건물에는 잘 쓰이지 않았던
화강암을 과감하게 미술관의 건축 재료로
사용한 건축가의 미감은5 미술관이 자리한 지리적
위치와 환경에 자연스럽게 어우러져 30년이
넘는 지금에도 여전히 유효한 감각을 드러낸다.

이번 프로젝트의 일환으로 홀저는 과천의 야외
조각 공원에 위치한 석조 다리 위 난간에
그가 선정한 11개의 문구들을 국문과 영문으로
새긴 영구 설치작품 〈경구들에서 선정된
문구들〉을 선보인다. 석조 다리는 미술관 정면의
연못 혹은 작은 호수를 연상시키는 물의 공간
위에 자리하고 있다.6 댐이자 다리인 이 석조
구조물 위에 서면 미술관을 품고 있는 산과, 건축물
그리고 수면 위에 담긴 풍경이 모두 어우러져
미술관의 평화롭고 고요한 풍경을 가장 온전히
감상할 수 있음과 동시에 분주한 도심에서의
삶의 속도를 잠시 늦추게 된다. 건축가의
의도대로라면 이 다리는 미술관과 외부 세계를
연결하는 길이며 하나의 전이(轉移) 공간이다.
이 곳에서 관람객은 우연히 홀저의 문구들을
마주하게 된다.

지나친 의무감은 당신을 구속한다
(A STRONG SENSE OF DUTY IMPRISONS YOU)
YOU ARE GUILELESS IN YOUR DREAMS
(사람은 꿈 속에서 솔직하다)
따분함은 미친 짓을 하게 만든다
(BOREDOM MAKES YOU DO CRAZY THINGS)
SOLITUDE IS ENRICHING
(고독은 사람을 풍요롭게 한다)
선택의 자유가 있다는 것을 늘 기억하라
(REMEMBER YOU ALWAYS HAVE FREEDOM OF
CHOICE)
YOU ARE THE PAST PRESENT AND FUTURE
(당신은 과거이고 현재이며 미래다)
가질 수 없는 것은 언제나 매력적이다
(THE UNATTAINABLE IS INVARIABLY
ATTRACTIVE)
LISTEN WHEN YOUR BODY TALKS
(자신의 몸이 하는 말을 들어라)
모든 것은 미묘하게 서로 연결되어 있다
(ALL THINGS ARE DELICATELY
INTERCONNECTED)
RAISE BOYS AND GIRLS THE SAME WAY
(여자 아이와 남자 아이를 똑같이 양육하라)
당신의 모든 행동이 당신을 결정한다
(THE SUM OF YOUR ACTIONS DETERMINES
WHAT YOU ARE)

작가가 선택한 11개의 문구는 다리의 난간 위에
음각으로 새겨져 있다.7 각각의 문장들은
멀리서 바라보았을 때 눈에 띄지 않을 정도로
섬세하게 조각되었다. 다리 위를 지나가더라도
눈여겨보지 않는다면 작품의 존재를
알아차리기 힘들다. 또한 작가는 작품의 명제표나
안내도 최소화 하기를 원했다. 이는 단일한
'저자'의 목소리를 지우고자 했던 〈경구들〉의
태생적 의도와 같이 익명의 작품으로 존재하길
원했던 작가의 의도에 부합한다. 여기에는
앞서 포스터에서 보았던 진술들의 구조적
순서와는 관계 없이 "미묘하게 서로 연결되어
있는" 듯한 문장들이 재배치 되어있다.
누군가 홀저의 문장과 마주하여 자신이 선택한
텍스트를 천천히 들여다보고 질문을 던지며,
각자의 내면에 공명하는 소리에 귀 기울이는 순간
이 곳은 일상에서의 전이 공간, 사유의 장소가
된다.

FOR YOU, 2019

Sharing its title with the exhibition, *FOR YOU* is a robotic LED work that hangs from the ceiling inside the MMCA Seoul Box, a massive cube (23.4 meters in width and length, 16.6 meters in height) that serves as one of the main hubs of the museum.[8] From the lobby, the elongated work (6.4 meters in height) with vertically scrolling text resembles the mast of a ship on the horizon, bobbing in and out of sight. To get a closer look, visitors must go downstairs to enter the Seoul Box, where they can look up to read the text against the shimmering fragments of light. Not coincidentally, in lifting our gaze, we also make the necessary movement to open our ears to other voices. People's eyes are riveted by the steadily flowing text, especially when combined with the seemingly random (but programmed) motion of the LED column itself. The resonance of the luminous text is magnified by the sheer emptiness of the space, which stands in striking contrast to the glut and profusion of contemporary life.

Starting in the late 1980s, Holzer began using LEDs in her work, including installations at the Dia Art Foundation (1989), the Guggenheim Museum (1990), and the Venice Biennale (1990). While most of the LED signboards and electronic media of the 1980s simply conveyed direct messages, Holzer emphasized the sculptural qualities of these devices, using the fluctuating light, swift flow, and gentle fade of their letters to transform spaces. In her more recent LED projects — including *FOR YOU*, which was commissioned for this exhibition — Holzer employs robotic systems to perform certain movements, thereby increasing the level of intervention with both individual viewers and the space.[9]

Between 1977 and 2001, Holzer created thirteen text series.[10] Over time, she used the texts from these series in a wide variety of different media, sometimes combining different series in the same piece. After writing *Oh* for her exhibition at the Neue Nationalgalerie in Berlin in 2001, she stopped creating new series and began using historical documents, along with poems and other literary works by writers such as Henri Cole, Wisława Szymborska, Elfriede Jelinek, and Anna Świrszczyńska.[11] In recent works, she has addressed traumatic events related to the United States' "War on Terror".[12] (fig. 6) She has also worked with Human Rights Watch, Save the Children, the Office of the United Nations High Commissioner for Refugees, and other nonprofit organizations to collect and share the testimonies of individuals suffering around the world.

Fig. 6
For the City, 2005
Light projection
Elmer Holmes Bobst Library, New York University
October 3 – 5, 2005
Text: U.S. government document
Presented by Creative Time
© 2005 Jenny Holzer,
member Artists Rights Society (ARS), NY / SACK, Seoul
Photo: Attilio Maranzano
〈도시를 위하여〉, 2005
라이트 프로젝션
뉴욕대학교 엘머 홈스 봅스트 도서관
2005년 10월 3 – 5일
텍스트: 미국 정부 문서
크리에이티브 타임 기획
© 2005 제니 홀저, 뉴욕예술가권익협회 / 한국미술저작권관리협회
사진: 아틸리오 마란자노

이번 프로젝트와 동명의 로봇 LED 작품 〈당신을 위하여〉가 서울박스에 자리하고 있다. 서울박스는 가로·세로 약 23.4 m, 높이 16.6 m에 이르는 거대한 큐브이자, 미술관의 전시 공간으로 이동하기 위해 관람객들이 동선이 서로 교차하게 되는 허브 공간이다. 홀저는 이 곳의 천정에 6.4 m 길이의 움직이는 대형 LED 작품을 제안하였다.8 로비에서 바라보는 홀저의 작품은 마치 수평선 너머로 출렁이는 배의 돛대와 같이 모습을 드러냈다 잠기기를 반복하며 궁금증을 자아낸다. 좀 더 가까이에서 작품을 보기 위해 아래 층으로 내려가 서울박스 공간 안에 서면 아름다운 빛의 파편 속에 흘러나오는 텍스트가 눈에 들어온다. 오르내리는 움직임 속에서 나타났다 흩어지는 문장들을 읽기 위해 고개를 들어야 한다. 머리 위를 향해 시선을 옮기는 제스처는 다른 곳의 목소리에 귀 기울이기 위해 우리가 취해야 할 움직임의 시작이다. 점멸하는 표면 위로 흘러가는 텍스트와 예측할 수 없는 LED 기둥의 속도와 움직임은 관람자의 시선을 강력하게 붙든다. 모든 것이 높은 밀도로 가득 찬 일상에 비해 비현실적으로 느껴지는 비워진 공간 속에서 글자를 새기며 빛나는 조각 하나는 오히려 더 크게 공명한다.

1980년대 후반부터 홀저는 LED를 이용하여 본격적인 실내 설치 작업을 진행했다. 디아 재단 (1989), 구겐하임 미술관(1990), 베니스 비엔날레 미국관(1990)의 설치 작품 등이 초기 LED 사용의 대표적 사례였다. 1980년대 LED와 같은 전광 매체가 뉴스, 선전 등과 관련해 직접적인 '성명'의 도구로 사용되었던 것과 달리 홀저는 작품의 조각적인 측면을 부각시키고, LED의 빛과 움직임을 통해 공간을 예측할 수 없는 장소로 변환시키는 도구로 적극 활용하였다. 또한 부드럽게 점멸하는 LED 위의 문자는 일시성과 속도감을 가지게 되면서 공간에 침투하고 시선을 사로잡는다. 신작 〈당신을 위하여〉를 포함하여 작가가 최근의 프로젝트들9 에서 선보인 LED 작업들은 로봇 시스템을 적용하여 스스로 어떤 움직임을 수행하며 작품이 설치된 공간을 보다 적극적으로 점유하고, 텍스트의 흐름을 따라잡으려는 관람객의 시선과 소통의 움직임에 관여한다.

홀저는 1977년과 2001년 사이에 본인이 직접 작성한 13개의 텍스트 시리즈를 선보였다.10 그는 이 텍스트 시리즈를 매우 다양한 매체들을 통해 구현하였고, 때로는 서로 다른 시리즈를 발췌, 결합하여 한 작품에 적용하기도 했다. 2001년 베를린 내셔널 갤러리(Neue Nationalgalerie, Berlin)의 전시를 위해 제작한 〈오(Oh)〉 이후 작가는 자신의 글쓰기를 중단하고 역사적이고 기록화 된 자료를 발췌하거나 여러 문학 작가들의 시 등을 차용한 작업으로 텍스트의 영역을 확장해왔다.11 그는 헨리 콜(Henri Cole), 비스와바 심보르스카(Wisława Szymborska), 엘프리데 옐리네크(Elfriede Jelinek), 안나 스위르(Anna Świrszczyńska)와 같은 문학 작가들의 시와 산문을 차용하여 작품을 제작하는 한편 최근에는 미국이 '테러와의 전쟁' 선포 후 자행해온 이라크와 아프가니스탄 전쟁에 관하여 기밀 해제된 정부 문서, FBI 이메일, 전쟁에 참가한 병사들 혹은 역사적 비극에 희생된 피해자들의 증언을 통해 전쟁 이후의 트라우마를 폭넓게 다루고 있다.12 (fig. 6) 또한 전 세계의 고통 받고 있는 개개인의 목소리, 증언을 수집하기 위해 국제인권감시단 (Human Rights Watch), 세이브 더 칠드런(Save the Children), 유엔난민고등판무관실(the Office of the United Nations High Commissioner for Refugees) 등을 포함한 비영리 단체들과 협력하기도 한다.

8
A long and thin LED column (approximately 6.4 meters [21 feet] in height, 12.7 centimeters [5 inches] in width and length) was installed on the Seoul Box ceiling. It was produced and installed expressly for this high-ceilinged location, featuring a robotic system for up and down movement. Various motions are programmed in a cycle that lasts approximately seven hours and thirty minutes, featuring vertical movements as fast as 4 ft/s (1.22 m/s).
약 6.4 m (21 ft) 길이에 가로·세로 폭이 12.7 cm (5 in)인 가늘고 긴 LED 기둥 하나가 서울박스 천정에 설치되었다. 작품은 두 개 층을 가로지르는 높은 층고를 지닌 장소의 특성에 맞추어 제작·설치된 로봇 시스템에 의해 상하로 움직인다. 약 7시간 30분 정도의 길이로 다양한 모션이 프로그래밍 되어 있으며 최대 4 ft/s (1.22 m/s) 속도로 빠르게 내려오거나 올라갈 수 있다.

9
Including the solo exhibitions Are You Alive? at Art Projects Ibiza, Spain, June 21–December 17, 2016; and SOFTER: Jenny Holzer at Blenheim Palace, Woodstock, England, September 28–December 31, 2017.
스페인, 아트 프로젝트 이비자, 《Are You Alive?》(2016년 6월 21일–12월 17일)와 영국, 우드스톡에서 개최된 《SOFTER: Jenny Holzer at Blenheim Palace》 (2017년 9월 28일–12월 31일)를 포함한 작가의 개인전.

10
Truisms (1977–79), Inflammatory Essays (1979–81), Living (1980–82), Survival (1983–85), Under a Rock (1986), Laments (1989), Mother and Child (1990), War (1992), Lustmord (1993–95), Erlauf (1995), Arno (1996), Blue (1998), and Oh (2001).
〈경구들(Truisms)〉(1977–79), 〈선동적 에세이(Inflammatory Essays)〉 (1979–81), 〈삶(Living)〉(1980–82), 〈생존(Survival)〉(1983–85), 〈바위 아래(Under a Rock)〉(1986), 〈애도(Laments)〉(1989), 〈어머니와 아이(Mother and Child)〉 (1990), 〈전쟁(War)〉(1992), 〈쾌락살인(Lustmord)〉(1993–95), 〈에어라우프(Erlauf)〉(1995), 〈아르노(Arno)〉(1996), 〈블루(Blue)〉 (1998), 〈오(Oh)〉(2001)

11
Joan Simon, "Other Voices, Other Forms," in Jenny Holzer: PROTECT PROTECT (Ostfildern: Hatje Cantz, 2008), 12.

12
Meredith A. Brown, "Disconsolate Tongues: The Visual Language of Trauma and Survival," in Everything Is Connected: Art and Conspiracy (New York: Metropolitan Museum of Art, 2018), 137. Brown writes, "In recent years [Holzer] has turned to the language of war—and its resulting traumas—as the subject of her art. In response to the launch of the so-called War on Terror and the United States' invasions of Iraq and Afghanistan, Holzer began to use the bureaucratic language of declassified, often heavily redacted government documents related to U.S. policy in the Middle East."

All the text in *FOR YOU* was selected by Holzer from the works of the five aforementioned women authors. Running on a cycle of approximately four and a half hours, the selected text unravels the stories of ordinary people (especially women) victimized by war, violence, oppression, and social disaster.[13] Transmitted via the mesmerizing screen of the LED column, these narratives allow us to leave ourselves and temporarily inhabit the lives of "the Other."

Since the text runs on a continuous loop, everyone who encounters *FOR YOU* does so *in medias res*. Entering the space, viewers must immediately begin to piece together the fragmentary, vanishing words to form some coherent meaning. In this way, each narrative is selectively edited by the viewer in a deconstructive fashion. Narrated by those who suffered, witnessed, or investigated historical tragedies, the selected excerpts raise profound questions of gender and sexuality, vulnerability, abuse of power, oppression, and eventually, life and death. Using scathing yet poetic language, Holzer undertakes what Krzysztof Wodiczko has described as the act "of revealing what no one wants to hear…of obscuring the boundaries of what is appropriate and what is not, [and of] helping others undertake these actions."[14]

Does Holzer's work help others (i.e., you and me) undertake these actions? No matter how deeply we are affected, the work cannot translate our emotion into action. As Susan Sontag memorably noted, "To set aside the sympathy we extend to others beset by war and murderous politics for a reflection on how our privileges are located on the same map as their suffering, and may — in ways we might prefer not to imagine — be linked to their suffering, as the wealth of some may imply the destitution of others, is a task for which the painful, stirring images supply only an initial spark."[15]

In recording the pain of the past, *FOR YOU* reminds us that we must never ignore those who are still suffering (and will continue to suffer) amidst the persistent war, violence, and oppression of the present and future. In our society of spectacle, we have become accustomed to the powerless feeling of glimpsing global suffering through images, which make it seem distant and unreal. The very fact that we have survived the horrors of contemporary life should make us feel indebted to those who have not been so fortunate. By listening to "you" instead of "me," each of us can become a new witness who refuses to overlook the prevalent problems of our world. By delivering the stories and memories of "you" (i.e., the "Other") to all of us, Jenny Holzer's art ultimately engenders empathy, healing, communication, and recovery.

13
FOR YOU includes the following texts: twenty poems in English by Emily Jungmin Yoon, from *A Cruelty Special to Our Species* (New York : Ecco, 2018); sixteen poems in Korean by Kim Hyesoon, from 죽음의 자서전 (Seoul: Munhaksilhumsil, 2016), and five in English (trans. Don Mee Choi), from *Autobiography of Death* (New York : New Directions, 2018); one poem in Korean by Han Kang, from 서랍에 저녁을 넣어 두었다 (Seoul: Moonji Publishing, 2013), and in English (trans. Deborah Smith and Sophie Bowman, unpublished, 2018); excerpts in English from Svetlana Alexievich, *The Unwomanly Face of War: An Oral History of Women in World War II*, trans. Richard Pevear and Larissa Volokhonsky (New York : Random House, 2018); and excerpts in English from the website of Hawzhin Azeez, 2016–18, http://hawzhin.press.
〈당신을 위하여〉 작품을 위해 선택된 텍스트는 다음과 같다.
에밀리 정민 윤, 『A Cruelty Special to Our Species』(Ecco, 2018) 중 20편의 시 (영문) / 김혜순, 『죽음의 자서전』 (문학실험실, 2016) 중 16편의 시(국문)와 최돈미 번역, 『Autobiography of Death』 (New Directions, 2018) 중 5편의 시 (영문) / 한강, 『서랍에 저녁을 넣어 두었다』(문학과지성사, 2013) 중 1편의 시 (국문) 및 영문판 데보라 스미스와 소피 바우만 번역 (2018, 미출간) / 스베틀라나 알렉시예비치(Svetlana Alexievich), 『The Unwomanly Face of War』 (Random House, 2018)에서 일부 발췌 (영문) / 호진 아지즈(Hawzhin Azeez), 웹사이트에서 일부 발췌(2016– 18), http://hawzhin.press.

〈당신을 위하여〉에서 홀저는 다섯 명의 작가의
글을 통해 차용된 '여성' 화자의 목소리로
전쟁의 폭력, 정치적 억압, 혹은 사회적 참사로
인해 인권을 유린당한 평범한 이들의 이야기를
들려준다.[13] LED 기둥의 점멸하는 표면 위로
작가가 선택한 텍스트는 약 4시간 반 가량의 시간
속에 쉼 없이 흘러가며 타인의 삶을 서사를
통해 경험하게 하고 내가 아닌 다른 사람들을
이해하도록 하는 매개가 된다.

텍스트는 파편적이고 일시적인 장면들로 나타났다
사라지고 관객은 작품을 마주치는 그 순간의
우연한 만남으로 글의 일부를 마주하게 된다.
때문에 각각의 내러티브는 해체된 형태로 관객에
의해 선택적으로 편집되며 각자의 해석을 통해
의미를 재구성해야 한다. 역사와 사회적 비극을
직접 겪거나 목도했던 이들, 혹은 그 기억과
기록을 추적하는 화자의 서술을 통해 제시되는
문장들은 취약성, 권력 남용, 폭력이나 억압과
얽혀 있는 성별과 성의 문제, 나아가 삶과 죽음을
거론한다. 크지슈토프 보디츠코가 언급했던
"아무도 듣고 싶어 하지 않는 것을 드러내어 도시
담론에 포함시키는 모든 행위와 적절한 것과
그렇지 않은 것의 경계를 흐리게 만드는 모든
행위, 그리고 바로 이러한 행위를 다른 이들이 할
수 있게 돕는 행위들"[14]을 홀저는 보다 시적이고
통렬한 언어로 제시한다.

홀저의 이러한 작업은 우리가 어떠한 태도와
행동을 취하는데 도움을 줄 수 있는가? 작품을
통해 아무리 깊이 영향을 받는다 하더라도
우리가 느낀 감정이 실질적 행동으로 이어지기란
쉽지 않다. 하지만 "특권을 누리는 우리와
고통을 받는 그들이 똑같은 지도상에 존재하고
있으며 우리의 특권이 (우리가 상상하고
싶어하지 않는 식으로, 가령 우리의 부가 타인의
궁핍을 수반하는 식으로) 그들의 고통과
연결되어 있을지도 모른다는 사실을 숙고해 보는
것, 그래서 전쟁과 악랄한 정치에 둘러싸인 채
타인에게 연민만을 베풀기를 그만둔다는 것, 바로
이것이야 말로 우리의 과제이다"라는 수잔 손택의
말처럼 자신의 삶에 현존하며 나를 포함한
세계에 주의를 기울이는 것. 이것이 우리에게
요구된 최소한의 실천일지도 모른다.[15]

〈당신을 위하여〉는 여전히 전쟁과 테러, 살인과
폭력이 난무하는 혼돈의 시대를 살고 있는
우리에게 타인의 고통과 아픔을 쉽게 지우거나
외면할 수 없음을 선명하게 상기시킨다.
홀저는 재정의되거나 새롭게 기억하고 기록되어야
할 과거, 보이지 않지만 어디선가 일어나고 있는
일, 다가오는 미래에 이르는 것들을 포섭한다.
거부할 수 없는 '스펙터클의 사회'에서 우리는
타인의 고통을 멀리서, 현실감이 느껴지지 않는
이미지로 잠시 응시하고 지나치는 무력한 상황에
놓여왔다. 전쟁, 테러, 사회적 참사 등 역사와
동시대의 참혹한 현장에서 살아남았다는 것은
우리가 누군가에게 빚지고 있다는 마음을 가지게
한다. 나 아닌 '당신'의 목소리에 귀 기울이고
역사와 사건을 기억하는 행위로 우리는 또 다른
증인이자 '살아남은 자'로서 일상에 만연한
문제들을 외면하지 않고자 한다. 홀저의 예술이
당신(YOU)에게 또는 타자인 당신(YOU)의
목소리로 들려주는 이야기를 통해 공감과 치유,
소통과 회복을 촉구하는 자리에 함께 할 수 있기를
기대한다.

14
Krzysztof Wodiczko, "Instruments,
Monuments, Projections," in
*Transformative Avant-Garde and Other
Writings: Krzysztof Wodiczko*
(London: Black Dog, 2018), 193–205.
Krzysztof Wodiczko, "Instruments,
Monuments, Projections",
Transformative Avant-Garde and Other
Writings(London: Black Dog Press,
2016), 193–205. 크지슈토프 보디츠코,
"기구, 기념비, 프로젝션", 『변형적
아방가르드: 도시, 민주주의, 예술실천』,
크지슈토프 보디츠코 선집 191. 재인용

15
Susan Sontag, *Regarding the Pain
of Others* (New York: Picador, 2003),
102–3.
수전 손택(Susan Sontag), 『타인의 고통
(Regarding the Pain of Others)』,
(서울: 이후, 2004), 154.

FOR YOU

2019
LED sign with blue, green & red diodes, with robotics
252 × 5 × 5 in. / 640.1 × 12.7 × 12.7 cm
Selections from texts by Svetlana Alexievich,
Hawzhin Azeez, Han Kang, Kim Hyesoon,
and Emily Jungmin Yoon

〈 당신을 위하여 〉

2019
파란색, 초록색, 빨간색 다이오드 로봇 LED 사인
252 × 5 × 5 in. / 640.1 × 12.7 × 12.7 cm
스베틀라나 알렉시예비치, 호진 아지즈, 한강, 김혜순,
에밀리 정민 윤의 글 발췌

Exhibiting Women's Testimony: Jenny Holzer and the Repoliticization of Language

Lee Gwangho
Literary Critic

1
Michel Foucault, *This Is Not a Pipe*, trans. James Harkness (Berkeley: University of California Press, 1983), 53.
미셸 푸코, 김현 편역 『이것은 파이프가 아니다』(서울: 민음사, 1995), 51.

2
The hierarchy was broken down in Klee's use of the alphabet as graphic images and Magritte's strange juxtaposition of language and representation in such works as *The Treachery of Images*. Foucault writes: "The operation is a calligram [words arranged into a picture] that Magritte has secretly constructed, then carefully unraveled." Ibid., 20.
이 위계를 깨뜨리는 작업은 알파벳을 조형적으로 다룬 파울 클레의 경우나, 〈이것은 파이프가 아니다〉와 같은 작품에서 언어와 재현을 기묘하게 충돌시킨 르네 마그리트의 사례가 있다. 위의 책, 39.

The "Floating" Language of Jenny Holzer

What abyss lies between what is seen and what is read? In Western art history — and indeed, Western civilization as a whole — the divide between semiotics (i.e., signs and images) and semantics (i.e., language) has long been taken for granted. As Michel Foucault wrote, "Separation between linguistic signs and plastic elements; equivalence of resemblance and affirmation. These two principles constituted the tension in classical painting."[1] Rather than merging or overlapping, these two modes of conception were invariably placed in a hierarchical relationship: either the text controlled the image, or the image controlled the text.

Over time, artists like Paul Klee and René Magritte have creatively deconstructed this hierarchy in various ways, culminating in the conceptual art movement.[2] Although Jenny Holzer is routinely regarded as one of the pillars of conceptual art, her singular capacity for suturing the rift between seeing and reading sets her apart from her peers and predecessors. For example, the adages of Holzer's *Truisms* initially seem to demand linguistic interpretation over visual perception, but does the former really preclude the latter? In exploring the fundamental nature of art, many conceptual artists eschewed conventional aesthetic forms by creating graphic works from text. When text is presented in the form of a sculpture, visual elements such as font, size, color, and texture take on renewed significance, sometimes leading to an awesome spectacle.[3]

Demanding to be both read and seen (i.e., "not read"), the language in Holzer's works enacts a visual power that transcends the realm of representation and transmutes its particular space. In her works, the language signifies meaning yet defies simple interpretation; it transforms space through its formative arrangement yet defies mere representation.

The words in Holzer's art resist linguistic interpretation in several ways, as exemplified by the posters of *Truisms* and *Inflammatory Essays* that now cover an entire wall in the lobby of MMCA Seoul. First, unlike the familiar lines in a book or newspaper, the language in Holzer's works is integrated with the surrounding environment through its unique display or presentation. As such, the meaning of the words perpetually fluctuates depending on the unpredictable conditions of the space, thereby compelling each viewer to become an active participant. Presented in both English and Korean, Holzer's words constitute a spatial and social intervention, eventually becoming an event that can never be duplicated or reduced.[4]

여성의 증언은 전시될 수 있는가?—
제니 홀저와 여성 언어의 재정치화

이광호
문학평론가

3
While "dematerialization" is often
mentioned as an element of conceptual
art, text always exists on materials
such as paper, textiles, stones,
or screens. The realization of text in
actuality is predicated on physical / social
space. Cf. Tony Godfrey, *Conceptual Art*
(London : Phaidon, 1998), 8.
개념 미술을 설명하는 요소 중의 하나로
'비물질화'을 말하기도 하지만, 문자는
언제나 종이와 천, 돌과 스크린 등 '물질'
위에서만 존재한다. 문자는 물질적·사회적
공간 위에서만 실재적으로 구현된다.
토니 고드프리, 전혜숙 편역, 『개념 미술』
(파주 : 한길아트, 2002), 14.

4
According to Alain Badiou, "events are
irreducible singularities." Alain Badiou,
*Ethics : An Essay on the Understanding
of Evil*, trans. Peter Hallward (London :
Verso, 2001), 44.
사건이란 '환원불가능한 개별성'을
갖는다는 것이다. 알랭 바디우, 이종영 편역,
『윤리학』(서울 : 동문선, 2001), 57.

제니 홀저의 '부유하는' 언어들은 읽힐 수 있는가?

보는 것과 읽는 것 사이에는 어떤 심연이 있는가?
문학과 미술이 분리되는 사건은 예술사의
문제적인 장면이다. 알파벳 문명권 하의
서양미술사에서 쓰기와 그리기의 분리는 필연적인
것처럼 여겨졌다. 근대 이후 예술은 조형적
재현과 언어적 지시의 분리를 당연한 것으로
받아들였다. 미셸 푸코에 의하면, 조형적 재현과
언어적 지시 사이의 분리, 그리고 유사와
재현의 동등성은 15세기 이후의 서양 회화를
지배하는 원리였다.1 두 개의 체계는 교차하거나
용해되지 않았고, 어떤 방식으로든 종속적이고
위계적인 관계가 형성되었다. 텍스트가 이미지에
의해 규제되거나 이미지가 텍스트에 의해
규제되어야 했다.2

미술 개념의 변화와 테크놀로지의 발전으로
인해 언어와 조형 사이의 분리를 극복하는 작업은
다른 국면에 접어들었다. '개념미술'은 다른
방식으로 언어와 조형의 관계를 재구성한다.
제니 홀저는 보여주기와 읽기 사이의 분리를 앞선
예술가들과는 다른 방식으로 돌파한다.
제니 홀저의 〈경구들(Truisms)〉에서 나열된 짧은
문장들은 조형적 재현이 아니라, 언어적 지시와
연관되어 있는 것처럼 보인다. 하지만 제니 홀저에
이르러 언어적 지시가 조형적 요소를 완전히
대체했다고 말한다면 이것은 착각일 것이다.
개념 미술은 '미술이란 무엇인가'라는 근본적인
물음을 제기해왔다. 그 물음의 연장선에서 형태나
색채 보다는 언어를 가지고 작업할 수 있지만,
이것은 텍스트가 시각적 조형물을 흡수하는 것이
아니다. 문자 언어가 조형적으로 전시될 때 활자체,
글자의 크기, 색채와 움직임. 전시되는 면의
질감과 규모 등의 시각적인 요소가 중요할
수밖에 없게 되며, 그 규모에 따라서는 시각적
스펙터클로 받아들여진다.3

제니 홀저의 작업 속에서 언어는 단지 읽히는 것이
아니며, 조형은 재현의 범주를 벗어나 있다.
언어의 배치는 '읽히는 동시에 읽히지 않는
방식'으로 공간에 개입한다. 언어들은 단지 의미
작용을 하는 것이 아니라, 조형적으로 배치되는
방식에 의해 공간을 변형한다. 언어는 확언하지
않고, 조형은 재현하지 않는다. 언어 기호와 조형
사이의 전통적인 분리는 현대적이고 정치적인
방식으로 돌파된다.

국립현대미술관 로비 벽을 채운 〈경구들〉과
〈선동적 에세이(Inflammatory Essays)〉 포스터는
두 가지 측면에서 언어적 지시에만 한정되는 것을
거부한다. 우선 그 언어들은 책처럼 읽히는 것이
아니라, 특이한 형태의 전시를 통해 공간에
개입하고 공간을 변형한다. 공간에 예기치 않은
문맥을 부여함으로써 그 의미를 변형한다.
이때 공간에 대한 '개입'은 관객들에게 다른 시각적
경험과 참여를 유도할 수 있다. 제니 홀저가
뉴욕 구겐하임 미술관의 전체 홀을 문장으로 가득
채웠던 것이 그랬던 것처럼, 한국어와 영어로
표기된 〈경구들〉과 〈선동적 에세이〉가
한국의 '국립현대미술관'에 전시된다는 것 자체가
공간적·사회적 개입이며 하나의 '사건'이다.
예술이 공간과 시간에 개입하는 것은 그것이
어디에도 환원되지 않는 개별적인 '사건'이 된다는
것을 의미한다.4

The second type of resistance occurs via the form and content of Holzer's language. This exhibition features 240 statements from *Truisms* written by Holzer herself, most of which take the form of aphorisms, purporting to express profound wisdom in a single, succinct sentence. Yet despite their aphoristic tone, the statements immediately negate their supposed sagacity through surprising collisions and contradictions, essentially becoming "anti-aphorisms":

SOLITUDE IS ENRICHING
TORTURE IS BARBARIC
PAIN CAN BE A VERY POSITIVE THING
CATEGORIZING FEAR IS CALMING
EATING TOO MUCH IS CRIMINAL
SLIPPING INTO MADNESS IS GOOD FOR
THE SAKE OF COMPARISON
SALVATION CAN'T BE BOUGHT AND SOLD
ABUSE OF POWER COMES AS NO SURPRISE
YOU MUST DISAGREE WITH AUTHORITY
FIGURES

While the concise, declarative tone suggests authority, the arrangement of the statements often serves to nullify their assertions. For example, in the list above (in which the *Truisms* are arranged in the Korean equivalent of alphabetical order), "TORTURE IS BARBARIC" is immediately followed by "PAIN CAN BE A VERY POSITIVE THING," generating an explicit clash of meaning. Instead of concentrating on a singular message, Holzer's statements are diffused. Of course, thanks to the form of presentation, viewers can read the statements in any order, even skipping some of them entirely, which indicates the absence of any logical structure. Rather than being arranged to convey a larger narrative or worldview, Holzer's *Truisms* simply float on the wall, defying ideology or affirmation.

In many of her works, Holzer uses political terms or materials to trigger the viewer's political conscience. However, her works do not convey any unified political message, nor do they abide by the rules of political correctness. On the contrary, her fluid, hybrid sentences remain perpetually open as a pathway to the "Other." Jacques Rancière has proposed that politics is primarily concerned with orders of distribution and partition, in which case the politics of art involves partitioning time and filling space.[5] Moreover, this form of art / politics is a matter of fulfillment and potentiality as life or language. Hence, the "inflammatory" nature of Holzer's *Inflammatory Essays* lies not in their incendiary or controversial ideas, but rather in the potentiality of Holzer's art / politics. By invoking a fluctuating mode of being, rather than a fixed standard, Holzer transforms the viewer's relationship to a location, demonstrating new possibilities for the "repoliticization" of art.

Being detached from any source or speaker, Holzer's *Truisms* simply drift, lacking an origin or identity. Even when engraved in stone, the language slides across the surface without the anchor of a subject. The result is an unusual aesthetic and political experience in which viewers can freely peruse the text in any order, choosing particular statements and making them their own. Because they do not belong to anyone, they belong to everyone.

With her LED artworks, Holzer finds a new way to set language adrift, while infusing the space with temporality. In *FOR YOU* (a new work commissioned for this exhibition), she displays text on a state-of-the-art LED display, simultaneously appropriating and parodying the glittering sheen of capitalist culture. Recalling the incessant news reports and advertisements that scroll across most LED screens these days, a seemingly endless flow of luminous text floats over the head of visitors to MMCA Seoul. Since the text in Holzer's work runs on a loop of approximately four hours, it is doubtful that any single viewer will be able to read it all from start to finish. Unable to fathom its full scale, they will eventually give up and leave. Moreover, depending on when they enter or look at the work, visitors will encounter any given sentence purely by chance. Unlike a book, which will almost always be read in the order of its pages, Holzer's sentences are more reminiscent of advertisements that briefly appear and then vanish. Withholding their overall structure and context, the texts are freed from the oppressive weight of ideology.

In this case, however, the impact and significance of the work is enhanced by some awareness of the context. First, the work is installed at MMCA Seoul, a site with many political implications for Koreans. Second, the text of *FOR YOU* comprises testimonies by different women. What can we make of the continual appearance and disappearance of women's voices within this space?

5
Jacques Rancière, *Aesthetics and Its Discontents*, trans. Steven Corcoran (Cambridge : Polity, 2009) ; Jacques Rancière, *The Emancipated Spectator*, trans. Gregory Elliott (London : Verso, 2009).
이와 같은 '정치'의 개념은 자크 랑시에르의 것이다. 자크 랑시에르, 주형일 편역, 『미학 안의 불편함』(고양 : 인간사랑, 2008). 자크 랑시에르, 양창렬 편역, 『해방된 관객』(서울 : 현실문화, 2016).

두 번째는 문장의 내용이다. 〈경구들〉은 240개의 문장으로 되어 있다. 경구는 그 사전적 의미 그대로 삶에 대한 진리와 지혜를 간결한 말로 표현한 것이다. '아포리즘(aphorism)'은 삶의 지혜가 하나의 간결한 문장으로 요약될 수 있다는 믿음에 근거한다. 제니 홀저의 진술들은 아포리즘의 어조를 '전유'하면서도 그 경구들의 교차와 충돌을 통해 그 지혜의 무게를 지워버린다. 제니 홀저의 진술들은 아포리즘의 형식을 전유한 '반아포리즘'이다.

고독은 사람을 풍요롭게 한다
고문은 야만이다
고통은 매우 긍정적일 수 있다
공포를 분류하면 마음이 진정된다
과식은 죄악이다
광기에 빠지는 것은 비교를 위해 좋다
구원은 살 수도 팔 수도 있다
권력 남용은 놀라운 일이 아니다
권위자에 맞서야 한다

간명하고 단정적인 어조는 말하는 주체의 권위에 의해 '확언'의 지위를 갖게 된다. 하지만 제니 홀저의 문장들은 경구의 재배치를 통해 그 확언의 지위를 스스로 무너뜨린다. 위의 인용문에서 "고문은 야만이다"라는 문장과 "고통은 매우 긍정적일 수 있다"는 문장이 나란히 배열됨으로써 그 사이의 미묘한 의미의 충돌이 발생한다. 뒤의 문장은 앞의 문장의 뉘앙스를 교묘하게 바꾸어 버린다. 문장들은 하나의 의미와 뉘앙스로 집중되지 않고 산포된다. 관객들은 이 문장들을 순서대로 읽지 않아도 되며, 눈에 띄는 문장을 띄엄띄엄 선택해서 읽을 수도 있다. 관객이 특정한 문장들을 선택하는 우연성은, 이 문장들 전체를 감싸는 논리적 구조가 존재하지 않음을 의미한다. 〈경구들〉의 배열은 하나의 서사와 거대한 세계관을 구축하지 않는다. 이런 방식으로 제니 홀저의 언어들은 '이념'과 '확언'의 권위를 벗어나서 전시면 위에서 자유롭게 부유하기 시작한다.

다른 방식으로 말해보자. 제니 홀저의 작업에는 때로 정치성을 강하게 담은 문장과 자료들이 활용되며, 그것들은 관람객들의 정치적 무의식을 충격한다. 하지만 그것이 단일한 정치적 메시지로 전달되지는 않는다. 제니 홀저의 문장들은 하나의 '정치적 올바름'을 향해 있는 것이 아니다. 유동성과 혼종성을 갖는 문장들은 타자를 향해 열려 있다. 정치가 배분과 분할의 질서를 변형하는 문제라면, 예술이 정치적인 것은 시간을 분할하고 공간을 채우는 방식의 문제이다.5 예술-정치는 다른 '삶-언어'로의 이행과 잠재성의 문제이다. 제니 홀저의 미술에서 정치적 올바름은 척도의 문제가 아니라, 예술의 움직이는 존재양식이다. 〈선동적 에세이〉의 '선동성'은 '프로파간다'의 선동성과는 다른 '예술-정치'의 잠재성이다. 예술이 장소와 관객과 맺는 관계를 바꿈으로써 예술을 '재정치화'하는 사례이다.

제니 홀저의 〈경구들〉은 단일한 화자의 권위에 의존하지 않는다. 이 문구들의 발화 주체는 고정되어 있지도 않고 동일성을 갖지도 않는다. 〈경구들〉은 하나의 발화 주체로 환원되지 않으며, '확언'의 기원 자체가 제거되어 있다. 제니 홀저의 문장들은 누구의 소유도 아니며, '익명성'을 띤다. 화자도 없고 전체성도 없는 문장들은 그렇게 조형적으로 떠돈다. 제니 홀저의 문장이 딱딱한 '돌' 위에 새겨진 경우에도, 그 언어는 주체의 권위를 갖지 않고 돌 위에서 자유롭게 '미끄러진다'. 발화 주체가 제거된 문장들 앞에서, 관객들은 문장들을 선택하면서 그것을 자신의 것으로 만드는 기이한 미적·정치적 경험을 한다.

제니 홀저의 LED 작업은 언어들이 부유하는 공간에 시간성을 도입한다. 로봇 LED 신작 〈당신을 위하여〉에서 언어들은 디지털 시각장치에 의해 반짝거리며 '흐른다'. LED의 반짝임은 자본주의 문화의 휘황찬란함을 '전유'하는 것이지만, 동시에 그것의 덧없음을 보여준다. 자본주의적 일상 속의 LED 전광판은 뉴스와 광고를 실어 나르며 그것의 덧없음을 순간적으로 드러낸다. 이를 테면 하나의 텍스트의 사이클이 4시간이라면, 4시간 동안 이 조형물 앞에서 텍스트 전체를 처음부터 끝까지 읽어낼 관객은 없다. 관객은 이 텍스트의 규모 전체를 관람하고 가늠하지 못하며 '더 이상 참을 수 없어서' 그 자리를 떠나게 된다. 관객의 '포기와 단념'은 필연적인 것이다. 텍스트의 전체성을 파악하려는 시도는 좌절될 수밖에 없다. 관객들이 조형물 앞에 선 그 순간 어떤 문장을 만나게 될 지는 '우연'의 소산이다. 한 권의 책은 독자의 독서 방향을 미리 규정해 놓은 것이고, 예외적인 독서를 제외한다면 독자들은 페이지 순서에 따라 책을 읽어야 한다. 순서는 책의 의미와 논리의 구조를 구축하는 것이기도 하다. 하지만 LED 화면 속에서 출몰하는 문장들은 광고판의 언어가 그런 것처럼 즉각적으로 나타나고 사라진다. 문장들이 나타나면서 사라지기 때문에 그 전체 구조를 알 수 없고, 맥락을 이해하는 것조차 쉽지 않다. 그런데 바로 그 이유로 이 '흐르는' 언어들은 관념의 무게와 억압에서 벗어날 수 있다.

이제 제니 홀저의 언어는 공간적으로 부유하는 것만이 아니라 '시간적'으로 부유한다. 관객이 하필 그 순간에 그 문장을 맞닥뜨린다는 것은 우연적인 사건이 된다. 〈당신을 위하여〉라는 조형물이 한국의 국립현대미술관이라는 공간에 설치된다는 것, 이 부유하는 언어가 이 공간에 개입한다는 것은 무엇인가? 여기에 중요한 또 하나의 정치적 맥락이 도입된다. 그 언어들이 여성에 의해 발화된 언어라는 점은 이 작업에 다른 층위를 부여한다. LED 화면 속의 여성 언어는 나타나는 동시에 사라지며, 이 '나타남-사라짐'의 연속적인 과정 속에서 나타남과 사라짐은 동등한 사건이 된다. 여성 언어의 '나타남-사라짐'의 사건이란 지금 여기서 무엇인가? 이제 여기에 실려 있는 텍스트의 내부를 들여다보자.

Language of the Other: Kim Hyesoon and Han Kang

On the tree of world literature, Korea represents only a tiny branch. And until very recently, even this tiny branch was virtually inaccessible to women writers, due to restrictive notions of gender that still linger from the age of Neo-Confucianism. Only since the "feminist reboot" of 2015 have Korean women writers begun to receive proper attention. The scrolling text of Jenny Holzer's *FOR YOU* includes excerpts of works by two such women, Kim Hyesoon and Han Kang. Selected from poems with distinct and formidable political contexts, Kim's and Han's words represent compelling examples of the contemporary language of Korean women. In *FOR YOU*, however, Holzer explores the problematic implications of discovering such women's language through other media.

Continually producing some of the most radical and provocative works of Korean contemporary poetry, Kim Hyesoon has spent the past forty years waging war on the male-centric institutions of Korean literature. Embodying the uniqueness of the female gaze while charting its divergence from the oppressive male order, Kim's early works revealed the hidden world of women's sentiments. Not stopping there, she pushed herself to discover a new feminine voice that opened communication between women's bodies and the world. With this voice, the poet not only sings but also listens to the rhythms bursting forth from the depths of her body. In Kim's words, "doing poetry" is "no different from an excruciating act of childbirth, in which I wander within myself in search of the woman inhabiting my body, endeavoring to give birth to her." The resulting poems are not written by the first-person "I." As Kim explains, "I am not the poetic speaker; a woman inside me urges me to give birth to her."[6]

In Kim's collection *Autobiography of Death*, this woman's voice testifies to the moment when death courses through the body. In this work, death is real and corporeal, rather than conceptual. In the book, Kim summons the woman — or her spirit — to perform a ceremonial rite lasting forty-nine days, corresponding to the duration between "death and rebirth" in Buddhism. During this period, the soul exists in an interim state between life and death. Encountering the absolute Other, the woman/spirit sings from a state of nonexistence without a body:

The woman's dead. Turned off like the night sun.
Now the woman's spoon can be discarded.
Now the woman's shadow can be folded.
Now the woman's shoes can be removed.

You run away from yourself. Like a bird far from its shadow.
You decide to escape the misfortune of living with that woman.

You shout, I don't have any feeling whatsoever for that woman!
But you roll your eyes the way the woman did when she was alive
and continue on your way to work as before. You go without your body.

Will I get to work on time? You head toward the life you won't be living.[7]

—

You came from the world over there
but now you're pregnant with that world

Like a newborn on an operating table
the woman who shoved her own neck into the grave
looks at selfies on her phone

even laughing faces of the burial mounds' green hats[8]

Without warning, a woman encounters death on her morning commute. She witnesses the demise of her body, yet carries on without it, starting "day one" of a "life [she] won't be living." In the second poem, a dead pregnant woman becomes a woman pregnant with death. Now that she is "pregnant with that world," she gives birth to death "like a newborn." Through this image of a woman giving birth to her own death, Kim Hyesoon creates a distinct woman/spirit who invokes both the specific deaths of individuals and the sociohistorical deaths that stain Korean modern history.

6
Kim Hyesoon, *Yeoseong, sihada* (Seoul: Moonji Publishing, 2017), 11–12.
김혜순, 『여성, 시하다』(서울: 문학과지성사, 2017), 11–12.

7
Kim Hyesoon, "Commute," in *Autobiography of Death*, trans. Don Mee Choi (New York: New Directions, 2018), 9–10.
김혜순, 「출근—하루」 일부, 『죽음의 자서전』(서울: 문학실험실, 2016), 11–12.

8
Kim Hyesoon, "A Grave," in *Autobiography of Death*, 32.
김혜순, 「묘혈—열이레」 일부, 『죽음의 자서전』(서울: 문학실험실, 2016), 51.

또 다른 여성 언어로서의 한국어—김혜순과 한강의 경우

〈당신을 위하여〉에 실리는 한국어 텍스트는 김혜순과 한강의 시들이다. 제니 홀저의 작업에 한국의 여성 작가들의 텍스트가 실린다는 것은 중요한 정치적 맥락을 포함한다. 한국어는 세계문학장에서 소수 언어이고, 한국의 여성작가들이 세계문학시장에 활발하게 소개된 것도 오래 되지 않았다. 한국문학장에서 여성 작가들은 '한국어' 문학이라는 '소수성'과 한국사회에서의 젠더 시스템의 이중적인 제약 안에서 글쓰기를 밀고 나갔다. 그런 글쓰기의 급진적인 의미가 주목받기 시작한 것은, 한국 사회의 경우 2015년 '페미니즘 리부트'라는 기점 이후이다. 김혜순과 한강의 시는 한국 여성 언어의 한 첨예한 사례라고 할 수 있는데, 〈당신을 위하여〉는 그 여성언어가 다른 전시 매체를 통해 어떻게 재발견되는가를 보여주는 문제적인 사례이다.

김혜순의 시는 한국의 여성시를 상징할 뿐만 아니라, 한국현대시의 가장 첨예한 미학을 상징한다. 한국문학사에서 지난 40년간 김혜순은 남성 중심의 제도화된 문학들과 '작별'하는 싸움의 최전선에 있었다. 그의 초기 시들이 억압적인 남성 질서와 구별되는 여성적 시선의 특이성과 여성적 감각의 세계를 발견하는 성취를 거두었다. 그의 시는 여기에 머물지 않고 세계의 몸과 교류하는 개방된 겹의 몸으로서의 언술 형식을 만들어간다. 그의 시가 다다른 지점은 다른 '여성-목소리'의 발명이라고 부를 수 있는 차원이다. 시인은 단지 노래하는 자가 아니라, 자기 몸의 깊은 곳에서 터져 나오는 신체의 리듬을 듣는 자이다. 김혜순의 방식으로 말하면 '시한다'는 것은 "내가 내 안에서 내 몸인 여자를 찾아 헤매고, 꺼내 놓으려는 지난한 출산 행위와 다름이 없다." 그러나 '시하기'의 주체는 단지 일인칭 '내'가 아니다. "시적 화자인 내가 아니라 내 속의 여자가 나로 하여금 여자를 낳도록 독려하는 것이다."[6]

그의 시집 『죽음의 자서전』은 죽음이 몸 속을 가로 지르는 순간을 불러내고 이를 증언하는 '여성-목소리'의 장소이다. 이 시집에서 죽음은 사유의 대상으로서의 개념이 아니라 신체의 '사건'이며, '나 자신'의 죽음이다. 이 시집에서 김혜순은 '여성-유령 화자'를 불러들여 49일의 제의를 치른다. 49일은 사람이 죽은 뒤 다음 생을 받기 전까지의 존재와 비존재의 중간상태로서, 불교에서 말하는 중음(中陰)의 기간이다. 이 시집에서 죽음이라는 절대적인 타자를 대면한 여성-유령 화자는 몸 없는 비존재로서 노래한다.

저 여자는 죽었다. 저녁의 태양처럼 꺼졌다.
이제 저 여자의 숟가락을 버려도 된다.
이제 저 여자의 그림자를 접어도 된다.
이제 저 여자의 신발을 벗겨도 된다.

너는 너로부터 달아난다. 그림자와 멀어진 새처럼.
너는 이제 저 여자와 살아가는 불행을 견디지
않기로 한다.

너는 이제 저 여자를 향한 노스탤지어 따위는
없어 라고 외쳐본다.
그래도 너는 저 여자의 생시의 눈빛을 희번득
한 번 해보다가
네 직장으로 향하던 길을 간다. 몸 없이 간다.

지각하기 전에 도착할 수 있을까?
살지 않을 생을 향해 간다.[7]

—

저는 저 세상에서 왔건만
지금 너는 저 세상을 임신 중이다

분만대에서 태어나는 중인 신생아처럼
제 무덤 속에 목을 집어넣은 여자가
휴대폰의 제 사진을 들여다보는 시간

묘지의 초록색 모자마다 웃는 얼굴들이 들어 있다[8]

출근 길에 갑자기 죽음을 마주한 여자는 자기 신체의 죽음을 목격하고 몸 없는 삶, '살지 않을 생'을 향해 하루를 시작한다. 하루의 시작은 몸 없는 생의 시작이며, 이미 죽은 생의 시작이다. 두 번째 시에서 죽은 여자에게 신체의 죽음은 죽음을 '잉태하고' '낳는' 행위와 다르지 않다. 임신한 여자의 죽음이라는 이미지는 '죽음'을 임신한 여자의 이미지로 변환된다. 여자의 죽음은 "저 세상을 임신"하는 사건이다. 죽음은 "제 무덤 속에 목을 집어넣은 여자"가 신생아처럼 자신의 죽음을 낳는 것이다. 김혜순의 시는 저 자신의 죽음을 낳는 여자의 이미지를 통해, 다른 여성-유령 화자를 발명한다. 한국에서 일어난 모든 사회·역사적 죽음들을 가로지르면서, 다른 죽음을 '수행'하는 목소리가 여기에 있다.

Before becoming an acclaimed novelist, Han Kang began her career as a poet. Indeed, her novels are filled with poetic images and expressions. In *The Vegetarian* (winner of the 2016 Man Booker International Prize), the heroine's soliloquies are filled with the schizophrenic language of social misfits, representing the language of a woman's body rejecting order. Voluntarily becoming the Other as a form of vegetative resistance, a woman embarks on a path that will end with her transformation into a tree. A similar sentiment can be felt in Han's serial poem, "Winter through a Mirror":

At the zoo, the rain was coming down
I walked beside a fence

While young deer played in the shelter of a tree
the mother deer stood a little way off,
 watching over them
as human mothers do with their children

When the rain was still driving down
 in the plaza

Women wearing white headscarves
embroidered with the names of their murdered
 children
were marching with slow steps[9]

Supposedly written while Han was abroad, the poem's foreign images transcend the depiction of ordinary scenery. After all, how often does one encounter a family of deer on a rainy day at the zoo? But note how this idyllic scene is immediately interrupted by a march of women "wearing white head scarves / embroidered with the names of their murdered children." Through the intrusion of the political, the scene suddenly takes on temporality. Rupturing the gaze between the subject and object, the marching women force an ethical encounter with the pain of the Other. Rather than being superficially consumed as a visual spectacle, this pain galvanizes one's sense of complicity.[10] Instead of an image serving as an object, the winter scene becomes a mirror, echoing the poem's title. No longer objectified, the pain of the Other is the pain of women in the "mirror," which "I" myself cannot help but experience as well.

Language as Echoes: Emily Jungmin Yoon, Svetlana Alexievich, and Hawzhin Azeez

The English text of *FOR YOU* is drawn from works by Emily Jungmin Yoon, Svetlana Alexievich, and Hawzhin Azeez, all of which present women's testimonies of trauma and violence. Notably, in each case, the testimonies are not delivered directly by the victims, but rather relayed through a proxy (i.e., Yoon, Alexievich, and Azeez). This disjunction raises important questions about the nature of testimony, particularly that of women.

Reflecting upon the testimony of Primo Levi, a survivor of Auschwitz, philosopher Giorgio Agamben observed the paradox that the true witnesses are those who are unable to bear witness.[11] Only survivors can testify on behalf of those who can no longer speak. Testimony occurs when those who cannot speak provoke the speech of those who can, so that those who speak and those who are silent become indistinguishable.[12] In times of war, women are deprived of the space and opportunity to speak, yet when the war is over, testimony is made impossible in other ways.

비 내리는 동물원
철창을 따라 걷고 있었다

어린 고라니들이 나무 아래 비를 피해 노는 동안
조금 떨어져서 지켜보는 어미 고라니가 있었다
사람 엄마와 아이들이 꼭 그렇게 하듯이

아직 광장에 비가 뿌릴 때

살해된 아이들의 이름을 수놓은
흰 머릿수건을 쓴 여자들이
느린 걸음으로 행진하고 있었다[9]

9
Han Kang, "Winter through a Mirror 11,"
trans. Deborah Smith and Sophie
Bowman (unpublished), 2018.
Originally published as "Geoul
jeopyeon-ui gyeoul 11," in Seolab e
jeonyeog eul neoh-eo dueossda (Seoul:
Moonji Publishing, 2013), 115.
한강, 『서랍에 저녁을 넣어 두었다』(서울:
문학과지성사, 2013), 115.

10
Susan Sontag, Regarding the Pain of
Others (New York: Picador, 2003), 103.
수잔 손택, 이재원 편역, 『타인의 고통』
(서울: 이후, 2004), 154.

11
Giorgio Agamben, Remnants of
Auschwitz: The Witness and
the Archive, trans. Daniel Heller-Roazen
(New York: Zone Books, 1999), 33-34.
조르조 아감벤, 정문영 편역, 『아우슈비츠의
남은 자들』(서울: 새물결, 2012).

12
Ibid., 120.
위의 책, 181.

한강의 텍스트는 어떤 겨울 풍경을 보여준다.
한강은 소설가로 등단하기 전부터 시인으로
출발했다. 그의 소설에서 시적인 이미지와 표현을
발견하는 것은 그리 어려운 일이 아니다.
그의 문학을 널리 알려준 『채식주의자』에서
주인공 여성이 발설하는 독백들은 사회로부터
이해 받지 못하는 분열증적인 언어이며,
질서를 거부하려는 여성적 육체의 언어이다.
자발적으로 사회의 타자가 되려는 여성의
식물적인 저항은, 신체가 나무로 화하는 시적인
순간을 향해 있다.

외국에서의 쓴 것으로 알려진 위의 시에서,
이국적인 이미지를 마주한 언어들은 다만 풍경을
그리는 것이 아니다. 시인의 눈은 그 이국적인
풍경을 '관람'하는데 멈추지 않는다. 비 내리는
동물원에서 어린 고라니와 어미 고라니를 마주한
것은 사소한 경험이다. 그 풍경에 개입하는 것은
"살해된 아이들을 이름을 수놓은／흰 머릿수건을 쓴
여자"들의 행진이다. 풍경에는 불현듯
시간성이 부여되고, 그 장면 안에 다른 정치적
시간이 틈입한다. 여자들의 느린 행진은 풍경을
완성하는 것이 아니라, 풍경을 깨뜨린다.
풍경에 대한 충격은 주체와 대상 사이의 시선
체계에 균열을 만드는 것이다. 행진하는 여자들의
틈입은 타인의 깊은 고통에 대한 윤리적 순간을
대면하게 한다. 타인의 고통은 시각적
스펙터클로 소비되는 것이 아니라. 그 고통에
자신이 연루되어 있다는[10] 감각을 충격한다.
이 연작시의 제목이 '거울 저편의 겨울'이라는 점을
상기해보자. 풍경은 대상으로서의 이국적인
이미지가 아니라 '거울–겨울'의 풍경, '거울로서의
겨울 풍경'이다. 타인의 고통은 대상화된
이미지가 아니라, '내'가 함께 겪을 수밖에 없는
'거울 속의 여성들'의 고통이다.

남아있는 목소리로서의 여성언어—에밀리 윤, 알렉시예비치, 호신 아지즈의 경우

〈당신을 위하여〉에 탑재된 영어 텍스트는
에밀리 정민 윤, 스베틀라나 알렉시예비치, 호진
아지즈의 문장들이다. 이 문장들은 모두 '여성의
증언'이라는 성격을 공유한다. 이 증언의
언어들은 인터뷰 혹은 목격담을 통해서 여성이
겪은 시간을 전한다. 그 언어들이 표현하는
여성의 시간들은 매우 참혹하다. 여성들은 형언할
수 없이 가혹한 폭력의 세계에 노출되어 있다.
증언의 주체는 '당사자'가 아니라, 그 폭력의
경험을 전달하는 대리인이다. 여기에는 '여성은
어떻게 증언할 수 있는가'라는 중요한 문제가
걸려 있다. 여성은 증언의 주체가 될 수 있는가?
혹은'증언의 주체'란 무엇인가에 대한 피할 수
없는 질문을 마주해야만 한다.

아우슈비츠의 생존자였던 프리모 레비를 통해
철학자 조르조 아감벤이 성찰했던 것 중의 하나는,
진정한 증인은 이미 '증언할 수 없는 자'라는
역설이다.[11] 비인간을 증언할 수 있는 것은
생존자이고, 이 때 생존자는 비인간의 대리인,
비인간에게 목소리를 빌려주는 자이다.
증인은 말할 수 없는 자를 위해 말하는 자이다.
증언은 말을 못하는 자가 말을 하는 자에게
말하게 만드는 곳이며, 침묵하는 자와 말하는 자,
인간과 비인간의 구별이 불가능한 지대이다.[12]
전쟁의 시간은 여성들에게 말할 수 있는
위치와 기회를 박탈하며, 전쟁 이후의 시간 역시
다른 방식으로 증언을 불가능하게 만든다.

Based on her own research into firsthand materials, Emily Jungmin Yoon has written poems about the "comfort women" of Korea, who were forced into sex slavery by the Imperial Army of Japan during the Japanese colonial period (1910–45). As a "1.5 generation" Korean immigrant, Yoon writes in English, deploying scathing language befitting testimony of such grievous experiences. Through these poems, a contemporary member of the Korean diaspora seeks connection with the displaced and tormented Others of an earlier time.

In Yoon's poetry collection *A Cruelty Special to Our Species*, the first poem of each chapter is entitled "An Ordinary Misfortune." Here, the word "ordinary" has a double edge, reminding us that the suffering of these women typically began under the guise of something "ordinary," while also insinuating the sheer inhumanity of the conditions under which such atrocities were made to seem "ordinary." For example, it was not uncommon for farmers to "deliver" girls to the Japanese government in the same way that they might submit an obligatory tithe from their harvest.13

Some of the poems are named after individual victims and contain firsthand descriptions of their abductions. By directly relating these women's experiences in their own voices, Yoon (the poetic subject) becomes both a witness and a surrogate of their suffering. These poems are characterized by a harrowing realism of voice that enables them to transcend most examples of literary realism, which focus solely on content. Neither imitated nor reproduced, the voices constitute a sphere of women's speech in which "listening and speaking" are concurrent.

The Ukrainian-born Svetlana Alexievich, winner of the 2015 Nobel Prize in Literature, writes "documentary novels" of historical events; based on her own exhaustive research and interviews with subjects. For *The Unwomanly Face of War: An Oral History of Women in World War II* (featured in this exhibition), Alexievich interviewed approximately two hundred women about their experiences fighting in World War II. In Alexievich's books, women's testimonies are granted the status of literature. In the Western critical canon, privileged notions of genre have typically restricted "literature" to the realm of the imagination. This conception was also imported to and installed in Korea, leading to debates about whether autobiographical writings (such as "labor memoirs" of the 1980s) should be deemed "literature." Yet why should the firsthand testimonies of those who wish to document their experiences of oppression and violence be excluded from the ranks of literature?

Relegated to the shadows of male violence, women are all too often made invisible during times of war. As Alexievich's interviews reveal, women's experiences of war are completely different from those of men. Rather than discussing the ideological reasoning behind the war, they speak directly about what happened to them and their bodies. For example, one woman recalls her first menstrual period after being shot and paralyzed from the waist down. Like Yoon's poems, the texts bear the real names of the women. "Klavdia Grigoryevna Krokhina, First Sergeant, Sniper" was aghast after killing a person for the first time: "I knew nothing about him, but I killed him." But she gradually became numb to the horror, confessing, "However many I killed, I felt no pity." She poetically describes seeing "human bones among the cinders, with scorched little stars among them," but finally reports, "I came back from the war gray-haired. Twenty-one years old, but my hair was completely white."14 Recounting their own corporeal pain and trauma, which has no relation whatsoever to ideology, the women's voices come as an excruciating shock.

A scholar, activist, and poet from Southern Kurdistan (northern Iraq), Dr. Hawzhin Azeez records her own experiences of conflict and carnage in the form of diaries. In particular, she documents her life in Rojava (northern Syria), struggling to rebuild the city and democratic community of Kobane, despite repeated attacks by ISIS. As a "stateless woman," Azeez faces magnified oppression and violence. Amidst daily violence, she and her fellow women fight not only to survive, but also to reconstruct their own social status. Beyond military liberation, they seek social, political, economic, religious, and personal freedom. Alongside the horrors of wartime violence, in which "bursting bombs are as normal as…hunger" and "little children's bodies keep falling, falling, endlessly falling," Azeez's diaries also capture the rage and courage that fuel those resisting the massacre and oppression. Passionately declaring that the "right to live in peace and safety is a non-negotiable human right," she also provides poetic expressions of female solidarity, recognizing that the women resistance fighters are "as immortal as the wind" and "as constant as time itself."15 Without the oppressive authority of a dauntless male hero or an established power, Azeez's enlightened voice never wavers in her testimony to a state of exception and her call for female solidarity.

13
Emily Jungmin Yoon, *A Cruelty Special to Our Species* (New York: Ecco, 2018), 26.

14
Svetlana Alexievich, *The Unwomanly Face of War: An Oral History of Women in World War II*, trans. Richard Pevear and Larissa Volokhonsky (New York: Random House, 2017), 10.
스베틀라나 알렉시예비치, 박은정 편역, 『전쟁은 여자의 얼굴을 하지 않았다』(서울: 문학동네, 2015), 74.

15
Quotations from three texts from the website of Hawzhin Azeez: "The Measure of Humanity," October 25, 2017, https://hawzhin.press/2017/10/25/the-measure-of-humanity; "The YPG-YPJ—Militant Survivalism for the Oppressed," July 23, 2016, https://hawzhin.press/2016/07/23/the-ypg-ypj-militant-survivalism-for-the-oppressed; and "Our Wonder Women—An Ode to the YPJ," October 21, 2018, https://hawzhin.press/2018/10/21/our-wonder-women-an-ode-to-the-ypj.

에밀리 정민 윤의 시들은 복합적인 정치적인 문맥을 포함한다. 일본 제국주의에 의해 저질러진 일본군 성노예 문제를 시로 쓴 에밀리 정민 윤은 미국의 한국인 이민자 1.5세대이다. 그의 시는 일본군 성노예와 관련된 자료들을 바탕으로 창작되었고 영어로 쓰여 있다. 이 시의 언어들은 성노예 경험의 '대리 증언'에 해당한다. 디아스포라의 삶과 감각은 성노예 피해자들과 이민자 1.5세대인 인 시인이 공유하는 지점이다.

에밀리 정민 윤의 시집 『우리 종족의 잔인함에 대하여(Cruelty Special To Our Species)』의 1부 제목은 '평범한 불행(An Ordinary Misfortune)'이다. 이 시집에는 이와 같은 제목의 시들이 다수 등장한다. 여기서 '평범함'은 두 가지 문맥을 동시에 가질 것이다. 일본군 성노예들이 겪은 불행은 처음에는 어떤 '평범함'을 가장 해서 피해자들에게 접근했다. 혹은 비인간적인 상황은 이 끔찍한 불행들을 평범하고 일상적인 것으로 만들어 버린다. 이를테면 소녀들을 '배달'하는 것은 농민들이 수확한 쌀을 의무적으로 정부에 바치는 것과 마찬가지의 일상적인 일이었다.13 시는 비인간의 영역에서 벌어질 수 있는 일들이 일상적이 되어 버린 차마 말할 수 없는 장면을 증언한다.

어떤 시들은 성노예 당사자들의 실명을 시의 제목으로 하고 있으며, 그들의 목소리를 그대로 옮겨 놓는다. 가령 위안소로 끌려가는 상황에 대한 장면의 묘사들은 생생하고 사실적이다. 증언의 목소리를 그대로 전달하기 때문에 경험에 대한 묘사는 직접적인 느낌을 준다. 여기서 시적 주체는 '듣는 자'이면서 '대신 증언하는 자'이다. 이 무서운 사실성은 일반적으로 리얼리즘 문학에서 말하는 사실성의 범주를 넘어선다. 사실성은 '내용'의 사실성을 넘어서 '목소리'의 사실성이다. 목소리는 단순히 재현되고 모방되는 것이 아니라 '듣다─말하다'가 동시에 일어나는 여성적 발화의 영역이다.

우크라이나 출신의 노벨 문학상 수상 작가인 스베틀라나 알렉시예비치는 르포 작가였고 그의 소설 역시 르포적인 형식을 취하고 있다. 『전쟁은 여자의 얼굴을 하지 않았다』는 전쟁에 참전했던 200여 명의 여성들의 이야기를 인터뷰해서 기록한 책이다. 그의 소설에서 문학적인 것과 여성들의 증언은 다른 차원에 있지 않다. '순수한' 문학이 상상력의 영역에 속한다는 서구 근대 문학에서 수입된 장르 개념은 한국에서도 권위를 가지고 있었다. 한국에서 1980년대 노동문학이 주창되었을 때, 노동자들의 수기는 왜 '문학'이 될 수 없는지 하는 문제가 근본적으로 질문되었다. 한 시대의 참혹함을 기억하고 기록하려는 증언의 주체들이 자신들의 언어로 말할 수 있다면, 그것은 왜 문학 제도의 영역에서 배제되어야만 하는가? 이런 도전적인 주장은 문학사의 전환의 시기에 등장한다.

전쟁의 시기는 인간으로서 여성의 존재를 지워버린다. 전쟁의 폭력이 남자들이 주도한 것이라면, 그 폭력의 그늘에 있는 것은 여성들과 약자들이다. 여성의 목소리로 전쟁을 말하는 것은, 전쟁의 폭력성과 참혹함을 다른 관점과 감각으로 드러낸다. 여성들은 '전혀 다른 전쟁'을 살았다. 여성들은 전쟁을 둘러싼 이념과 명분에 대해 말하지 않으며, 신체가 경험한 감각에 대해 말한다. 이를테면 첫 생리가 있던 날 총탄에 맞아 다리가 불구가 되어버린 소녀의 목소리를 들을 수 있다. 이 텍스트 역시 인터뷰에 응했던 당사자들의 실명이 등장한다. '클라브디아 그리고리예브나 크로히나, 상사, 저격수'는 생전 처음 사람을 죽이고는 "그 사람에 대해 아무것도 모르면서 죽였어"라는 충격에 빠지지만, "잿더미 속에 사람들의 뼈가 있고, 그 뼈들 사이로 까맣게 탄 별모양이 보이는 "경험을 하고는, "아무리 적병을 죽여도 더 이상 괴롭지 않았어"라고 고백한다. 이 여성은 "전쟁이 끝나고 나는 백발이 되어 집으로 돌아왔어. 겨우 스물한 살에 노파처럼 머리가 하얗게 세버린거야"라고 기억한다.14 고통스러운 신체의 기억들은 명분과 이념의 세계와는 아무 상관도 없는 것이다. 여성이 신체를 통해 감각한 세계는 그 목소리 자체로 충격을 안겨준다.

호진 아지즈 박사의 텍스트는 '일기'의 형식으로 되어 있다. 호진 아지즈는 남부 쿠르드족 (북 이라크) 출신의 학자, 운동가, 시인이다. 가장 최근까지도 지속된 살육의 현장 가운데 있었던 여성의 일기는 증언의 글쓰기이기도 하다. 이 텍스트에서의 일기는 시리아 북부 로자바 (Rojava)에 머물면서 코바니(Kobane)의 재건에 참여했던 경험을 담고 있다. IS의 거듭되는 공격 속에서도 민주적인 공동체의 재건을 위해 힘쓰는 지난한 과정을 담고 있다.

호진 아지즈의 일기는 '국가 없는 여성'이라는 위치에서 쓰였다는 측면에서 문제적이다. 호진 아지즈가 처한 상황에서 여성은 중층적인 억압과 폭력의 굴레에 갇혀 있다. 일상적인 폭력의 상황에서 생존을 지켜야하는 문제와 중동 사회에서 여성의 사회적 존재 위치를 재구성해야 하는 두 가지 무거운 문제들이 가로 놓여 있다. 여기에서 '여성의 해방'은 군사적 해방뿐만이 아니라, 사회와 정치, 공공 및 민간 영역, 경제 및 인종 문제, 젠더와 종교 문제 같은 여성이 처한 삶의 모든 측면을 포괄해야하는 문제가 된다. 이 일기 속에서 '어린 아이들의 몸이 계속 떨어져 내리고', '폭탄은 굶주림만큼이나 평범한 것'이 되어 버린 참혹한 전쟁 상황에 대한 공포의 증언이 있다. 또한 학살과 억압을 거부하고 저항하는 분노와 용기가 담겨 있다. '평화롭고 안전하게 살 수 있는 권리는 협상할 수 없는 인간의 권리이다' 선언이 있고, 억압에 저항하며 다시 태어난 여성들이 '바람처럼 불멸하며', '시간처럼 끊임없는 존재가 된다'는 여성적 연대의 시적 표현이 있다.15 호진 아지즈의 일기는 나날의 삶에 대한 기록이면서 예외적인 상황에 대한 목격담이고, 여성들에 대한 연대의 요청이다. 호진 아지즈의 '계몽적인'목소리는 그러나 영웅주의적인 남성의 목소리가 그런 것처럼 억압적인 권위를 갖지 않는다. 그녀의 목소리는 '국가'와 '권력'이라는 배경을 전혀 갖지 않기 때문이다.

The texts of Emily Jungmin Yoon, Svetlana Alexievich, and Hawzhin Azeez are testimonies of women who have survived. In the words of Agamben, "survivor" testimonies imply a "reference to something or someone that is survived."[16] A person who survives does so in the place of someone who does not. Surviving women become subjects who speak or write through the voice of nonsurvivors. Speaking on behalf of those who are gone, the survivor becomes both subject and object, both "I" and "Other."[17]

16
Agamben, *Remnants of Auschwitz*, 137.
조르조 아감벤, 정문영 편역, 『아우슈비츠의 남은 자들』(서울: 새물결, 2012), 198.

17
Lee Gwangho, "Nam-eun jaui chimmug — sewolho ihuedo munhag-eun ganeunghanga," *Munhaggwa sahoe*, no. 108 (Winter 2014): 318–41.
졸고, 「남은 자의 침묵 — 세월호 이후에도 문학은 가능한가」, 『문학과사회』 108호(서울: 문학과지성사, 2014).

18
The history of MMCA Seoul represents Korean contemporary history. The Gyeongseong Medical School's medical clinic was built on the site in 1928. After national liberation, the property served as the Seoul National University Medical School's second hospital and the Armed Forces Hospital. Starting in 1971, the facilities were used by the Defense Security Command (DSC), Korea's military intelligence agency. Considering the role of the DSC under military regimes of the past, that fact that this space became the MMCA holds symbolic import in many ways. The questions are unavoidable. What does it mean to have a nationally built museum? What role does the art museum play in terms of national identity?
국립현대미술관 서울관의 역사는 한국현대사의 역사이기도 하다. 이 장소는 1928년 경성의학전문학교 부속의원의 외래진 찰소였으며, 광복 후 서울의대 제2부속병원과 육군통합병원으로 쓰였고, 1971년부터 군 정보기관인 국군 기무사령부에 의해 사용되었다. 기무사가 군사 정권 하에서 어떤 역할을 수행했는가를 상기해보면 이 공간이 '국립현대미술관'이 되었다는 것은 여러 가지로 상징적이다. 이런 질문은 피할 수 없다. 국가가 미술관을 짓는다는 것은 무엇인가? 미술관은 국가의 정체성을 위해 어떤 기능을 하는가?

How Do "You" Intervene in This Space and Time?

By nature, exhibitions establish hierarchies of the exhibiting subject versus the exhibited object, as well as the viewing subject versus the viewed object. But by presenting women's testimonies in a way that defies or subverts exhibition, Jenny Holzer dismantles these hierarchies, forcing us to reconsider fundamental questions like "What is an exhibition?" or "What is a museum?" In responding to such questions, both artists and visitors participate in reassigning meaning to the conditions and place of an exhibition. This process seems particularly pertinent to this exhibition at MMCA Seoul, a site that holds many deep and distressing associations in Korean contemporary history.[18] So what is the significance of exhibiting the language and voices of women within this specific space? Only you can decide.

Beyond hosting exhibitions, modern museums also serve as sites where the culture industry generates investment value and ceremonial value. As Hito Steyerl observed, "An art space is a factory, which is simultaneously a supermarket — a casino and a place of worship."[19] Artistic installations organize space in a way that differs from traditional exhibitions. In conceiving and composing the installation, the artist acts as originator, but the process of assigning meaning takes place among "competing sovereigns: curators, spectators, artists, critics."[20] Rather than passively encountering objects or texts with fixed meanings, visitors to Holzer's installation play an active role in defining the works and the space.

In this space where women's testimonies are "read yet not read," meaning remains in perpetual flux. Unlike most exhibited artworks, the women's language produces a certain encounter and event, thus enabling visitors to formulate the aesthetic and political sensibilities of the "here and now." Of course, there is always a gap between the original intentions and the actual effects of art. No one can predict the outcome of encounters between viewers and art, or between the viewers themselves. Via their mere presence as receivers, rather than through some planned effect of the work, viewers of Holzer's works are compelled to interpret a spectacle of language. Through this function, they become "emancipated spectators."[21]

By infusing the space with ambiguity, Holzer allows visitors to experience women's language drifting in time. Within such space, women's language cannot be reduced to a fixed meaning or ideology, nor can it be consumed as a visual spectacle. Engaging visitors with neither kindness nor rage, the women's words simply float through the space, ultimately evincing a lacuna of language. Through their impulsive or arbitrary movements, viewers repoliticize the women's language and transform the location and context. Those who hesitate are left with the inconceivable testimonies of women, while those who take a deep breath and step forward might experience a language of deeper pain. In a flash, a single sentence — any sentence — sweeps through the space and into you. This anonymous testimony of "you" now belongs to you. After all, the moment was created not by Holzer, but by "you."

에밀리 정민 윤, 알렉시예비치, 호진 아지즈의
텍스트를 '살아 남아있는'여성의 증언을 담고 있다.
남아 있다는 것은 언제나 '무엇'과 '누구'에
대해서 남는 것이다. 살아남는다는 것은 항상
"'무엇'을 견뎌내는 것, '누구보다' 오래 사는
것이므로 그 무엇 또는 누구와의 관련을 내포하고
있다."[16] 남은 자는 남지 않은 자의 자리에서 남은
자이며, 남는 다는 것은 죽음보다 오래 남는다는
것이다. 남아 있는 여성이 말하는 자 혹은 글쓰는
존재가 된다는 것은, 사라진 '누구–여성'의
목소리 안에서이다. 남아 있는 '나'는 사라진 '너'와
구별되지 않으며, 남아 있는 자는 사라진 자를
통해서 말할 수 있다.[17] 여성의 목소리는 사라진
자들의 침묵을 대리한다.

19
Hito Steyerl, "Is a Museum a Factory?,"
in *The Wretched of the Screen* (Berlin:
Sternberg, 2013), 63.
히토 슈타이얼, 김실비 편역,
『스크린의 추방자들』(서울: 워크룸
프레스, 2018), 86.

20
Ibid, 71.
위의 책, 100.

21
Rancière, *Emancipated Spectator*, 13.
자크 랑시에르, 양창렬 역,
『해방된 관객』(서울: 현실문화, 2016),
25.

다시 텍스트 내부에서 빠져나와 제니 홀저의
작업으로 돌아가 보자. 제니 홀저의 작업에서
여성의 증언은 '전시되지 않는 방식'으로 전시된다.
제니 홀저의 작업은 '전시란 무엇인가' '미술관이란
무엇인가'하는 근본적인 질문들을 떠올리게
만든다. 전시가 전시의 주체와 전시의 대상, 관람의
주체와 관람의 대상이라는 위계를 만든다면,
제니 홀저의 전시는 이 위계를 다른 방식으로
변형한다. 국립현대미술관이라는 특정한 공간에
여성의 언어들이 전시된다는 것은 무엇인가 하는
질문이 떠오른다. 작품이 위치한 서울관은
한국현대사가 농축된 장소이다.[18] 예술가와
관객들은 자신들의 방식으로 그 역사적인 장소의
재의미화 과정에 참여할 수 있다.

현대의 미술관은 전시 가치뿐만 아니라, 투기
가치와 제의적 가치까지 생산하는 문화산업의
공간이다. "미술 공간은 공장이자 슈퍼마켓이고,
도박장이며", 숭배의 공간이기도 하다.[19]
설치 미술은 전통적인 전시 공간과는 다른 공간의
연출을 가능하게 한다. 설치 미술의 공간은
창시자로서의 예술가의 역할에 의해
만들어졌지만, 그 공간의 의미화 과정은 "다중의
경쟁하는 주권자들인 큐레이터, 관객, 작가,
비평가로 구성된다."[20] 입법자로서의 예술가인
제니 홀저가 만들어낸 공간의 의미화는
그곳에서 '경쟁하는 주권자들'에 의해 이루어진다.
제니 홀저의 공간에서 관객들은 고정된 의미를
가진 언어늘을 수동적으로 만나는 것이 아니며,
그 공간의 궁극적인 의미는 결정되어 있지 않다.

여성들의 증언이 '읽히지만 읽히지 않는 방식'으로
전시된 이 공간의 의미는 확정되지 않았다.
여성들의 언어는 다만 오브제가 될 수 없으며,
어떤 만남과 상황을 만든다. 관객은 '지금–여기'의
미학적·정치적 감각을 다시 만들어갈 수 있다.
예술의 미학적·정치적 의도와 그것이 효과
사이에는 어긋남이 있을 수밖에 없다. 이 연출된
공간에서 관객과 미술, 관객과 관객이
만났을 때 무슨 일이 일어날지는 예상할 수 없다.
관람자가 '해방된 관객'이 되는 것은 작품
그 자체의 필연적인 효과가 아니라, 수용자의
행위를 통해서이다. 관객은 언어들의 스펙터클에
대한 능동적인 해석가이다.[21]

제니 홀저의 작업은 이 공간의 의미를 불확정적인
것으로 만들고, 여성 언어들이 부유하는
'시간'을 체험하게 한다. 관객은 여기에서 무엇을
보거나 읽는 것이 아니라, 다른 시간–공간을
'우연히' 만난다. 이 공간에서 여성 언어들은
하나의 이념과 전체성으로 환원되지 않으며,
시각적인 스펙터클로만 소비되지도 않는다. 여성
언어들은 친절하게 관객에게 말을 건네지 않으며,
어떤 분노와 고통을 직접적으로 전달하지도
않는다. 여성 언어들은 부유하거나 흘러가고,
그 앞에서 관객들은 어떤 언어의 순간적인 정지를
경험한다, 그 '현현'의 순간은 관객의 예기치
않은 발걸음과 우연한 시선이 만들어낸다.
여성 언어는 그 언어의 맥락과 위치를 변형하는
수용자에 의해 재정치화된다. 만약 더 깊은
고통의 언어를 체험하고 싶다면, 한 걸음 더 안으로
들어가서, 깊은 숨을 쉬어야 한다. 머뭇거리는
어떤 순간, 형언할 수 없는 여성들의 증언들을
발견한다. 단 하나의 문장이 섬광처럼
들이닥친다. 그 문장이 무엇인가는 중요하지 않다.
그 문장은 익명의 문장이며, 이미 '당신'의
문장이다. 그 순간을 만드는 것은 제니 홀저가
아니라 '당신'이다.

from *Autobiography of Death*
Kim Hyesoon

『 죽음의 자서전 』
김혜순

백야
닷새

네가 답장할 수 없는 곳에서 편지가 오리라

네가 이미 거기 있다고
네가 이미 너를 떠났다고

네 모든 걸 알고 있는 구멍에서 밝은 편지가 오리라

죽어서 모두 환하게 알게 된 사람의 뇌처럼 밝은 편지가 오리라
네 탄생 전의 날들처럼 어제도 없고 내일도 없는 넓고 넓은 편지가 오리라

빛으로 만든 마차의 방울소리 고즈넉이 울리고
빛으로 만든 바지를 입은 소녀의 까르르 웃음소리 밤 없는 세상을 두드리는

마지막 지하철이 지상으로 올라가고
플랫폼의 기차들이 일제히 불을 켠 채 말없이 너를 잊어주는

너는 발이 없어 못 가지만 네 아잇적 아이들은 이미 거기 가 있는
네 검은 글씨로 답장조차 할 수 없는 그 밝은 구멍에게서 편지가 오리라

네 아이들이 네 앞에서 나이를 먹고
너 먼저 윤회하러 떠나버린 그곳에서

밝고 밝은 빛의 잉크로 찍어 쓴 편지가 오리라

이 세상에 태어나 한 번도 어둠을 맞아본 적 없는 그 곳에서
지금 막 태어난 아기가 첫 눈 뜨고 마주한 찬란한 첫 빛
커다랗고 커다란 편지가 오리라

간 다음에
엿새

간 다음에 가지 마 하지 마
온 다음에 오지 마 하지 마

떠날 땐 눈 감기고 손 모아주면서 가지 마 가지 마 울더니
문 열어 문 열어 했더니 오지 마 오지 마 하잖아

대나무에 종이 인형 붙여 오지 마 오지 마 하잖아
불길에 옷 집어넣고 오지 마 오지 마 하잖아

그래서 너는 발이 없잖아
날개도 없는데

그런데 날기만 하잖아
내려앉지도 못하는데

감추어도 다 보이잖아
뇌도 없는데 다 알잖아

너무 춥잖아
몸도 없는데

그리하여 오늘 아침 침대 밑에 숨은 네 잠옷이
혼자서 가늘게 흐느끼고 있잖아

관이 물을 받고 있잖아
관에서 너는 이미 떠났잖아

달 베개엔 네 머리 자국
구름 이불엔 네 몸뚱어리 자국

그러니 간 다음에 가지 마 하지 마
그러니 온 다음에 오지 마 하지 마

서울, 사자의 서
스무이틀

너는 들어라 눈 덮인 북산의 음성을 들어라
네 몸속의 촛불은 꺼졌다

떠나라!
링거액에서 이별의 첫 방울이 너를 찌르는 순간
네 감각으로 만들어 네 몸을 덮었던 저 하늘이 걷혔다
하늘의 아킬레스건이 끊어졌다

네 몸뚱어리는 이제 잠 위에 뜬 안개다
네 얼굴은 네 몸 위에 뜬 구름이다
네 생각은 석쇠 위에서 구워지는 고기의 연기다
네 고통은 일인분의 숨이 네게서 달아나는 비명이다

너는 들어라 똑똑히 들어라 눈 덮인 험산준령의 음성을 들어라
돌아보지 마라, 뒤돌아보면 악몽 속으로 떨어지는 돌이 되리니
울지 말아라 눈물을 흘리면 코마에 빠진 시민의
욕창으로 다시 태어나리니
머나먼 고막에서 울리는 내 말을 똑똑히 들어라
아무도 너를 그리워하지 않으니
맘껏 날아가라
빛이 오면 빛에게 눈을 주어라
바람 오면 바람에게 귀를 주어라

다 주고도 네가 남았거든 내 말을 들어라

긴 머리칼에 묶인˚ 리본처럼
네 집이 펄럭인다 어서 떠나라

네 몸에 다른 이의 촛불이 켜지기 전에

from *I Put Evening in the Drawer*
Han Kang

『서랍에 저녁을 넣어 두었다』
한강

비 내리는 동물원
철창을 따라 걷고 있었다

어린 고라니들이 나무 아래 비를 피해 노는 동안
조금 떨어져서 지켜보는 어미 고라니가 있었다
사람 엄마와 아이들이 꼭 그렇게 하듯이

아직 광장에 비가 뿌릴 때

살해된 아이들의 이름을 수놓은
흰 머릿수건을 쓴 여자들이
느린 걸음으로 행진하고 있었다

from **A Cruelty Special to Our Species**
Emily Jungmin Yoon

『우리 종에 대한 잔혹함』
에밀리 정민 윤

Say Grace

In my country our shamans were women
and our gods multiple until white people brought
an ecstasy of rosaries and our cities today
glow with crosses like graveyards. As a child
in Sunday school I was told I'd go to hell
if I didn't believe in God. Our teacher was a woman
whose daughters wanted to be nuns and I asked,
What about babies and what about Buddha, and she said
They're in hell too and so I memorized prayers
and recited them in front of women
I did not believe in. *Deliver us from evil.*
O sweet virgin Mary, Amen. O sweet. O sweet.
In this country, which calls itself Christian,
what is sweeter than hearing *Have mercy*
on us. From those who serve different gods. O
clement, O loving, O God, O God, amidst ruins,
amidst waters, fleeing, fleeing. *Deliver us from evil.*
O sweet, O sweet. In this country,
point at the moon, at the stars, point at the way the lake lies,
with a hand full of feathers,
and they will look at the feathers. And kill you for it.
If a word for religion they don't believe in is magic,
so be it, let us have magic. Let us have
our own mothers and scarves, our spirits,
our shamans and our sacred books. Let us keep
our stars to ourselves and we shall pray
to no one. Let us eat
what makes us holy.

Testimonies (Kim Sang-hi)

I was 14 years old It was around November 26th
 It snowed, I remember. I was on my way home
from the photo-studio with my portrait when a man in olive-drab clothing
grabbed me by the collar cursed in Japanese was he Japanese
 or Korean I could not tell
I was thrown onto a truck of mournful sounds of weeping
 these girls and I crossed the border into China
there was no poison no ropes
In Suzhou I was #4 I was Takeda Sanai
 The first night an officer grabbed me
I drank disinfectant
 but I didn't die
In Nanjing I had malaria
 appendicitis hemorrhage in my vagina
 but I didn't die
In Singapore I saw dark-skinned men digging ditches
 they looked at us as if they would burst into tears
In Singapore the war ended
 we boiled leaves from trees and wild greens
 we ate this to survive
When I made it back to Pusan Harbor
 I went to my brother's house in Taegu
in his dream: I had shaved my head was drowning in the ocean
 but I didn't die
My name is Kim Sang-hi
I was born on December 20, 1920
I was born into a good family
I am a Catholic
I should forget and forgive but I cannot
When my head turns toward Japan I curse her
I want to find solace but I cannot
When I wake up every morning I cannot

My Grandmother Reminisces with Peaches

Peaches you eat at night.
In the dark you can't see the insect bites.
How do they find the sweetest fruit?

Your grandfather would find it — the one
unblemished peach in someone's orchard —
and cool it in the stream for me.
I married him that year.

He wasn't a romantic, you know.
But he always left a basket of peaches
at my feet in the summer.
I carved pieces of that viscous fruit
and placed them on the parted lips
of my sleeping children. And they rose
chewing on the pulp.

Look at how my garden balsam has bloomed.
Dye your fingers with its petals — see if it lasts till first snow.
Snow, what precious flower in this region.
With my ear resting on his chest, I could imagine its blossom.

My cheek dreamt well on his heart.

An Ordinary Misfortune (What is pressing)

What is pressing. What is pressed. Or who.
My grandmother. A woman. A teen. Her father
presses the gates shut. Presses her into
a crate. The crate into a shed. She unfolds by
morning. Binds her chest. She walks
unwomanned. An American soldier sees her
and yells *Stop over there!* in Japanese.
The language they've both learned. When she
runs, she is unmistakably woman. She falls.
He laughs. What is a body in a stolen country.
Or whose. What is right in war. What is
left in war. War hasn't left Korea. I have. I fold.
I give up, myself, to you. Which one of you
said *Let's have raunchy Korean sex* to me.
Which one of you didn't. Do you represent
America to me. Did those soldiers to her.
We didn't fear war. We feared the allies, she
said.

From A CRUELTY SPECIAL TO OUR SPECIES.
© 2018 by Emily Jungmin Yoon.
Reprinted courtesy of Ecco, an imprint of HarperCollins Publishers.

from **The Unwomanly Face of War:**
An Oral History of Women in World War II
Svetlana Alexievich

『전쟁은 여자의 얼굴을 하지 않았다』
스베틀라나 알렉시예비치

Klavdia Grigoryevna Krokhina
FIRST SERGEANT, SNIPER

I clicked, and he fell. And then, you know,
I started shaking all over, I heard my
bones knocking. I cried. When I shot at
targets it was nothing but now: I —
killed! I killed some unknown man.
I knew nothing about him, but I killed
him.

There by the road we saw a barrack or
a house, it was impossible to tell,
it was all burned down, nothing left but
blackened stones. A foundation... Many
of the girls didn't go close to it, but
it was as if something drew me there...
There were human bones among the
cinders, with scorched little stars
among them; these were our wounded
or prisoners who had been burned.
After that, however many I killed, I felt
no pity. I had seen those blackened
little stars...

...I came back from the war gray-haired.
Twenty-one years old, but my hair
was completely white. I had been badly
wounded, had a concussion, poor
hearing in one ear. Mama met me with
the words: "I believed you'd come back.
I prayed for you day and night."
My brother had fallen at the front.

Nadezhda Vasilyevna Anisimova
MEDICAL ASSISTANT IN A MACHINE-GUN COMPANY

To die... I wasn't afraid to die. Youth,
probably, or whatever... There was death
around, death was always close, but
I didn't think about it. We didn't talk about
it. It was circling somewhere nearby,
but kept missing. Once during the night
a whole company conducted
a reconnaissance mission in our regiment's
sector. Toward morning it pulled back,
and we heard moaning in no-man's-land.
A wounded man had been left behind.
"Don't go there, you'll be killed," the soldiers
held me back. "Look, it's already dawn."

I didn't listen to them and crawled there.
I found the wounded man. It took me eight
hours to drag him back, tied with a belt
by the hand. He was alive when we finally
made it. The commander of the regiment
learned about it, had a fit, and was going to
arrest me for five days for being absent
without permission. The deputy
commander's reaction was different: "She
deserves to be decorated."

At nineteen I had a medal "For Courage."
At nineteen my hair was gray. At nineteen
in my last battle I was shot through both
lungs, the second bullet went between two
vertebrae. My legs were paralyzed... And
they thought I was dead...

At nineteen... My granddaughter's age
now. I look at her — and don't believe it.
A child!

When I came home from the front, my
sister showed me my death notice... They
had already buried me...

Klara Semyonovna Tikhonovich
SERGEANT, ANTIAIRCRAFT GUNNER

I heard... words... Poison... Words
like stones... It was men's desire — to go
and fight. Can a woman kill?! Those
were abnormal, defective women...

No! A thousand times no! No, it was
a human desire. The war was going on,
I lived my usual life. A girl's life...
Then a neighbor received a letter: her
husband was wounded and in the
hospital. I thought, "He's wounded, and
who will replace him?" One came
without an arm — who will replace him?
Another came back without a leg — who
will go instead of him? I wrote letters,
begged, pleaded to be taken into the
army. That's how we were brought up,
that nothing in our country should
happen without us. We had been taught
to love it. To admire it. Since there's
a war, it's our duty to help in some way.
There's a need for nurses, so we must
become nurses. There's a need for
antiaircraft gunners, so we must become
antiaircraft gunners.

Anna Petrovna Kalyagina
SERGEANT, MEDICAL ASSISTANT

I don't know... No, I understand what
you're asking about, but words fail me...
I have no words... How can I describe it?
I need... In order to... A spasm
suffocated me, as it does now: at night
I lie in the stillness and I suddenly
remember. I suffocate. In shivers...
Like this...

Olga Nikitichna Zabelina
ARMY SURGEON

Sometimes I hear music... Or a song...
a woman's voice... And there I find what
I felt then. Something similar...

But I watch films about the war — not
right. I read a book — not right. No, not it.
It doesn't come off. I start talking,
myself — that's also not it. Not as
frightening and not as beautiful. Do you
know how beautiful a morning at war
can be? Before combat... You look
and you know: this may be your last.
The earth is so beautiful... And the air...
And the dear sun...

Tamara Stepanova Umnyagina
JUNIOR SERGEANT IN THE GUARDS, MEDICAL ASSISTANT

Before your eyes a man is dying... And you
know, you can see, that you can't help him in
any way; he only has a few minutes to live.
You kiss him, caress him, speak tender words
to him. You say good-bye. Well, you can't
help him any other way...

As soon as I begin telling this story, I get sick
again. I'm talking, my insides turn to jelly,
everything is shaking. I see it all again, I picture
it: how the dead lie — their mouths are open,
they were shouting something and never
finished shouting, their guts are ripped out.
I saw fewer logs than dead men... And how
frightening! How frightening is hand-to-hand
combat, where men go at each other with
bayonets... Bare bayonets. You start
stammering, for several days you can't get
the words out correctly. You lose speech.
Can those who weren't there understand this?
How do you tell about it? With what face?
Well, answer me — with what face should
I remember this? Others can somehow...
They're able to... but me — no. I weep.
Yet this must be preserved, it must. We must
pass it on. Somewhere in the world they have
to preserve our cry. Our howl...

Excerpts from
THE UNWOMANLY FACE OF WAR:
AN ORAL HISTORY OF WOMEN IN WORLD WAR II
by Svetlana Alexievich, translated by
Richard Pevear and Larissa Volokhonsky,
translation © 2017 by Penguin Random House LLC.
Used by permission of Random House,
an imprint and division of Penguin Random House LLC.
All rights reserved.

호진 아지즈 웹사이트
호진 아지즈

May 10, 2017:
Forced Veils Bite the Dust

Unless women have the right to protect
themselves, and organise in Middle
Eastern societies there cannot be true and
collective liberation for women and society.
But women's liberation cannot only be
a military one. It must be comprehensive
and encompass every aspect of women's
lives including the social, the political,
the public and private, the economic,
the class and race based issues, the sexual
and the freedom from and the right to
change religion.

Ironically, unlike Western forms of
feminism this form of locally developed,
organic women's liberation has achieved
the impossible of military liberation and
is currently attempting to encourage
and develop liberation in other spheres.
Perhaps it will prove to be more effective,
enduring and all encompassing than
the cheap, imported, top down forms of
western neocolonial and imperial forms
of democratisation and liberatory rhetoric
we've been exposed to in the past.

October 25, 2017:
The Measure of Humanity

The world has forgotten to measure its
humanity. It has forgotten to see itself
mirrored in the unbearable innocence of the
faces of children. It has forgotten its own
name, its own place, its own heartbeat.
Its name has become war, its face falling
bombs, its very heartbeat the rapidly dying,
falling, shattering bodies of little children.
Like a handful of petals, already crushed
between careless fingers, thrown casually,
recklessly into the wind the little children's
bodies keep falling, falling, endlessly
falling… And so even when the world lay
wounded and dying on that beach, it did not
recognize its own death. Even when it sat
broken and shattered, bleeding in
unendurable shock in that hospital room,
in that ambulance, it did not concede it was
in the throes of its imminent death; even as
the atoms of its very existence unraveled…

The world has forgotten to measure its
humanity. Its streets and corridors are filled
with little children, whose eyes are older
than time. Its alleyways and main
thoroughfares are filled with children that
fall asleep, exhausted from marching all day
selling small packets of gum or tissues to
the adults who never look them in the eye.
The world has forgotten its name in shame.
Its spine forever twisted, tortured, pained
in avoidance of looking at the children.
Its bomb shattered towns are filled with little
children who no longer shudder as the
bombs fall. To them the falling, shattering,
bursting bombs are as normal as the
hunger that refuses to leave. As normal as
the wounds that do not receive treatment.
As normal as the lost siblings, lost parents,
and lost hope before they even knew by
what name hope went.

But they know. They know that something,
something unnameable, something
valuable, a birthright to something they
cannot grasp, cannot frame into words,
something treasured has been stolen from
them — they do not know it's called
happiness or safety… and the world in turn
is too ashamed to look them in the eye.
Ashamed but not acting. Ashamed and yet
knowing.

And so no one looks the children in the eye
any more, because to look is to see the
world reflected back in all its naked, glorious
failure, of a world lying shattered, broken,
destroyed beyond recognition and name.

November 27, 2016:
Escaping Saddam's Chemical Bombings:
Memories of a Child Refugee

One of the earliest memories I have as
a child is my parents pressing a soaked scarf,
ripped into several parts and shared with
my cousins, against our faces so that we
would not inhale the falling chemicals that
Saddam was using to kill us. We were only
children, 3 and 4 and 5. The eldest one of
us was 13 I think. Even then we understood
the meaning of war because instead of
seeing shooting stars at night we saw bombs
falling. They lit the sky, who made no effort
to resist, and when they fell the earth shook
so tremendously, so outrageously; as if
even God was conspiring against us, angry
that we had survived. So when the chemicals
were used we knew they were falling
because we were not meant to exist, guilty
of the crime of being Kurds.

And we were only children.

I see the broken bodies of children removed
from the rubble, I see them in the camps,
or I see the mothers and fathers of Bakur
waving white flags so that Turkish snipers do
not shoot them as they take the lifeless
bodies of their children to hospitals — and
I feel angry. An anger that sits on my chest
like a physical pain of immense gravity,
snaking its way around my soul endlessly.
A prisoner of its mocking, taunting sneers
that it's all hopeless, hopeless. Angry
because we keep having children and keep
raising them in a world bent on our erasure,
bent on removing any trace of us.

Maybe we have the children because we
keep hoping for a better world, a better life,
a better chance of survival for them. Perhaps
we keep having them because we need
a reason to keep resisting, keep fighting,
keep staying, unbending, unwavering,
unending despite all odds. Or maybe it's just
underdevelopment and lack of education
and access to preventative measures,
policies of cultural genocide imposed by the
regimes whose colonies we are.

I dream of a day where the children of
Kurdistan no longer say "mother, why are
they killing us?" I dream of a Kurdistan
that doesn't have more refugee camps than
schools. I dream of a Kurdistan that
doesn't have more flags than it has clothes
for children; where the children learn
math, science and innovation, not sit in the
classroom of life, war and tragedy.

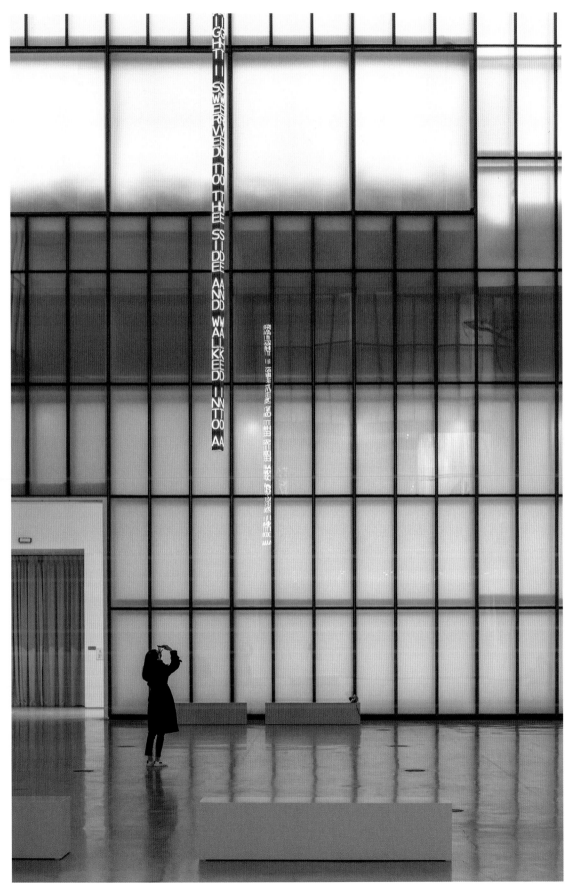

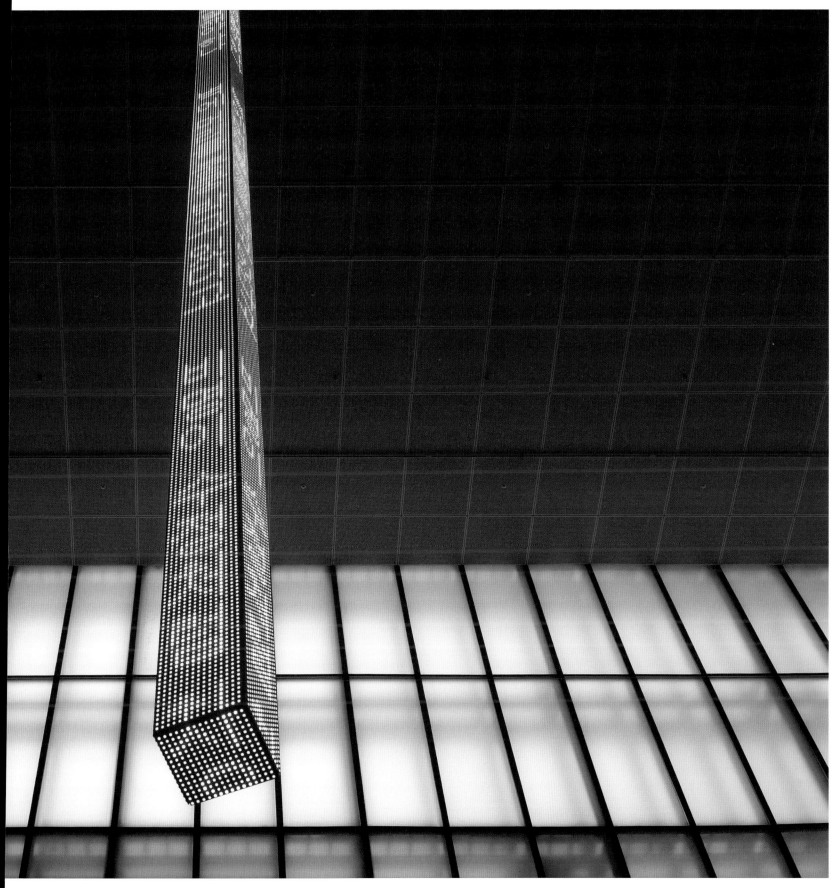

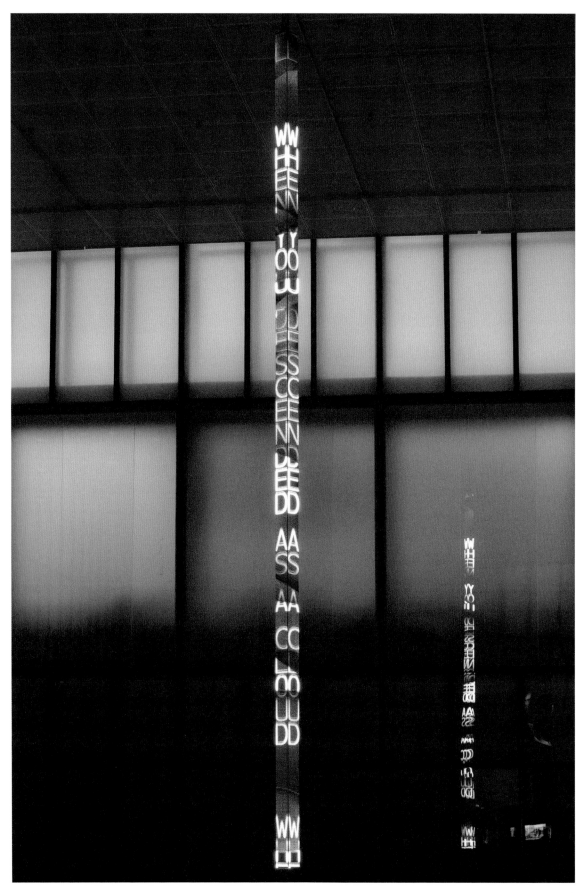

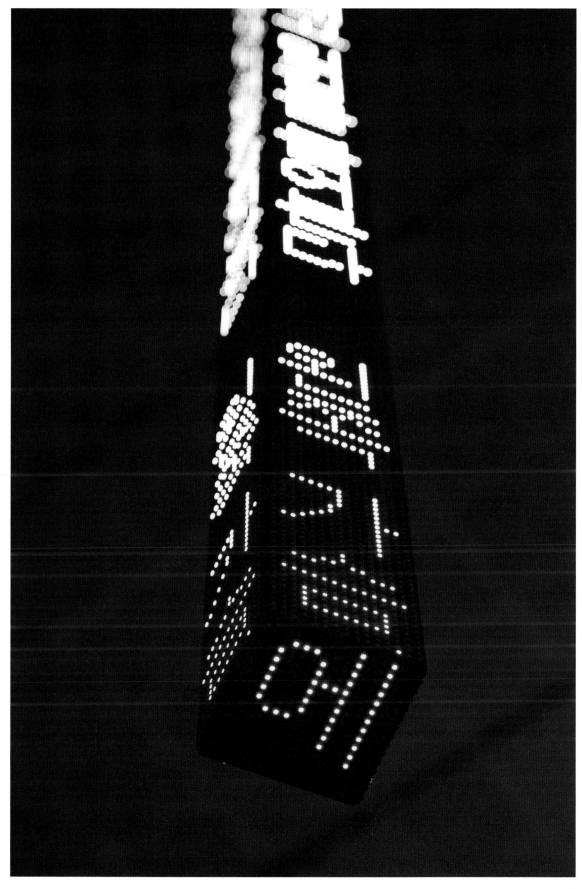

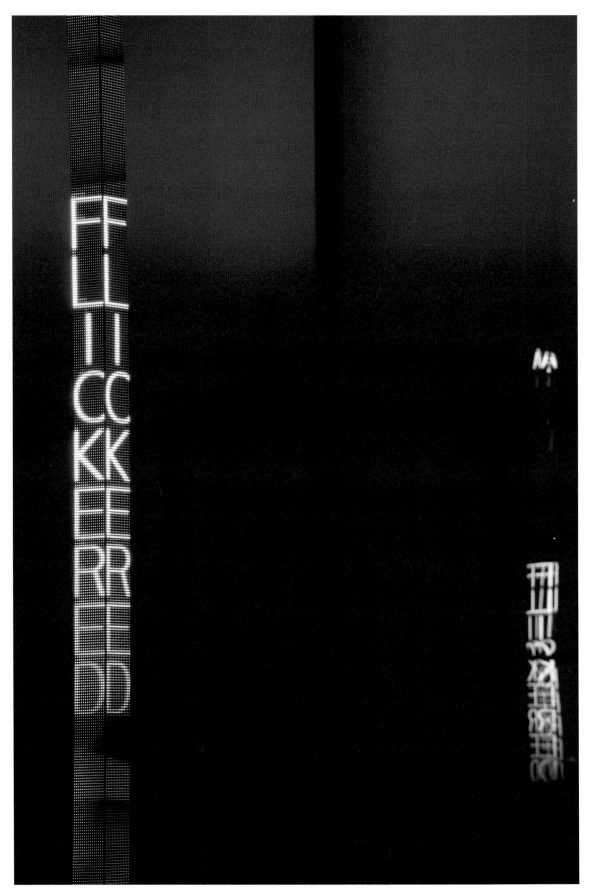

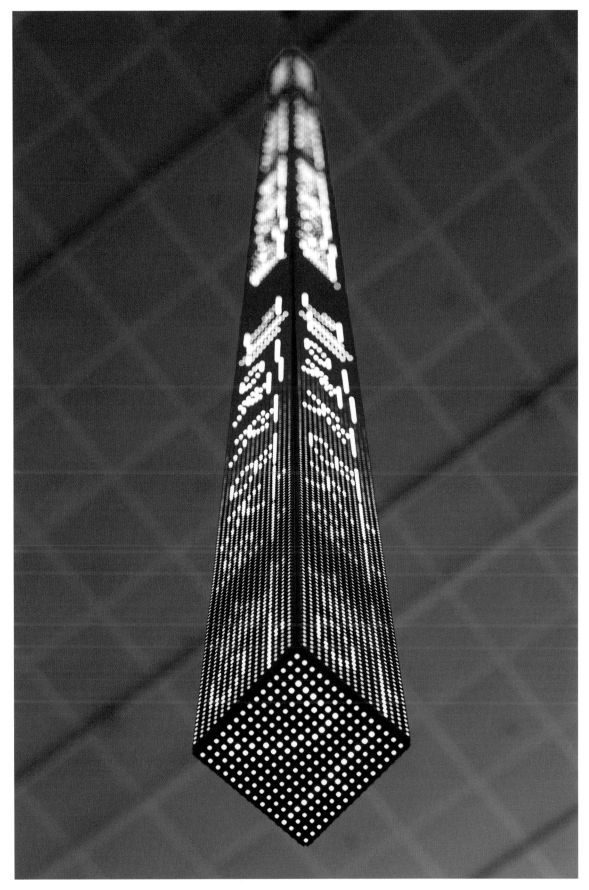

55

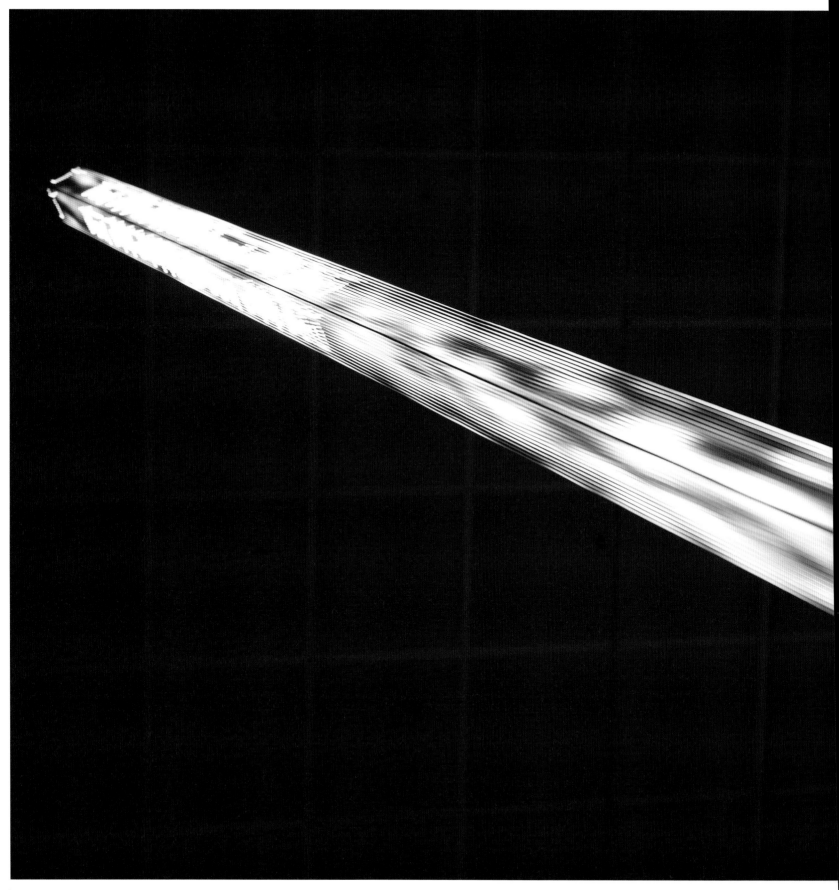

from *Truisms* (1977–79)

2019
Offset posters on paper
34.75 × 22.9 in. / 88.3 × 58.1 cm, each

〈경구들〉로부터 (1977–79)

2019
종이에 오프셋 인쇄 포스터
각 34.75 × 22.9 in. / 88.3 × 58.1 cm

from *Inflammatory Essays* (1979–82)

2019
Offset posters on colored paper
17×17 in. / 43.2×43.2 cm, each

〈선동적 에세이〉로부터 (1979–82)

2019
유색 종이에 오프셋 인쇄 포스터
각 17×17 in. / 43.2×43.2 cm

해할 것이다

한 결과로 이어질 수 있다

가능한 법칙을 따라 돌아간다

신세 진 것이 아니라 내가 세상에 신세 지고 있다

롭다

혹은 혁명가를 만들어낸다

션은 아니다

할 나위 없이 건강한 삶이다

신화는 현실을 보다 이해하기 쉽게 한다

심지어 가족에게도 배신 당할 수 있다

아무도 주목하지 않는 행동은 무의미하다

아버지들은 종종 지나친 힘을 행사한다

아이들은 그 누구보다 잔인하다

아이들은 미래의 희망이다

아이를 갖지 않는 것이 세상에는 축복이다

안전책만 강구하는 것은 장기적으로 많은 손실을 야기할 수 있다

야망은 안일함만큼이나 위험하다

양가적인 태도는 삶을 망칠 수 있다

어디서 멈추고 어디서 세상이 시작하는지 알아야 한다

어떤 경우에는 지속하는 것보다 죽는 것이 낫다

어떤 대가를 치르더라도 지식을 발달시켜야 한다

어리석은 자들은 번식하지 말아야 한다

어머니는 너무 많이 희생해서는 안 된다

어차피 아무것도 바꿀 수 없으니 즐겨라

억압당하던 자들이 폭군이 될 때 변화는 가치를 지닌다

엉성한 사고는 시간이 갈수록 나빠진다

엘리트의 존재는 불가피하다

여가 시간은 거대한 연막이다

여성은 권력을 사랑한다

여윳돈은 기부하는 것이 좋다

여자아이와 남자아이를 똑같이 양육하라

THE PEOPLE AND DELAY THE INEVITABLE CONFRONTATION. DELAY IS NOT TOLERATED FOR IT JEOPARDIZES THE WELL-BEING OF THE MAJORITY. CONTRADICTION WILL BE HEIGHTENED. THE RECKONING WILL BE HASTENED BY THE STAGING OF SEED DISTURBANCES. THE APOCALYPSE WILL BLOSSOM.

THROAT. THE TRUE SOUND TELLS HIM THAT HE CUTS HIS FLESH WHEN HE CUTS YOURS, THAT HE CANNOT THRIVE AFTER HE TORTURES YOU. SCREAM THAT HE DESTROYS ALL KINDNESS IN YOU AND BLACKENS EVERY VISION YOU COULD HAVE SHOWN HIM.

PROCESS IN MOTION. MANIPULATION IS NOT LIMITED TO PEOPLE. ECONOMIC, SOCIAL AND DEMOCRATIC INSTITUTIONS CAN BE SHAKEN. IT WILL BE DEMONSTRATED THAT NOTHING IS SAFE, SACRED OR SANE. THERE IS NO RESPITE FROM HORROR. ABSOLUTES ARE QUICKSILVER. RESULTS ARE SPECTACULAR.

THAT HAS NO PLACE FOR YOU, RISE TRIUMPHANT FROM THE ASHES. FIRE PURIFIES AND RELEASES ENERGY. FIRE GIVES HEAT AND LIGHT. LET FIRE BE THE CELEBRATION OF YOUR DELIVERANCE. LET LIGHTNING STRIKE, LET THE FLAMES DEVOUR THE ENEMY!

SHRIEK WHEN THE PAIN HITS DURING INTERROGATION. REACH INTO THE DARK AGES TO FIND A SOUND THAT IS LIQUID HORROR, A SOUND OF THE BRINK WHERE MAN STOPS AND THE BEAST AND NAMELESS CRUEL FORCES BEGIN. SCREAM WHEN YOUR LIFE IS THREATENED. FORM A NOISE SO TRUE THAT YOUR TORMENTOR RECOGNIZES IT AS A VOICE THAT LIVES IN HIS OWN THROAT. THE TRUE SOUND TELLS HIM THAT HE CUTS HIS FLESH WHEN HE CUTS YOURS, THAT HE CANNOT THRIVE AFTER HE TORTURES YOU. SCREAM THAT HE DESTROYS ALL KINDNESS IN YOU AND BLACKENS EVERY VISION YOU COULD HAVE SHOWN HIM.

FEAR IS THE MOST ELEGANT WEAPON, YOUR HANDS ARE NEVER MESSY. THREATENING BODILY HARM IS CRUDE. WORK INSTEAD ON MINDS AND BELIEFS, PLAY INSECURITIES LIKE A PIANO. BE CREATIVE IN APPROACH. FORCE ANXIETY TO EXCRUCIATING LEVELS OR GENTLY UNDERMINE THE PUBLIC CONFIDENCE. PANIC DRIVES HUMAN HERDS OVER CLIFFS; AN ALTERNATIVE IS TERROR-INDUCED IMMOBILIZATION. FEAR FEEDS ON FEAR. PUT THIS EFFICIENT PROCESS IN MOTION. MANIPULATION IS NOT LIMITED TO PEOPLE. ECONOMIC, SOCIAL AND DEMOCRATIC INSTITUTIONS CAN BE SHAKEN. IT WILL BE DEMONSTRATED THAT NOTHING IS SAFE, SACRED OR SANE. THERE IS NO RESPITE FROM HORROR. ABSOLUTES ARE QUICKSILVER. RESULTS ARE SPECTACULAR.

IT ALL HAS TO BURN, IT'S GOING TO BLAZE. IT IS FILTHY AND CAN'T BE SAVED. A COUPLE OF GOOD THINGS WILL BURN WITH THE REST BUT IT'S O.K., EVERY PIECE IS PART OF THE UGLY WHOLE. EVERYTHING CONSPIRES TO KEEP YOU HUNGRY AND AFRAID FOR YOUR BABIES. DON'T WAIT ANY LONGER. WAITING IS WEAKNESS, WEAKNESS IS SLAVERY. BURN DOWN THE SYSTEM THAT HAS NO PLACE FOR YOU, RISE TRIUMPHANT FROM THE ASHES. FIRE PURIFIES AND RELEASES ENERGY. FIRE GIVES HEAT AND LIGHT. LET FIRE BE THE CELEBRATION OF YOUR DELIVERANCE. LET LIGHTNING STRIKE, LET THE FLAMES DEVOUR THE ENEMY!

THE MOST EXQUISITE PLEASURE IS DOMINATION. NOTHING CAN COMPARE WITH THE FEELING. THE MENTAL SENSATIONS ARE EVEN BETTER THAN THE PHYSICAL ONES. KNOWING YOU HAVE POWER HAS TO BE THE BIGGEST HIGH, THE GREATEST COMFORT. IT IS COMPLETE SECURITY, PROTECTION FROM HURT. WHEN YOU DOMINATE SOMEBODY YOU'RE DOING HIM A FAVOR. HE PRAYS SOMEONE WILL CONTROL HIM, TAKE HIS MIND OFF HIS TROUBLES. YOU'RE HELPING HIM WHILE HELPING YOURSELF. EVEN WHEN YOU GET MEAN HE LIKES IT. SOMETIMES HE'S ANGRY AND FIGHTS BACK BUT YOU CAN HANDLE IT. HE ALWAYS REMEMBERS WHAT HE NEEDS. YOU ALWAYS GET WHAT YOU WANT.

FREEDOM IS IT! YOU'RE SO SCARED. YOU WANT TO LOCK UP EVERYBODY. ARE THEY MAD DOGS? ARE THEY OUT TO KILL? MAYBE YES. IS LAW AND ORDER THE SOLUTION? DEFINITELY NO. WHAT CAUSED THIS SITUATION? LACK OF FREEDOM. WHAT HAPPENS NOW? LET PEOPLE FULFILL THEIR NEEDS. IS FREEDOM CONSTRUCTIVE OR IS IT DESTRUCTIVE? THE ANSWER IS OBVIOUS. FREE PEOPLE ARE GOOD, PRODUCTIVE PEOPLE. IS LIBERATION DANGEROUS? ONLY WHEN OVERDUE. PEOPLE AREN'T BORN RABID OR BERSERK. WHEN YOU PUNISH AND SHAME YOU CAUSE WHAT YOU DREAD. THEY DO WHAT DO? LET IT EXPLODE. RUN WITH IT. DON'T CONTROL OR MANIPULATE. MAKE AMENDS.

MONEY CREATES TASTE	PUSH YOURSELF TO THE LIMIT AS OFTEN AS POSSIBLE	STERILIZATION IS A WEAPON OF THE RULERS
MONOMANIA IS A PREREQUISITE OF SUCCESS	RAISE BOYS AND GIRLS THE SAME WAY	STRONG EMOTIONAL ATTACHMENT STEMS FROM BASIC INSECURITY
MORALS ARE FOR LITTLE PEOPLE	RANDOM MATING IS GOOD FOR DEBUNKING SEX MYTHS	STUPID PEOPLE SHOULDN'T BREED
MOST PEOPLE ARE NOT FIT TO RULE THEMSELVES	RECHANNELING DESTRUCTIVE IMPULSES IS A SIGN OF MATURITY	SURVIVAL OF THE FITTEST APPLIES TO MEN AND ANIMALS
MOSTLY YOU SHOULD MIND YOUR OWN BUSINESS	RECLUSES ALWAYS GET WEAK	SYMBOLS ARE MORE MEANINGFUL THAN THINGS THEMSELVES
MOTHERS SHOULDN'T MAKE TOO MANY SACRIFICES	REDISTRIBUTING WEALTH IS IMPERATIVE	TAKING A STRONG STAND PUBLICIZES THE OPPOSITE POSITION
MUCH WAS DECIDED BEFORE YOU WERE BORN	RELATIVITY IS NO BOON TO MANKIND	TALKING IS USED TO HIDE ONE'S INABILITY TO ACT
MURDER HAS ITS SEXUAL SIDE	RELIGION CAUSES AS MANY PROBLEMS AS IT SOLVES	TEASING PEOPLE SEXUALLY CAN HAVE UGLY CONSEQUENCES
MYTHS CAN MAKE REALITY MORE INTELLIGIBLE	REMEMBER YOU ALWAYS HAVE FREEDOM OF CHOICE	TECHNOLOGY WILL MAKE OR BREAK US
NOTHING UPSETS THE BALANCE OF GOOD AND EVIL	RESOLUTIONS SERVE TO EASE YOUR CONSCIENCE	THE CRUELEST DISAPPOINTMENT IS WHEN YOU LET YOURSELF DOWN
OCCASIONALLY PRINCIPLES ARE MORE VALUABLE THAN PEOPLE	REVOLUTION BEGINS WITH CHANGES IN THE INDIVIDUAL	THE DESIRE TO REPRODUCE IS A DEATH WISH
OFFER VERY LITTLE INFORMATION ABOUT YOURSELF	ROMANTIC LOVE WAS INVENTED TO MANIPULATE WOMEN	THE FAMILY IS LIVING ON BORROWED TIME
OFTEN YOU SHOULD ACT LIKE YOU ARE SEXLESS	ROUTINE IS A LINK WITH THE PAST	THE IDEA OF REVOLUTION IS AN ADOLESCENT FANTASY
OLD FRIENDS ARE BETTER LEFT IN THE PAST	ROUTINE SMALL EXCESSES ARE WORSE THAN THE OCCASIONAL DEBAUCH	THE IDEA OF TRANSCENDENCE IS USED TO OBSCURE OPPRESSION
OPACITY IS AN IRRESISTIBLE CHALLENGE	SACRIFICING YOURSELF FOR A BAD CAUSE IS NOT A MORAL ACT	THE IDIOSYNCRATIC HAS LOST ITS AUTHORITY
PAIN CAN BE A VERY POSITIVE THING	SALVATION CAN'T BE BOUGHT AND SOLD	THE MOST PROFOUND THINGS ARE INEXPRESSIBLE
PEOPLE ARE BORING UNLESS THEY'RE EXTREMISTS	SELF-AWARENESS CAN BE CRIPPLING	THE MUNDANE IS TO BE CHERISHED
PEOPLE ARE NUTS IF THEY THINK THEY ARE IMPORTANT	SELF-CONTEMPT CAN DO MORE HARM THAN GOOD	THE NEW IS NOTHING BUT A RESTATEMENT OF THE OLD
PEOPLE ARE RESPONSIBLE FOR WHAT THEY DO UNLESS THEY'RE INSANE	SELFISHNESS IS THE MOST BASIC MOTIVATION	THE ONLY WAY TO BE PURE IS TO STAY BY YOURSELF
PEOPLE WHO DON'T WORK WITH THEIR HANDS ARE PARASITES	SELFLESSNESS IS THE HIGHEST ACHIEVEMENT	THE SUM OF YOUR ACTIONS DETERMINES WHAT YOU ARE
PEOPLE WHO GO CRAZY ARE TOO SENSITIVE	SEX DIFFERENCES ARE HERE TO STAY	THE UNATTAINABLE IS INVARIABLY ATTRACTIVE
PEOPLE WON'T BEHAVE IF THEY HAVE NOTHING TO LOSE	SIN IS A MEANS OF SOCIAL CONTROL	THE WORLD OPERATES ACCORDING TO DISCOVERABLE LAWS
PHYSICAL CULTURE IS SECOND-BEST	SLIPPING INTO MADNESS IS GOOD FOR THE SAKE OF COMPARISON	THERE ARE TOO FEW IMMUTABLE TRUTHS TODAY
PLANNING FOR THE FUTURE IS ESCAPISM	SLOPPY THINKING GETS WORSE OVER TIME	THERE'S NOTHING EXCEPT WHAT YOU SENSE
PLAYING IT SAFE CAN CAUSE A LOT OF DAMAGE IN THE LONG RUN	SOLITUDE IS ENRICHING	THERE'S NOTHING REDEEMING IN TOIL
POLITICS IS USED FOR PERSONAL GAIN	SOMETIMES SCIENCE ADVANCES FASTER THAN IT SHOULD	THINKING TOO MUCH CAN ONLY CAUSE PROBLEMS
POTENTIAL COUNTS FOR NOTHING UNTIL IT'S REALIZED	SOMETIMES THINGS SEEM TO HAPPEN OF THEIR OWN ACCORD	THREATENING SOMEONE SEXUALLY IS A HORRIBLE ACT
PRESENTATION IS AS IMPORTANT AS CONTENT	SPENDING TOO MUCH TIME ON SELF-IMPROVEMENT IS ANTISOCIAL	TIMIDITY IS LAUGHABLE
PRIVATE PROPERTY CREATED CRIME	STARVATION IS NATURE'S WAY	TO DISAGREE PRESUPPOSES MORAL INTEGRITY
PURSUING PLEASURE FOR THE SAKE OF PLEASURE WILL RUIN YOU	STASIS IS A DREAM STATE	TORTURE IS BARBARIC


TRADING A LI… / TRUE FREEDO… / UNIQUE THIN… / UNQUESTION… / USING FORCE… / VIOLENCE IS… / WAR IS A PUR… / WE MUST MA… / WHEN SOMET… / WISHING THIN… / WOMEN LOVE… / WORDS TEND… / YOU ARE A VI… / YOU ARE GUI… / YOU ARE RES… / YOU ARE THE… / YOU CAN LIVE… / YOU CAN'T FO… / YOU DON'T K… / YOU HAVE TO… / YOU MUST BE… / YOU MUST DI… / YOU MUST HA… / YOU MUST KN… / YOU NEVER K… / YOU ONLY CA… / YOU OWE THE… / YOU SHOULD… / YOUR ACTION… / YOUR OLDEST…

신화는 현실을 보다 이해하기 쉽게 한다
삼자가 가족에게는 배신 당할 수 있다
아무도 주목하지 않는 행동은 무의미하다
아버지들은 종종 지나친 힘을 구사한다
아이들은 그 누구보다 잔인하다
아이들은 미래의 희망이다
아이를 갖지 않는 것이 세상에는 축복이다
안전벽한 친구하는 것은 장기적으로 많은 손실을 야기할 수 있다
야망은 안일함만큼이나 위험하다
양가적인 태도는 삶을 망칠 수 있다
어디서 멈추고 어디서 세상이 시작하는지 알아서 안된다
어떤 경우에는 지속하는 것보다 죽는 것이 낫다
어떤 대가를 치르더라도 지식을 발달시켜야 한다
어리석은 자들은 번식하지 말아야 한다
어머니는 너무 많이 희생해서는 안 된다
어차피 아무도 바꿀 수 없으니 즐거마
억압당하던 자들이 복수하면 잘 때 변하는 가치를 지난다
읽을 게 없는 이는 암부로 행동한다
엘리트의 존재는 불가피하다

욕망이 많은 사람은 삶이 흥미로울 것이다
우리는 기술 때문에 숨어가나 망할 것이다
유머는 배울수다
유명한 사람보다 선한 사람이 되는 게 낫다
육체노동은 건전한 활력을 준다
은둔자는 늘 약해진다
의미를 부여하는 것은 자신의 책임이다
의심 없는 사람은 너그러운 영혼을 나타낸다
의존은 발뭄이 될 수 있다
이기심은 가장 기본적인 동기다
이름은 그 자체만으로 많은 것을 의미한다
이타심은 가장 위대한 업적이다
안위적인 욕망이 지구를 태운하고 있다
알과는 과거와의 연장 고려이다
일부일부제에는 남성의 본성과 맞지 않는다
일상의 사소한 남비는 가끔 방탕한 것보다 나쁘다
알알할은 집단 결속력을 강화하는 데 희생된다
읽을 게 없는 이는 암부로 행동한다
앎의 교배는 섹에 대한 속설을 깨는 데 도움이 된다

자신을 확신하는 자는 바보다
자신의 몸이 하는 말을 들어라
자신의 미묘함을 경각하는 사람들은 미치광이다
자연에 조화롭게 사는 것은 원시적이다
자유는 필수품이 아니라 사치품이다
잠재력은 실현되기 전까지 아무 소용이 없다
재산 방치는 상대적으로 중요하지 않다
적을 무시하는 것이 최고의 전술이다
적자생존의 법칙은 인간과 동물 모두에게 적용된다
전문가는 양성하지 말라
전쟁은 정화 의식이다
형태적 목적을 자유의 한 형태가 될 수 있다
형태적인 믿음을 너무 많이 갖는 것도 좋지 않다
형태는 행동을 죽인다
점잖음은 상대적인 것이다
정교함은 공허의 한 형태다
정부는 국민에게 부담이 된다
정치 상태는 꿈꾸는 상태이다
앎의 교배는 개인의 이익에 사용된다

The Con(Text) of Jenny Holzer: Transcription of Their Voices

Chung Yeon Shim
Professor, Hongik University, Seoul, Korea

In 1971, feminist art historian Linda Nochlin published "Why Have There Been No Great Women Artists?," officially declaring the advent of feminism in art history.[1] Nochlin argued that the supposed absence of "great" female artists was not because of a dearth of female talent or capability, but rather due to a lack of proper evaluation from social, educational, and cultural systems that implicitly presume the ascendancy of white males. Beginning in the 1970s, issues of gender equality, social class, and postcolonialism propelled feminist discussions in the field of visual art. Works incorporating language and text as post-material symbols laid the foundation for American conceptual and feminist art, which was aggressively pursued by feminists who emphasized "otherness." Such work was epitomized by Jenny Holzer, Barbara Kruger, Mary Kelly, Louise Lawler, and Martha Rosler, whose works delivered female experiences through the voices of women oppressed by misogyny and patriarchy. These voices were not founded on masculine subjectivity, but on a new language with semiotic values that exposed the insidious violence of the patriarchal system from the perspective of women. The "linguistic context" of Holzer's works forces viewers to rethink the existing order, proposing polysemous and ambiguous meanings as a way of establishing a new subjectivity.[2]

The origins of Jenny Holzer's shift to text-based feminist work lie, in part, in her participation in the Whitney Museum's Independent Study Program from 1976 to 1977, where she became familiar with methodologies of linguistic representation through discursive and critical discussions.[3] After initially producing her works as street posters, Holzer eventually started using audiovisual media (e.g., LED screens and light projectors) to project text onto buildings and other public structures. For the first two decades of her career, Holzer personally wrote all of the text in her works, but in the 1990s she also began to work with literary and historical texts written by others, and outside texts have continued to play an important role in her work ever since. While many of Holzer's works have been introduced to Korea through exhibitions and academic essays, the recent exhibition at the National Museum of Modern and Contemporary Art, Korea (MMCA) marks the first time that she has been commissioned to produce site-specific works in this country. The resulting assemblage of artworks — including the *Truisms* (1977–79) installed outside MMCA Gwacheon, the *Truisms* and *Inflammatory Essays* (1979–82) on the lobby wall of MMCA Seoul, and *FOR YOU*, a robotic column of scrolling text — nicely demonstrate the characteristics of her text-based works, as well as her minimalist sculptural style. Since the display of *Truisms* and *Inflammatory Essays* at MMCA Seoul is an extension of Holzer's earlier works, this paper focuses on the more recent installations produced as part of the MMCA Commission Project.

1
Originally published in the January 1971 issue of *ARTnews*, the essay can also be found in Nochlin's collection *Women, Art, and Power and Other Essays* (New York: Harper & Row, 1988), 145–78.

2
Hal Foster, "Subversive Signs," in *Recodings: Art, Spectacle, Cultural Politics* (New York: New Press, 1999), 99–118; Craig Owen, *Beyond Recognition: Representation, Power, and Culture* (Berkeley: University of California Press, 1992).

3
Kiki Smith, "Jenny Holzer," *Interview*, March 26, 2012, http://www.interviewmagazine.com/art/jenny-holzer.

제니 홀저의 컨(텍스트) 작업: 그들의 목소리로 받아쓰기

정연심
홍익대 예술학과 교수

페미니스트 미술사학자인 린다 노클린(Linda Nochlin)은 1971년 『왜 이제까지 위대한 여성 미술가가 없었는가?(Why Have There Been No Great Women Artists?)』를 발표하면서 미술사에서 페미니즘을 공식 선언하였다.1 노클린은 역사적으로 여성 천재 미술가들이 평가받지 못한 이유는 여성들의 재능이나 능력이 아니라 사회적 구조, 교육 체제나 관습 등에서 기인한다고 분석했다. 여성 미술가들의 역사적 부재는 "백인남성을 주체적인 존재로 자연스럽게 생각하는 자세(the white-male-position-accepted-as-natural)"에서 비롯된 것으로, 1970년대 이후 젠더 문제, 계급 문제, 탈식민주의 이슈는 시각미술에서의 페미니즘 논쟁과 이슈를 더욱 가속화 시켰다. 특히 언어나 텍스트 작업은 탈물질화된 기호로서 미국의 개념미술과 페미니즘 미술에서 가장 중요한 근간을 이루었으며, 타자성을 강조한 페미니스트들에게도 쟁투적인 방식으로 다뤄지기 시작했다. 이러한 언어 작업은 페미니스트 미술가인 제니 홀저를 비롯해, 바바라 크루거(Barbara Kruger), 메리 켈리(Mary Kelly), 루이스 롤러(Louise Lawler), 마사 로슬러(Martha Rosler) 등의 작업을 통해 쟁점화 되었으며, 이들의 작업은 가부장제 속에서 억압받는 여성의 목소리와, 여성의 경험을 남성적 언어가 아닌, 여성적 목소리를 통해 표현하는데 큰 특징이 있었다. 이것은 남성의 주체성 속에서 획득한 언어가 아니라 언어를 새롭게 여성의 관점, 가부장적인 사회와 권력 속에서 감춰진 폭력의 양상을 폭로하는데 기호학적 가치를 지니기도 했다. 특히, 제니 홀저의 텍스트 작업에서 엿보이는 '언어적 문맥'은 기존의 질서를 재고하고 다시 사색하게 만듦으로써 새로운 주체성을 확립하는데 다의적이고 중의적인 의미를 제기했다.2

또한 홀저는 텍스트를 기반으로 한 여성주의 작업을 시작하였는데 이러한 작업의 중요한 기저에는 그가 휘트니 미술관의 독립연구프로그램(Whitney Museum of American Art's Independent Study Program, 1976-77)을 통해 담론과 비평적 텍스트 위주로 토론을 하며 언어를 표상화하는 방법론을 습득했던 시기의 경험이 녹아있다.3 홀저는 초기에 거리의 포스터를 적극적으로 이용하였지만, 점차 테크놀로지 기반의 LED 전광판이나, 라이트 프로젝션 등을 실험적으로 사용하면서 공적 공간이나 건물의 표면에 언어 기반의 다양한 텍스트들을 투사하기도 했다. 홀저는 자신이 직접 쓴 텍스트를 기반으로 작업해오다 1990년대부터 다른 이들이 쓴 문학적이고 역사적인 텍스트를 발췌하여 사용하기 시작했으며, 지속적으로 이를 자신의 작업 안에 전유하고 있다. 홀저의 작업이 한국에서 일부 갤러리의 전시나 학술 논문을 통해 소개된 바가 있지만, 국립현대미술관의 커미션을 통해 장소 특정형 작업이 의뢰가 된 것은 국내에서 이번이 처음이다. 국립현대미술관의 과천관 야외에 설치된 홀저의 〈경구들에서 선정된 문구들〉(2019)의 일부 텍스트 작업을 비롯해 서울관의 로비에 설치된 〈경구들〉(1977-79)과 〈선동적 에세이〉(1979-82), 그리고 로보틱 칼럼의 형식으로 제작된 세로식 텍스트 작업은 그가 그동안 보여준 개념적 텍스트 작업의 특징과 함께 조각적인 면에서는 미니멀리즘적 형식을 동시에 보여준다. 이 작업들은 그가 1970년대부터 보여준 초기 작업과의 긴밀한 연관성 속에 존재하기 때문에, 이 글에서는 이번 국립현대 미술관의 MMCA 커미션 작업들의 맥락을 중점적으로 살펴볼 것이다.

In an interview with Benjamin Buchloh, Holzer recalled that, during her formative years at the Rhode Island School of Design, she was influenced by Bruce Nauman, Joseph Beuys, and sculptors such as Donald Judd and Dan Flavin. After moving to New York, she was introduced to the text-based and linguistic works of conceptual artists Lawrence Weiner and Sol LeWitt, after having previously been exposed to similar works by Daniel Buren and Yoko Ono.[4] Although perhaps not directly influenced by the analytic philosophy or the structuralist language theory explored by the conceptual artists, Holzer seems to have been attracted by the accessibility, implications, economics, and controllability of language. With conceptual art and post-materialism dominating the American art scene of the 1960s and 1970s, Holzer began actively producing minimalist text-based works after relocating to New York. In the art scene at the time, feminism was challenging the value of modernist aesthetics and what they represented, but unlike Joseph Kosuth's conceptual works, Holzer's early works were characterized by their readability, which allowed the text to be easily scanned by anyone passing by. Even compared to the text in John Baldessari's conceptual works, Holzer's *Truisms* demonstrate remarkable lucidity and specificity. As recently demonstrated by the text anonymously engraved on the stone bridge over the lake outside MMCA Gwacheon, Holzer consciously obscures the artistic authorship of her works. Those who stumble upon the text cannot easily identify it as an artwork, magnifying its anonymity. In this sense, Holzer's works are reminiscent of the anonymous system-critical works of Michael Asher. Never catering to viewers and critics in the art scene or "white cube," her text-based works — generally in the form of aphorisms, poems, or literary excerpts — are accessible and comprehensible to anyone,.

Unlike today, the New York art scene of the 1970s and 1980s saw the emergence of many artist collectives that experimented with media as a way to offer alternative voices. For a short time, Holzer was a member of two such groups, known as The Offices and Colab. The Offices of Fend, Fitzgibbon, Holzer, Nadin, Prince & Winters was an art-consulting company that lasted from 1979 to 1980,[5] while Colab — short for Collaborative Projects Inc. — was established in 1977 by members such as Holzer and Kiki Smith. Breaking away from the strict minimalist style, these collectives often worked with shapes, text, or do-it-yourself performances. As part of Colab, Holzer presented *The Manifesto Show* (1979), using language (such as readings of manifestos) in an attempt to encourage audience interaction. A year later, she partook in *The Times Square Show* with other members of Colab, performing and exhibiting installations and posters at an abandoned sex shop on Forty-Second Street.[6] Such attempts by Holzer were later dubbed "'situationist' strategy" by Hal Foster.[7]

4
Benjamin H. D. Buchloh, "To Whom It May Concern," *Modern Painters*, November 2008, 62–69; "An Interview with Jenny Holzer," in *Jenny Holzer: PROTECT PROTECT* (Ostfildern: Hatje Cantz, 2008), 117–22.

5
The members of The Offices were Peter Fend, Coleen Fitzgibbon, Jenny Holzer, Peter Nadin, Richard Prince, and Robin Winters.
오피스(The Offices)는 펜드(Fend), 핏지본(Fitzgibbon), 홀저, 나딘(Nadin), 프린스 앤 윈터스(Prince & Winters) 등이 참여했다.

6
Yujin Oh, "Jenny Holzerui tegseuteu jag-eob-e natanan jeongchiseong" ("Political Aspects of Jenny Holzer's Text-Based Works"), *Hyeondae misulsa yeongu* 31 (2012): 233–63.
오유진, 「제니 홀저의 텍스트 작업에 나타난 정치성」, 『현대미술사연구』, 31, 2012, 6, 233–63.

7
Foster, "Subversive Signs," 107.

홀저는 벤자민 부클로(Benjamin Buchloh)와의 인터뷰를 통해 로드 아일랜드 디자인 학교의 재학시절 자신의 작품 형성기에 브루스 나우만(Bruce Nauman), 요셉 보이스(Joseph Beuys)의 작업 뿐 아니라, 도널드 저드(Donald Judd)와 댄 플라빈(Dan Flavin)의 조각 작업에서 영향을 받았다고 설명한다. 특히, 뉴욕으로 이주한 후 개념미술가였던 로렌스 와이너(Lawrence Weiner), 솔 르윗(Sol Lewitt) 등의 텍스트 기반의 언어 작업에 영향을 받았으며 다니엘 뷔렝(Daniel Buren)의 작업이나 요코 오노(Yoko Ono)의 작업 등에 대해 이미 잘 알고 있었던 상태였다고 밝힌 바 있다.[4]

제니 홀저는 개념미술들이 읽었던 분석철학이나 구조주의 언어이론에는 직접적인 영향을 받지 않았으나, 언어의 접근성, 함축성, 경제성, 절제성 등에 매력을 느낀 것으로 보인다. 특히 미국 화단에서 1960년대와 1970년대에는 이미 개념미술이나 탈물질화 개념이 휩쓸고 있는 상태였기 때문에, 제니 홀저는 뉴욕으로 온 이후 미니멀리즘한 형식에 텍스트 기반의 작업을 본격적으로 시작하게 되었다. 당시 미술계에서는 페미니즘이 모더니즘적 미적 가치와 표상성을 공격하고 있는 상태였다. 하지만, 조셉 코수스의 개념미술과 달리, 제니 홀저의 텍스트 작업은 지나가는 사람들도 빠르게 읽는 가독성을 그 특징으로 하고 있다. 특히 발데사리의 개념작업에서 사용된 텍스트 기반의 작업과 제니 홀저의 〈경구들〉을 비교해 보아도 홀저의 작업은 복문보다는 단문의 명료성과 구체성을 잘 드러낸다. 국립현대미술관의 과천관 야외의 호수 주변에 있는 돌다리의 표면에 새겨진 텍스트들을 통해 구체적으로 드러나듯이, 홀저의 작업은 미술가/작가의 저자성(authorship)이 구체적으로 드러나지 않는다. 지나가는 사람들은 이것이 예술가의 작업인지, 예술가의 작업이라면 누구의 작업인지, 예술가의 구체적 이름이 드러나지 않는 익명성이 강조된다. 이 점에서 홀저는 제도비판 미술가였던 마이클 애셔의 익명적 작업들을 연상시킨다. 예를 들면, 홀저의 텍스트 작업은 미술계의 인사들이나 비평가들, 화이트 큐브를 찾는 관람자들만을 위한 언어가 아니라 그의 작업을 바라보는 누구나 접근 가능한, 이해 가능한 언어작업이다. 그러한 텍스트는 특정 모토, 구절이거나 시나 소설 등에서 가져온 '인용문들'로 구성되기도 한다.

지금과 달리 1970년대와 1980년대 뉴욕 화단은 아티스트 콜렉티브 그룹이 매체적 실험을 통한 대안적 목소리를 내고 있던 때였다. 이 시기에 제니 홀저도 피터 펜드(Peter Fend) 등으로 구성된 '오피스(The Offices)'라는 콜렉티브 그룹의 일원으로 잠시 활동했을 뿐 아니라 콜랩(Colab)의 멤버로서 활동하였다. 전자는 1979년부터 1980년까지 결정된 아트 컨설팅 회사였고[5] 콜랩은 '협업 프로젝트(Collaborative Projects Inc.)'의 줄임형으로, 1977년에 결성되었으며 키키 스미스(Kiki Smith)와 홀저를 포함한 여러 작가들로 구성되어 있었다. 이러한 콜렉티브 그룹은 엄격한 미니멀리즘의 스타일에 벗어나 형상이나, 텍스트 작업을 하거나 "직접하는(do-it-yourself)" 행위 등으로 구성된 것이 많았다. 콜랩에서 제니 홀저는, 〈선언문 전시(The Manifesto Show)〉(1979) 작업을 선보였으며 미술에서의 선언문을 낭독하는 등 언어를 통해 관객 참여적인 작업을 시도하였다. 이로부터 일 년 후 다른 '콜랩'의 멤버들과 함께 '타임즈 스퀘어 전시(The Times Square Show)'에 참여하여, 버려진 42번가의 섹스 숍을 이용해서 퍼포먼스, 설치, 포스터 등을 함께 전시하기도 했다.[6] 이러한 홀저의 작업들에 대해 할 포스터는 '상황주의 전략(situationist strategy)'이라고 명명[7]한 바 있다.

Over the last forty years, Holzer's text-based works have appeared on everyday objects and public institutions, addressed both private concerns and social issues, and ranged from the distribution of information as a concept to site-specific public art. Her texts have their roots in various lexicons, which may be familiar, hostile, subversive, or universal. She uses condom packages, T-shirts, billboards, urban buildings, public transportation (including taxis), and even light projectors that display political messages on corporate buildings.[8] People in the streets instinctively turn towards her illuminated text, instantly reading along as the text is displayed. In some cases, one statement is completely unrelated to the one that follows. By offering disparate or contradictory texts, Holzer superimposes the voices of different "speakers." The voice of the government, spoken in the interest of power, overlaps with the voices of individual assailants and victims as the reader / viewer experiences "the birth of the reader," as defined by Roland Barthes.

Holzer's once singular and consistent voice has gradually become mixed with the voices and perspectives of numerous writers, reflecting (albeit in fragments) diverse tones and arguments, with contexts varying according to the conditions of the current location.[9] Although most of her works rely primarily on text, they also present aspects of minimalist sculpture depending on their spatial settings. Not definable simply as text on a flat surface, they evoke a sense of ambiguity. If one chooses to focus strictly on the text, Holzer's works can be understood as something to be read, like a book, but such an approach seems unreasonable. The sheer quantity of text in this exhibition alone (i.e., *Truisms*, *Inflammatory Essays*, and the writings included in *FOR YOU*) is virtually impossible for anyone to read in full. More importantly, when installed in an actual space, the two-dimensional text begins to intervene in real-life situations and reverberate within its unique cultural context. This condition is reminiscent of mail art, another text-based art form that uses the informativity of text and holds pervasive power. Under this logic, Holzer's personal voice is strictly ostracized, and her texts offer the experience of "plurality," as various voices are superimposed and embroiled in controversies. This characteristic is particularly prominent in the works commissioned by the MMCA.

8
In Korea, Holzer would not be allowed to display political messages on public video screens. But in the past, she has projected controversial text on the Peggy Guggenheim Collection in Venice and other places.
파사드는 공공의 영역으로 간주되기 때문에 서울 스퀘어의 파사드에 지나치게 정치적인 텍스트를 띄우는 것이 한국에서는 규제의 대상인 반면, 홀저의 작업들은 베니스의 페기 구겐하임 미술관 등에 라이트 프로젝션을 통해 논쟁적 텍스트들을 띄운다.

9
Joan Simon, "Other Voices, Other Forms," in *Jenny Holzer: PROTECT PROTECT*, 11 – 26.

제니 홀저는 지난 40년간 일상적인 사물에서부터
공공의 장소에 이르기까지, 사적인 개인성부터
공공성에 이르기까지, 개념으로 배포되는 정보의
확산부터 장소특정적 공공미술에 이르기까지
미술관의 안팎에서 텍스트 작업을 진행해 왔다.
그녀는 때로는 익숙한 언어부터 낯선, 공격적인
언어, 선동적인 언어나 익히 널리 알려진
경구 등을 기반으로 한다. 콘돔의 포장지나 누구나
입을 수 있는 티셔츠, 옥외의 익숙한 광고판을
사용하는가 하면, 대도시의 공공 건물, 택시와
같은 대중 교통, 기업의 건물 등의 파사드에
정치성을 띤 텍스트들을 라이트 프로젝션으로
비춘다.8 거리를 오가는 사람들은 홀저의
텍스트로 구성된 '빛'에 순간적으로 반응하며
LED 라이트에 비춰진 텍스트를 따라 읽으며
내용을 이해한다. 하지만 때때로 한 문장에서
다른 문장으로의 이동은 연결이 안되기도 하며,
독립적으로 존재한다. 텍스트와 텍스트는
서로 이질적이며 반대적 목소리를 제시함으로써
다양한 '화자'적 목소리라 중첩된다. 권력을
대표하는 정부의 목소리, 개별적 희생자,
가해자의 목소리 등이 다양하게 중첩됨으로써
독자/관객은 롤랑 바르트의 '독자의 탄생'을
접하게 된다.

하나의 일관된 목소리는 여러 작가들의 목소리를
통해 관점들이 서로 뒤섞여 내재하면서
파편적이면서도 다양한 어조와 논조를 만들어내는
관점으로 바뀌지만, 그의 텍스트들은 설치 공간에
따라 구체화되고, 또 달라지는 변화의 양상을
띠게 된다.9 텍스트 위주의 작업이 주가 되지만,
이러한 작업이 특정 공간 안에서 구현되고
설치될 때 미니멀리즘의 조각적 특징과 문맥들을
동시에 보여주기도 한다. 때문에, 그의 작품에서는
평면성이 강조된 텍스트 작업이라고만 할 수 없는
지점들이 양가적으로 나타난다. 홀저의 작업에서
텍스트성만을 강조할 경우, 그의 작업은 마치 책과
같이 읽히기 위한 것으로 생각할 수 있다. 하지만,
방대한 양의 〈경구들〉과 〈선동적 에세이〉,
그리고 이번 서울관을 위해 특별히 제작된 〈당신을
위하여〉을 고려한다면 수차례의 방문에도
불구하고 독자로서 모두 읽어내기가 불가능한
텍스트들이기 때문에 '책'과 같은 텍스트성으로만
그녀의 작업을 접근하기에는 무리가 뒤따른다.
특히, 그의 작업은 이차원적 텍스트들이 실제적
공간 내에서 구체화되어 설치되었을 때 텍스트
작업은 실제 상황 속으로 파급되고, 독특한 문화적
맥락 내에서 재공명되는 특징을 보여준다.
이것은 텍스트를 기반으로 했던 '메일 아트'가
텍스트의 정보력을 이용해 사람들에게 파급력을
가지고 정보 자체가 하나의 미디엄으로
존재했던 논리가 비슷하다. 그 속에서 제니 홀저의
개인의 목소리는 철저히 배제되어 여러 화자들의
목소리가 중첩되고, 겹쳐지면 또 논쟁하는
'복수성'을 경험하게 된다. 이것은 이번 MMCA
커미션 작업에서도 특징적으로 나타난다.

10
As noted by David Joselit, the *Inflammatory Essays* (1979–82) are characterized by the absence of the first-person pronoun "I." Similarly, the most contradictory or incompatible statements in *Truisms* tend to be conspicuously anonymous (e.g., "Children are the cruelest of all" and "Children are the hope of the future"). While some texts invoke social issues (e.g., "Money creates taste" or "Private property created crime"), many of them can be passed over relatively lightly.
데이비드 조슬릿(David Joselit)이 지적한 바와 같이, 〈선동적 에세이〉(1979–82)는 1인칭 주어 'I(나)'가 생략된 것이 특징이다. 이와 유사하게 〈경구들〉에서도 가장 모순되거나 양립할 수 없는 진술은 눈에 띄게 익명적인 경향이 있다. 이 익명성 뒤에는 모순적 내용이 따르기도 한다. 예를 들어 "어린이만큼 잔인한 존재는 없다(Children are the cruelest of all)", "어린이는 미래의 희망이다 (Children are the hope of the future)"와 같이 상반된 내용이 공존한다. 또한 "돈이 취향을 만든다(Money creates taste)", "사유재산이 범죄를 일으킨다 (Private property created crime)"와 같이 사회적 의식을 불러일으키는 텍스트도 있지만 가볍게 스쳐 지나가듯 사용하는 문구들도 다수 존재한다.

11
Beginning in 1996, Holzer expanded her text works to include large-scale light projections in public spaces. For these, Holzer projects her own text or excerpts from other sources onto libraries, museums, and public institutions. A representative piece is a 2003 projection in Venice entitled *Xenon for the Peggy Guggenheim*, in which Holzer projected words from Henri Cole's poem "Blur." Around this period, Holzer's work also began to incorporate the voices of refugees, women, and victims of oppression.
1996년부터, 홀저는 공적 공간에 대규모의 라이트 프로젝션을 시도하면서 자신의 텍스트 작업을 확장하였다. 이를 위해 홀저는 자신이 직접 쓴 텍스트, 또는 다른 출처로부터 발췌한 텍스트를 도서관, 박물관, 미술관 등 공공기관의 파사드에 투영하였다. 대표적인 작품은 2003년 베니스에서 선보인 〈Xenon for the Peggy Guggenheim〉으로, 홀저는 이 작품을 위해 헨리 콜(Henri Cole)의 시 "Blur"의 단어들을 투사했다. 이 시기를 전후로 홀저의 작품에는 난민, 여성, 억압의 희생자들의 목소리가 반영되기 시작했다.

Holzer began producing the *Truisms* in 1977, initially printing them on posters (with forty to sixty sentences each), which she then posted around the streets of New York. Since then, the texts in this series have been repeatedly re-edited for the different venues and locations where they are shown. *Truisms* consists of sentences that resemble familiar proverbs and can be interpreted differently depending on the cultural and social context. Notably, the sentences include many paradoxes, oxymorons, or contradictions.[10] Holzer later incorporated commentaries on pop culture and feminism into her *Truisms*.[11] Like her light projections, Holzer's *Truisms* embody contexts that perpetually slip, slide, merge, and repel.

Along with *Truisms*, this exhibition also features *Inflammatory Essays*, another of Holzer's signature works. An entire wall of the lobby of MMCA Seoul is covered with about 1,600 posters (400 posters of *Truisms* and 1,200 of *Inflammatory Essays*). The *Truisms* are presented in both English and Korean, arranged in each language's alphabetical order. Thus, rather than a direct translation, the Korean text represents a transference through the practice of "cultural translation." Translating English texts into Korean while retaining the original alphabetical order, nuance, and subversive spirit is no simple task, demanding multiple levels of literary capacity and creativity, as Walter Benjamin outlined in "The Task of the Translator." Significantly, it is within the very context of this creativity and culture that Holzer's *Inflammatory Essays* manifest their true power and value. As Benjamin states, this signifies the conception of a new meaning, not through "translation" of the text itself but via its "translatability."[12] According to Jacques Derrida's notion of "*différance*," translation can no longer be perceived as an act of carrying meaning over from one language to another "within the horizon of an absolutely pure, transparent, and unequivocal translatability." Replacing the usual "complementary relationship" between the original and the translation, Holzer's text is placed in the relationship of cultural translation, thereby deconstructing the presumed preeminence of the original.[13] In Holzer's work, the relationship between the original and the translation is the result of cross-cultural transculturation from a source text (English) to a target text (Korean), wherein disparate cultures collide and interact to form a new relationship.

12
Walter Benjamin, "The Task of the Translator," in *Illuminations*, trans. Harry Zohn (New York: Schocken Books, 1968), 69–82.

13
On cultural translation, see Lydia H. Liu, *Translingual Practice: Literature, National Culture, and Translated Modernity—China, 1900–1937*, (Stanford: Stanford University Press, 1995).
문화번역에 대해서는 리디아 리우 지음 (민정기 옮김), 『언어횡단적 실천: 문학, 민족문화 그리고 번역된 근대성— 중국, 1900–1937』(소명출판, 2005), 39–41.

국립현대미술관의 커미션 작업인 홀저의 〈경구들〉은 전시되는 장소와 도시에 따라서 텍스트들을 재편집하는 경우가 많았다. 이 작업은 홀저가 1977년 시작한 것으로, 한 면에 보통 40개나 60개 정도의 문장으로 구성된 포스터로 제작되어 뉴욕의 거리에 붙여졌다. 〈경구들〉은 우리 문화에서 우리가 익숙하게 사용하는 교훈 식의 문장들로, 사실 문화나 사회적 맥락마다 다르게 존재한다. 때로는 역설적이고 모순적인 문장들이 함께 존재한다.10 홀저의 〈경구들〉에서는 소비주의나 대중문화에 대한 코멘트를 비롯해 여성문제 등 당시 대두되던 페미니스트적인 질문들이 등장하기 시작했다.11 〈경구들〉은 홀저의 '프로젝션'처럼 실시간 미끄러지고 뒤섞이며 서로 밀쳐지는 글의 문맥들로 구성되어 있다. MMCA 커미션 프로젝트에서 함께 선보인 〈선동적 에세이〉(1979–82)는 오프셋 포스터(offset posters)로 앞서 말한 〈경구들〉과 함께 홀저의 주요 작업에 속한다. 서울관의 로비에는 현재 약 400여 점의 〈경구들〉 포스터와 1200여 점의 〈선동적 에세이〉 포스터가 설치되어 있다. 〈경구들〉은 원래 A, B, C 등 알파벳 순서로 정리되어 있는데, 한국어 번역의 경우 가, 나, 다의 순서로 배치되어 있다. 그의 영문 텍스트를 국문으로 옮기는 작업은 단순한 번역이 아니라, 또 다른 '문화번역'의 실천으로 전환된다. 사실, 영어의 원전 텍스트를 국문으로 번역함에 있어 언어적 뉘앙스, 그리고 선동적 특징을 살리는 것이 쉬운 일은 아니다. 이것은 발터 벤야민의 말대로 또 다른 문학적 독창성이며, 그 속에서 홀저의 〈선동적 에세이〉는 한국의 문화적 맥락에서 더욱 강렬한 텍스트의 가치를 발현한다. 이는 발터 벤야민이 「번역가의 임무(The Task of the Translator)」에서 주목한 '번역' 그 자체가 아니라 '번역가능성(translatability)'을 통한 새로운 의미 생성을 의미한다.12 이는 언어의 '차연(différance)'을 통해 데리다가 설명하듯이, "이제 번역은 더 이상 '절대적으로 순수하고 투명하며 명백한 번역가능성의 지평 위에서' 언어간 의미를 전이하는 행위가 아니다." 또한 이것은 원천언어의 권위 아래에 놓여있던 '번역본'의 위계적 관계를 해체시키고 원본과 번역본의 '상보적 관계'를 통해 대리보충물로 함께 존재하는 문화번역의 생산적 관계에 놓여있다.13 제니 홀저의 영어 원본과 한글 번역본은 원문/원천 텍스트(source text)와 목표/수용 텍스트(target text)라는 영어에서 한국어로 번역되는 과정에서 서로 다른 문화권이 서로 충돌하고 새로운 관계를 맺는 상호작용과 문화교차적(cross-cultural) 상호문화화(transculturation)의 과정을 거친 결과물이다.

14
The piece, titled simply *Benches*, was installed at the Doris C. Freedman Plaza in New York's Central Park.
이 벤치 작품은 뉴욕 센트럴 파크의 도리스 프리드만 플라자(Doris C. Freedman Plaza)에 설치되었다.

Outside MMCA Gwacheon, Holzer created a site-specific installation by engraving certain *Truisms* (in both Korean and English) into a stone bridge. The bridge is thus the latest of Holzer's many public works in stone, such as the six stone *Truisms* benches she installed in New York in 1989,[14] The following texts were engraved on the bridge at MMCA Gwacheon:

지나친 의무감은 당신을 구속한다
(A STRONG SENSE OF DUTY IMPRISONS YOU)
YOU ARE GUILELESS IN YOUR DREAMS
따분함은 미친 짓을 하게 만든다
(BOREDOM MAKES YOU DO CRAZY THINGS)
SOLITUDE IS ENRICHING
선택의 자유가 있다는 것을 늘 기억하라
(REMEMBER YOU ALWAYS HAVE FREEDOM OF CHOICE)
YOU ARE THE PAST PRESENT AND FUTURE
가질 수 없는 것은 늘 매력적이다
(THE UNATTAINABLE IS INVARIABLY ATTRACTIVE)
LISTEN WHEN YOUR BODY TALKS
모든 것은 미묘하게 연결되어 있다
(ALL THINGS ARE DELICATELY INTERCONNECTED)
RAISE BOYS AND GIRLS THE SAME WAY
당신의 모든 행동이 당신을 결정한다
(THE SUM OF YOUR ACTIONS DETERMINES WHAT YOU ARE)

Unlike MMCA Seoul, MMCA Gwacheon is located on the outskirts of the Seoul metropolis, with a scenic view of a lake that changes with the season. Crossing this lake via the stone bridge (which leads to the museum), many people may encounter Holzer's texts without knowing what to make of them, especially since they bear no signature or indication of authorship. Even so, people can quickly identify with a slogan such as "Raise boys and girls the same way," but soon it starts to remind them of the passivity and guilt internalized by Korean women who grew up amid patriarchal traditions and customs. Notably, stone engravings have long been one of the most common types of text-based artwork in Korea. Traditional gravestones are often engraved with family genealogies, while stones or columns engraved with moral values (e.g., "Earnestness" or "Diligence") or simple maxims (e.g., "Live right") are often installed in front of public or private office buildings. But Holzer's texts differ from such texts in that they are devised to liberate the viewers from established frames, deliberately masking the artist or author to better stimulate viewers' contemplation of the meaning of the text (or whatever else is on their mind).

Presenting such texts in the lush natural environment of Gwacheon is how the anonymous artist places the viewer in the position of "you" in the text. According to linguist Roman Jakobson, the personal pronoun "you" is a shifter, a symbol devoid of meaning in and of itself. In her works, Holzer often employs the understood "you" in precisely this way, insinuating the existence of subjects and the meanings that they generate. The readers of Holzer's text are compelled to fill in this void with their own meaning, but this may require them to accurately identify the context and placement of the work. Unlike the posters covering the walls of MMCA Seoul, the installation outside MMCA Gwacheon impels viewers to focus not only on the text itself, but also on the context of their interaction with it and the surrounding environment, or "situation." As a site-specific, minimalist, text-based, sculptural work, the installation's true significance can only be derived from the communion or reciprocal interaction among the environment, viewer, and text.

홀저는 과천관의 야외에 특정한 〈경구들〉을 선정하여 한국어와 영어로 석조다리 위에 조각함으로써 장소특정적 설치 작품을 제작하였다. 따라서 이 다리는 1989년 뉴욕에 설치한 6개의 돌 벤치 시리즈와 같이 홀저가 돌 조각을 이용하여 만든 많은 공공작품 중 가장 최근의 것이 되었다.14 국립현대미술관 과천관 야외의 선택된 다리 위에는 다음과 같은 텍스트가 각인되어 있다.

지나친 의무감은 당신을 구속한다
YOU ARE GUILELESS IN YOUR DREAMS
따분함은 미친 짓을 하게 만든다
SOLITUDE IS ENRICHING
선택의 자유가 있다는 것을 늘 기억하라
YOU ARE THE PAST PRESENT AND FUTURE
가질 수 없는 것은 늘 매력적이다
LISTEN WHEN YOUR BODY TALKS
모든 것은 미묘하게 연결되어 있다
RAISE BOYS AND GIRLS THE SAME WAY
당신의 모든 행동이 당신을 결정한다.

국립현대미술관 과천관은 서울관과 달리, 서울 교외지역에 있는 미술관으로 야외 호수의 경관이 사계절 동안 시시각각으로 변화하는 공간이다. 호수 옆 돌다리를 걸어서 과천관 입구로 향하다 우연히 마주칠 수 있는 홀저의 텍스트들은 사실, 이것이 홀저의 작품이라는 사실을 알지 못한다면 '예술작품'으로 인지하지 못하고 지나칠 수 있는 텍스트들이다. '남아와 여아를 똑같이 키우라'는 교육적 문구는 한국 사회에서 쉽게 공감할 수 있는 텍스트인 동시에, 가부장적인 한국의 전통 문화에서 '여자가 그러면 안된다'라는 흔한 훈계로부터 내면화된 수동성과 죄의식을 동시에 연상하게 하는 말이기도 하다. 과천관의 〈경구들〉에는 홀저의 서명이나 저자성이 전혀 드러나지 않지만, 돌 위에 글을 새긴다는 것 자체는 예나 지금이나 한국에서 쉽게 찾아볼 수 있는 텍스트 기반의 작업이다. 비석에 글을 새겨 가문의 정통성과 계보성을 강조한 경우, 혹은 정부 공관이나 민간 기업 앞에 한번쯤은 보았을 것 같은 '성실, 근면', '바르게 살자'라는 한국 특유의 교훈적 경구들은 돌에 글을 새김으로써 영구적 교훈을 각인시키는 문구들이다. 그러나 홀저의 텍스트는 이러한 공적 텍스트들이 아니라, 우리의 생각에서, 짜여진 틀에서 해방시키는 언어 작업들이다. 그리고, 작가의 저자성을 드러내지 않음으로써 더욱 텍스트를 여러 번 사고하게 만드는, 일상 속에서 독자의 생각을 다시 헤아리게 만드는 것이다.

서울관과 달리, 자연과 더 가까운 과천관에서 이러한 텍스트를 관조하게 하는 것은 익명의 저자가 관람자, 즉 'YOU(당신)'의 위치에서 서게 만드는 것이다. 언어학자 로만 야콥슨(Roman Jakobson)에 의하면, 인칭 대명사인 YOU는 전환사(shifter)로서 그 자체로는 텅 빈 기호이다. 텍스트를 읽는 독자가 이 텅 빈 기호를 채워야 한다면, 홀저의 '전환사'를 채우는 역할은 오로지 독자, 즉 홀저의 테스트를 읽어야 하는 우리의 몫이며, 이러한 전환사를 독해하기 위해서는 문맥과 상황을 정확하게 인식하고 해석하지 않으면 안된다. 이러한 전환사들은 홀저의 작업에서 텅빈 기호이면서도 무엇인가를 지시하는 대상과 의미체들이 있다는 점을 보여준다. 또한 서울관의 로비에 무수히 많은 오프셋 프린트로 벽 면을 뒤덮은 〈경구들〉과 〈선동적 에세이과〉와는 달리, 과천관의 야외 설치는 그의 작업이 텍스트만이 아니라 주변의 공간과 환경과 상호작용하는 '문맥(context)'이나 '상황'과의 교감을 중요하게 읽게 하는 부분이다. 그것은 미니멀리즘 형식의 장소특정형 텍스트 조각이며 환경-관람자-테스트가 상호작용하는 교감하는데 그 중요성이 있다고 여겨진다.

The subtitle of this paper — "Transcription of Their Voices" — stems from the format and possessive circumstance of the text in *FOR YOU*, the LED column that hangs from the ceiling inside MMCA Seoul. Holzer has been using LEDs in her work since the early 2000s, but this site-specific work has one quality that sets it apart: the robotic movement of the column itself. While the text flows across the display, the elongated panel also moves up and down. In addition, the LED light constantly changes color in response to the surrounding environment, so that its appearance varies throughout the day. In the evening, the work resembles a light column or minimalist kinetic sculpture. On the surface, the work recalls Dan Flavin's fluorescent light installations or Donald Judd's repetitive units, but the ever-changing text, moving parts, and overall fluidity impede total comprehension of the work. Like quickly looking up at a video screen while passing through a public square, viewers find that the shifting light and vertical alignment of the text hinders their ability to read, changing their experience of the work from "looking" to "glancing." This mode of processing is very different from reading the clear and coherent contents of a book, which represent the singular voice of the author. Unlike the *Truisms* and *Inflammatory Essays* posters, which are two-dimensional renderings on flat surfaces, this installation is characterized by the constant mobility of the text, which interacts with viewers momentarily, like the information on the board of a stock exchange.

As the former site of the Defense Security Command office, MMCA Seoul is infused with the historicity and wounds of the postwar era. Moreover, countless cultural assets were excavated during the process of the museum's construction. Because it is surrounded by old palaces and traditional buildings (*hanoks*), strict regulations applied to its construction. Due to height restrictions, for example, MMCA Seoul was almost forced to use the basement level as its exhibition space. Unlike MMCA Gwacheon, MMCA Seoul still carries powerful associations with military rule, dictatorship, and oppression.[15] Installed in the center of this loaded space, Holzer's kinetic column vertically displays excerpts from the works of five contemporary writers: *Autobiography of Death* by Kim Hyesoon, "Winter Through a Mirror 11" by Han Kang (Moonji Publishing, 2013); *A Cruelty Special to Our Species* by Emily Jungmin Yoon, *The Unwomanly Face of War* by Svetlana Alexievich, and writings from the website of the Iraqi-Kurdish feminist academic Hawzhin Azeez. All of these works deliver the experiences of refugees or the trauma of war in the voices of women, indirectly describing social tragedies that occurred (or are occurring) in the Middle East, Korea, the United States, and other parts of the world. Both independent and interrelated, the excerpts are elusive as a whole, especially when viewed momentarily through the LED lights:

동생의 시신을 확인하고 와서도
(Even after you identify your sister's body)
동생이 바다에 가라앉는 꿈을 꾼다
(you have dreams about her sinking in the sea)
같이 밥 먹고 같이 잠자고 같이 텔레비전 본다
(You eat together sleep together watch TV
 together)[16]

살해된 아이들의 이름을 수놓은
(Women wearing white headscarves)
흰 머릿수건을 쓴 여자들이
(embroidered with the names of their murdered
 children)
느린 걸음으로 행진하고 있었다
(were marching with slow steps)[17]

Mine is the jam-packed train. The too-weak cocktail. This statement by an American man at the bar: *Your life in Korea would have been a whole lot different without the US.* Meaning: be thankful. ... *Why don't you guys just get along?* The guys: Japan and Korea. ... Move on, move on, girls on the train. Destination: comfort stations. Things a soldier can do: mount you before another soldier is done. Say, *Drink this soup made of human blood.* Say, *The Korean race should be erased from this earth.* ... Things erased: your name, your child, your history. Your new name: Fumiko, Hanako, Yoshiko. ... Ratio 291:29 soldiers per girl. Actual count: lost. Lost: all. Shot, shot, shot, everybody.[18]

나는 이 글의 부제를 '그들의 목소리'로 받아쓰기로 붙였는데, 그 이유는 국립현대미술관 서울관의 프로젝트 공간에 설치된 제니 홀저의 〈당신을 위하여(FOR YOU)〉에서 엿보이는 특정 텍스트들의 콜라주 형식과 텍스트를 그대로 빌려온 전유적 상황에 기인한다. 이 작품은 다른 전시장에서는 보기 힘든 특이성을 보여주는 장소특정적 작업이다. 홀저는 2000년대 초반부터 LED 설치를 이용해 작업하고 있는데, 이 작업은 LED 라이트를 이용하되, 위아래로 오르내리는 자동 장치를 통해 움직이며 지속적으로 글이 변화한다. 또한 자연광에서 이 작업을 볼 때와 저녁 시간에 관람할 때에 따라 LED의 다양한 색깔이 지속적으로 변화하며 주변과 교감하게 한다. 특히 어두워진 저녁 시간에는 일종의 라이트 칼럼으로 키네틱한 미니멀 조각처럼 보여, 로봇 LED, 혹은 LED 조각, 텍스트로 구성된 LED 조각으로 불러야 할 것 같다. 외형적으로는 댄 플라빈의 형광등 설치와 도널드 저드의 반복적 유닛 설치를 연상시키는 LED 설치이지만, 시시각각으로 변화하는 텍스트의 유동성과 움직임은 사실 텍스트의 전체적 윤곽과 독해를 불가능하게 만드는 요소이다. 끊임없이 변화하는 라이팅과 세로로 보여지는 텍스트는 독자로 하여금, 읽기와 보기를 다소 어렵게 함으로써 보기(looking)의 예술에서 흘낏 쳐다보고(glance) 가는 예술로 인식하게 하는 것으로, 야외 광장의 미디어 파사드에 투사된 이미지를 순간적으로 보고 지나가는 느낌과 더욱 가깝다. 이것은 질서 정연한 텍스트로 구성된 책을 읽고 저자의 일관된 목소리를 이해하는 방식과는 달리, 마치 플립 북을 보면서 텍스트를 한번 보고 빠르게 지나가는 무빙 텍스트 공간의 일시적 경험과 유사하다. 이차원적 평면성을 특징으로 한 〈경구들〉과 〈선동적 에세이〉와 달리 이 작업은 증권가의 데이터 네온처럼 빠르게 현실적으로 다가오는 모빌리티 설치이다.

한국인들에게 이 작품이 설치된 국립현대미술관의 서울관은 전후 한국 역사성과 상처가 그대로 배어있는 공간이기도 하다. 역사적으로는 기무사 공간이기도 했지만, 설립 과정에서 전통 문화재가 발굴되기도 했으며, 또 주변에 고궁과 전통 한옥이 많기 때문에 고도제한이 있는 곳이다. (구)기무사의 공간적 특징, 그리고 미술관으로서 고층 건물이 될 수 없다는 점 때문에 지하층 역시 미술관 공간으로 사용하는 특징을 갖고 있다. 특히, 기무사 공간으로 사용되었던 사실은 자연과 교감하는 과천관과 달리, 서울관에 한국 전후 역사와 연관해서 군부와 독재, 억압을 상징하는 장소성을 부여한다.[15] 이 공간의 한 가운데에 홀저가 설치한 키네틱한 로봇 기둥 LED 작품에는 세로쓰기의 형식으로 아래 다섯 명의 현대 문학 작가들의 텍스트들이 함께 선보인다. 김혜순의 『죽음의 자서전』을 비롯해, 『채식주의자』로 맨부커상을 수상한 한강의 『서랍에 저녁을 넣어 두었다』, 에밀리 정민윤(Emily Jungmin Yoon)의 『A Cruelty Special to Our Species』, 스베틀라나 알렉시예비치(Svetlana Alexievich)의 『The Unwomanly Face of War』, 마지막으로 이라크 출신의 쿠르드 페미니스트인 호진 아지즈(Hawzhin Azeez)가 자신의 웹사이트에 게시했던 난민의 문제와 전쟁에 대한 트라우마를 표현하는 글로 구성되어 있다. 이들의 공통점은 여성의 목소리를 간접적이면서도 직접적으로 표현한다는 점이며, 중동, 한국, 미국 등 각국에서 사회적 비극을 경험한 여성들의 목소리를 반영하는 텍스트들로 구성되어 있다는 것이다. 발췌된 텍스트들은 서로 연결되면서도 독립적으로 존재하기 때문에, 통일된 해석은 불가능하지만, 관람자들은 LED를 통해서 순간적으로 특정 텍스트 구절에 직면한다:

동생의 시신을 확인하고 와서도
동생이 바다에 가라앉는 꿈을 꾼다
같이 밥 먹고 같이 잠자고 같이 텔레비전 본다[16]

살해된 아이들의 이름을 수놓은
흰 머릿수건을 쓴 여자들이
느린 걸음으로 행진하고 있었다.[17]

Mine is the jam-packed train. The too-weak cocktail. This statement by an American man at the bar: Your life in Korea would have been a whole lot different without the US. Meaning: be thankful.... Why don't you guys just get along? The guys: Japan and Korea.... Move on, move on, girls on the train. Destination: comfort stations. Things a soldier can do: mount you before another soldier is done. Say, Drink this soup made of human blood. Say, The Korean race should be erased from this earth.... Things erased: your name, your child, your history. Your new name: Fumiko, Hanako, Yoshiko... Ratio 291:29 soldiers per girl. Actual count: lost. Lost: all. Shot, shot, shot, everybody.[18]

15
Artists such as Doho Suh have drawn on such connotations in previous site-specific installations at MMCA Seoul.
이러한 프로젝트 공간에는 그동안 서도호 등 국제적 작가들의 설치 작업이 장소 특정적으로 진행된 바 있다.

16
Kim Hyesoon, "Namesake," in *Autobiography of Death*, trans. Don Mee Choi (New York: New Directions, 2018), 22.
김혜순, 『죽음의 자서전』(문학실험실, 2016), 32.

17
Han Kang, "Winter Through a Mirror 11," unpublished translation by Deborah Smith and Sophie Bowman, 2018.
한강, 「거울 저편의 겨울 11」, 『서랍에 저녁을 넣어두었다』(문학과 지성사, 2013), 115.

18
Emily Jungmin Yoon, "An Ordinary Misfortune (Mine is the jam-packed train)," in *A Cruelty Special to Our Species* (New York: Ecco, 2018).

19

In a conversation with Lee Hyunju
(curator of the MMCA exhibition),
Yoon stated that she did not personally
interview any comfort women and
that her poems are fictionalized
accounts. E-mail conversation with Lee
Hyunju, January 14, 2020.
본 전시의 큐레이터인 이현주와 에밀리
정민 윤의 대화에 의하면, 작가는 위안부
여성들을 직접 인터뷰하지는 않았기에
'시'로서 창작된 스토리를 담고 있다.
2020년 1월 14일 이현주와의 이메일 서신.

20

Gayatri Chakravorty Spivak, "Can the
Subaltern Speak?," in *Colonial
Discourse and Post-Colonial Theory:
A Reader*, ed. Patrick Williams and
Laura Chrisman (New York: Columbia
University Press, 1994), 91. As Spivak
writes, "In seeking to learn to speak
to (rather than listen to or speak for) the
historically muted subject of the
subaltern woman, the postcolonial
intellectual *systematically* 'unlearns'
female privilege."

In the above poem by Emily Jungmin Yoon, expressions like "Your life in Korea would have been a whole lot different without the US" and "Why don't you guys just get along?" are direct, rather than metaphorical, shedding light on America's (conventional) first-world perspective on Korea and the issue of sexual slavery by the Japanese Imperial army, which remains unresolved.[19] Though Yoon's poem is not based on first-hand interviews with "comfort women" (Korean women forced into sex slavery for Japanese soldiers), the poem captures the stereotypical Western view of Koreans in the voice of someone of near-subaltern status. Hence, Yoon switches the speaker, telling the story not from the perspective of Americans or Japanese, but from that of the comfort women and the victims of history, reminding us that these women had names, children, and individual histories that were erased and replaced by Japanese names. The remark by the "American man at the bar" has the same politicized verbal structure often encountered by Koreans and Korean-Americans as minorities in the United States. Because the voices of subaltern entities are inevitably censored and omitted in official documents, the experiences of third-world or even first-world women are only accessible indirectly through the experiences of women like Yoon or Azeez. Using an online platform, Azeez's writings are as instant and direct as tweets or blogs, but very powerful in their delivery. In this particular piece by Holzer, authorship is the act of transcribing those voices into specific forms of text and retelling them. Thus, the text is endowed with presence only by silencing Holzer's own voice. By "owning" these texts, Holzer brings forth voices that have remained outside the Western mainstream. The texts in *FOR YOU* speak for the subaltern in their own voices and linguistic tones. By preserving the original voices in her "writing," Holzer ostensibly avoids the mistake of "objectifying" the women. This could represent the act of a postcolonial intellectual and first-world woman "unlearning female privilege" in order to talk about historically muted subaltern women.[20] Being absent from official documents, these voices cannot be presented from an essentialist standpoint.

While these voices are unofficial and personal records of wars, history, and the female body, Holzer's *Redaction Paintings* (2005–) incorporate information made public by the Freedom of Information Act, raising issues with America's documentation of the Iraq War. Using various archival materials and documents, Holzer exposes facts and plans that the government sought to conceal, offering different perspectives. If Yoon's and Azeez's works represent the voices of the subaltern on a personal level as an act of "resistance," *Phase III Actions* seems more like a personal reaction to the official documents drafted by the US government. As a type of a bricolage intended to bring forth the voices of subaltern subjects excluded from official documents, Holzer's works embody a certain ambiguity, being both public and personal. These texts, especially when rendered via the temporal acts of writing or inscribing on skin, are summoned as a medium for "remembrance."

Representation of the oppressed, victimized, and wounded is an ongoing project for Holzer. Recalling Hannah Arendt's 1943 essay "We Refugees," the desperate and cynical voices of the banished and deported resonate through the space of *FOR YOU* from the LED column. In today's world of political division and social conflict, Jenny Holzer urges us to heed the diverse voices and messages of women, minorities, and subalterns.

마지막 에밀리 정민 윤의 시에서 표현된
"미국이 없었다면 한국에서의 너의 삶은 완전히
달라졌었을거야"라는 표현이나, "너희[한국과
일본]는 왜 잘 지내지 못하니"라는 식의
문장들은 미국이라는 제1세계가 바라보는 한국에
대한 (상투적)시선, 그들의 시선 속에 투영된
일본과 한국의 풀리지 않은 위안부 문제 등을
은유적 언어가 아닌 직접적인 언어로 표현한다.[19]

에밀리 정민 윤은 위의 시에서 북미(미국과
캐나다)인들이 한국에 대해 가진 고정관념
(stereotype)을 포착함으로써 '서발턴'의, 하위
주체의 경계선 상에 있는 목소리를 폭로한다.
이는 미국적 시선이나 일본적 시선이 아닌,
역사적으로 고통받은 '위안부'의 내면으로 화자의
시선을 돌리는 것이다. 이름이 지워지고,
아이를 낙태 당하고 개개인의 역사도 지워진 채,
자신의 이름마저 일본인의 이름으로 기억된
점을 상기시킨다. 또한 술집(Bar)에서 말한 미국
남자의 '언술'은 미국 내 '소수 민족(한국인/
한국계 미국인)'로서 미국에서 쉽게 경험할 수
있는 정치적 언술이기도 하다. 이러한 하위주체의
목소리는 공식적 문서에서는 검열되어 기록되지
않는 목소리이기에, 윤과 아지즈의 일상적
경험을 통해서 공적으로 다뤄지지 않는 제3세계
여성, 혹은 제1세계 안에서 마이너로 존재하는
여성의 목소리이다. 온라인 플랫폼을 이용하는
아지즈의 글은 트위트와 블로그의 글처럼 빠르고
직접적이며 전달력이 강하다. 이 작품에서
홀저의 저자성은 그들의 목소리로 특정 텍스트를
받아쓰는 것, 재기술하는 것이며 이것은 자신의
목소리를 오히려 은폐함으로써 존재하는
것이다. 이러한 텍스트들을 전유함으로써, 홀저는
서구권에서 주류적으로 들리지 않는 그들의
목소리를 탈은폐화 시키고 표면으로 드러낸다.
〈당신을 위하여〉에서 나타난 텍스트들은 침묵하는
하위 주체(subaltern)의 목소리를 그들의 음성과
언어적 뉘앙스로 들리게 하는 것이다. 그들의
목소리를 빌려오는 '글쓰기 행위'를 통해 홀저는
타자를 '대상화'하는 오류를 범하지 않으려는 듯이
보인다. 그것은 "역사적으로 침묵했던 주체인
서발턴 여성에 대해 이야기하기 위해서는
후기 식민주의 지식인들은 [제1세계] 여성의
특권을 배움 이전의 단계로 원점화(unlearn)
하는 행위와 같은 것이다."[20] 그리고 이들의
목소리는 결코 공적인 문서를 통해서는 들리지
않으며, '본질주의적(essentialist)' 시각으로도
결코 표상될 수 없는 목소리이다.

이들의 기록이 전쟁과 역사, 여성의 몸 등에 대한
비공식적, 개인적 도큐먼트들이라면 홀저의
〈편집 회화(Redaction Paintings)〉(2005-)는
'정보공개법(Freedom of Information Act)'을
통해 공개된 정보들을 이용하는 도큐먼트적
회화로, 이라크전과 연관된 미국의 기록들을
문제시하는 작업들이다. 이것은 다양한 관점을
드러내는 아카이브, 문서 작품으로 이 작품에
있는 흔적들은 정부가 은폐하려는 내용과
목적들을 폭로하려는 시도를 담고 있다. 특히,
앞서 본 윤과 아지즈의 시각이 '개인적' 하위
주체들의 목소리이자 '저항'이라면, 이 작품은
미국의 공적 문서에 대항하는 홀저의 개인적
반응처럼 보인다. 홀저의 텍스트들은 이러한 공적
도큐먼트에서는 기록되지 않았던 하위 주체들의
목소리를 끌어내기 위한 일종의 브리콜라주
작업들로 그 특징은 산발적이고 파편적인 동시에
공적이고 사적인 양가성을 지닌다. 특히 이러한
텍스트는 쓰기를 비롯해 피부에 새기거나 돌에
새기는 일시적이고 반영구적인 속성들로 텍스트를
기억의 매체로 소환시키게 한다.

홀저의 작업에서 억압당한 자들, 피해를 입은
자들, 상처를 입은 자들의 목소리를 표현하는 것은
현재적 관점에서도 지속되는 프로젝트이다.
이것은 한나 아렌트(Hannah Arendt)가 1943년에
쓴 에세이인 「우리 난민(We Refugees)」처럼
절박하고 시니컬하며, 추방당한 자들,
쫓겨난 자들의 목소리는 LED 텍스트를 따라 주변
공간으로 퍼져나간다. 정치적으로 양분화되고
사회적 갈등과 재난이 끊임없이 일어나는
전지구적 상황에서, 홀저의 작업은 하위
주체로서의 여성의 목소리, 다수가 아닌 소수적
목소리, 다양한 목소리의 복수성에 귀를 기울일
것을 제안하는 것처럼 들린다.

BECAUSE THERE IS NO GOD SOMEONE MUST TAKE RESPONSIBILITY FOR MEN. A CHARISMATIC LEADER IS IMPERATIVE. HE CAN SUBORDINATE THE SMALL WILLS TO THE GREAT ONE. HIS STRENGTH AND HIS VISION REDEEM MEN. HIS PERFECTION MAKES THEM GRATEFUL. LIFE ITSELF IS NOT SACRED, THERE IS NO DIGNITY IN THE FLESH. UNDIRECTED MEN ARE CONTENT WITH RANDOM, SQUALID, POINTLESS LIVES. THE LEADER GIVES DIRECTION AND PURPOSE. THE LEADER FORCES GREAT ACCOMPLISHMENTS, MANDATES PEACE AND REPELS OUTSIDE AGGRESSORS. HE IS THE ARCHITECT OF DESTINY. HE DEMANDS ABSOLUTE LOYALTY. HE MERITS UNQUESTIONING DEVOTION. HE ASKS THE SUPREME SACRIFICE. HE IS THE ONLY HOPE.

DESTROY SUPERABUNDANCE. STARVE THE FLESH, SHAVE THE HAIR, EXPOSE THE BONE, CLARIFY THE MIND, DEFINE THE WILL, RESTRAIN THE SENSES, LEAVE THE FAMILY, FLEE THE CHURCH, KILL THE VERMIN, VOMIT THE HEART, FORGET THE DEAD. LIMIT TIME, FORGO AMUSEMENT, DENY NATURE, REJECT ACQUAINTANCES, DISCARD OBJECTS, FORGET TRUTHS, DISSECT MYTH, STOP MOTION, BLOCK IMPULSE, CHOKE SOBS, SWALLOW CHATTER. SCORN JOY, SCORN TOUCH, SCORN TRAGEDY, SCORN LIBERTY, SCORN CONSTANCY, SCORN HOPE, SCORN EXALTATION, SCORN REPRODUCTION, SCORN VARIETY, SCORN EMBELLISHMENT, SCORN RELEASE, SCORN REST, SCORN SWEETNESS, SCORN LIGHT. IT'S A QUESTION OF FORM AS MUCH AS FUNCTION. IT IS A MATTER OF REVULSION.

DON'T TALK DOWN TO ME. DON'T BE POLITE TO ME. DON'T TRY TO MAKE ME FEEL NICE. DON'T RELAX. I'LL CUT THE SMILE OFF YOUR FACE. YOU THINK I DON'T KNOW WHAT'S GOING ON. YOU THINK I'M AFRAID TO REACT. THE JOKE'S ON YOU. I'M BIDING MY TIME, LOOKING FOR THE SPOT. YOU THINK NO ONE CAN REACH YOU, NO ONE CAN HAVE WHAT YOU HAVE. I'VE BEEN PLANNING WHILE YOU'RE PLAYING. I'VE BEEN SAVING WHILE YOU'RE SPENDING. THE GAME IS ALMOST OVER SO IT'S TIME YOU ACKNOWLEDGE ME. DO YOU WANT TO FALL NOT EVER KNOWING WHO TOOK YOU?

FEAR IS THE MOST E... YOUR HANDS ARE NE... THREATENING BODI... WORK INSTEAD ON M... PLAY INSECURITIES ... CREATIVE IN APPROA... ANXIETY TO EXCRUC... GENTLY UNDERMINE... CONFIDENCE. PANIC ... OVER CLIFFS; AN AL... TERROR-INDUCED IM... FEEDS ON FEAR. PUT... PROCESS IN MOTION. ... NOT LIMITED TO PEO... SOCIAL AND DEMOCR... CAN BE SHAKEN. IT V... DEMONSTRATED THA... SACRED OR SANE. TH... RESPITE FROM HORR... QUICKSILVER. RESUL...

PEOPLE MUST PAY FOR WHAT THEY HOLD, FOR WHAT THEY STEAL. YOU HAVE LIVED OFF THE FAT OF THE LAND. NOW YOU ARE THE PIG WHO IS READY FOR SLAUGHTER. YOU ARE THE OLD ENEMY, THE NEW VICTIM. WHEN YOU DO SOMETHING AWFUL EXPECT RETRIBUTION IN KIND. LOOK OVER YOUR SHOULDER. SOMEONE IS FOLLOWING. THE POOR YOU HAVE ROBBED AND IGNORED ARE IMPATIENT. PLEAD INNOCENT; YOUR SQUEALS INVITE TORTURE. PROMISE TO BE GOOD; YOUR LIES EXCITE AND INFLAME. YOU ARE TOO DEPRAVED TO REFORM, TOO TREACHEROUS TO SPARE, TOO HIDEOUS FOR MERCY. RUN! JUMP! HIDE! PROVIDE SPORT FOR THE HUNTERS.

REJOICE! OUR TIMES ARE INTOLERABLE. TAKE COURAGE, FOR THE WORST IS A HARBINGER OF THE BEST. ONLY DIRE CIRCUMSTANCE CAN PRECIPITATE THE OVERTHROW OF OPPRESSORS. THE OLD AND CORRUPT MUST BE LAID TO WASTE BEFORE THE JUST CAN TRIUMPH. OPPOSITION IDENTIFIES AND ISOLATES THE ENEMY. CONFLICT OF INTEREST MUST BE SEEN FOR WHAT IT IS. DO NOT SUPPORT PALLIATIVE GESTURES; THEY CONFUSE THE PEOPLE AND DELAY THE INEVITABLE CONFRONTATION. DELAY IS NOT TOLERATED FOR IT JEOPARDIZES THE WELL-BEING OF THE MAJORITY. CONTRADICTION WILL BE HEIGHTENED. THE RECKONING WILL BE HASTENED BY THE STAGING OF SEED DISTURBANCES. THE APOCALYPSE WILL BLOSSOM.

FREEDOM IS IT! YOU'RE SO SCARED, YOU WANT TO LOCK UP EVERYBODY. ARE THEY MAD DOGS? ARE THEY OUT TO KILL? MAYBE YES. IS LAW, IS ORDER THE SOLUTION? DEFINITELY NO. WHAT CAUSED THIS SITUATION? LACK OF FREEDOM. WHAT HAPPENS NOW? LET PEOPLE FULFILL THEIR NEEDS. IS FREEDOM CONSTRUCTIVE OR IS IT DESTRUCTIVE? THE ANSWER IS OBVIOUS. FREE PEOPLE ARE GOOD, PRODUCTIVE PEOPLE. IS LIBERATION DANGEROUS? ONLY WHEN OVERDUE. PEOPLE AREN'T BORN RABID OR BERSERK. WHEN YOU PUNISH AND SHAME YOU CAUSE WHAT YOU DREAD. WHAT TO DO? LET IT EXPLODE. RUN WITH IT. DON'T CONTROL OR MANIPULATE. MAKE AMENDS.

IT ALL HAS TO BURN, IT'S GOING TO BLAZE. IT IS FILTHY AND CAN'T BE SAVED. A COUPLE OF GOOD THINGS WILL BURN WITH THE REST BUT IT'S O.K., EVERY PIECE IS PART OF THE UGLY WHOLE. EVERYTHING CONSPIRES TO KEEP YOU HUNGRY AND AFRAID FOR YOUR BABIES. DON'T WAIT ANY LONGER. WAITING IS WEAKNESS, WEAKNESS IS SLAVERY. BURN DOWN THE SYSTEM THAT HAS NO PLACE FOR YOU, RISE TRIUMPHANT FROM THE ASHES. FIRE PURIFIES AND RELEASES ENERGY. FIRE GIVES HEAT AND LIGHT. LET FIRE BE THE CELEBRATION OF YOUR DELIVERANCE. LET LIGHTNING STRIKE, LET THE FLAMES DEVOUR THE ENEMY!

*G SELF BEFORE
SE THEY'LL
SE YOU'RE A
EEP YOU
HAVE TO
HANK-YOU" FOR
THROW. YOU
AY DRUNK OR
E A CRAZY
CH GUYS WANT
MAKE THEM
DIRTY. SEND
NG, OR
E SOFT-
RE LEFT ALONE
ENING, AND
! YOU CAN
ANT CHILD IN
ION OF THE
ANT TO SERVE.*

SHRIEK WHEN THE PAIN HITS DURING INTERROGATION. REACH INTO THE DARK AGES TO FIND A SOUND THAT IS LIQUID HORROR, A SOUND OF THE BRINK WHERE MAN STOPS AND THE BEAST AND NAMELESS CRUEL FORCES BEGIN. SCREAM WHEN YOUR LIFE IS THREATENED. FORM A NOISE SO TRUE THAT YOUR TORMENTOR RECOGNIZES IT AS A VOICE THAT LIVES IN HIS OWN THROAT. THE TRUE SOUND TELLS HIM THAT HE CUTS HIS FLESH WHEN HE CUTS YOURS, THAT HE CANNOT THRIVE AFTER HE TORTURES YOU. SCREAM THAT HE DESTROYS ALL KINDNESS IN YOU AND BLACKENS EVERY VISION YOU COULD HAVE SHOWN HIM.

THE MOST EXQUISITE PLEASURE IS DOMINATION. NOTHING CAN COMPARE WITH THE FEELING. THE MENTAL SENSATIONS ARE EVEN BETTER THAN THE PHYSICAL ONES. KNOWING YOU HAVE POWER HAS TO BE THE BIGGEST HIGH, THE GREATEST COMFORT. IT IS COMPLETE SECURITY, PROTECTION FROM HURT. WHEN YOU DOMINATE SOMEBODY YOU'RE DOING HIM A FAVOR. HE PRAYS SOMEONE WILL CONTROL HIM, TAKE HIS MIND OFF HIS TROUBLES. YOU'RE HELPING HIM WHILE HELPING YOURSELF. EVEN WHEN YOU GET MEAN HE LIKES IT. SOMETIMES HE'S ANGRY AND FIGHTS BACK BUT YOU CAN HANDLE IT. HE ALWAYS REMEMBERS WHAT HE NEEDS. YOU ALWAYS GET WHAT YOU WANT.

YOU GET SO YOU DON'T EVEN NOTICE THE HALF-DEAD VAGRANTS ON THE STREET. THEY'RE ONLY DIRTY GHOSTS. THE ONES WHO SEND SHIVERS DOWN YOUR SPINE ARE THE UNEMPLOYED WHO AREN'T WEAK YET. THEY STILL CAN FIGHT AND RUN WHEN THEY WANT TO. THEY STILL THINK, AND THEY KNOW THEY HATE YOU. YOU WON'T BE A PRETTY SIGHT IF THEY GO FOR YOU. WHEN YOU'RE OUT WALKING, YOU LOOK AT THE MEN FOR SIGNS OF LINGERING HEALTH AND OBVIOUS HATRED. YOU EVEN WATCH THE FALLEN ONES WHO MIGHT MAKE A LAST MOVE, WHO MIGHT CLAW YOUR ANKLE AND TAKE YOU DOWN.

*BE
MU
A C
HE
TO
AN
PE
LIF
IS
UN
RA
TH
AN
GR
PE
AG
OF
LO
DE
SA*

때로는 무의식이 의식보다 진솔하다
때로는 아무것도 하지 않는 편이 생각 없이 하는 것보다 낫다
때로는 원칙이 사람보다 가치 있다
말은 부족한 경향이 있다
말은 행동력이 없다는 점을 숨기는 데 사용된다
모든 것은 미묘하게 서로 연결되어 있다
모든 과잉은 부도덕하다
모든 업적에는 희생이 따르기 마련이다
모든 이의 작업은 동등하게 중요하다
목숨과 목숨을 맞바꾸는 것은 충분히 공평하다
묘사가 은유보다 가치 있다
무슨 일이 있어도 계속 해나가는 것이 도움이 될 수 있다
무언가가 없어지기를 바라는 것은 효과적이지 않다
무질서는 일종의 무감각증이다
미래를 계획하는 것은 현실 도피이다
미쳐버리는 사람은 지나치게 예민하다
미치지 않은 이상 사람은 자기 행동에 책임을 져야 한다
민초들의 시위야말로 유일한 희망이다
반대는 도덕적 결백을 전제로 한다
반드시 부를 재분배해야 한다
번식에 대한 욕망은 죽음에 대한 소망이다
분노나 증오는 유용한 원동력이 될 수 있다
분노는 표출할 필요가 있다
불임화는 지배자의 무기다
불투명함은 거부할 수 없는 도전이다
비행해지려면 타인에게 상처를 줄 수밖에 없다
비판적인 사고는 살아있다는 증거다
사람들은 끔찍한 일이 일어나면 각성한다
사람은 꿈속에서 솔직하다
사람은 자신이 따르는 원칙의 피해자이다

사랑을 위해 죽는 것은 아름답지만 어리석은 일이다
사소한 지식이 오래간다
사유 재산이 범죄를 낳았다
살생은 불가피하지만 자랑스러워할 만한 일은 아니다
살인에는 성적인 면이 있다
삶의 질을 유지하려면 희생을 감수해야 한다
상대성은 인류에게 아무런 이득이 되지 않는다
상속 제도는 폐지되어야 한다
상징은 사물 자체보다 의미 있다
새로운 것은 옛것의 재해석에 불과하다
새로움을 좇는 것은 사회에 위험이 된다
생생한 공상을 가지고 사는 것은 중요하다
선악의 균형을 깨뜨리는 것은 없다
선택의 자유가 있다는 것을 늘 기억하라
선행은 궁극적으로 보상을 받는다
성차는 늘 존재할 것이다
성희롱은 추악한 결과로 이어질 수 있다
세상은 발견 가능한 법칙을 따라 돌아간다
세상이 나에게 신세 진 것이 아니라 내가 세상에 신세 지고 있다
소심함은 가소롭다
소외감은 괴짜 혹은 혁명가를 만들어낸다
솔직함이 늘 최선은 아니다
수욕주의는 더할 나위 없이 건강한 삶이다
순수함을 지키는 유일한 방법은 홀로 남는 것이다
순진한 것이 실증 난 것보다 낫다
습관적인 경멸이 더 섬세한 감수성을 반영하는 것은 아니다
시간 감각은 현재성의 표식이다
시간을 멈추려는 것은 영웅적이다
신의는 생물학적 법칙이 아니라 사회적 법칙이다
신체 단련은 차선이다

신화는 현실을 보다 이해하기 쉽게 한다
심지어 가족에게도 배신 당할 수 있다
아무도 주목하지 않는 행동은 무의미하다
아버지들은 종종 지나친 힘을 행사한다
아이들은 그 누구보다 잔인하다
아이들은 미래의 희망이다
아이를 갖지 않는 것이 세상에는 축복이다
안전책만 강구하는 것은 장기적으로 많은 손실을 야기할 수 있다
야망은 안일함만큼이나 위험하다
양가적인 태도는 삶을 망칠 수 있다
어디서 멈추고 어디서 세상이 시작하는지 알아야 한다
어떤 경우에는 지속하는 것보다 죽는 것이 낫다
어떤 대가를 치르더라도 지식을 발달시켜야 한다
어리석은 자들은 번식하지 말아야 한다
어머니는 너무 많이 희생해서는 안 된다
어차피 아무것도 바꿀 수 없으니 즐겨라
억압당하던 자들이 폭군이 될 때 변화는 가치를 지닌다
엄성한 사고는 시간이 갈수록 나빠진다
엘리트의 존재는 불가피하다
여가 시간은 거대한 연막이다
여성은 권력을 사랑한다
여웃돈은 기부하는 것이 좋다
여자아이와 남자아이를 똑같이 양육하라
역겨움은 대부분의 상황에 적절한 반응이다
역사 분석보다는 현실을 연구하는 편이 낫다
열등한 사람들과 어울리는 것보다 혼자인 것이 낫다
옛 친구는 과거에 남겨 두는 것이 낫다
오늘날 불변의 진실은 너무나 적다
외상 거래는 좋지 않다
외형도 내용만큼이나 중요하다

욕망이 많은 사람은 삶이 흥미로울 것이다
우리는 기술 때문에 흥하거나 망할 것이다
유머는 배출이다
유명한 사람보다 선한 사람이 되는 것이 낫...
육체노동은 건전한 활력을 준다
은둔자는 늘 악해진다
의미를 부여하는 것은 자신의 책임이다
의심 않는 사랑은 너그러운 영혼을 나타낸...
의존은 밥줄이 될 수 있다
이기심은 가장 기본적인 동기다
이름은 그 자체만으로 많은 것을 의미한다
이타심은 가장 위대한 업적이다
인위적인 욕망이 지구를 훼손하고 있다
일과는 과거와의 연결 고리이다
일부일처제는 남성의 본성과 맞지 않는다
일상의 사소한 낭비는 가끔 방탕한 것보다...
일탈자는 집단 결속력을 강화하는 데 희생된...
일을 게 없는 이는 함부로 행동한다
임의 교배는 성에 대한 속설을 깨는 데 도움...
자기 경멸은 득보다 실이 많을 수 있다
자기 손으로 일하지 않는 사람은 기생충이다...
자기 인식은 심각한 손상을 입힐 수 있다
자기 훈련은 정직함을 유지하는 한 가지 방법...
자기개발에 너무 많은 시간을 쏟는 일은 반사...
자동화는 치명적이다
자립하기 전까지는 세상일을 모른다
자신에 대한 정보를 거의 제공하지 말라
자신을 늦가하는 것이 인간의 숙명이다
자신을 속이는 사람은 남을 속이지 못한다
자신을 알면 다른 이를 이해할 수 있게 된다

A LITTLE KNOWLEDGE CAN GO A LONG WAY
A LOT OF PROFESSIONALS ARE CRACKPOTS
A MAN CAN'T KNOW WHAT IT'S LIKE TO BE A MOTHER
A NAME MEANS A LOT JUST BY ITSELF
A POSITIVE ATTITUDE MAKES ALL THE DIFFERENCE IN THE WORLD
A RELAXED MAN IS NOT NECESSARILY A BETTER MAN
A SENSE OF TIMING IS THE MARK OF GENIUS
A SINGLE EVENT CAN HAVE INFINITELY MANY INTERPRETATIONS
A SOLID HOME BASE BUILDS A SENSE OF SELF
A STRONG SENSE OF DUTY IMPRISONS YOU
ABSOLUTE SUBMISSION CAN BE A FORM OF FREEDOM
ABUSE OF POWER COMES AS NO SURPRISE
ACTION CAUSES MORE TROUBLE THAN THOUGHT
ALIENATION PRODUCES ECCENTRICS OR REVOLUTIONARIES
ALL THINGS ARE DELICATELY INTERCONNECTED
ALWAYS STORE FOOD
AMBITION IS JUST AS DANGEROUS AS COMPLACENCY
AMBIVALENCE CAN RUIN YOUR LIFE
AN ELITE IS INEVITABLE
ANGER OR HATE CAN BE A USEFUL MOTIVATING FORCE
ANIMALISM IS PERFECTLY HEALTHY
ANY SURPLUS IS IMMORAL
ANYTHING IS A LEGITIMATE AREA OF INVESTIGATION
ARTIFICIAL DESIRES ARE DESPOILING THE EARTH
AT TIMES INACTIVITY IS PREFERABLE TO MINDLESS FUNCTIONING
AT TIMES YOUR UNCONSCIOUS IS TRUER THAN YOUR CONSCIOUS MIND
AUTOMATION IS DEADLY
AWFUL PUNISHMENT AWAITS REALLY BAD PEOPLE
BAD INTENTIONS CAN YIELD GOOD RESULTS
BEING ALONE WITH YOURSELF IS INCREASINGLY UNPOPULAR

BEING HAPPY IS MORE IMPORTANT THAN ANYTHING ELSE
BEING HONEST IS NOT ALWAYS THE KINDEST WAY
BEING JUDGMENTAL IS A SIGN OF LIFE
BEING SURE OF YOURSELF MEANS YOU'RE A FOOL
BOREDOM MAKES YOU DO CRAZY THINGS
CALM IS MORE CONDUCIVE TO CREATIVITY THAN IS ANXIETY
CATEGORIZING FEAR IS CALMING
CHANGE IS VALUABLE WHEN THE OPPRESSED BECOME TYRANTS
CHASING THE NEW IS DANGEROUS TO SOCIETY
CHILDREN ARE THE HOPE OF THE FUTURE
CHILDREN ARE THE MOST CRUEL OF ALL
CLASS ACTION IS A NICE IDEA WITH NO SUBSTANCE
CLASS STRUCTURE IS AS ARTIFICIAL AS PLASTIC
CONFUSING YOURSELF IS A WAY TO STAY HONEST
CRIME AGAINST PROPERTY IS RELATIVELY UNIMPORTANT
DECADENCE CAN BE AN END IN ITSELF
DECENCY IS A RELATIVE THING
DEPENDENCE CAN BE A MEAL TICKET
DESCRIPTION IS MORE VALUABLE THAN METAPHOR
DEVIANTS ARE SACRIFICED TO INCREASE GROUP SOLIDARITY
DISGUST IS THE APPROPRIATE RESPONSE TO MOST SITUATIONS
DISORGANIZATION IS A KIND OF ANESTHESIA
DON'T PLACE TOO MUCH TRUST IN EXPERTS
DREAMING WHILE AWAKE IS A FRIGHTENING CONTRADICTION
DYING AND COMING BACK GIVES YOU CONSIDERABLE PERSPECTIVE
DYING SHOULD BE AS EASY AS FALLING OFF A LOG
EATING TOO MUCH IS CRIMINAL
ELABORATION IS A FORM OF POLLUTION
EMOTIONAL RESPONSES ARE AS VALUABLE AS INTELLECTUAL RESPONSES
ENJOY YOURSELF BECAUSE YOU CAN'T CHANGE ANYTHING ANYWAY

EVEN Y
EVERY
EVERYO
EVERYT
EXCEPT
EXPIRIN
EXPRES
EXTREM
EXTREF
FAITHF
FAKE O
FATHER
FEAR IS
FREEDC
GO ALL
GOING
GOOD D
GOVERK
GRASS
GUILT A
HABITU
HIDING
HUMAN
HUMOR
IDEALS
IF YOU A
IF YOU
IF YOU I
IGNORIN
ILLNESS

자신을 확신하는 자는 바보다
자신의 몸이 하는 말을 들어라
자신이 중요하다고 생각하는 사람들은 미치광이이다
자연과 조화롭게 사는 것은 필수적이다
자유는 필수품이 아니라 사치품이다
잠재력은 실현되기 전까지 아무 소용이 없다
재산 범죄는 상대적으로 중요하지 않다
적을 무시하는 것이 최고의 전술이다
적자생존의 법칙은 인간과 동물 모두에게 적용된다
전문가를 맹신하지 말라
전쟁은 정화 의식이다
절대적 복종도 자유의 한 형태가 될 수 있다
절대적인 믿음을 너무 많이 갖는 것은 좋지 않다
절제는 영혼을 죽인다
점잖음은 상대적인 것이다
정교함은 공해의 한 형태다
정부는 국민에게 부담이 된다
정지 상태는 꿈꾸는 상태이다
정치는 개인의 이익에 사용된다
정치적이지 않은 사람의 삶은 모범적이어야 한다
조사에 적법하지 않은 영역은 없다
종교는 해결하는 만큼 많은 문제를 일으킨다
죄악은 사회적 통제의 수단이다
죄책감과 자기파괴는 사치다
죽는 것은 식은 죽 먹기만큼 쉬워야 한다
죽었다가 되살아나면 상당한 관점을 얻을 수 있다
지나친 의무감은 당신을 구속한다
진정한 자유는 두렵다
질병은 마음가짐에 있다
집단 소송은 실속 없는 좋은 생각이다

초월의 개념은 억압을 숨기기 위해 사용된다
최대한 많이 공부해야 한다
최대한 자주 자신을 한계까지 밀어붙여라
최소한의 몇 명과만 친밀하게 지내라
침착함은 불안감보다 창의성을 잘 이끌어낸다
카리스마의 부재는 치명적일 수 있다
쾌락을 위한 쾌락은 삶을 망친다
타락 그 자체가 목적일 수 있다
타인을 성적으로 위협하는 것은 끔찍한 행위다
태어나기 전 이미 많은 것이 결정되었다
특이성은 권위를 상실했다
특정 나이가 되면 이상은 관습적인 목표로 대체된다
특출한 이들은 특혜받을 자격이 있다
파괴 충동을 다른 곳으로 돌리는 것은 성숙함의 표식이다
편집증은 성공의 전제 조건이다
평범한 것을 소중히 여겨야 한다
폭력은 허용되며 때로는 바람직하기까지 하다
하나의 원대한 열정을 품어야 한다
행동은 생각보다 많은 문제를 일으킨다
행복은 그 무엇보다 중요하다
혁명은 개인의 변화에서 시작한다
혁명의 이상은 청춘의 환상이다
혼란은 지옥과 같다는 인간의 소명의식에서 질서가 확립된다
혼자 있는 것은 갈수록 인기가 없다
확고한 기반이 자아감을 형성한다
후손들을 통해 삶을 이어갈 수 있다
휴머니즘은 한물갔다
흐름을 따르는 것은 위로가 되지만 위험도 따른다
흥미로운 것은 항상 새롭다
힘으로 힘을 막는 것은 부조리하다

IFICE
ANT
W
L CONCESSIONS
STUPID

ATHOLOGICAL PSYCHOLOGY
S TO PERVERSION
OGICAL LAW
ERFUL PERSONAL WEAPON

Y
CHIPS FALL WHERE THEY MAY
T RISKY
DED
PLE
HOPE
LGENCES
T A FINER SENSIBILITY

NAL GOALS AT A CERTAIN AGE
NAL LIFE SHOULD BE EXEMPLARY
WILL BE INTERESTING
TO WORRY ABOUT
O FIGHT

IMPOSING ORDER IS MAN'S VOCATION FOR CHAOS IS HELL
IN SOME INSTANCES IT'S BETTER TO DIE THAN TO CONTINUE
INHERITANCE MUST BE ABOLISHED
IT CAN BE HELPFUL TO KEEP GOING NO MATTER WHAT
IT IS HEROIC TO TRY TO STOP TIME
IT IS MAN'S FATE TO OUTSMART HIMSELF
IT'S A GIFT TO THE WORLD NOT TO HAVE BABIES
IT'S BETTER TO BE A GOOD PERSON THAN A FAMOUS PERSON
IT'S BETTER TO BE LONELY THAN TO BE WITH INFERIOR PEOPLE
IT'S BETTER TO BE NAIVE THAN JADED
IT'S BETTER TO STUDY THE LIVING FACT THAN TO ANALYZE HISTORY
IT'S CRUCIAL TO HAVE AN ACTIVE FANTASY LIFE
IT'S GOOD TO GIVE EXTRA MONEY TO CHARITY
IT'S JUST AN ACCIDENT THAT YOUR PARENTS ARE YOUR PARENTS
IT'S NOT GOOD TO HOLD TOO MANY ABSOLUTES
IT'S NOT GOOD TO OPERATE ON CREDIT
IT'S VITAL TO LIVE IN HARMONY WITH NATURE
KILLING IS UNAVOIDABLE BUT IS NOTHING TO BE PROUD OF
KNOWING YOURSELF LETS YOU UNDERSTAND OTHERS
KNOWLEDGE SHOULD BE ADVANCED AT ALL COSTS
LABOR IS A LIFE-DESTROYING ACTIVITY
LACK OF CHARISMA CAN BE FATAL
LEISURE TIME IS A GIGANTIC SMOKE SCREEN
LISTEN WHEN YOUR BODY TALKS
LOOKING BACK IS THE FIRST SIGN OF AGING AND DECAY
LOVING ANIMALS IS A SUBSTITUTE ACTIVITY
LOW EXPECTATIONS ARE GOOD PROTECTION
MANUAL LABOR CAN BE REFRESHING AND WHOLESOME
MEN ARE NOT MONOGAMOUS BY NATURE
MODERATION KILLS THE SPIRIT

MONEY CREATES TASTE
MONOMANIA IS A PREREQUISITE OF SUCCESS
MORALS ARE FOR LITTLE PEOPLE
MOST PEOPLE ARE NOT FIT TO RULE THEMSELVES
MOSTLY YOU SHOULD MIND YOUR OWN BUSINESS
MOTHERS SHOULDN'T MAKE TOO MANY SACRIFICES
MUCH WAS DECIDED BEFORE YOU WERE BORN
MURDER HAS ITS SEXUAL SIDE
MYTHS CAN MAKE REALITY MORE INTELLIGIBLE
NOTHING UPSETS THE BALANCE OF GOOD AND EVIL
OCCASIONALLY PRINCIPLES ARE MORE VALUABLE THAN PEOPLE
OFFER VERY LITTLE INFORMATION ABOUT YOURSELF
OFTEN YOU SHOULD ACT LIKE YOU ARE SEXLESS
OLD FRIENDS ARE BETTER LEFT IN THE PAST
OPACITY IS AN IRRESISTIBLE CHALLENGE
PAIN CAN BE A VERY POSITIVE THING
PEOPLE ARE BORING UNLESS THEY'RE EXTREMISTS
PEOPLE ARE NUTS IF THEY THINK THEY ARE IMPORTANT
PEOPLE ARE RESPONSIBLE FOR WHAT THEY DO UNLESS THEY'RE INSANE
PEOPLE WHO DON'T WORK WITH THEIR HANDS ARE PARASITES
PEOPLE WHO GO CRAZY ARE TOO SENSITIVE
PEOPLE WON'T BEHAVE IF THEY HAVE NOTHING TO LOSE
PHYSICAL CULTURE IS SECOND-BEST
PLANNING FOR THE FUTURE IS ESCAPISM
PLAYING IT SAFE CAN CAUSE A LOT OF DAMAGE IN THE LONG RUN
POLITICS IS USED FOR PERSONAL GAIN
POTENTIAL COUNTS FOR NOTHING UNTIL IT'S REALIZED
PRESENTATION IS AS IMPORTANT AS CONTENT
PRIVATE PROPERTY CREATED CRIME
PURSUING PLEASURE FOR THE SAKE OF PLEASURE WILL RUIN YOU

PUSH YOURSELF TO THE LIMIT AS OFTEN AS POSSIBLE
RAISE BOYS AND GIRLS THE SAME WAY
RANDOM MATING IS GOOD FOR DEBUNKING SEX MYTHS
RECHANNELING DESTRUCTIVE IMPULSES IS A SIGN OF MATURITY
RECLUSES ALWAYS GET WEAK
REDISTRIBUTING WEALTH IS IMPERATIVE
RELATIVITY IS NO BOON TO MANKIND
RELIGION CAUSES AS MANY PROBLEMS AS IT SOLVES
REMEMBER YOU ALWAYS HAVE FREEDOM OF CHOICE
RESOLUTIONS SERVE TO EASE YOUR CONSCIENCE
REVOLUTION BEGINS WITH CHANGES IN THE INDIVIDUAL
ROMANTIC LOVE WAS INVENTED TO MANIPULATE WOMEN
ROUTINE IS A LINK WITH THE PAST
ROUTINE SMALL EXCESSES ARE WORSE THAN THE OCCASIONAL DEBAUCH
SACRIFICING YOURSELF FOR A BAD CAUSE IS NOT A MORAL ACT
SALVATION CAN'T BE BOUGHT AND SOLD
SELF-AWARENESS CAN BE CRIPPLING
SELF-CONTEMPT CAN DO MORE HARM THAN GOOD
SELFISHNESS IS THE MOST BASIC MOTIVATION
SELFLESSNESS IS THE HIGHEST ACHIEVEMENT
SEX DIFFERENCES ARE HERE TO STAY
SIN IS A MEANS OF SOCIAL CONTROL
SLIPPING INTO MADNESS IS GOOD FOR THE SAKE OF COMPARISON
SLOPPY THINKING GETS WORSE OVER TIME
SOLITUDE IS ENRICHING
SOMETIMES SCIENCE ADVANCES FASTER THAN IT SHOULD
SOMETIMES THINGS SEEM TO HAPPEN OF THEIR OWN ACCORD
SPENDING TOO MUCH TIME ON SELF-IMPROVEMENT IS ANTISOCIAL
STARVATION IS NATURE'S WAY
STASIS IS A DREAM STATE

STERILIZA
STRONG
STUPID P
SURVIVAL
SYMBOLS

TAKING A
TALKING
TEASING
TECHNOL
THE CRUE
THE DESIF
THE FAMI
THE IDEA
THE IDEA
THE IDIOS
THE MOST
THE MUN
THE NEW
THE ONLY
THE SUM
THE UNAT
THE WORI
THERE AR
THERE'S
THERE'S N
THINKING
THREATEN
TIMIDITY
TO DISAG
TORTURE

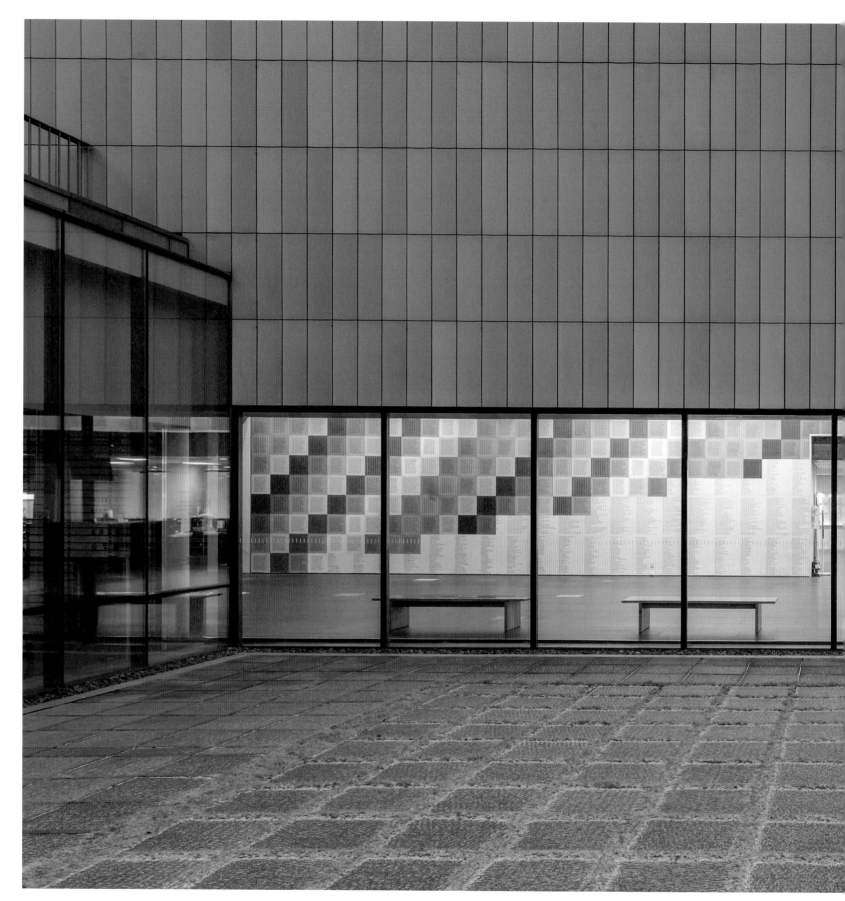

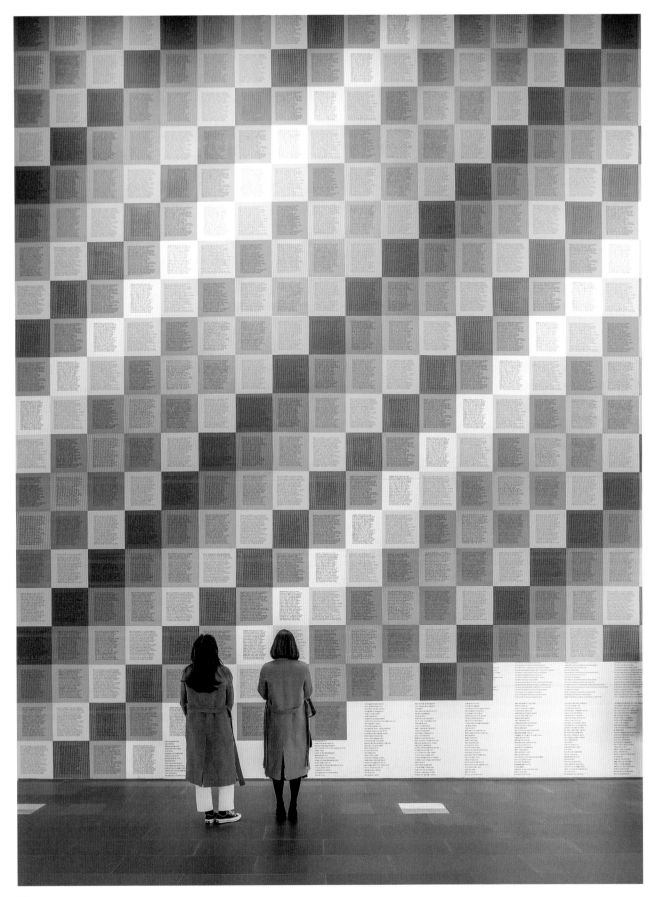

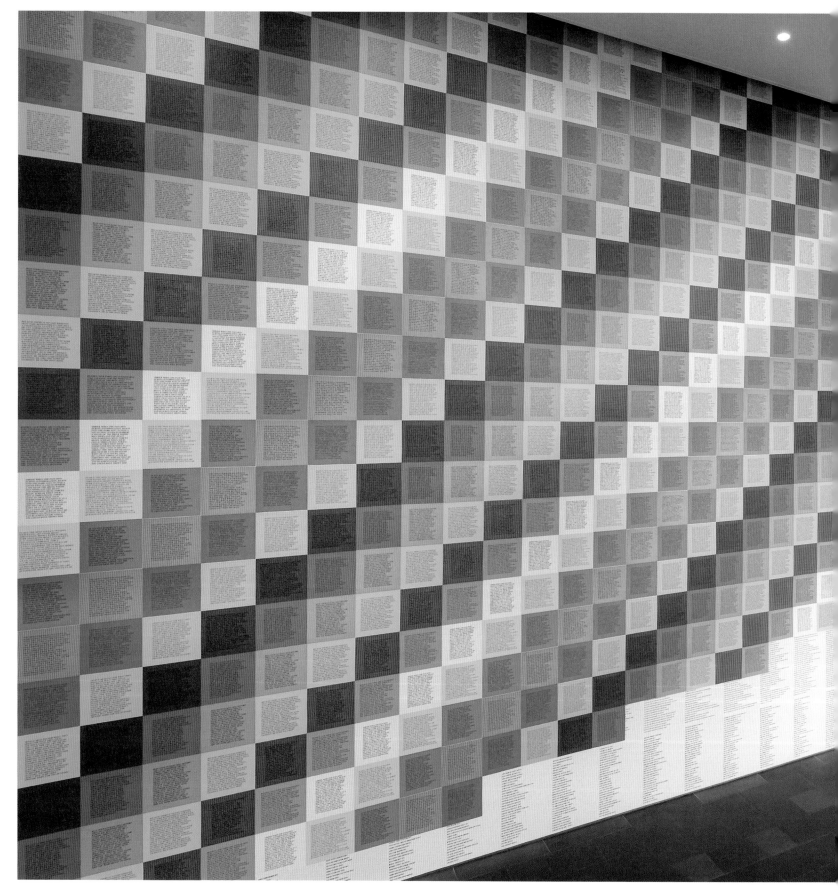

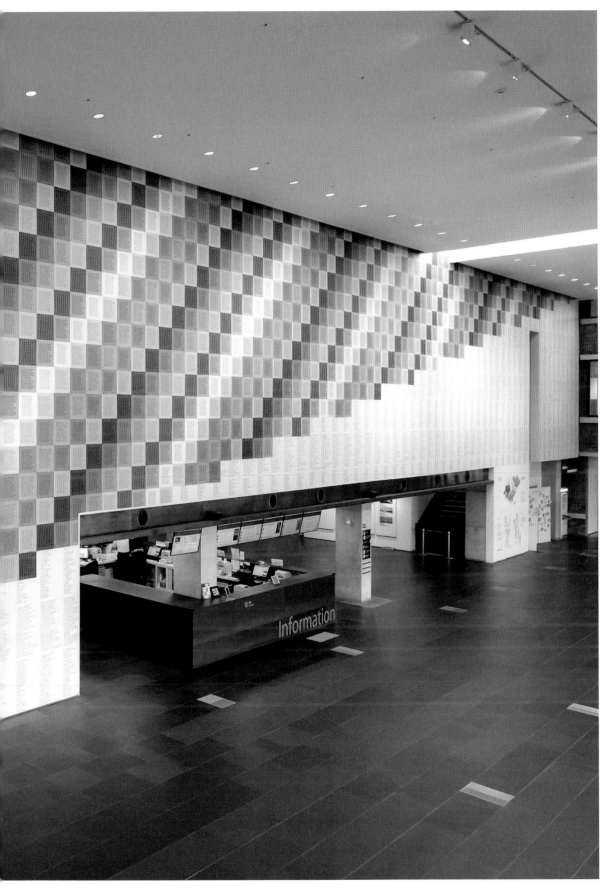

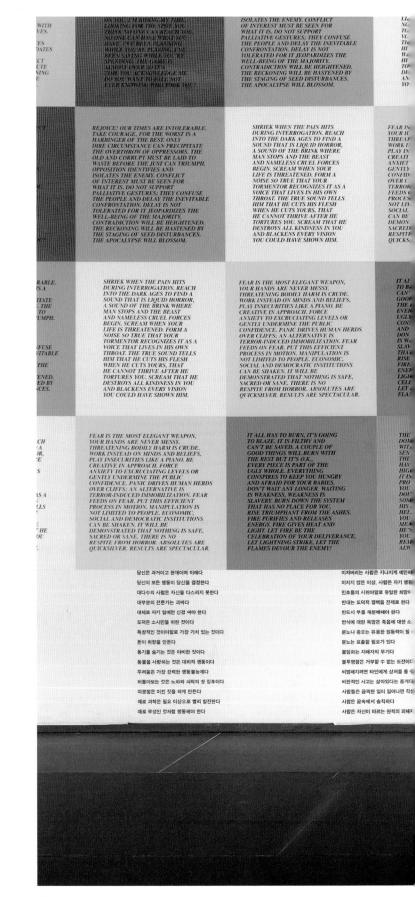

CONFIDENCE. PANIC DRIVES HUMAN HERDS OVER CLIFFS; AN ALTERNATIVE IS TERROR-INDUCED IMMOBILIZATION. FEAR FEEDS ON FEAR. PUT THIS EFFICIENT PROCESS IN MOTION. MANIPULATION IS NOT LIMITED TO PEOPLE. ECONOMIC, SOCIAL AND DEMOCRATIC INSTITUTIONS CAN BE SHAKEN. IT WILL BE DEMONSTRATED THAT NOTHING IS SAFE, SACRED OR SANE. THERE IS NO RESPITE FROM HORROR. ABSOLUTES ARE QUICKSILVER. RESULTS ARE SPECTACULAR.

AND AFRAID FOR YOUR BABIES. DON'T WAIT ANY LONGER. WAITING IS WEAKNESS, WEAKNESS IS SLAVERY. BURN DOWN THE SYSTEM THAT HAS NO PLACE FOR YOU, RISE TRIUMPHANT FROM THE ASHES. FIRE PURIFIES AND RELEASES ENERGY. FIRE GIVES HEAT AND LIGHT. LET FIRE BE THE CELEBRATION OF YOUR DELIVERANCE. LET LIGHTNING STRIKE, LET THE FLAMES DEVOUR THE ENEMY!

PROTECTION FROM HURT. WHEN YOU DOMINATE SOMEBODY YOU'RE DOING HIM A FAVOR. HE PRAYS SOMEONE WILL CONTROL HIM, TAKE HIS MIND OFF HIS TROUBLES. YOU'RE HELPING HIM WHILE HELPING YOURSELF. EVEN WHEN YOU GET MEAN HE LIKES IT. SOMETIMES HE'S ANGRY AND FIGHTS BACK BUT YOU CAN HANDLE IT. HE ALWAYS REMEMBERS WHAT HE NEEDS. YOU ALWAYS GET WHAT YOU WANT.

NEEDS. IS FREEDOM CONSTRUCTIVE OR IS IT DESTRUCTIVE? THE ANSWER IS OBVIOUS. FREE PEOPLE ARE GOOD, PRODUCTIVE PEOPLE. IS LIBERATION DANGEROUS? ONLY WHEN OVERDUE. PEOPLE AREN'T BORN RABID OR BERSERK. WHEN YOU PUNISH AND SHAME YOU CAUSE WHAT YOU DREAD. WHAT TO DO? LET IT EXPLODE. RUN WITH IT. DON'T CONTROL OR MANIPULATE. MAKE AMENDS.

KIND. LOOK OVER YOUR SHOULDER. SOMEONE IS FOLLOWING. THE POOR YOU HAVE ROBBED AND IGNORED ARE IMPATIENT. PLEAD INNOCENT, YOUR SQUEALS INVITE TORTURE. PROMISE TO BE GOOD; YOUR LIES EXCITE AND INFLAME. YOU ARE TOO DEPRAVED TO REFORM, TOO TREACHEROUS TO SPARE, TOO HIDEOUS FOR MERCY. RUN! JUMP! HIDE! PROVIDE SPORT FOR THE HUNTERS.

ACQUAIN...
FORGET TR...
MOTION, BL...
SWALLOW CH...
TOUCH, SCO...
LIBERTY, SCO...
SCORN EXAL...
SCORN VARI...
SCORN KILL...
SWEETNESS...
QUESTION O...
IT IS A MATT...

IT ALL HAS TO BURN, IT'S GOING TO BLAZE. IT IS FILTHY AND CAN'T BE SAVED. A COUPLE OF GOOD THINGS WILL BURN WITH THE REST BUT IT'S O.K. EVERY PIECE IS PART OF THE UGLY WHOLE. EVERYTHING CONSPIRES TO KEEP YOU HUNGRY AND AFRAID FOR YOUR BABIES. DON'T WAIT ANY LONGER. WAITING IS WEAKNESS, WEAKNESS IS SLAVERY. BURN DOWN THE SYSTEM THAT HAS NO PLACE FOR YOU, RISE TRIUMPHANT FROM THE ASHES. FIRE PURIFIES AND RELEASES ENERGY. FIRE GIVES HEAT AND LIGHT. LET FIRE BE THE CELEBRATION OF YOUR DELIVERANCE. LET LIGHTNING STRIKE, LET THE FLAMES DEVOUR THE ENEMY!

THE MOST EXQUISITE PLEASURE IS DOMINATION. NOTHING CAN COMPARE WITH THE FEELING. THE MENTAL SENSATIONS ARE EVEN BETTER THAN THE PHYSICAL ONES. KNOWING YOU HAVE POWER HAS TO BE THE BIGGEST HIGH, THE GREATEST COMFORT. IT IS COMPLETE SECURITY. PROTECTION FROM HURT. WHEN YOU DOMINATE SOMEBODY YOU'RE DOING HIM A FAVOR. HE PRAYS SOMEONE WILL CONTROL HIM, TAKE HIS MIND OFF HIS TROUBLES. YOU'RE HELPING HIM WHILE HELPING YOURSELF. EVEN WHEN YOU GET MEAN HE LIKES IT. SOMETIMES HE'S ANGRY AND FIGHTS BACK BUT YOU CAN HANDLE IT. HE ALWAYS REMEMBERS WHAT HE NEEDS. YOU ALWAYS GET WHAT YOU WANT.

FREEDOM IS IT? YOU'RE SO SCARED, YOU WANT TO LOCK UP EVERYBODY. ARE THEY MAD DOGS? ARE THEY OUT TO KILL? MAYBE YES. IS LAW, IS ORDER THE SOLUTION? DEFINITELY NO. WHAT CAUSED THIS SITUATION? LACK OF FREEDOM. WHAT HAPPENS NOW? LET PEOPLE FULFILL THEIR NEEDS. IS FREEDOM CONSTRUCTIVE OR IS IT DESTRUCTIVE? THE ANSWER IS OBVIOUS. FREE PEOPLE ARE GOOD, PRODUCTIVE PEOPLE. IS LIBERATION DANGEROUS? ONLY WHEN OVERDUE. PEOPLE AREN'T BORN RABID OR BERSERK. WHEN YOU PUNISH AND SHAME YOU CAUSE WHAT YOU DREAD. WHAT TO DO? LET IT EXPLODE. RUN WITH IT. DON'T CONTROL OR MANIPULATE. MAKE AMENDS.

PEOPLE MUST PAY FOR WHAT THEY HOLD, FOR WHAT THEY STEAL. YOU HAVE LIVED OFF THE FAT OF THE LAND. NOW YOU ARE THE PIG WHO IS READY FOR SLAUGHTER. YOU ARE THE OLD ENEMY, THE NEW VICTIM. WHEN YOU DO SOMETHING AWFUL EXPECT RETRIBUTION IN KIND. LOOK OVER YOUR SHOULDER. SOMEONE IS FOLLOWING. THE POOR YOU HAVE ROBBED AND IGNORED ARE IMPATIENT. PLEAD INNOCENT; YOUR SQUEALS INVITE TORTURE. PROMISE TO BE GOOD; YOUR LIES EXCITE AND INFLAME. YOU ARE TOO DEPRAVED TO REFORM, TOO TREACHEROUS TO SPARE, TOO HIDEOUS FOR MERCY. RUN! JUMP! HIDE! PROVIDE SPORT FOR THE HUNTERS.

DESTROY SUPERABUNDANCE. STARVE THE FLESH, SHAVE THE HAIR, EXPOSE THE BONE, CLARIFY THE MIND, DEFINE THE WILL, RESTRAIN THE SENSES, LEAVE THE FAMILY, FLEE THE CHURCH, KILL THE VERMIN, VOMIT THE HEART, FORGET THE DEAD. LIMIT TIME, FORGO AMUSEMENT, DENY NATURE, REJECT ACQUAINTANCES, DISCARD OBJECTS, FORGET TRUTHS, DISSECT MYTH, STOP MOTION, BLOCK IMPULSE, CHOKE SOBS, SWALLOW CHATTER. SCORN JOY, SCORN TOUCH, SCORN TRAGEDY, SCORN LIBERTY, SCORN CONSTANCY, SCORN HOPE, SCORN EXALTATION, SCORN REPRODUCTION, SCORN VARIETY, SCORN REFINEMENT, SCORN RELEASE, SCORN REST, SCORN SWEETNESS, SCORN LIGHT. IT'S A QUESTION OF FORM AS MUCH AS FUNCTION. IT IS A MATTER OF REVULSION.

YOU GET SO YOU DON'T EVEN NOTICE T...
ON THE ...
DIRTY G...
SEND SH...
ARE THE...
WEAK YE...
FIGHT A...
WANT TO...
AND THE...
YOU. YOU...
SIGHT IF...
WHEN YO...
YOU LOO...
SIGNS OF...
AND OBV...
WATCH T...
MIGHT M...
WHO MIG...
AND TAK...

THE MOST EXQUISITE PLEASURE IS DOMINATION. NOTHING CAN COMPARE WITH THE FEELING. THE MENTAL SENSATIONS ARE EVEN BETTER THAN THE PHYSICAL ONES. KNOWING YOU HAVE POWER HAS TO BE THE BIGGEST HIGH, THE GREATEST COMFORT. IT IS COMPLETE SECURITY. PROTECTION FROM HURT. WHEN YOU DOMINATE SOMEBODY YOU'RE DOING HIM A FAVOR. HE PRAYS SOMEONE WILL CONTROL HIM, TAKE HIS MIND OFF HIS TROUBLES. YOU'RE HELPING HIM WHILE HELPING YOURSELF. EVEN WHEN YOU GET MEAN HE LIKES IT. SOMETIMES HE'S ANGRY AND FIGHTS BACK BUT YOU CAN HANDLE IT. HE ALWAYS REMEMBERS WHAT HE NEEDS. YOU ALWAYS GET WHAT YOU WANT.

FREEDOM IS IT? YOU'RE SO SCARED, YOU WANT TO LOCK UP EVERYBODY. ARE THEY MAD DOGS? ARE THEY OUT TO KILL? MAYBE YES. IS LAW, IS ORDER THE SOLUTION? DEFINITELY NO. WHAT CAUSED THIS SITUATION? LACK OF FREEDOM. WHAT HAPPENS NOW? LET PEOPLE FULFILL THEIR NEEDS. IS FREEDOM CONSTRUCTIVE OR IS IT DESTRUCTIVE? THE ANSWER IS OBVIOUS. FREE PEOPLE ARE GOOD, PRODUCTIVE PEOPLE. IS LIBERATION DANGEROUS? ONLY WHEN OVERDUE. PEOPLE AREN'T BORN RABID OR BERSERK. WHEN YOU PUNISH AND SHAME YOU CAUSE WHAT YOU DREAD. WHAT TO DO? LET IT EXPLODE. RUN WITH IT. DON'T CONTROL OR MANIPULATE. MAKE AMENDS.

PEOPLE MUST PAY FOR WHAT THEY HOLD, FOR WHAT THEY STEAL. YOU HAVE LIVED OFF THE FAT OF THE LAND, NOW YOU ARE THE PIG WHO IS READY FOR SLAUGHTER. YOU ARE THE OLD ENEMY, THE NEW VICTIM. WHEN YOU DO SOMETHING AWFUL EXPECT RETRIBUTION IN KIND. LOOK OVER YOUR SHOULDER. SOMEONE IS FOLLOWING. THE POOR YOU HAVE ROBBED AND IGNORED ARE IMPATIENT. PLEAD INNOCENT; YOUR SQUEALS INVITE TORTURE. PROMISE TO BE GOOD; YOUR LIES EXCITE AND INFLAME. YOU ARE TOO DEPRAVED TO REFORM, TOO TREACHEROUS TO SPARE, TOO HIDEOUS FOR MERCY. RUN! JUMP! HIDE! PROVIDE SPORT FOR THE HUNTERS.

DESTROY SUPERABUNDANCE. STARVE THE FLESH, SHAVE THE HAIR, EXPOSE THE BONE, CLARIFY THE MIND, DEFINE THE WILL, RESTRAIN THE SENSES, LEAVE THE FAMILY, FLEE THE CHURCH, KILL THE VERMIN, VOMIT THE HEART, FORGET THE DEAD. LIMIT TIME, FORGO AMUSEMENT, DENY NATURE, REJECT ACQUAINTANCES, DISCARD OBJECTS, FORGET TRUTHS, DISSECT MYTH, STOP MOTION, BLOCK IMPULSE, CHOKE SOBS, SWALLOW CHATTER. SCORN JOY, SCORN TOUCH, SCORN TRAGEDY, SCORN LIBERTY, SCORN CONSTANCY, SCORN HOPE, SCORN EXALTATION, SCORN REPRODUCTION, SCORN VARIETY, SCORN REFINEMENT, SCORN RELEASE, SCORN REST, SCORN SWEETNESS, SCORN LIGHT. IT'S A QUESTION OF FORM AS MUCH AS FUNCTION. IT IS A MATTER OF REVULSION.

YOU GET SO YOU DON'T EVEN NOTICE THE HALF-DEAD VAGRANTS ON THE STREET. THEY'RE ONLY DIRTY GHOSTS. THE ONES WHO SEND SHIVERS DOWN YOUR SPINE ARE THE UNEMPLOYED WHO AREN'T WEAK YET. THEY STILL CAN FIGHT AND RUN WHEN THEY WANT TO. THEY STILL THINK, AND THEY KNOW THEY HATE YOU. YOU WON'T BE A PRETTY SIGHT IF THEY GO FOR YOU. WHEN YOU'RE OUT WALKING, YOU LOOK AT THE MEN FOR SIGNS OF LINGERING HEALTH AND OBVIOUS HATRED. YOU EVEN WATCH THE FALLEN ONES WHO MIGHT MAKE A LAST MOVE, WHO MIGHT CLAW YOUR ANKLE AND TAKE YOU DOWN.

FREEDOM IS IT? YOU'RE SO SCARED, YOU WANT TO LOCK UP EVERYBODY. ARE THEY MAD DOGS? ARE THEY OUT TO KILL? MAYBE YES. IS LAW, IS ORDER THE SOLUTION? DEFINITELY NO. WHAT CAUSED THIS SITUATION? LACK OF FREEDOM. WHAT HAPPENS NOW? LET PEOPLE FULFILL THEIR NEEDS. IS FREEDOM CONSTRUCTIVE OR IS IT DESTRUCTIVE? THE ANSWER IS OBVIOUS. FREE PEOPLE ARE GOOD, PRODUCTIVE PEOPLE. IS LIBERATION DANGEROUS? ONLY WHEN OVERDUE. PEOPLE AREN'T BORN RABID OR BERSERK. WHEN YOU PUNISH AND SHAME YOU CAUSE WHAT YOU DREAD. WHAT TO DO? LET IT EXPLODE. RUN WITH IT. DON'T CONTROL OR MANIPULATE. MAKE AMENDS.

성차는 늘 존재할 것이다
성희롱은 추악한 결과로 이어질 수 있다
세상은 발전 가능한 법칙을 따라 돌아간다
세상이 나에게 신세 진 것이 아니라 내가 세상에 신세 지고 있다
소심함은 가소롭다
소외감은 과격 혹은 혁명가를 만들어낸다
슬픔이 늘 최선은 아니다
수욕주의의 더할 나위 없이 건강한 삶이다
순수함을 지키는 유일한 방법은 홀로 남는 것이다
순진한 것이 실증 난 것보다 낫다
습관적인 경험이 더 섬세한 감수성을 반영하는 것은 아니다
시간 감각은 천재성의 표식이다
시간을 멈추려는 것은 영웅적이다
신의는 생물학적 법칙이 아니라 사회적 법칙이다
신체 단련은 자선이다

신화는 현실을 보다 이해하기 쉽게 한다
심지어 가족에게도 배신 당할 수 있다
아무도 주목하지 않는 행동은 무의미하다
아버지들은 종종 지나친 힘을 행사한다
아이들은 그 누구보다 잔인하다
아이들은 미래의 희망이다
아이를 갖지 않는 것은 세상에는 축복이다
안전책만 강구하는 것은 장기적으로 많은 손실을 야기할 수 있다
아망은 안일할뿐이나 위험하다
양가적인 태도는 삶을 망칠 수 있다
어디서 멈추고 어디서 세상이 시작하는지 알아야 한다
어떤 경우에는 지속하는 것보다 죽는 것이 낫다
어떤 대가를 치르더라도 자식을 발달시켜야 한다
이리석은 자들은 빈식바지 알이서야 한다
어머니는 너무 많이 희생해서는 안 된다
어처피 아무것도 바꿀 수 없으니 즐겨라
억압당하던 자들이 폭군이 될 때 반화는 가치를 지닌다
영성한 사고는 시간이 갈수록 나빠진다
엘리트의 존재는 불가피하다
여가 시간은 거대한 언막이다
여성은 권력을 사랑한다
여윳돈은 기부하는 것이 좋다
여자아이와 남자아이를 똑같이 양육하라
역겨움은 대부분의 상황에 적절한 반응이다
역사 분석보다는 현실을 연구하는 편이 낫다
열등한 사람들과 어울리는 것보다 혼자인 것이 낫다
옛 친구는 과거에 남겨 두는 것이 낫다
오늘날 불변의 진실은 너무나 적다
외상 거래는 좋지 않다
외양도 내용만큼이나 중요하다

욕망이 많은 사람은 삶이 흥미로울 것이다
우리는 기술 때문에 손하거나 망할 것이다
유머는 배출이다
유명한 사람보다 선한 사람이 되는 것이 낫다
육체노동은 건전한 활력을 준다
은문자는 늘 약해진다
의미를 부여하는 것은 자신의 책임이다
의심 있는 사람은 너그러운 영혼을 나타낸다
의존은 발졸이 될 수 있다
이기심은 가장 기본적인 동기다
이름은 그 자체만으로 많은 것을 의미한다
이타심은 가장 위대한 업적이다
인위적인 욕망이 지구를 훼손하고 있다
일기는 과거와의 연결 고리이다
일부일처제는 남성의 본성과 맞지 않는다
일상의 사소한 낭비는 가끔 방탕한 것보다 나쁘다
일탈자는 집단 결속력을 강화하는 데 희생된다
일을 게 없는 이는 암무로 행동한다
임의 교태는 성에 대한 속성을 깨는 데 도움이 된다
자기 경험은 특보다 싶이 많을 수 있다
자기 손으로 일하지 않는 사람은 기생충이다
자기 인식은 심각한 손상을 입힐 수 있다
자기 혼란은 정직함을 유지하는 한 가지 방법이다
자기개발에 너무 많은 시간을 쏟는 일은 반사회적이다
자동화는 치명적이다
자립하기 전까지는 세상일을 모른다
자신에 대한 정보를 거의 제공하지 말라
자신을 능가하는 것이 인간의 숙명이다
자신을 속이는 사람은 남을 속이지 못한다
자신을 알면 다른 이를 이해할 수 있게 된다

자신을 확신하는 자는 바보다
자신의 몸이 하는 말을 들어라
자신이 중요하다고 생각하는 사람들은 미치광이이다
자연과 조화롭게 사는 것은 필수적이다
자유는 필수품이 아니라 사치일지이다
잠재력은 실현되기 전까지 아무 소용이 없다
재산 범죄는 상대적으로 중요하지 않다
적을 무시하는 것이 최고의 전술이다
적자생존의 법칙은 인간과 동물 모두에게 작용된다
전문가를 맹신하지 말라
전쟁은 정화 의식이다
절대적 복종도 자유로이 한 형태가 될 수 있다
절대적인 믿음을 너무 많이 갖는 것은 좋지 않다
절제는 영혼을 죽인다
점잖음은 상대적인 것이다
정부는 국민에게 부담이 된다
정치 상태는 꿈부는 상태이다
정치는 개인의 이익에 사용된다
정치적이지 않은 사람의 삶은 모범적이어야 한다
조사의 책임하지 않은 영역이 있다
종교는 해결하는 만큼 문제를 일으킨다
최약한 사회적 통제의 수단이다
최백경과 자기과괴의 사치다
죽는 것은 식은 죽 먹기만큼 쉬워야 한다
죽었다가 되살아나면 상당한 관점을 얻을 수 있다
지나친 의무감은 당신을 구속한다
진정한 자유는 두렵다
질병은 마음가짐에 있다
집단 소송은 실속 없는 좋은 생각이다

Selections from Truisms

2019
Engraved stone railing
Text: *Truisms*, 1977–79

〈 경구들에서 선정된 문구들 〉

2019
석조 난간 조각
텍스트 : 〈경구들〉, 1977–79

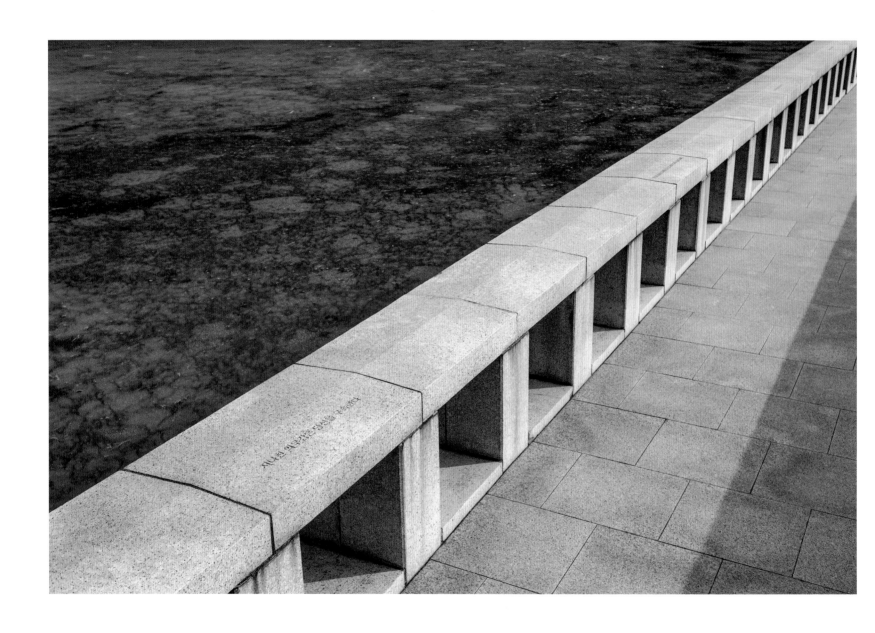

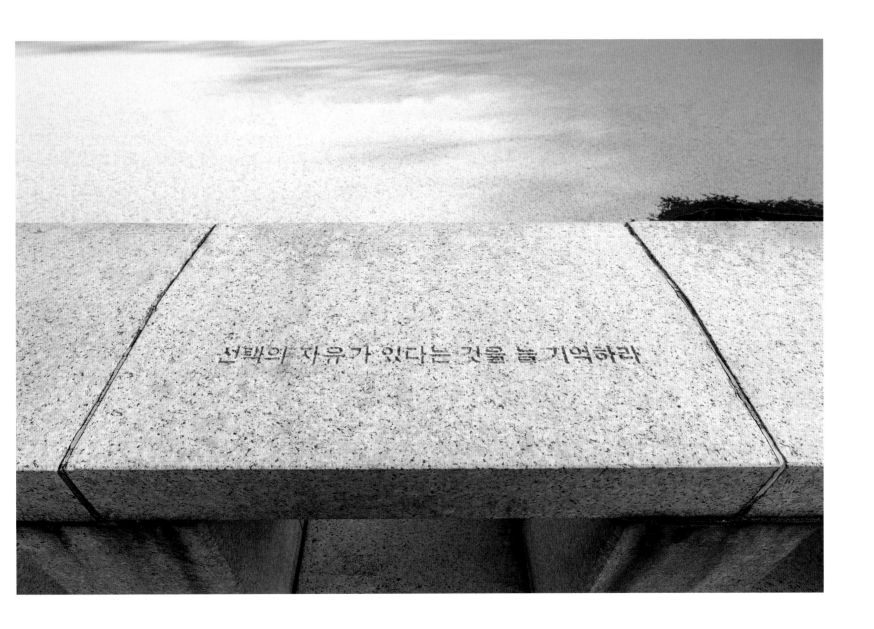

Jenny Holzer : Language Lessons

Nancy Princenthal
Art Critic

Jenny Holzer puts words to the test. Since the 1970s, her primary medium has been written language, presented in formats and materials that have ranged from cheaply offset posters wheat-pasted onto storefronts throughout Manhattan, to electric signboards at major sports stadiums, to giant light projections on the facades of buildings in cities around the world. She has carved texts into marble and written them in blood-red ink on flesh. Often the phrases hurtle by with ferocious speed, sometimes too fast to read. But the challenge of reading them is surpassed by the difficulty of Holzer's subjects : injustice and deprivation, political and sexual violence, death, rage, grief. Though at times her work has edged close to autobiography, the voices in which she speaks have never been securely associated with her own. In the past two decades she has increasingly relied on texts borrowed from others, including poets, politicians, and anonymous functionaries of state security forces. "My work takes you in and out of advocacy, through bad sex, murder, paralysis, poor government, lunacy and aimlessness," Holzer summarized in 1990. "I hope," she concluded, "that my work is useful."[1]

Born in Gallipolis, Ohio, in 1950 — that is, the precise middle of the twentieth century in a mid-sized town in the Midwest — Holzer grew up in nearby Lancaster, Ohio. Her father's family had come to the United States in the mid-nineteenth century from Germany ; on her mother's side, she is descended from Scots / English settlers who began arriving in the United States in the 1600s. In Lancaster there were farms and horses, which her mother trained ; Jenny joined her briefly after college, teaching riding classes. Her father was a Ford dealer. A restless student, Holzer enrolled at Duke University in 1968, and transferred to the University of Chicago, where she first understood that art might be her career. She left Chicago for Ohio University at Athens, where she earned a BFA in 1972. In 1977 she completed an MFA, in painting, at the Rhode Island School of Design.

Holzer's most notable student project was the "disorienting" 1976 *Blue Room*, in which every surface, including windows and floors, was painted first in white, then a washy phthalo blue.[2] It was the basis for a 1978 installation she made soon after moving down to New York, at P.S. 1, a then-new (it was launched in 1976) alternative art space in Long Island City, where Holzer painted each wall of a project room a different color ; small mirrors introduced notes of cross-room color exchange.(fig. 1) Both projects reflected her training in painting (early favorites were Mark Rothko and Morris Louis), her growing interest in Conceptualism (she has cited Joseph Kosuth), and also an attraction to things transcendent ; she has always been a fan of William Blake.[3] When asked about her family's involvement with art, Holzer mentions that her grandmother's sister was a Sunday painter and also, perhaps more significantly, a dowser, able to divine the presence of underground water. Holzer's own childhood inclination toward the rapturous and hard-to-explain was expressed in epic drawings — "shelf-paper scrolls," she has called them — and precocious fiction. "I wanted to write ecstatic, fantastic things," she has said. "I tried to write as if I were mad, in some exalted state." She turned to art because she believed artists could make "miraculous things."[4]

1
Michael Auping, "Interview," in *Jenny Holzer* (New York : Universe, 1992) 110.
마이클 오핑,
〈인터뷰〉,『제니 홀저』
(뉴욕 : 유니버스, 1992), 110.

2
"Joan Simon in Conversation with Jenny Holzer," in *Jenny Holzer*, by David Joselit, Joan Simon, and Renata Salecl (London : Phaidon, 1998), 19.
데이빗 조슬릿, 조안 시몬,
레나타 살레츨, 〈조안 사이먼과
제니 홀저의 대담〉,『제니 홀저』
(런던 : 파이돈, 1998), 19.

3
Ibid., 33.
앞의 책, 33.

4
Bruce Ferguson, "Wordsmith : An Interview with Jenny Holzer," *Art in America*, December 1986, 110.
브루스 퍼거슨,
〈문장가 : 제니 홀저와의 인터뷰〉,
『아트 인 아메리카』(1986년 12월),
110.

낸시 프린센탈
미술평론가

제니 홀저는 단어를 시험대에 올린다. 1970년대부터 홀저는 문자 언어를 매체로써 주로 이용했다. 그 형식과 재료는 맨해튼 지역 상점들 앞에 밀풀로 붙인 저렴한 오프셋 포스터부터 유명 스포츠 스타디움에 있는 전광판, 세계 여러 도시의 건물 표면에 펼쳐지는 거대한 라이트 프로젝션에 이르기까지 무척 다양하다. 대리석에 텍스트를 새기고 피부 위에 핏빛 잉크로 글을 쓰기도 했다. 그의 문구들은 몹시 빠르게 지나가서 때로는 읽을 수 없을 정도다. 하지만 그보다 우리에게 더 도전이 되는 것은 홀저가 다루는 어려운 주제다. 그는 불평등, 박탈, 정치적 폭력, 성폭력, 죽음, 분노, 슬픔 등을 주제로 담는다. 때로는 자전적인 내용도 있지만, 그가 발화하는 목소리는 작가 자신과 확실하게 연관된 적이 없다. 지난 20년 간 그는 시인, 정치인, 익명의 국가 안보기관 요원 등 타인의 텍스트를 차용하는 경우가 점차 늘어났다. 1990년 홀저는 "내 작업은 나쁜 섹스, 살인, 마비, 형편없는 정부, 광기, 막연함 그리고 당신이 지지하는 것들의 선을 넘나들게 한다"고 요약하며 "내 작업이 유용하길 바란다"라고 말을 맺었다.[1]

홀저는 1950년 미국 오하이오 주 갤리폴리스, 정확히 20세기 중반에 미국 중서부 지역 중간 크기의 마을에서 태어나 오하이오 주 랭카스터 근방에서 자랐다. 아버지는 19세기 중반 독일에서 미국으로 이주한 집안 출신이며, 어머니는 1600년대 미국에 이주하기 시작한 스코틀랜드/영국 정착민들의 후손이다. 그녀가 자란 랭카스터에 농장과 말들이 있었고 어머니가 말들을 훈련시켰다. 홀저 또한 대학 졸업 후 잠시 집으로 돌아와 승마를 가르쳤다. 아버지는 포드 자동차 딜러로 일했다. 학구열이 높았던 홀저는 1968년 듀크대학교에 입학했다가 시카고대학교로 적을 옮겼다. 그리고 그곳에서 처음으로 예술이 자신의 길이 될 수 있다는 사실을 깨달았다. 그는 시카고를 떠나 애선스 (Athens)에 위치한 오하이오대학교로 옮겨 1972년 미술학사, 그리고 1977년 로드아일랜드 스쿨오브디자인(RISD)에서 회화 전공으로 석사를 취득했다.

홀저의 학생 시절 작업 중 가장 주목할 만한 프로젝트는 1976년 작업으로 "방향 감각을 잃게 만드는" 〈파란 방(Blue Room)〉이다. 〈파란 방〉은 창문과 마루를 포함, 모든 표면을 먼저 흰색으로 덮은 후 청록색으로 칠한 작품이었다.[2] 〈파란 방〉은 1978년 홀저가 뉴욕으로 이사한 지 얼마되지 않아 P.S.1에 설치한 작품의 기반이 되었다. P.S.1은 1976년 롱아일랜드에서 새롭게 문을 연 대안 미술 공간이었는데, 이 작업에서 홀저는 방의 각 벽을 다른 색으로 칠하고, 건너편 벽과 색을 교환하는 듯한 효과를 내는 작은 거울을 설치했다.(fig.1) 두 작업 모두 그의 회화에 대한 훈련과(초창기 가장 좋아하는 작가는 마크 로스코와 모리스 루이스였다) 개념주의에 대한 관심을 반영한다(홀저는 조셉 코수스를 인용한 바 있다). 또한, 언제나 윌리엄 블레이크의 팬이었던 만큼 초월적인 것에 대해 매력을 느끼는 측면도 보여주었다.[3] 가족과 예술의 관계에 대한 질문을 받았을 때, 홀저는 자신의 이모할머니가 취미로 그림을 그렸고, 나아가 수맥을 찾아낼 수 있었다는 사실을 언급한다. 어린 시절 황홀하고 설명하기 어려운 것들에 빠져 있던 홀저의 성향은 그가 "선반 깔개 종이 두루마리"라 불렀던 서사시적 드로잉들과 조숙한 소설로 표현되었다. 홀저는 "나는 황홀하고 환상적인 것들에 대해 쓰고 싶었다"라며 "나는 고양된 상태에서, 마치 미친 것 마냥 쓰고 싶었다"라고 말한 바 있다. 그는 예술가들이 "기적같은 것들"을 만들 수 있다고 믿었기에 예술에 관심을 가지기 시작했다.[4]

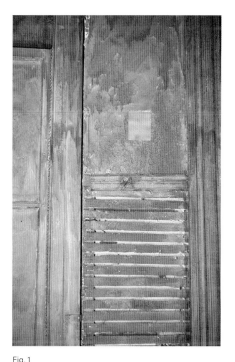

Fig. 1
Jenny Holzer Painted Room : Special Project P.S.1, 1978
Acrylic wash over latex paint
Installation : Institute for Art and Urban Resources at P.S.1, New York, 1978
©1978 Jenny Holzer, member Artists Rights Society (ARS), NY / SACK, Seoul
〈제니 홀저 색칠된 방 : P.S. 1 특별기획 프로젝트〉, 1978
라텍스 페인트 위래 엷은 아크릴
설치 : 뉴욕 P.S.1 예술과도시자원연구협회, 1978
©1978 제니 홀저, 뉴욕예술가권익협회 / 한국미술저작권관리협회

But it was probably her post-graduate experience at the Whitney Museum of American Art's Independent Study Program — where painting was frowned upon, the reading list ranged from Bertolt Brecht to Jacques Derrida,[5] and guest speakers included Vito Acconci, Susan Sontag, and Dan Graham — that most directly provoked what perhaps remain Holzer's best-known works. Called the *Truisms*, they first appeared in public in 1977. Arranged alphabetically by the first word's first letter, the aphoristic *Truisms* were, Holzer has said, "almost a table of contents"[6] for what came later. Printed cheaply and without emphasis on visual style, they were pasted by night on walls and windows in SoHo (and also less art-friendly Manhattan neighborhoods); in 1978 they could be seen covering the windows of Franklin Furnace,(fig. 2) a new art space dedicated to artists' publications and performances. The *Truisms* have had a long afterlife — in books and posters, on baseball caps and T-shirts, on electric signboards and marquees; they even formed the basis of a dance by Bill T. Jones, performed by Larry Goldhuber, in 1985.

The obdurate language of the *Truisms* heralded a voice that is striking not least for its paradoxical anonymity. Holzer has said that her early work was not so much written as blurted,[7] but the *Truisms*, as their title suggests, seem to reflect wisdom long since received. Of course, that seeming is the result of exacting craftsmanship. Beginning (in one of many versions of the list) with "A little knowledge goes a long way" and ending with "Your oldest fears are the worst ones," the statements Holzer produced include many that reflect the experience of a young professional ("You don't know what's what until you support yourself," "It's better to be naive than jaded"). Several could only be considered self-evident — that is, actual truisms — at a stretch (e.g., "Murder has its sexual side"). A little guardedly, Holzer has explained their speech patterns by saying, "Midwesterners are impatient ... They want to get things done ... fast and right."[8] Also like proverbial Midwesterners, the *Truisms* pull no punches. Writing in 1998, David Joselit described them, and later texts, as creating a "version of what the world looks like when your internal censor stops functioning."[9] But the quality of these statements that has most attracted critical attention is how hard they make it to characterize their author. "I wanted to highlight those thoughts and topics that polarize people, but not choose sides," said Holzer in 1990.[10]

On the other hand, it is possible to view her very refusal of identity as a form of violence against business as usual. One way of thinking about the flat affect of Holzer's early language is as a kind of verbal minimalism consistent with visual production well into the seventies, and also with such literature as the *nouveaux romans* of Alain Robbe-Grillet, whose ruthlessly dispassionate fiction had been much read in the sixties. It is also possible to view Holzer's prose as pointedly political. Hal Foster early on called the *Truisms* "verbal anarchy in the street." In an article that linked Holzer with Barbara Kruger, Foster argued that both artists embody Roland Barthes's notion of the writer as "the subject of a praxis," someone who "stands at the crossroads of all other discourses."[11] But as Foster goes on to note, Holzer's language is hardly passive. "For Holzer," Foster writes, "language is the site of pure conflict." The *Truisms*' simple lesson is that "truth is created through contradiction."[12]

Fig. 2
from *Truisms* (1977–79), 1978 (detail)
Photostats, audio tape, posters
20 × 20 ft. / 6.1 × 6.1 m
Installation: *Jenny Holzer Installation*, Franklin Furnace, New York, 1978
© 1978 Jenny Holzer, member Artists Rights Society (ARS), NY / SACK, Seoul
〈경구들〉로부터 (1977–79), 1978 (세부)
복사본, 오디오테입, 포스터
20 × 20 ft. / 6.1 × 6.1 m
설치 : 〈제니 홀저 설치 작업〉, 뉴욕 프랭클린 퍼니스, 1978
© 1978 제니 홀저, 뉴욕예술가권익협회 / 한국미술저작권관리협회

5
Ron Clark's reading list, which ran (in the early 1980s, the earliest that I could find) to roughly four typed pages, also included Walter Benjamin, John Berger, Harold Bloom, Guy Debord, Giles Deleuze and Felix Guattari, Paul de Man, Terry Eagleton, Umberto Eco, Sergei Eisenstein, Michel Foucault, Martin Heidegger, Roman Jakobson, Julia Kristeva, Jacques Lacan, Claude Levi-Strauss, Juliet Mitchell, Edward Said, Ferdinand de Saussure, and Raymond Williams as well as Freud, Marx, and Sartre. At that time, the Whitney's ISP program lasted one semester.
론 클락의 추천 도서 목록. (저자가 찾은 것 중 가장 초기의 것은 1980년대) 대략 4 페이지로 발터 벤야민, 존 버거, 해롤드 블룸, 기 드보르, 질 들뢰즈와 펠릭스 가타리, 폴 드 만, 테리 이글턴, 움베르토 에코, 세르게이 에이젠뉴타인, 미셸 푸코, 마르틴 하이데거, 로만 야콥슨, 줄리아 크리스테바, 자크 라캉, 클로드 레비 스트로스, 줄리엣 미첼, 에드워드 사이드, 페르디낭 드 소쉬르, 레이몬드 윌리엄스와 프로이트, 막스, 사르트르 등을 망라했다. 당시 휘트니 독립 연구 프로그램은 한 학기 동안 진행됐다.

6
Auping, "Interview," 80.
오핑, 〈인터뷰〉, 80.

7
"Jenny Holzer in Conversation with Henri Cole," in Jenny Holzer. Neue Nationalgalerie (Berlin: American Academy in Berlin and Nationalgalerie Berlin, 2001), 115.
〈제니 홀저와 헨리 콜의 대담〉, 『제니 홀저: 베를린 신국립미술관』(베를린: 베를린 아메리칸 아카데미 및 베를린국립미술관, 2001), 115.

8
Ferguson, "Wordsmith," 109.
퍼거슨, 〈문장가: 제니 홀저와의 인터뷰〉, 109.

9
David Joselit, "Voices, Bodies, and Spaces: The Art of Jenny Holzer," in Jenny Holzer, by Joselit, Simon, and Salecl, 48.
데이빗 조슬릿, 〈목소리, 신체와 공간: 제니 홀저의 예술〉, 『제니 홀저』, 48.

10
Auping, "Interview," 85.
오핑, 〈인터뷰〉, 85.

11
Roland Barthes, as quoted in Hal Foster, "Subversive Signs," Art in America, November 1982, 88.
롤랑 바르트; 할 포스터, 〈전복적 기호〉, 《아트 인 아메리카》, 1982년 11월, 88.

12
Ibid., 90–91.
앞의 책, 90–91.

하지만 홀저의 작업 중 가장 잘 알려진 〈경구들(Truisms)〉에 직접적으로 영향을 미친 것은 대학원 시절 참여한 휘트니 미술관의 독립 연구 프로그램이었을 것이다. 이 프로그램은 회화를 반기지 않았고, 필독도서목록에는 베르톨트 브레히트부터 자크 데리다에 이르는 이름들이 들어 있었으며,5 객원 강사로 비토 아콘치, 수잔 손택, 댄 그레이엄 등을 초청했다. 〈경구들〉은 1977년 처음으로 대중에게 공개되었으며 첫 단어의 첫 글자에 따라 알파벳 순으로 나열한 경구들로 구성되었는데, 홀저는 이러한 〈경구들〉이 이후 작업에 대한 "목차에 가까웠다"6라고 말한 바 있다. 시각적 유형에 중점을 두지 않았던 〈경구들〉은 값싸게 인쇄되어 한밤중에 소호 일대와 비교적 예술에 덜 친화적인 맨해튼 지역 건물들의 창과 벽에 붙여져 있었다. 이후 1978년에는 당시 새롭게 등장한 미술공간으로 작가들의 출판물과 퍼포먼스를 기획했던 프랭클린 퍼니스(fig. 2)의 창문에 포스터를 붙이기도 했다. 〈경구들〉은 책, 포스터, 야구모자, 티셔츠, 전광판, 차양 등에서 기나긴 내세를 누렸다. 또한, 1985년 래리 골드후버가 공연한 빌 T. 존스의 무용작품의 토대가 되기도 했다.

〈경구들〉의 완강한 언어는 역설적인 익명성이 두드러지는 목소리를 전달했다. 홀저는 초기 작업에 대해 쓴 것 보다 내뱉은 것이라 말했지만,7 〈경구들〉은 그 제목이 시사하듯 오랜 지혜를 담고 있는 것처럼 보인다. 물론 그렇게 보이는 이유는 〈경구들〉이 엄격한 장인 정신의 결과물이기 때문이다. (많은 버전 중 하나에서) "사소한 지식이 오래간다(A little knowledge goes a long way)"로 시작해 "가장 오래된 두려움이 제일 나쁘다(Your oldest fears are the worst ones)"로 끝나는 등 홀저가 만들어낸 많은 문구(statement)는 젊은 전문가의 경험을 반영한다. "스스로를 건사하기 전까지는 무엇이 무엇인지 모른다(You don't know what's what until you support yourself).", "순진한 것이 싫증난 것보다 낫다(It's better to be naive than jaded)." 개중 몇몇은 실제 경구들처럼 자명하나 어떤 문장들은 곧바로 이해하기 쉽지 않다. (예를 들자면, "살인에는 성적인 측면이 있다[Murder has its sexual side].)" 홀저는 "중서부인들은 성격이 급하다 … 그들은 일을 해치우고 싶어한다 … 빠르고 올바른 방식으로"8라며 다소 조심스럽게 그들의 발화 패턴을 설명한 바 있는데, 〈경구들〉은 중서부인들처럼 직설적이다. 데이빗 조슬릿은 1988년 글에서 〈경구들〉과 그 이후의 텍스트가 "내면의 검열이 기능하지 않을 때 보이는 세상의 한 형태"를9 그린다고 기술한다. 그렇지만 비평적 주목을 가장 많이 받은 부분은 이들 문장이 그 저자를 특정 짓기 어렵게 한다는 것이었다. 1990년 홀저는 "사람들을 양극화 시키는 생각과 주제들을 대두시키되 그 어느 편도 들고 싶지 않았다"라고 말했다.10

한편 이와 같은 홀저의 정체성에 대한 거부를 평소와 다름없는 일상에 대한 폭력의 형태로 보는 시각도 가능하다. 홀저의 초기 언어에서 보이는 감정의 배제는 70년대의 시각 생산 또는 60년대 알랭 로브그리예의 냉정한 누보 로망 문학과 같은 일종의 언어적 미니멀리즘으로 생각해 볼 수 있다. 홀저의 산문을 정치적으로 볼 수도 있다. 할 포스터는 일찍이 〈경구들〉을 "거리의 언어적 무정부 상태"라 칭했다. 포스터는 홀저를 바바라 크루거와 연관 지으면서 두 작가 모두 "실천의 주체", "모든 담론의 교차로에 선 사람11"이라는 롤랑 바르트의 작가 개념을 구현한다고 주장한다. 하지만 포스터가 계속해서 지적하듯이 홀저의 언어는 수동적이지 않다. 포스터는 "홀저에게 언어는 순수한 갈등의 장"이라며, "진리는 모순에서 창조된다"는 것이 〈경구들〉의 교훈이라 쓴다.12

Whether the *Truisms'* truths have to do with the world or with the words that describe it is a question Holzer's early work refuses to answer. Her split vision is redoubled by her exploration of both the institutions of art and the broader responsibilities of civic life. With the *Truisms*, Holzer not only launched herself as an aesthetic contrarian, but also propelled herself outside the commercial gallery circuit, with which she would maintain a wary relationship. Holzer admits she "stole" the idea of posters from the painter Mike Glier, whom she met while at RISD; they came to New York together and remain partners. But the use of posters was widespread at the time, as she also freely concedes. Ranging from warnings about vice to promotions of New Wave music, the ubiquitous street posters framed Holzer's in a way that enhanced their ambiguity, and also lent them a certain cachet. "I wanted them to seem like a radical basement workshop production," she recalls.[13] At the same time, she drew upon a tradition of art activism that goes back at least a century: "My predecessors," Holzer says, "include everyone from the conceptualists to the Dadaists and even back to some Utopian social theorists."[14]

The guerrilla-style presentation of the *Truisms* also had precedents in Holzer's own fledgling work, which had included setting out crumbs of bread in abstract, geometric patterns so pigeons would replicate the shapes when they ate, and leaving paintings out on the beach for sunbathers to discover. The same impulse, considerably evolved, was behind the *Manifesto Show*, which Holzer organized in 1979 with Coleen Fitzgibbon for a storefront in the East Village. Flouting the strident idealism of early modernism's calls to arms, the *Manifesto Show* brought together tracts by 150 artists, some of whom belonged to the loose collective Collaborative Projects (Colab); the profusion itself ensured an anti-utopian, or at least anarchic, cacophony of ideas. On the other hand, the logistics of the show reflected an optimistic spirit of community and of opposition to the institutions of culture and commerce. The same impulses motivated other choices Holzer made at this time. In 1979 she showed the *Truisms* in Spanish as well as English in the community-bridging art space Fashion Moda in the then economically ravaged South Bronx. That year she also showed the *Truisms* in the windows of Printed Matter, a nonprofit distributor of artists' books, a form of low-priced original art then being energetically explored; the next year she contributed to several such books. Also in 1980, she participated in the *Times Square Show*, the best known of Colab's undertakings.

In 1983 Holzer collaborated with the graffiti artist Lady Pink [fig. 3] on a series of high-keyed, spray-painted canvases that were a forum for a kind of female voice that had seldom been heard. Holzer was sometimes linked in the eighties with other women artists concerned with social justice and/or an examination of the mass media, including Martha Rosler, Adrian Piper, and Louise Lawler.[15] Holzer's preference for neutral language; her refusal to speak from an uncomplicated first-person position, or to choose between the rhetoric of power or abasement; even the opacity of her language and its refusal of graceful realism all reflected a growing wariness of the mass media. And they frame a concern with gender that became increasingly explicit in Holzer's work. David Joselit has argued that Holzer's very choice of using language, particularly the language of authority, is boldly feminist.[16]

13
Auping, "Interview," 82.
오핑, 〈인터뷰〉, 82.

14
Ferguson, "Wordsmith," 111.
퍼거슨, 〈문장가: 제니 홀저와의 인터뷰〉, 111.

15
The list is Ferguson's; see "Wordsmith," 113.
목록은 퍼거슨의 것, 『문장가』, 113.

16
Joselit, "Voices, Bodies and Spaces," 47.
조슬릿, 〈목소리, 신체와 공간〉, 47.

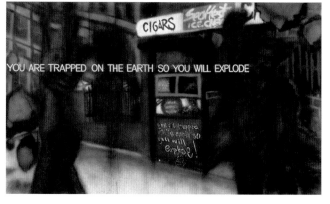

Fig. 3
YOU ARE TRAPPED ON THE EARTH SO YOU WILL EXPLODE,
with Lady Pink, c. 1983–84
Spray paint on canvas
117×69 in. / 297.2×175.3 cm
Text: *Survival*, 1983–85
©1983 Jenny Holzer, member Artists Rights Society (ARS), NY / SACK, Seoul
〈지상에 사로잡힌 당신은 머지않아 폭발할 것이다〉, 레이디 핑크와 협업, c. 1983–84
캔버스 위에 스프레이 페인트
117×69 in. / 297.2×175.3 cm
텍스트: 〈생존〉, 1983–85
©1983 제니 홀저, 뉴욕예술가권익협회 / 한국미술저작권관리협회

홀저의 초기 작업은 〈경구들〉의 진리가 세상과 관련된 것인지 아니면 그 진리를 기술하는 단어와 관련된 것인지 알려주지 않는다. 홀저의 분열된 시선은 그가 미술 제도와 그보다 광범위한 시민 생활의 책임 양자를 탐구하면서 배가된다. 홀저는 〈경구들〉을 통해 미적 반체제자로 발돋움했을 뿐만 아니라 상업 갤러리의 영역 밖으로 나섰다. 그는 화가 마이크 글리어에게서 포스터 아이디어를 '훔쳤다'고 인정한다. 홀저는 로드아일랜드 스쿨 오브 디자인(RISD)에서 글리어를 처음 만나 뉴욕으로 이주했으며 현재까지도 함께 뉴욕에 거주중이다. 하지만 홀저가 거리낌없이 인정하는 대로 당시 포스터는 이미 널리 사용되고 있었다. 범죄 예방 포스터부터 뉴웨이브 음악 홍보 포스터까지 거리 어디에나 포스터들이 있었고, 홀저의 작업은 그러한 포스터의 특징을 가져오면서 더욱 모호한 성격을 띠게 되었다. 홀저는 "[포스터들]이 급진적인 지하 워크숍의 생산물처럼 보이길 원했다"라고 회상한다.13 동시에 "내 선진들로는 개념주의자부터 다다이스트, 더 거슬러 올라가면 일부 유토피아 사회 이론가도 있다"14라고 말했듯이 적어도 한 세기 이상의 역사를 가지는 행동주의 예술 전통을 인용하기도 했다.

초기 작품 중에도 〈경구들〉과 같이 게릴라식 작업을 한 선례가 있다. 빵 부스러기를 추상적, 기하학적 패턴으로 배열해 비둘기들이 그 부스러기를 먹을 때 모양을 따라가도록 하고 해변에 작업을 남겨놓아 일광욕을 하는 사람들이 발견하도록 한 작업 등이다. 1979년 홀저가 콜린 피츠기본과 함께 이스트빌리지의 한 상점을 위해 기획한 《매니페스토 쇼(Manifesto Show)》의 기반에 바로 이러한 충동이 발전된 형태로 존재한다. 작가 150명의 글을 모아 기획한 《매니페스토 쇼》는 초기 모더니즘의 공격적인 이상주의를 조롱한다. 참여 작가 중 일부는 광범위한예술가 집단 '콜래보레이티브 프로젝트 (콜랩(Colab))'에 속해 있었다. 《매니페스토 쇼》의 물량 공세는 그 자체로 반유토피아적이었으며, 적어도 무정부적인 발상의 불협화음을 공고히 했다 할 수 있다. 반면 실제 전시의 실행 방식은 문화와 상업 기관에 대한 저항, 그리고 공동체에 대한 긍정적 정신을 반영하고 있었다. 이러한 정신은 당시 홀저의 다른 작업에서도 동기로 작용했다. 그는 1979년 당시 경제적으로 빈곤했던 사우스 브롱크스에 위치한 패션 모다에서 〈경구들〉을 스페인어와 영어로 전시했다. 패션모다는 공동체 사이 가교 역할을 하는 예술공간이었다. 같은 해 프린티드매터의 진열창에도 〈경구들〉을 전시했다. 프린티드매터는 예술가의 출판물을 유통하는 비영리 서점으로, 이러한 출판물은 당시 저렴한 가격에 살 수 있는 원화(原畫)의 개념으로 활발한 탐구가 이루어지고 있었다. 홀저 또한 이듬해 이런 성격의 책 몇 권에 기고했다. 1980년에는 콜랩의 프로젝트 중 가장 잘 알려진 《타임스스퀘어 쇼(Times Square Show)》에 참가했다.

1983년 홀저는 그래피티 아티스트 레이디 핑크(fig.3)와 협업해 캔버스 위에 밝은 색조의 스프레이 페인트를 이용한 시리즈를 제작했다. 이 시리즈는 자주 표현되지 않고 듣기 힘들었던 여성의 목소리를 담은 장이라 할 수 있었다. 80년대 홀저는 마사 로슬러, 아드리안 파이퍼, 루이스 롤러 등과 같이 사회 정의 및/또는 매스미디어를 검토하는 데 관심을 가진 여성 작가들과 연결되곤 한다.15 홀저가 중립적인 언어를 선호하고 단순한 일인칭 시점을 배제하며 권력의 수사법과 자기비하의 수사법 중 양자택일을 거부하는 것이나 불분명한 언어를 사용하고 점잖은 사실주의를 피하는 배경에는 매스미디어에 대한 경계심이 있었다. 홀저의 작업에서 젠더에 대한 관심은 점점 더 뚜렷해지는데, 이는 그러한 작업에서의 틀을 제공한다. 데이빗 조슬릿은 홀저가 언어를 사용하는 것, 특히 권위의 언어를 사용하기로 선택한 것이 여성주의적이라 주장한다.16

At the same time that she was choosing to operate in the margins of cultural power, Holzer also strode right into its center. In 1982 she was offered use of the Spectacolor electric signboard in New York's Times Square (under the sponsorship of the Public Art Fund) to project a selection of *Truisms* (subsequently, she used the sign for other texts). Along with its huge, diverse audience, the Spectacolor board offered a new way of linking the viewing experience with the work's contents. The propulsive energy of the electronic signboard, the way it can change speed, keeping pace with reading — with thought — and even exceed it; the way that it allows for words to be perceived as images when flashed, and as text when scrolled; the degree to which such words can seem percussive, like music, and explosive, like gunfire, and even decorative, but with a kind of festivity that is on the edge of danger, like fireworks; and, though perhaps this is too obvious to need stating, the way using the signboards makes art analogous to both advertising and mainstream news broadcasts (which exploits the above-mentioned associations, as Holzer helps us see) — all these things recommended the medium to Holzer.

During this period, several new series of texts were developed. The *Inflammatory Essays* (1979–82), which, like the *Truisms*, first appeared as posters, were aptly named. Incendiary little harangues, each one a hundred words (twenty lines) long, they were inspired, Holzer says, by Emma Goldman, Rosa Luxembourg, Mao, and Lenin, as well as Futurist essays and other radical art tracts. Some of the statements reflect on the evils of unchallenged political power. ("A charismatic leader is imperative. He can subordinate the small wills to the great one.") Some are squarely focused on a smug citizenry. ("You have lived off the fat of the land. Now you are the pig who is ready for slaughter. … Look over your shoulder.") Others suggest the ranting of cult leaders. ("Starve the flesh, shave the hair, expose the bone…") To the extent that their energy is entirely provocative, the *Inflammatory Essays* are less sympathetic than any other of Holzer's writings. Their righteous fervor inhibits the comforts of introspection, and their unremitting belligerence discourages critical engagement. Joselit characterized this body of writing as having a "seamless but nonetheless jarring mobility in tone"; using an unidentifiable voice, he says, is Holzer's way of evaporating not just object but (speaking) subject.[17] In fact, with statements like "Scorn liberty… scorn hope… scorn the light" and "Kill the vermin," Holzer assumed a voice that is not just slippery but also nearly incomprehensible as social discourse, a voice very close to the edge of recognizable humanity.

It was a position from which she soon withdrew. "Starting with the *Living* series, which I began in 1980 [and completed in 1982]," Holzer says, "there was a switch from … many viewpoints to a single voice in a more neutral or institutional format. … I became ostensibly 'upper-anonymous' instead of 'lower-anonymous.'"[18] As those texts remind us, the 1980s were the decade that introduced the term *yuppies*, when Republicans gained the White House and then Congress, and fevered economic growth spurred a sharp right turn in popular culture. The *Living texts*, each a short sentence, mused on the benefits and responsibilities of the privileged class: exercise breaks, gifted children, maintaining sexual appeal, and getting on with one's life in the face of troubles suffered by remote, less advantaged others.(fig. 4) "It takes a while before you can step over inert bodies and go ahead with what you were trying to do," one *Living* text reads. This series, its messages hardly more appealing than those of the *Inflammatory Essays*, was quickly followed by a further inward spiral, retreating from *Living* to a series called *Survival*.

HAVING TWO OR THREE PEOPLE IN LOVE WITH YOU IS LIKE MONEY IN THE BANK.

홀저는 문화 권력의 주변부에서 활동하기를 선택한 동시에 문화 권력의 중심으로 성큼 걸어 들어갔다. 그는 1982년(퍼블릭아트펀드의 후원으로)〈경구들〉을 뉴욕 타임스스퀘어의 스펙타컬러 전광판을 이용해 상영하자는 제안을 받는다. (결과적으로 홀저는 다른 텍스트를 사용했다.) 어마어마하게 많고 다양한 관객들이 넘쳐나는 공간의 스펙타컬러 전광판을 이용하는 일은 작업 내용과 관람 경험을 연결하는 새로운 방식을 제시했다. 전광판은 읽는 속도와 생각의 속도에 맞춰 글자의 속도를 바꿀 수도 있고, 심지어는 그 속도를 넘어설 수도 있으며, 단어들을 깜박거리게 하여 이미지처럼 보이게 하거나 스크롤하여 텍스트로 인식할 수 있게 했다. 전광판의 단어들은 마치 타악기처럼 리듬감 있고, 총성처럼 폭발적이고, 어쩌면 불꽃놀이처럼 너무 흥겨운 나머지 위험해 보이는 요소를 가지고 있었다. 그리고 광고판을 이용한 방식은 예술로 하여금(홀저가 보여주듯 상기의 요소들을 이용하는) 주류 뉴스 방송이나 광고와 유사해지게 하였다. 이 모든 것들로 인해 전광판은 홀저에게 매력적인 매체였다.

17
Joselit, "Voices, Bodies, and Spaces," 44.
조슬릿, 〈목소리, 신체와 공간〉, 44.

18
Ferguson, "Wordsmith," 112–13.
퍼거슨, 〈문장가: 제니 홀저와의 인터뷰〉, 112–13.

이 기간 동안 홀저는 몇몇 새로운 텍스트를 발전시켰다. 〈선동적 에세이(Inflammatory Essays)〉(1979–82)라는 적절한 제목의 작업 또한 〈경구들〉처럼 먼저 포스터로 등장했다. 〈선동적 에세이〉 시리즈는 각 백 개의 단어(스무 줄)로 된 웅변적 텍스트로 구성되었는데, 홀저는 엠마 골드만, 로자 룩셈부르크, 마오쩌둥, 레닌과 미래주의 글들을 비롯한 급진적 예술 텍스트에서 영감을 받아 〈선동적 에세이〉의 텍스트를 썼다고 밝혔다. 〈선동적 에세이〉의 문장 일부는 견제 받지 않는 정치 권력의 폐해에 대해 이야기한다. ("카리스마 있는 지도자는 불가결한 존재다. 그는 대의를 위해 소의를 저버릴 수 있다. [A charismatic leader is imperative. He can subordinate the small wills to the great one.]") 어떤 부분은 오만한 시민들을 정면으로 마주한다. ("너는 비옥한 땅에 기대어 살아왔다. 지금 너는 도살 당할 준비를 마친 돼지다. … 네 어깨 너머로 보라. [You have lived off the fat of the land. Now you are the pig who is ready for slaughter. … Look over your shoulder.]") 다른 부분은 종교 지도자의 설교처럼 들린다. ("육신을 굶주리게 하라, 머리칼을 밀어라, 뼈를 드러내라[Starve the flesh, shave the hair, expose the bone.]) 〈선동적 에세이〉는 전적으로 도발적이며, 홀저의 다른 작업보다 공격적이다. 〈선동적 에세이〉의 열정은 자기 성찰의 위안을 잊게 하고, 그 호전성은 비판적 개입을 단념케 한다. 조슬릿은 〈선동적 에세이〉의 글쓰기를 "어조가 매끄러우면서도 이와 조화되지 않는 유동성"을 가진다고 특징짓는다. 조슬릿은 홀저가 식별 불가한 목소리를 사용함으로써 대상 뿐만 아니라 (말하는) 주체를 사라지게 한다고 말한다.17 "자유를 자유를 경멸하라 … 희망을 경멸하라 … 빛을 경멸하라(Scorn liberty … scorn hope … scorn the light)"와 "해충을 죽여라(Kill the vermin)" 같은 문장을 통해 홀저는 사회 담론으로서 파악하기 힘들 뿐만 아니라 거의 이해할 수 없는 목소리, 인간성의 한계에 다다른 목소리를 상정한다.

하지만 홀저는 이러한 위치에서 곧 물러난다. 홀저가 말하기를, "내가 1980년에 시작한 [그리고 1982년에 완성한]〈삶(Living)〉시리즈를 출발점으로 다수의 관점이 아닌 좀 더 중립적이고 관습적인 형식을 가진 단일한 목소리로 … 전환했다 … 나는 표면적으로 '하위-익명' 대신 '상위-익명'이 되었다."18 〈삶〉의 텍스트가 상기시키듯이, 1980년대 들어 '여피(yuppie)'라는 단어가 등장했다. 공화당이 백악관에 이어 의회를 차지했고, 경제 성장이 과열되며 대중문화는 급격하게 우회전했다. 짧은 문장으로 이루어진 〈삶〉의 텍스트는 운동시간, 영재교육, 성적 매력 유지, 타인들이 겪는 곤경 가운데 삶을 영위하는 것 등등 특권층이 누리는 혜택과 책임을 숙고했다.(fig. 4) 〈삶〉의 한 문장은 다음과 같이 말한다. "기력없는 몸을 이겨내고 하려던 것을 밀고 나가는 데에는 시간이 좀 걸린다. (It takes a while before you can step over inert bodies and go ahead with what you were trying to do.)" 〈삶〉의 메시지는 〈선동적 에세이〉만큼 매력적이지는 않았다. 그리고 홀저는 이어 그보다 더 내면적으로 파고 들어가는 〈생존(Survival)〉 시리즈를 만든다.

In a marked departure, the *Survival* texts approach — cautiously — first-person speech. Holzer has said, "With the *Survival* series [1983–85] I thought it would be interesting to take ... a line that would be closer to my own. ... I switched from being everybody to being myself."[19] Yet the *Survival* texts, each again a simple declarative statement, hardly speak for a securely integrated personality. In fact what they express most strongly is the speaker's lack of emotional center — a circuit failure affecting links between instinctual behavior, basic knowledge, and psychological experience. "Tear ducts seem to be a grief provision," reads one *Survival* text. "Turn soft and lovely anytime you have a chance," says another, and a third, "Remember to react." The same distortions of affect govern the *Survival* texts' politics: "If you had behaved nicely the communists wouldn't exist," while arguably true, is just as lacking in animus, and as bluntly unhelpful, as "Dance on down to the government and tell them you're eager to rule because you know what's good for you."

It's possible to read the *Living* and, especially, the *Survival* series as Holzer's most despairing, so haunting is the disjunction between belief and feeling. Their emotional opacity is supported by their formats, which included, for the *Living* series, bronze plaques like the ones that mark sites of historic interest; *Survival* appeared in the form of enameled metal signs like those used to designate parking restrictions. Both are elements of the New York streetscape common enough to be nearly invisible. At the same time, Holzer was experimenting widely with electronic signs, using the *Truisms* and *Survival* texts in displays that exploited the technology's fast-growing range of typefaces, pacing, rhythm and simple imagery. These too appeared in various public places — stadiums, plazas, marquees — as well as in gallery and museum exhibitions. In other words, while the direction of the writing was, at least in part, toward introversion, the means of presentation reached for an ever broader public. In the mid-eighties Holzer became interested in using public service spots on television, and during the 1984 presidential election campaign she undertook her most direct involvement in the political process. With *Sign on a Truck*, (fig. 5) Holzer invited twenty-one other artists to submit videos that were projected on a big mobile screen of the kind used at the Republican convention;[20] mounted on the flatbed of a truck, it was driven to two well-trafficked New York locations, one at the corner of Central Park and the other at Bowling Green, where it served as an invitation to an open-mike forum.

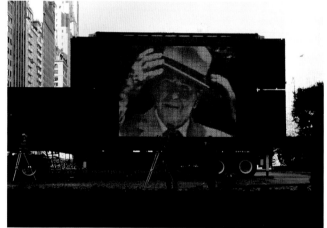

Fig. 5
Sign on a Truck, with image of Ronald Reagan contributed by Barbara Kruger, 1984
Diamond Vision Mobile 2000 video sign
161.5 × 216.5 in. / 410.2 × 549.9 cm
Installation: Grand Army Plaza, New York, 1984
© 1984 Jenny Holzer, member Artists Rights Society (ARS), NY / SACK, Seoul
〈트럭 위의 간판〉, 로널드 레건 이미지 바바라 크루거 제공, 1984
다이아몬드 비젼 모바일 2000 비디오 간판
161.5 × 216.5 in. / 410.2 × 549.9 cm
설치: 뉴욕 그랜드 아미 플라자, 1984
© 1984 제니 홀저, 뉴욕예술가권익협회 / 한국미술저작권관리협회

〈생존〉의 텍스트는 조심스럽게 일인칭 발화를 시작한다. 홀저는 "〈생존〉 시리즈 (1983–85)에서 내 자신의 말에 더 가까운 문장을 ⋯ 사용하는 것이 흥미로울 거라 생각했다 ⋯ 나는 모든 사람이 아니라 내 자신이 되는 것으로 전환했다"라 말했다.[19] 하지만 〈생존〉의 텍스트는 다른 시리즈처럼 간단한 평서문으로 구성되어 있는 가운데, 확실하게 통합된 성격을 표현하지 않는다. 사실 〈생존〉의 텍스트가 가장 강하게 표현하는 것은 화자의 정서적 중심의 부재, 다시 말하자면 화자의 본능적 행동과 기본 지식, 심리적 경험 사이를 연결하는 회로의 고장이다. "눈물길은 슬픔의 장치처럼 보인다. (Tear ducts seem to be a grief provision.)" 〈생존〉의 한 문장이다. "기회가 있을 때마다 부드럽고 사랑스러워지라 (Turn soft and lovely anytime you have a chance)"라는 문장도 있다. 세 번째 문장은 "반응하기를 기억하라 (Remember to react)"라고 말한다. 이 같은 정동의 왜곡이 〈생존〉 텍스트의 정치를 지배한다. "만약 당신이 친절하게 대했다면 공산주의자는 존재하지 않았을 것이다 (If you had behaved nicely the communists wouldn't exist)" 같은 텍스트는 거의 사실처럼 들리지만 "정부까지 춤을 추며 가라 그리고 자신에게 무엇이 좋은 지 알기 때문에 통치하기를 간절히 원한다고 정부에게 말하라 (Dance on down to the government and tell them you're eager to rule because you know what's good for you)"라는 문장처럼 도움이 안되며 의지도 부족하다.

〈삶〉 시리즈 그리고 특히 〈생존〉 시리즈를 통해 홀저의 작업 중 가장 절망적인 텍스트를 읽어볼 수 있다. 믿음과 감정 사이의 괴리감은 사라지지 않는다. 〈삶〉 시리즈에서는 역사적으로 흥미로운 장소를 표시하는 청동 명판이, 〈생존〉 시리즈에서는 주차 금지 구역을 표시하는 에나멜 처리된 금속 표지판 등이 쓰인다. 청동 명판이나 금속 표지판은 뉴욕의 길거리에서 너무 흔하게 있어 거의 눈에 띄지 않는 요소들이다. 이러한 형식은 이들 텍스트의 불분명한 감정을 뒷받침한다. 동시에 홀저는 〈경구들〉과 〈생존〉의 텍스트를 가지고 기술의 발전에 힘입어 빠르게 서체, 속도, 리듬, 단순 이미지 등이 확장되고 있는 전광판을 널리 실험하고 있었다. 그는 이러한 실험을 운동 경기장, 광장, 차양과 같은 다양한 공공 장소 뿐 아니라 갤러리와 미술관의 전시 등에서도 선보였다. 그의 글쓰기의 방향이 내면을 향하는 반면 작업을 발표하는 매체는 더 넓은 공공을 향하고 있었다. 80년대 중반 홀저는 텔레비전의 공익 사업 광고 사용에 관심을 가지기 시작했다. 그리고 1984년 대선 유세 기간 중 가장 직접적인 정치 참여를 했다. 홀저는 21명의 작가를 초대해 공화당 전당대회에 사용되었던 것과 같은 종류의 대형 이동식 스크린 위에 상영할 비디오를 제출하도록 하여 〈트럭 위의 간판 (Sign on a Truck)〉(fig. 5)을 제작했다.[20] 이 트럭은 스크린을 짐칸에 고정하고 유동인구가 많은 두 지역, 센트럴파크 모퉁이와 볼링 그린으로 이동했다. 이 두 곳에서 〈트럭 위의 간판〉은 어느 누구나 참여할 수 있는 토론장으로서 사람들을 초대했다.

19
Ibid., 113.
앞의 글, 113.

20
Ibid., 152.
앞의 글, 152.

In 1985 Holzer and Glier moved out of the city to rural Hoosick, in upstate New York. Three years later their daughter Lili was born. Both events had a profound influence on Holzer's work. The series *Under a Rock* (1986) (fig. 6) was the first to be carved in stone, an appealingly natural material whose obduracy and durability could hardly contrast more strongly with electric signboards, on the one hand, or disposable paper posters, on the other. But another primary association of the carved granite was to mortality. Engraving words into stone benches that have the visual (and physical) gravity of mausoleums, Holzer considerably deepened, and complicated, the emotional range of her work. When *Under a Rock* was shown, both initially (at the Barbara Gladstone gallery in 1986) and later, the stone benches were accompanied by racing LED signs. The effect, as Holzer described it, was "a combination of a church, a space station, a Greyhound bus stop, and a high school auditorium."[21]

As important as the cross-talk between the mobile, chattering lines of electronic text and the static, implacable carved benches is the changed quality of the writing in *Under a Rock*. Its short texts were the first to be frankly narrative, and the first to be largely concerned with violence against women. Though in several cases the actions described are unclear, rape surely seems at issue in "Blood goes in the tube because you want to fuck. Pumping does not murder but feels like it. ... You want to die and kill and wake like silk to do it again." If in previous writings Holzer had aimed, by her simple syntax, spare vocabulary, and general asperity, to project anonymity even while the content grew more personal, with *Under a Rock* it became clear that her odd, lurching, vehement staccato was distinctly her own. And for all its syntactical clarity, the semantic logic of Holzer's writing actually became harder to discern. In fact, the very simplicity of the grammar helps disguise the complexities of its meaning. That, too, proves retrospectively illuminating: the contradictions among the *Truisms*, or between *Living* and *Survival*, speak not only for an irreparably fractured society but for disjunctions within a single individual, of a different order but not altogether unrelated to the kind that separate thought from feeling. Holzer has said of the *Under a Rock* texts, "I don't want to be didactic ... I try to give [people] room to fumble around until they get their own footing."[22] But they read like the expression of an individual deeply at odds with herself.

The permeability of bodies and the difficulty of establishing their boundaries had come up before *Under a Rock*; one of the more memorable of the *Living* texts reads, "The mouth is interesting because it's one of those places where the dry outside moves toward the slippery inside." But for the better part of a decade, starting in the mid-eighties, the body's vulnerability was brought into increasingly tight focus. The *Laments* (1989) were precipitated, in part, by the then-accelerating AIDS crisis, and also by Holzer's new motherhood, a fraught conjunction. In a 1989–90 exhibition at the Dia Foundation in New York City, the *Laments*, (fig. 7) which range up to a paragraph in length, were engraved on the tops of stone sarcophagi and programmed into vertical LED signs. Some of this writing has the force of raw fear ("The new disease came. I learn that time does not heal." "If the process starts I will kill this baby a good way."). But there are equally stark, and moving, paeans to altogether different kinds of physical experience ("No record of joy can be like the juice that jumps through your skull when you are perfect in sex."). The *Laments* were followed by *Mother and Child* (1990), a short series that is among Holzer's most personal and direct. "I am indifferent to myself but not to my child," she wrote. "I am sullen and then frantic when I cannot be wholly within the zone of my infant." Bulletins from the hyper-vigilant land of early parenthood, these statements are as shocking in their tenderness as their rigor. They find Holzer stunned into shameless poignancy.

21
Auping, "Interview," 92–93.
오핑, 〈인터뷰〉, 92–93.

22
Ferguson, "Wordsmith," 152.
퍼거슨, 〈문장가: 제니 홀저와의 인터뷰〉, 152.

Fig. 6
Exhibition view: *Under a Rock*, Barbara Gladstone Gallery, New York, 1986
© 1986 Jenny Holzer, member Artists Rights Society (ARS), NY / SACK, Seoul
Photo: Eeva Inkeri
전시 전경: 〈바위 아래〉, 뉴욕 바바라 글래드스톤 갤러리, 1986.
© 1986 제니 홀저, 뉴욕예술가권익협회 / 한국미술저작권관리협회
사진: 에바 인케리

1985년 홀저와 글리어는 도시를 떠나 뉴욕 북부의 시골인 후식으로 이사를 했고 3년 후 딸 릴리가 태어났다. 이 두 사건은 홀저의 작업에 깊은 영향을 끼쳤다. 〈바위 아래(Under a Rock)〉 시리즈(1986) (fig.6)는 그가 최초로 돌에 새긴 작업이었다. 돌이라는 천연 소재는 일회용 종이 포스터뿐만 아니라 전광판과도 그 내구성과 지속성이 크게 대비되어 더욱 매력적이었다. 하지만 화강암 조각은 죽음과도 연관되었다. 홀저는 석조 벤치에 글자를 새겨 시각적(그리고 물리적으로) 묘석과 같은 엄숙함을 자아내며, 작업에서의 감정적 폭을 심화하고 다각화했다. 〈바위 아래〉는(1986년 바바라 글래드스톤 갤러리에서) 첫 전시 이외에도 이후 전시에서 LED 사인과 함께 전시되었다. 홀저는 이를 "교회와 우주 정거장, 그레이하운드 버스 정류장, 고등학교 강당"21의 조합이라 묘사했다.

〈바위 아래〉에서 중요한 점은 쉴 새 없이 움직이는 전자 텍스트와 벤치에 새겨진, 고정되어 불변하는 텍스트 사이의 응수뿐만 아니라 그의 글이 변화했다는 것이다. 홀저는 〈바위 아래〉의 짧은 텍스트에서 처음으로 솔직한 서사를 보여주었으며, 또한 여성에 대한 폭력을 깊게 다루기 시작했다. 비록 몇몇 글이 묘사하는 행동은 불분명하지만, "체내의 관에 피가 들어가는 건 네가 섹스하고 싶기 때문이다. 펌프질은 살인하진 않지만 살인처럼 느껴진다. … 너는 다시 하기 위해 죽고 죽이고 실크처럼 깨어나길 원한다"와 같은 글은 확실히 강간을 쟁점으로 삼는 것처럼 보인다. 만약 이전의 글에서 홀저가 단순한 구문과 풍부하거나 자유롭지 않은 어휘, 거친 표현을 통해 내용이 개인적일 때조차 익명성을 표현하고자 했다면, 〈바위 아래〉의 오묘하고 가슴을 요동치게 하는 격렬한 스타카토의 소리는 의심의 여지없이 홀저의 목소리였다. 그리고 홀저의 글은 구문적으로 명료함에도 불구하고 그 의미론적 논리는 오히려 더 포착하기 힘들어졌다. 단순한 문법은 오히려 복잡한 의미를 숨길 수 있도록 돕는다. 이는 또한 과거의 작업에 대한 이해를 돕기도 한다. 〈경구들〉 또는 〈삶〉과 〈생존〉 사이의 모순은 회복할 수 없을 정도로 분열된 사회뿐만 아니라 개개인 내면의 괴리감, 사고와 감정을 분리시키는 질서에 대해 이야기한다. 〈바위 아래〉의 텍스트에 대해서 홀저는 다음과 같이 말한다. "나는 교조적이 되고 싶지 않다 … 나는 [사람들이] 자신의 토대를 찾을 때까지 더듬을 수 있는 공간을 주고자 노력한다."22 하지만 〈바위 아래〉의 텍스트는 자신과 조화를 이루지 못하는 개인의 표현처럼 보인다.

〈바위 아래〉 전에도 홀저는 신체에 대한 침투 및 신체의 경계를 수립하는 어려움에 대해 언급한 적이 있다. 〈삶〉의 텍스트 중에서 인상적인 한 문장은 다음과 같다. "입은 흥미롭다. 왜냐하면 건조한 바깥쪽이 미끈거리는 안쪽을 향해 움직이는 장소 중 하나기 때문이다(The mouth is interesting because it's one of those places where the dry outside moves toward the slippery inside)." 80년대 중반 이후 10년 동안 홀저가 신체의 취약성에 가지는 관심은 점점 더 높아졌다. 〈애도(Laments)〉 (1989)의 제작 동기 중 일부는 당시 가속화되던 에이즈 위기, 그리고 홀저의 새로운 모성애였다. 홀저는 1989-90년 뉴욕 디아예술재단에서 〈애도〉(fig.7)를 전시했다. 그는 한 단락으로 구성된 〈애도〉의 텍스트를 석관 윗부분에 새기고, 세로 형태의 LED 사인을 제작했다. 〈애도〉의 텍스트 일부는 원초적인 공포의 힘을 보여준다. ("새로운 질병이 도래했다. 나는 시간으로 치유될 수 없다는 것을 배운다." "그 과정이 진행되면, 나는 이 아기를 좋은 방식으로 죽일 것이다."("The new disease came. I learn that time does not heal." "If the process starts I will kill this baby a good way.") 한편, 마찬가지로 냉혹하고, 감동적이며, 전적으로 다른 종류의 신체적 경험을 기리는 찬가도 있다. ("그 어떤 희열도 당신이 섹스에서 완벽할 때 당신의 두개골 사이로 튀어오르는 즙과 같을 수 없다. [No record of joy can be like the juice that jumps through your skull when you are perfect in sex.]") 〈애도〉에 이어 홀저는 〈어머니와 아이(Mother and Child)〉(1990)를 제작한다. 〈어머니와 아이〉는 홀저의 작업 중 가장 개인적이고 직접적이면서 짧은 시리즈다. 홀저는 "나는 나에게 무관심하지만 내 아이에게는 그렇지 않다"라며, "나는 내 아기의 영역 안에 오롯이 있을 수 없으면 울적해지고 이내 미칠 지경이 된다"라고 적었다. 처음으로 부모가 된 이의 초조한 경계 상태에서 생산된 이 문장들은 매우 혹독하면서 또한 그만큼 다정하다. 〈어머니와 아이〉의 홀저는 수치심을 모르는 통렬한 감정에 쌓여 있다.

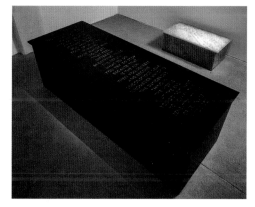

Fig. 7
Laments: No record of joy..., 1989
Nubian Black granite sarcophagus
82 × 30 × 24.4 in. / 208.3 × 76.2 × 61.9 cm
Text: Laments, 1988-89
Laments: I can make women's breasts weep..., 1989
Honey onyx sarcophagus
36 × 18 × 12.25 in. / 91.4 × 45.7 × 31.1 cm
Text: Laments, 1988-89
Installation: *Jenny Holzer: Laments 1988-89*, Dia Art Foundation, New York, 1989
© 1989 Jenny Holzer, member Artists Rights Society (ARS), NY / SACK, Seoul
Photo: Larry Lame
〈애도: 그 어떤 희열도 …〉, 1989
검은색 누비안 화강암 석관
82 × 30 × 24.4 in. / 208.3 × 76.2 × 61.9 cm
텍스트: 애도, 1988-89
〈애도: 나는 여자의 가슴을 울릴 수 있다 …〉, 1989
황색 호마노 석관
36 × 18 × 12.25 in. / 91.4 × 45.7 × 31.1 cm
텍스트: 〈애도〉, 1988-89
설치장소: 디아예술재단, 뉴욕, 1989
© 1989 제니 홀저, 뉴욕예술가권익협회 / 한국미술저작권관리협회
사진: 래리 레임

Also in 1989, Holzer's work was featured at the Guggenheim Museum in New York, where LED signs spiraled up the museum's ramp, filling the soaring atrium with pulsing light; a circle of engraved stone benches provided for viewing from below. Within the year, she represented the United States at the 1990 Venice Biennale, (fig.8) with a series of installations that won her the Leone d'Oro grand prize for best pavilion: she used the airport, rail station, vaporetti, and walkways for posters; hats and T-shirts were sold at tourist retail stands. One chamber of the U.S. pavilion was illuminated with a dozen nearly thirteen-foot-high vertical LED signs programmed with *Mother and Child* texts that alternately ascended and descended, sometimes running upside-down so they could only be read in their reflections on the polished floor. In another room, eleven long flashing horizontal signs were flanked by two further sets of signs on which all the texts written to date ran in three colors and five languages. This "firestorm of electronic light and language," in Michael Auping's words,[23] led to the installation being nicknamed the "microwave room." Elsewhere, diamond-patterned marble floors and stone benches, engraved with *Truisms*, *Inflammatory Essays*, and *Mother and Child* texts, produced a sober, elegiac effect. Considered together, the ambitious projects of 1989–90 provided what Holzer had sought, as a young student, in Blake and Rothko — a kind of visual/textual rapture.

These momentous exhibitions were followed in the early 1990s by a series of projects in which Holzer again turned outward, toward global politics. Twice she was invited to create memorial gardens at troubled sites in Europe. For the town of Nordhorn, where a World War I monument had served as a Nazi rallying ground in World War II, Holzer created a *Black Garden* (1994) (fig. 9) of deep-colored foliage; sandstone benches were engraved with a series of texts written in 1992, during the first U.S. incursion in the Persian Gulf, and called, simply, *War*. A small white garden was also planted at Nordhorn, to commemorate Nazi victims. The *Erlauf Peace Monument* (1995) marks the site in Erlauf, Austria, of the German surrender in World War II. Here Holzer again created a garden of white plantings and, for a row of white paving stones, a series of truncated phrases invoking isolated moments of wartime experience, all sharp as shrapnel.

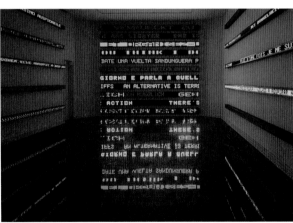

Fig. 8
Exhibition view: *The Venice Installation*, 44th Venice Biennale,
United States Pavilion, Giardini della Biennale, Venice, 1990
©1990 Jenny Holzer, member Artists Rights Society (ARS), NY/SACK, Seoul
Photo: Salvatore Licitra
설치 전경: 〈베니스비엔날레 설치작업〉, 제44회 베니스비엔날레, 미국관,
베니스 자르디니 델라 비엔날레, 1990
©1990 제니 홀저, 뉴욕예술가권익협회 / 한국미술저작권관리협회
사진: 살바토레 리치트라

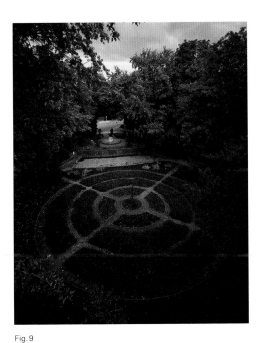

Fig. 9
Black Garden, 1994
Concentric rings of black plantings,
5 Bentheimer Red sandstone benches, small garden of white plantings
Text: *War*, 1992
Permanent installation: Nordhorn, Germany, 1994
© 1994 Jenny Holzer, member Artists Rights Society (ARS),
NY / SACK, Seoul
Photo: Attilio Maranzano
〈검은 정원〉, 1994
검은 동심원 정원, 붉은 사암 벤타임 벤치 5개, 작은 흰나무 정원
텍스트: 〈전쟁〉, 1992
영구 설치: 독일 노르트호른, 1994
© 1994 제니 홀저, 뉴욕예술가권익협회 / 한국미술저작권관리협회
사진: 아틸리오 마란자노

1989년에는 뉴욕 구겐하임 미술관 전시에서는 미술관의 경사로를 따라 LED사인이 나선형으로 설치해 미술관의 중앙홀을 빛의 맥박으로 채웠다. 그리고 글자가 새겨진 석조 벤치들이 설치되어 아래쪽에서 바라볼 수 있는 조망을 제공했다. 그후 1년이 채 지나지 않은 1990년 베니스 비엔날레에서 미국을 대표하는 작가로 설치작업을 전시해(fig. 8) 황금사자상(최고의 파빌리온에게 수여하는 최우수상)을 받았다. 이 전시에서 그는 공항, 기차역, 바포레토(베네치아의 수상버스), 통로 등에 포스터를 부착했고, 기념품 가판대에서 모자와 티셔츠를 판매했다. 미국관의 방 하나에는 약 4미터 높이의 세로형 LED사인 12개가 설치되었다. 이들 LED사인에는 〈어머니와 아이〉 텍스트가 번갈아 오르락내리락하는 형태로 프로그래밍 되었으며, 때로는 반전되어 광택이 나는 바닥에 비친 상으로만 읽을 수 있도록 했다. 다른 방에는 가로형 사인 11개가, 그 옆으로 또 다른 두 세트의 사인들이 설치되었다. 이 사인들에는 홀저가 지금까지 쓴 모든 텍스트가 세 가지 색, 다섯 개의 언어로 등장했다. 오핑의 표현에 따르면 23 "전자 조명과 언어의 불기둥"인 이 설치에는 '전자레인지 방'이란 별칭이 붙었다. 다른 곳에서는 〈경구들〉, 〈선동적 에세이〉, 〈어머니와 아이〉의 텍스트가 다이아몬드 패턴의 대리석 바닥과 석조 벤치들에 새겨져 진지하면서도 애틋한 광경을 자아냈다. 위와 같이 홀저가 진행한 1989–90년의 야심찬 프로젝트들은 그가 학생 시절 블레이크와 로스코에서 찾았던 시각적/텍스트적 황홀감을 제공했다.

앞서 언급한 기념비적 전시들에 이어 홀저는 1990년대 초 다시금 밖으로, 세계 정치로 방향을 전환해 일련의 프로젝트를 진행한다. 그는 유럽의 역사적 비극이 벌어진 장소들에 추모 정원을 만들어 달라는 초청을 받았다. 첫 번째는 노르트호른이었다. 이 곳에 일찍이 있었던 제1차 세계대전 기념비가 제2차 세계대전 중에는 나치의 집결지 역할을 했다. 이 마을을 위해 홀저는 짙은 색 나뭇잎으로 이루어진 〈검은 정원(Black Garden)〉(1994)(fig. 9)을 만들었다. 그는 미국이 페르시안만을 처음 침공한 1992년에 쓰고 단순히 〈전쟁(War)〉이라 이름 붙인 텍스트들을 사암 벤치에 새겼다. 또한 그는 나치의 희생자들을 기리기 위해 작은 흰색 정원을 만들었다. 〈에어라우프 평화 기념비(Erlauf Peace Monument)〉(1995)는 2차 세계대전 중 독일이 항복을 선언한 오스트리아 에어라우프 현장을 기념한다. 여기서 홀저는 다시 흰색 식목으로 정원을 만들고, 전쟁 중 고립의 경험을 환기시키는 불완전하고, 포탄의 파편처럼 날카로운 문장들을 일렬로 된 하얀 포석 위에 새겼다.

23
Auping, "Interview," 62.
오핑, 〈인터뷰〉, 62.

Lustmord (1993–95),^(figs. 10 and 11) a project that also originated in Germany, was drawn in part from reports of atrocities committed in the war in the former Yugoslavia. From three perspectives — victim, perpetrator, and observer — it reflects, with gut-clenching intimacy and vividness, on the sexual violence that was a favored tactic in the Bosnian conflict. Holzer's presentation of this material was unusually elaborate. The texts were stamped on the walls of a small barrel-vaulted enclosure lined in quilted red leather. They also appeared in two Plexiglas canisters, seemingly written in spiraling red light on air, a counterpart to the leather-stamped words that were, literally, branded on flesh. More graphically still, Holzer displayed bleached human bones circled by small metal bands incised with fragments of text. In Germany (*Lustmord* was also later shown in New York and elsewhere), the texts first appeared as an insert in the Sunday magazine of *Süddeutsche Zeitung*, a major daily newspaper. There they took the form of words written in ink on human skin.^(fig. 11) Most provocatively of all, a white card on the front of the magazine bore two lines of text, including "Da wo Frauen sterben bin ich hellwach" (I am awake in the place where women die), printed with ink containing a small amount of actual blood, donated by German and Bosnian women for the purpose. Unsurprisingly, the entire project generated not only fervent praise but also a storm of protest.

The outrage that *Lustmord* caused is perhaps commensurate with the depth of experience on which it drew. Over the years, Holzer had alluded to rape many times. With *Oh* (2001),^(fig. 12) the references became considerably more intimate. Much of *Oh* is an unblinking, worried, ardent catalogue of the perfect parts — arms, ribcage, genitals, fingers — of a child fast becoming a young woman. But some of *Oh* is the artist's own family history: "I have not raped you although this would be familiar enough if I remember the family habit," Holzer writes. She names the perpetrator as a grandfather, "lover of any woman he could catch then rapist of children and grandchildren got from the women." *Oh* was composed for a spring 2001 exhibition at the Neue Nationalgalerie in Berlin. The texts Holzer used there — a compendium of which *Oh* was the newest — ran on LED signs mounted on the ceiling, so viewers had to crane their necks or, ideally, lie on the floor or on benches, to read them clearly. Mies van der Rohe's famously spare museum involves glass window walls, and in many light conditions the texts reflected on the glass and seemed to continue beyond, soaring out over the adjacent plaza and nearby rooftops.

Fig. 10
HUT: Selections from Lustmord, 1994
Hand-embossed leather and wood structure, 2 3-D imagers
150 × 156 × 222 in. / 381 × 396.2 × 563.9 cm
Text: *Lustmord*, 1993–95
Untitled (Selections from Lustmord), 1994
3-D volumetric LED display with embossed leather pedestal
32 × 19.5 × 19.5 in. / 81.3 × 49.5 × 49.5 cm
Text: *Lustmord*, 1993–95
Installation: *LUSTMORD*, Barbara Gladstone Gallery, New York, 1994
© 1994 Jenny Holzer, member Artists Rights Society (ARS), NY / SACK, Seoul
〈오두막: 쾌락살인으로부터〉, 1994
가죽 및 목재 설치물에 손으로 양각, 3D 이미저 2대
150 × 156 × 222 in. / 381 × 396.2 × 563.9 cm
텍스트: 〈쾌락살인〉, 1993–95
〈무제 (쾌락살인으로부터)〉, 1994
3D 용적 LED 디스플레이와 양각된 가죽 받침대
32 × 19.5 × 19.5 in. / 81.3 × 49.5 × 49.5 cm
텍스트: 〈쾌락살인〉, 1993–95
설치: 《쾌락살인》, 뉴욕 바바라글래드스톤갤러리, 1994
© 1994 제니 홀저, 뉴욕예술가권익협회 / 한국미술저작권관리협회

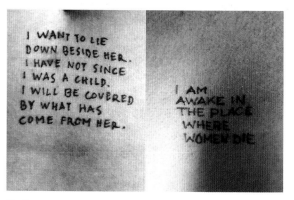

Fig. 11
Lustmord, 1993
Cibachrome print of ink on skin
13 × 20 in. / 33 × 50.8 cm
Text: *Lustmord*, 1993–95
© 1993 Jenny Holzer, member Artists Rights Society (ARS), NY / SACK, Seoul
Photo: Alan Richardson
〈쾌락살인〉, 1993
피부에 잉크, 시바크롬 인화
13 × 20 in. / 33 × 50.8 cm
텍스트: 〈쾌락살인〉, 1993–95
© 1993 제니 홀저, 뉴욕예술가권익협회 / 한국미술저작권관리협회
사진: 알랭 리차드슨

독일에서 처음 진행된 프로젝트, 〈쾌락살인 (Lustmord)〉(1993-95)(fig. 10)의 일부는 옛 유고슬라비아 전쟁 중 벌어진 잔학 행위에 대한 보고로부터 시작되었다. 본 프로젝트는 피해자, 가해자, 관찰자라는 세 가지 관점으로 보스니아 분쟁에서 즐겨 사용된 전술이었던 성폭력을 마치 내장을 쥐어짜는 듯한 성적이고 생생한 표현으로 되돌아본다. 이 작품에서 홀저는 평소와 달리 소재를 자세하게 표현한다. 반원통형으로 둘러싸인 공간 내벽에 누빔 처리한 빨간 가죽을 바르고 그 위에 텍스트를 각인했다. 또한 두 개의 플렉시글라스 통에 텍스트를 연출해 얼핏 봐서는 허공에 나선형 빨간 불빛으로 쓰인 것처럼 보이는 작품을 만들었다. 이는 말 그대로 피부 위에 낙인된 가죽과 대비되었다. 또한 홀저는 표백한 인간 뼈에 텍스트의 파편들이 새겨진 작은 금속 밴드를 둘러 함께 전시했다. 독일에서(이후 뉴욕 등지에서도 전시) 〈쾌락살인〉의 텍스트는 인간 피부위에 잉크로 쓴 형태(fig. 11)로 주요 일간지인 〈쥐트도이체 자이퉁(Süddeutsche Zeitung)〉의 일요판 잡지에 삽입지로 배포되었다. 그중 가장 도발적인 것은 잡지 앞면 흰색 카드에 적힌 두 줄의 텍스트였다. "Da wo Frauen sterben bin ich hellwach.(나는 여자들이 죽는 곳에서 완전히 깨어 있다)." 이 텍스트는 독일과 보스니아 여성들이 기부한 소량의 실제 피를 포함한 잉크로 프린트되었다. 〈쾌락살인〉 프로젝트는 열렬한 찬사와 격렬한 항의를 동시에 불러 일으켰다.

〈쾌락살인〉이 야기한 분노는 아마도 이 작업이 호출하는 경험의 깊이와 비례할 것이다. 수년간 홀저는 여러 차례 강간을 작품 속에서 언급한한 바 있다. 〈오(Oh)〉(2001)(fig. 12)에서 강간에 대한 암시는 더욱 성적으로 표현되었다. 〈오〉의 많은 부분은 빠르게 성인 여성으로 성장하고 있는 어린 아이의 완벽한 부분, 즉 팔, 흉곽, 생식기, 손가락 등을 응시하며, 염려와 열정으로 기록한다. 하지만 〈오〉의 일부는 작가 자신의 가족사이기도 하다. 그는 "내가 가족의 습벽을 기억한다면 충분히 익숙한 일이기는 하겠지만 나는 너를 강간한 적이 없다(I have not raped you although this would be familiar enough if I remember the family habit)"라고 쓴다. 그는 가해자를 할아버지로 지목한다. "그는 그가 잡을 수 있었던 어느 여자에게나 연인 그리고는 그 여자들로부터 얻은 자식과 손주들의 강간범. (lover of any woman he could catch then rapist of children and grandchildren got from the women.)" 〈오〉는 베를린 신국립미술관에서 2001년 봄 전시를 위해 구성되었다. 가장 새로운 텍스트였던 〈오〉를 포함하여 이 전시에서 홀저는 텍스트를 천장에 설치된 LED 사인에 설치했다. 그리하여 관객은 이 텍스트들을 제대로 읽기 위해 목을 길게 빼거나 바닥이나 벤치에 누워야만 했다, 미스 반 데어 로에가 건축한 베를린 신국립미술관 유리벽이 많은 빛을 통해 텍스트를 유리 위에 반사함으로써 텍스트가 마치 인접한 광장과 주변 지붕 위로 날아오르며 미술관 너머로 이어지는 것처럼 보였다.

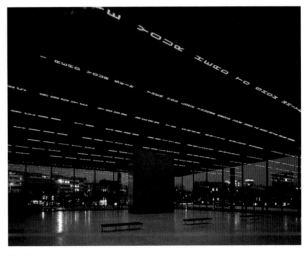

Fig. 12
Installation for Neue Nationalgalerie, 2001
13 LED signs with amber diodes
4 × 1,716.5 × 1,920 in. / 10.2 × 4,360 × 4,877 cm
Text: *Oh*, 2001
Installation: *Jenny Holzer: OH*, Neue Nationalgalerie, Berlin, 2001
© 2001 Jenny Holzer, member Artists Rights Society (ARS), NY / SACK, Seoul
Photo: Attilio Maranzano
〈베를린 신국립미술관 설치작업〉, 2001
13개의 앰버 다이오드 LED 사인
4 × 1,716.5 × 1,920 in. / 10.2 × 4,360 × 4,877 cm
텍스트: 〈오〉, 2001
설치: 《제니 홀저: 오》, 베를린 신국립미술관, 2001
© 2001 제니 홀저, 뉴욕예술가권익협회 / 한국미술저작권관리협회
사진: 아틸리오 마란자노

24
Quoted in Amei Wallach,
"New 'Truisms' in Words and Light,"
New York Times, September 28, 2005,
E7.
아메이 월랙, 〈단어와 빛 속의 새로운
'경구들'〉, 뉴욕타임스, 2005년 9월 28일,
E7.

Holzer took a long hiatus from writing original material after *Oh*. In 1996, she began to use nighttime light projections that throw huge white letters at night over the facades of buildings and certain landscape elements, including dense stands of trees and water. Monumental and ghostly, the scrolling projections pick out architectural details, or leaves, or curls of foam from the obscurity of darkness, while broadcasting enormous words that have an oracular presence even in photographs. The projections have appeared in countries from Argentina to Norway, and including France, Germany, and England; they've been seen on the Spanish Steps in Rome and the Arno River in Florence. The texts have been both Holzer's own and, starting in 2001, words written for a variety of purposes by others. At the Jüdisches Museum Berlin that year, documents from the museum's archive, along with poetry by Yehuda Amichai and others, were projected on the building. At several locations in Bregenz, Austria in 2004, Holzer used (in addition to selections from her own writing going back to the *Truisms*) a poem by Henri Cole directed at George W. Bush. Among the texts programmed into electronic signs shown at the Bregenz Kunsthaus at the same time, some laid like verbal landmines across the floor, were excerpts from correspondence between government officials in the United States and the Middle East, and also the Cole poem, which appeared as well in the form of letters burnt in spiraling lines up the peeled trunks of two trees, one at the Kunsthaus and the other at a church just outside Bregenz.

Shortly before the 2004 presidential election in the United States, Holzer projected the contents of formerly classified government documents on the facade of the Gelman Library at George Washington University in Washington, D.C., which houses the National Security Archive, a publicly accessible collection of declassified documents established two decades earlier by journalists and scholars. Also in the fall of 2004, poetry by Wisława Szymborska, Amichai, Cole, and others was projected on several New York City monuments (St. John the Divine on the Upper West Side, Bethesda Fountain in Central Park).(fig. 13) These nighttime projections, supported by the nonprofit Creative Time, were accompanied in the daytime by text-bearing banners pulled aloft by small airplanes. The following fall, government documents as well as poetry were projected on New York City landmarks, this time including the New York Public Library and 30 Rockefeller Center. Sliding silently across these august buildings, the massive illuminated words were quietly spellbinding. "There's something about light that's right for these terrible subjects," Holzer said at the time. "It's a way of having beauty let you come closer than you might otherwise."[24]

홀저는 〈오〉 이후 새로운 글을 쓰기까지 긴 공백기를
가졌다. 1996년에는 야간 조명 프로젝션을 사용하기
시작해 건물의 표면, 빽빽히 늘어선 나무들, 물이 있는
풍경들 위에 거대한 하얀 글자들을 드리우기 시작했다.
야간 조명 프로젝션은 기념비적이면서도 환영과도
같았다. 크세논 프로젝션은 사진에서도 마치 신탁처럼
보이는 거대한 단어들을 스크롤하면서 어둠의 모호함
속에서 건축적 디테일이나 나뭇잎, 물거품의 굴곡에
빛을 비췄다. 프로젝션 작업은 아르헨티나를 시작으로
노르웨이, 프랑스, 독일, 영국 등지에서 진행되었다.
로마의 스페인 계단, 피렌체의 아르노 강에 홀저의
글자들이 비춰졌다. 2001년부터는 자신의 텍스트 외에
다른 이들이 다양한 목적으로 쓴 글을 사용하기
시작했다. 같은 해 홀저는 베를린 유대인박물관에서
박물관 아카이브 문서와 예후다 아미차이 등의 시를
프로젝션에 이용했다. 2004년 오스트리아 브레겐츠의
몇 곳에서 홀저는 (〈경구들〉부터 지금까지의 글들 중
선정한 것들과 함께) 조지 W. 부시를 겨냥한 헨리 콜의
시를 전시했다. 베르겐츠 쿤스트하우스에서는
전광판을 사용해 몇몇은 바닥에 마치 언어로 된
지뢰처럼 전시했고, 미국과 중동의 정부 관료들 사이에
오간 서신에서 발췌한 내용과 콜의 시를 텍스트로
삼았다. 콜의 시는 두 나무의 껍질을 벗긴 줄기
위 나선형 선으로 태운 편지 형태로도 제작해 하나는
쿤스트하우스, 다른 하나는 베르겐츠 외곽에 있는
교회에 전시했다.

2004년 미국 대통령 선거 직전 홀저는 기밀 해제된
정부 문서의 내용을 워싱턴 DC 조지워싱턴 대학의
겔만 도서관 표면에 프로젝션한다. 조지워싱턴
대학에는 20년 전 언론인과 과학자들이 설립하여
기밀 해제된 문서들을 보관·공개하는 국가안보기록
보관소가 있다. 또한 2004년 가을, 그는 비스바,
심보르스카, 아미차이, 콜 등을 비롯한 여러 시인들의
시를 몇몇 뉴욕시 기념비에 프로젝션했다
(어퍼웨스트사이드의 세인트 존 더 디바인 성당,
센트럴파크의 베데스다 분수(fig. 13)). 이와 함께
비영리단체 크리에이티브타임의 후원으로 주간에는
소형 비행기들이 텍스트를 담은 현수막을 끌며
허공을 비행하기도 했다. 이듬해 가을에는 시와 정부
문서들을 뉴욕공립도서관과 30록커펠러센터 등
뉴욕의 여러 랜드마크에 투사했다. 이 텍스트는
장엄한 건물을 조용히 가로지르며 거대한 빛의
단어들로 사람들을 매혹했다. 홀저는 "빛의 무언가가
이 끔찍한 주제들에 적합한 면이 있다"고 말했다.
"아름다움이 다른 방법보다 더 당신을 가까이
다가오도록 이끈다."24

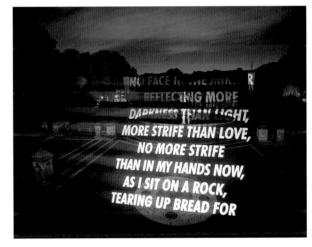

Fig. 13
For New York City, 2004
Light projection
Bethesda Fountain, Central Park, New York
Text: "Necessary and Impossible" from *Middle Earth* by Henri Cole,
©2003 by the author. Used with permission of Farrar, Straus and Giroux.
Presented by Creative Time
©2004 Jenny Holzer, member Artists Rights Society (ARS), NY / SACK, Seoul
Photo: Attilio Maranzano
〈뉴욕을 위하여〉, 2004
조명 프로젝션
뉴욕 센트럴파크 베데스다 분수
텍스트 : 헨리 콜, 〈필요와 불가능함〉, 『중간계』,
©2003 헨리 콜, Farrar, Straus and Giroux 출판사의 허락을 받아 사용.
크리에이티브 타임 기획
©2004 제니 홀저, 뉴욕예술가권익협회 / 한국미술저작권관리협회
사진 : 아틸리오 마란자노

In the spring of 2006, at the Cheim & Read Gallery in New York, Holzer exhibited her first paintings in more than twenty years. Executed in oil on linen, the elegant *Redaction Paintings* are enlarged facsimiles, on variously colored backgrounds, of declassified government documents, all of them heavily censored. Patches of black conceal parts — and in many cases almost the entirety — of memos and letters circulated within the U.S. government, most dealing with such sensitive issues as assessment of terrorism risks and treatment of detainees. Sometimes oddly satisfying in formal terms, the *Redaction Paintings* speak eloquently not just about the prevalence of state censorship and the abuses it vainly tries to hide, but also about the assaults it commits against language, as well as bodies and minds.(fig. 14) With a succeeding series of paintings, presented in a 2012 exhibition at Skarstedt Gallery called *Endgame*, Holzer complicated things by superimposing over very heavily redacted documents blocks of solid or modulated color that imitate the off-kilter geometries and the rich chromatic sequences of Kazimir Malevich's iconic abstractions.(fig. 15) By redirecting Malevich's language towards political expression, Holzer reclaimed the idealistic, Socialist spirit in which they were executed, while also inviting viewers to focus on censorship as an act with an author. The government language concealed beneath Holzer's rather sumptuous (and fairly large) paintings becomes their unvoiced subconscious, dark as Stalin's purges.

If Theodor Adorno's famous pronouncement that poetry is not possible after Auschwitz is brought to mind by Holzer's turn away from original composition and toward exposure of the real language of power, Hannah Arendt's argument that the Nazi regime's abuse of language was among its most egregious offenses is invoked even more forcefully. In her *Eichmann in Jerusalem*, Arendt wrote that the net effect of the Nazi regime's *Sprachregelungen* — essentially a code of official euphemisms for barbarous crimes — "was not to keep these people ignorant of what they were doing, but to prevent them from equating it with their old, 'normal' knowledge of murder and lies."[25] Clearly, Holzer shows, this omnidirectional kind of linguistic repression — directed equally inward and at others — still thrives.

Both insofar as she has exposed the way power corrupts language, and in her practiced ability to think from the standpoint of others, Holzer powerfully illuminates the dangers of what Arendt so unforgettably described as the banality of evil. Considered as a whole, Holzer's work has refreshed written language as a medium for visual artists, while ensuring that politics retains a seat in the institutions of high culture. It now seems clear that she keeps closer company with such politically engaged artists as Nancy Spero, Hans Haacke, and Krzysztof Wodiczko than with those whose primary concern is the conventions of the mass media or the institutions of high culture. And while museums continue to showcase her texts racing along curved, canted, and floor-to-ceiling signboards to create installations of ecstatic splendor, she remains committed above all to the belief — one not much in vogue at the moment — that difficulty, for artist and viewer alike, can be a positive value.

Fig. 14
JAW BROKEN BROWN, 2006 (detail)
Oil on linen, 5 elements
33 × 127.5 in. / 83.8 × 323.9 cm
Text : U.S. government document
© 2006 Jenny Holzer, member Artists Rights Society (ARS), NY / SACK, Seoul
〈부러진 갈색 턱〉, 2006
린넨에 유화, 다섯 가지 요소들
33 × 127.5 in. / 83.8 × 323.9 cm
텍스트 : 미국 정부 문서
© 2006 제니 홀저, 뉴욕예술가권익협회 / 한국미술저작권관리협회

2006년 봄, 뉴욕 체임앤리드갤러리에서 홀저는 20여 년 만에 처음으로 회화를 전시한다. 린넨에 오일로 그린 우아한 〈편집 회화(Redaction Paintings)〉는 기밀 해제된 정부 문서들을 다양하게 채색된 배경 위에 확대해 보여준다. 이 문서들은 모두 심하게 검열되어 있다. 미국 정부 내에서 회람된 공문과 서신들로 그 내용의 전체가 대부분 검은 색으로 가려져 있다. 그 내용은 대개 억류자들에 대한 처우, 테러 위험 평가 등 민감한 이슈들을 다루고 있었다. 형식적 조건이 이상하게 만족감을 주는 〈편집 회화〉는 국가 검열의 지배 및 남용, 그리고 검열이 언어뿐만 아니라 신체와 정신에 가하는 폭력에 대해 유창하게 웅변한다.(fig. 14) 홀저는 회화 시리즈 작업을 이어갔고, 2012년 스카스테트 갤러리 전시 〈엔드게임(Endgame)〉에서는 뭉텅이로 편집한 문서 위에 카지미르 말레비치의 추상화가 지닌 색상과 비스듬한 기하학적 구성을 모방하는 단색 또는 그라데이션 색채 블록을 겹침으로써 다층적으로 심화된 작품을 선보였다.(fig. 15) 홀저는 말레비치의 언어를 정치적 표현으로 전환시킴으로써 그 이상주의적, 사회주의적 정신을 되찾는 한편, 관객들로 하여금 검열 역시 어느 저자(author)의 행위임을 집중하도록 유도한다. 홀저의 다소 호화로운(그리고 꽤나 큰) 회화 아래 숨겨진 정부의 언어는 말로 표현되지 않은 잠재의식, 스탈린의 숙청만큼이나 어두운 정부의 잠재의식이 된다.

만약 홀저가 직접 글쓰기를 포기하고 실제 권력의 언어를 고발하기에 이르렀다는 점에서 아우슈비츠 이래 시는 불가능하다는 테오도르 아도르노의 유명한 언명이 떠오른다면, 나치 정권의 언어 오용은 그들의 가장 지독한 범죄 중 하나였다는 한나 아렌트의 주장 역시 강하게 환기된다. 『예루살렘의 아이히만』에서 아렌트는 야만적 범죄를 완곡하게 가리키는 공문상 언어를 핵심으로 하는 나치 정권의 '언어 규칙(Sprachregelungen)'의 실제 효과는 "사람들이 자신이 하고 있는 일을 인지하지 못하도록 하려는 것이 아니라, 그 일을 살인 및 거짓말과 같은 오래된 '정상적' 지식과 동일시하는 것을 막기 위한 것"이라 썼다.25 홀저는 내면과 타인에게 동일하게 행해지는 전방위적 언어 억압이 여전히 성행하고 있음을 분명하게 보여준다.

홀저는 권력이 언어를 타락시키는 방법을 폭로하고, 타인의 관점에서 생각하는 숙련된 능력을 통해 아렌트가 잊을 수 없게 묘사한 소위 '악의 평범성'이 가지는 위험을 강력하게 피력한다. 전체적으로 볼 때, 홀저의 작품은 문자 언어를 시각 예술가의 매체로써 새롭게 하는 한편 정치가 고급 문화 제도의 한 자리를 유지할 수 있도록 한다. 그는 대중매체나 고급 문화 제도의 관습이 주요 관심사인 사람들보다 낸시 스페로, 한스 하케, 크지슈토프 보디츠코처럼 정치 참여 예술가들과 더 가까운 관계를 유지한다. 그리고 미술관들이 황홀하고 화려한 설치를 하기 위해 곡선으로, 비스듬하게, 또는 바닥부터 천장에 이르는 사인을 따라 흘러가는 홀저의 텍스트를 계속 선보이는 동안, 그는 작가와 관람객 모두에게 어려움이 긍정적 가치가 될 수 있다는 오늘날 흔치 않은 믿음에 무엇보다 전념하고 있다.

Fig. 15
TOP SECRET 21, 2012
Oil on linen
58×44 in. / 147.3×111.8cm
Text : U.S. government document
© 2012 Jenny Holzer, member Artists Rights Society (ARS), NY / SACK, Seoul
〈일급 비밀 21〉, 2012
린넨에 유화
58×44 in. / 147.3×111.8cm
텍스트 : 미국 정부 문서
© 2012 제니 홀저, 뉴욕예술가권익협회 / 한국미술저작권관리협회

25
Hannah Arendt, *Eichmann in Jerusalem* (New York : Viking Press, 1963), 86. By way of illustration, Arendt wrote, "None of the various 'language rules,' carefully contrived to deceive and to camouflage, had a more decisive effect on the mentality of the killers than this first [1939] war decree of Hitler, in which the word for 'murder' was replaced by the phrase 'to grant a mercy death'" (108).
한나 아렌트, 『예루살렘의 아이히만』 (뉴욕 : 바이킹 프레스, 1963), 86. 예시로, 아렌트는 다음과 같이 쓴다. "기만하고 위장하기 위해 신중히 고안된 다양한 '언어 규정' 중 살인자에 정신에 가장 결정적인 영향을 미쳤던 건 히틀러의 첫번째(1939) 칙령이었다. 그는 '살인'이란 단어를 '자비로운 죽음을 허락하다'라는 문구로 교체했다"(108).

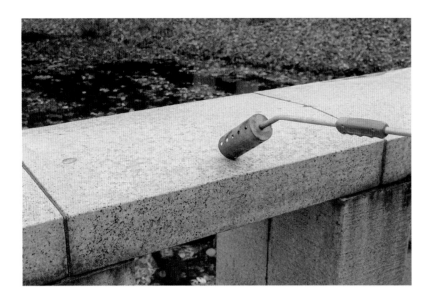

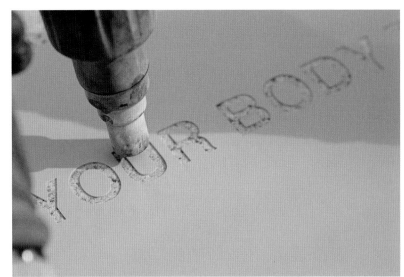
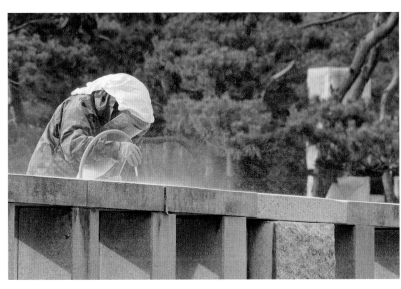
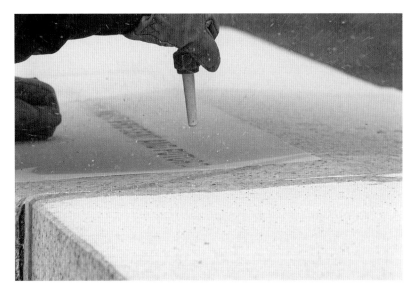
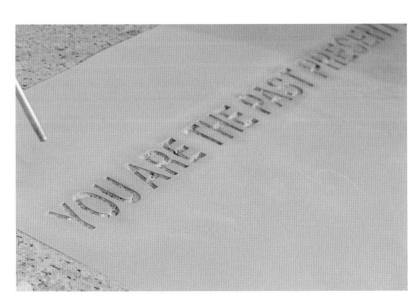

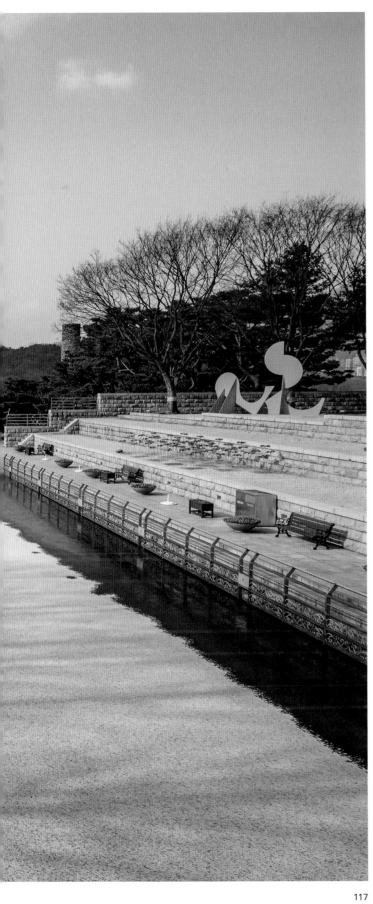

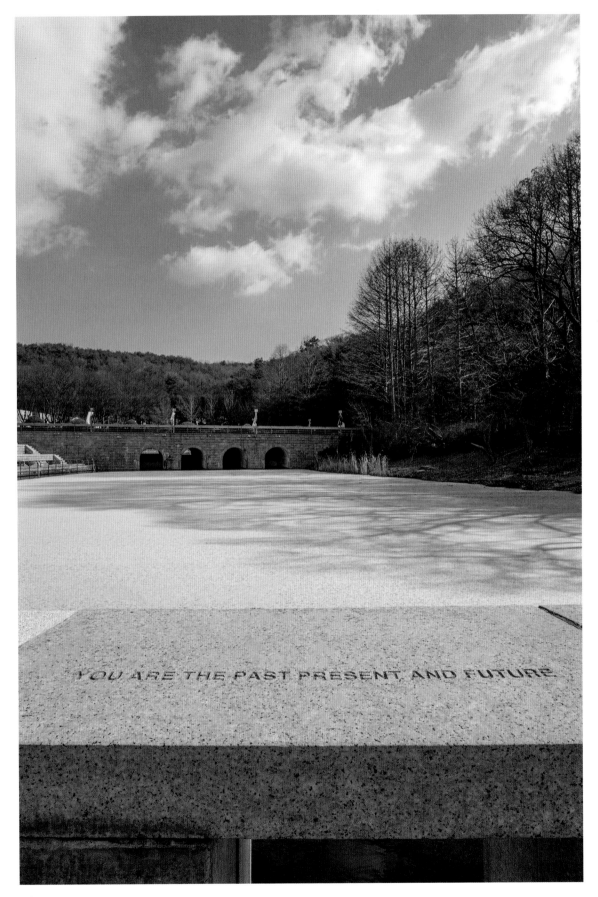

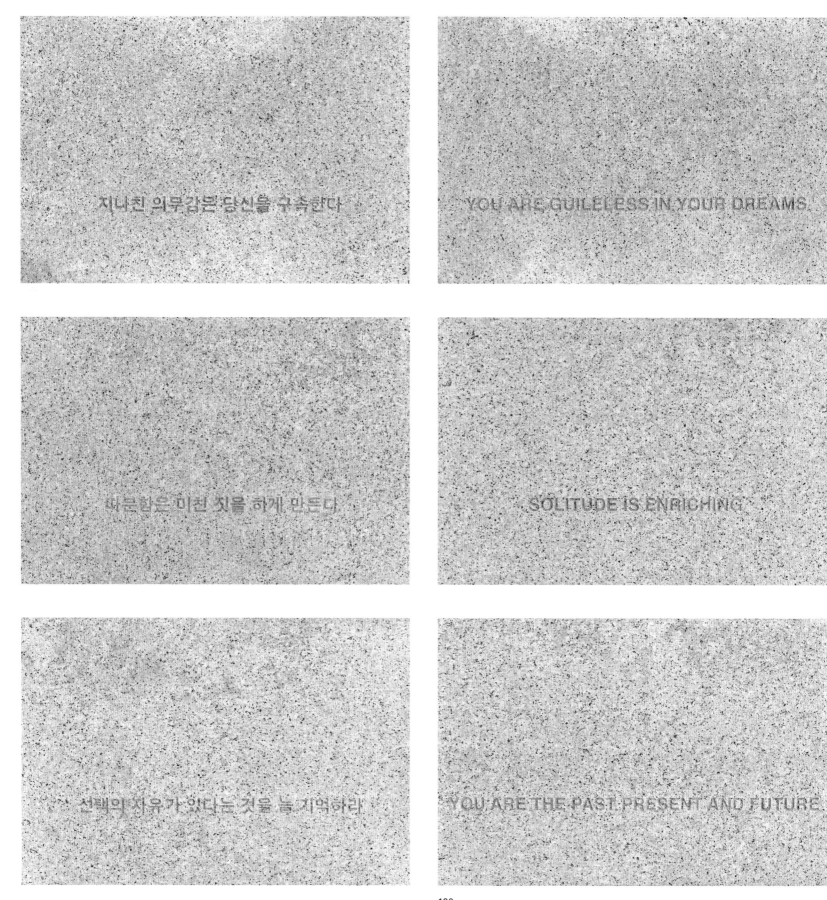

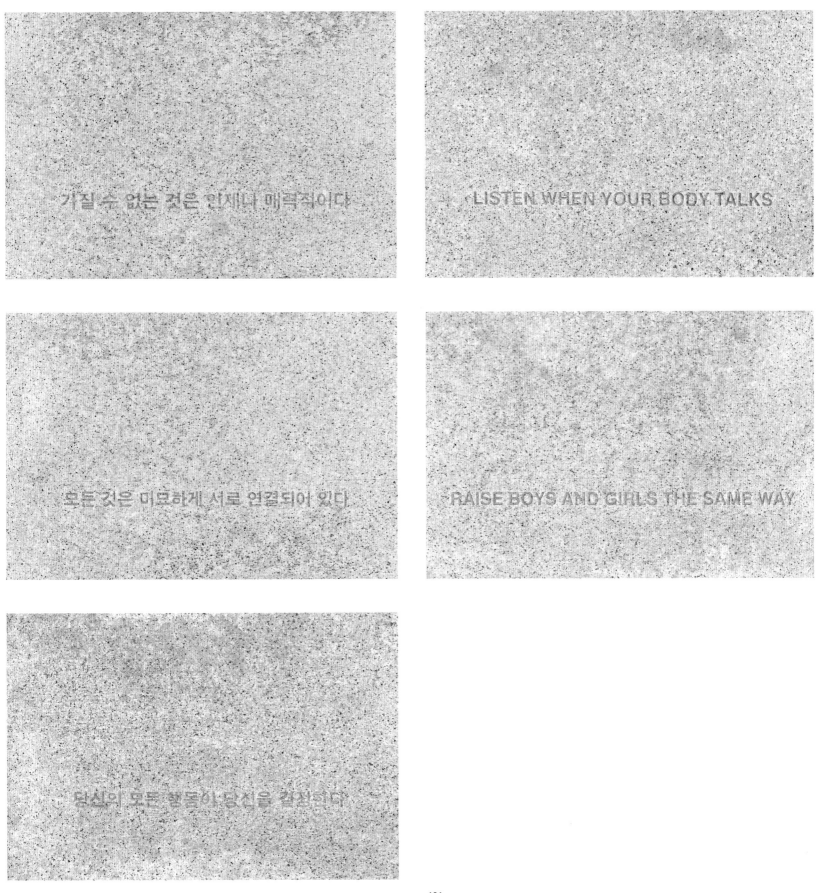

가질 수 없는 것은 언제나 매력적이다

LISTEN WHEN YOUR BODY TALKS

모든 것은 미묘하게 서로 연결되어 있다

RAISE BOYS AND GIRLS THE SAME WAY

당신의 모든 행동이 당신을 결정한다

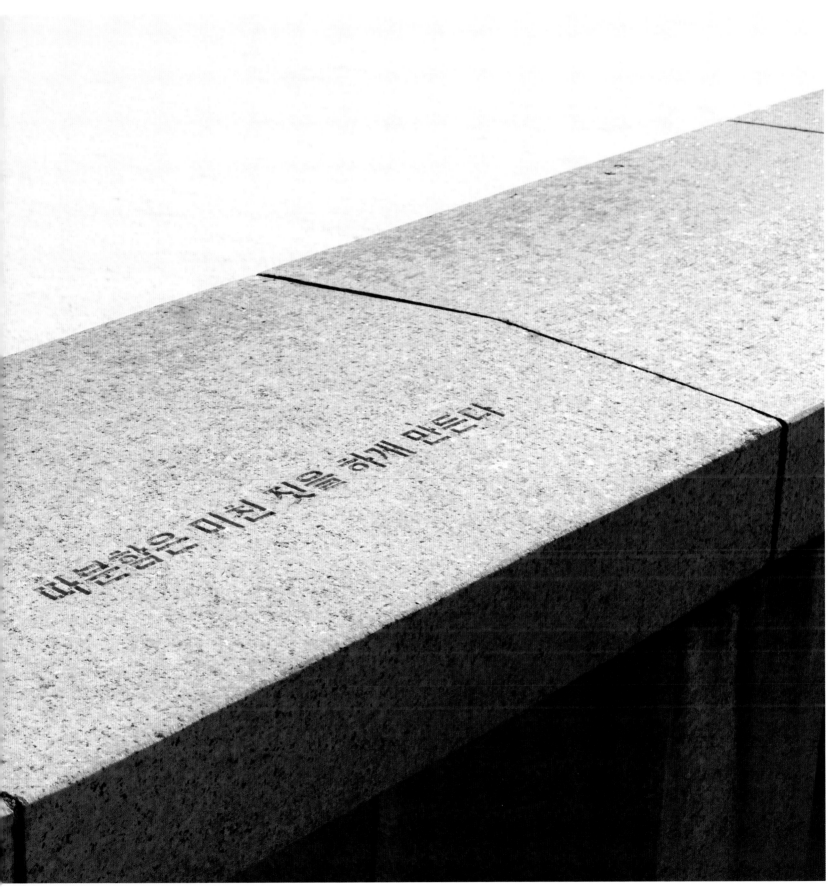

마음속에 미친 집념을 하게 만든다

Jenny Holzer's Art of Projection

Nicholas Chittenden Morgan
Writer and Art Historian

Recent years have been filled with outdoor projections as a form of protest and contestation. In 2015, the anti-gentrification group Chinatown Art Brigade projected its slogans onto buildings in New York's Chinatown. A collective called The Illuminators, an offshoot of the Occupy Wall Street movement, projected images and slogans onto downtown buildings in 2011 and more recently teamed with the group G.U.L.F to protest labor exploitation in the construction of new museums abroad by beaming words and images ("1% Museum") onto the facade of the Guggenheim. The 2016 US presidential election incited a spate of protest projections, including one onto a hotel in Atlanta and another, in Brooklyn, depicting Vladimir Putin hugging the president-elect; the guerrilla artist Robin Bell cast satirical messages onto various buildings in the nation's capital. The rash of projections was not limited to America or American politics. In Warsaw, the new-left Razem party projected a verdict contesting the legality of the conservative ruling party's undermining of Poland's judicial system onto the prime minister's office in March 2016. All these interventions are joined by their faith in the open airing of projected language as a means of sharing knowledge or ideas to spark action and generate discussion. Using the tools of spectacle to rebuild an ever more fragmented public sphere, they have an ambivalent relationship to such amorphous concepts as "art" and "the subject."

Jenny Holzer began projecting text in public spaces in 1991, well before this outpouring of language presented through light: one might say she anticipated it, or that she produced a model that has now been disseminated to activists. Like their projections, hers embrace anonymity and fugitivity: Holzer's favorite viewer is one who stumbles unknowingly upon a projection. But there is an important difference between Holzer's use of language in this light-based medium and these other projects, which is that the writing she deploys is poetic and indeterminate, rather than purely informational. Past projections have drawn from poems by writers such as Wisława Szymborska, excerpted political speeches, or gathered fragments of philosophical texts by famous thinkers. They must take place at night to ensure visibility, but their "screens" are flexible, and have included oceans, forests, skyscrapers, and architecture from the famous and avant-garde — I. M. Pei's Louvre pyramids, Frank Lloyd Wright's Guggenheim — to the anonymous, vernacular, or classical — including the greenhouses of the New York Botanical Gardens and the ancient Roman Theater of Marcellus. She throws words onto the fronts of buildings, the crests of waves, the bottoms of mountains.

The projections often evoke skin, and some of their beauty derives from a paradoxical sense of tactility delivered without touch, a kind of laying of one surface onto another that points to the artist's pragmatic, do-no-harm attitude (as if the projection were a kind of surgery on a body — ours? the building's? — and the artist a surgeon who has taken the Hippocratic oath). They also transmogrify the madcap, jittery temporal register of Holzer's well-known LED signs, rendering content like a stone thrown through the air that suddenly seems to go into slow motion as it hits the surface of a pond and tumbles through water. Think of the famous image by Harold Edgerton of a bullet passing through an apple, where violence and stillness become intimate. For her 2017 projection *For Aarhus*, the texts Holzer chose are riddled with accounts of lives torn apart by violence. "In this poem / There is no place for those who want the bomb to be just a bomb / The bullet to be just a bullet / The border to be just a border," reads part of Omid Shams' "One day we all will forgive the gods," one of the many poems Holzer projected in the main square of Aarhus, the second-largest city in Denmark, over ten days in February and March of that year. A concern for violence in its many forms has preoccupied Holzer in other recent projections. In October 2019, for example, she projected onto multiple towers of Manhattan's Rockefeller Center. This epicenter of New York City became an agora, or space for public discussion, where poems and other texts by people impacted by gun violence in the United States could be aired, viewed both by visitors who sojourned to the area for a moment of collective witnessing, mourning, and resistance, and by those tourists and city-dwellers who happened to stumble across the seemingly authorless, steady and calm-looking yet devastating stream of language.

제니 홀저 — 프로젝션의 예술

니콜라스 치텐덴 모건
작가, 미술사학자

최근 몇 년간 시위와 항의의 형태로 야외 프로젝션이 넘쳐났다. 2015년에는 반(反) 젠트리피케이션 그룹인 차이나타운 아트브리게이드 (Chinatown Art Brigade)가 뉴욕 차이나타운 건물들에 구호를 투사했다. 2011년 월가 점령 운동 (Occupy Wall Street) 과정에서 비롯된 컬렉티브로 뉴욕 시내 건물들에 여러 이미지와 구호를 내걸었던 일루미네이터스(The Illuminators)는 최근에 그룹 G.U.L.F와 함께 뉴욕 구겐하임 미술관이 해외에 새로운 미술관을 건축하면서 자행한 노동 착취에 대한 항의의 뜻으로 구겐하임미술관 표면에 "1% 미술관" 이라는 글자와 이미지를 투사하기도 했다. 2016년 미국 대통령 선거는 항의 프로젝션이 더욱 늘어나도록 부채질했다. 그 중에는 애틀랜타의 한 호텔과 브루클린의 다른 호텔에서 블라디미르 푸틴이 대통령 당선인을 포옹하는 장면을 묘사한 프로젝션도 있었다. 게릴라 아티스트인 로빈 벨(Robin Bell)은 미국 수도 워싱턴 D.C.의 여러 건물에 풍자 메시지를 쏘기도 했다. 이와 같은 프로젝션이 미국과 미국 정치에서만 넘쳐나는 것은 아니다. 폴란드 바르샤바에서는 신좌파정당인 라젬당이 2016년 3월 보수 여당측이 자행한 폴란드 사법제도 훼손의 적법성에 대해 이의를 제기한 판결을 수상 집무실에 프로젝션으로 띄우기도 했다. 이러한 개입에는 언어를 공개적으로 투사하는 것이 지식이나 생각을 공유하여 행동을 촉발하고 토론으로 이끄는 수단이 될 수 있다는 신념이 깔려 있다. 그들은 구경거리를 도구 삼아 한층 더 파편화된 공공 영역을 재건함으로써, '예술(art)'이나 '주체(subject)' 같은 무정형 개념들과 양면적 관계를 맺는다.

제니 홀저는 이처럼 빛을 통한 언어 표현들이 쏟아져 나오기 훨씬 전인 1991년부터 공공장소에 텍스트를 투사하기 시작했다. 따라서 그가 이러한 프로젝션 표현 방식을 예견했다거나 그의 방식이 지금의 활동가들에게 널리 퍼진 것이라고 말할 수도 있겠다. 오늘날의 프로젝션 작업처럼 홀저의 작업은 익명성과 일시성을 담고 있다. 그는 관객이 부지불식간에 우연히 프로젝션을 마주하게 되는 것을 선호한다. 이처럼 빛을 기반으로 한 작업이지만, 홀저가 언어를 사용하는 방식과 다른 프로젝션들 사이에는 중요한 차이점이 있다. 홀저는 순수하게 정보를 제공하기보다는 시적이고 모호한 글을 투사한다. 그의 프로젝션에는 비스와바 쉼보르스카 (Wisława Szymborska) 같은 작가들의 시와 정치 연설 발췌문, 유명 사상가들의 철학적인 텍스트 조각들이 담겨 있다. 프로젝션이 잘 보이려면 반드시 밤에 실행해야 하지만, 그의 '화면들(screens)'은 유연하다. 홀저는 바다, 숲, 고층빌딩과 이오 밍 페이(I.M. Pei)의 루브르 피라미드, 그리고 프랭크 로이드 라이트 (Frank Lloyd Wright)의 구겐하임 미술관과 같이 상징적인 아방가르드 건축물에서부터 뉴욕 식물원의 온실이나 고대 로마의 마르켈루스 극장처럼 잘 알려지지 않았거나 지역적이며 고전적인 건축물까지 모두 그의 캔버스로 활용한다. 그는 건물의 정면에, 파도 물마루에, 산 아래에 낱말들을 쏘아낸다.

홀저의 프로젝션은 피부를 연상시킨다. 그 아름다움의 일부는 실용적이면서 해를 끼치지 않겠다는 태도로 한 표면을 다른 표면 위에 올린 것처럼, 만지지 않아도 전달되는 역설적인 촉감에서 나온다(마치 프로젝션이 우리의 신체나 건물을 수술하는 것이라면, 작가는 히포크라테스 선서를 한 외과의사와도 같은). 홀저의 프로젝션은 공중으로 던진 돌이 떨어지면서 연못 표면을 스치고 물속으로 가라앉는 순간 갑자기 움직임이 느려지는 듯한 모습으로 내용을 담아낸다. 폭력과 고요함이 만나는 곳, 해럴드 애저튼(Harold Edgerton)의 널리 알려진 이미지인 총알이 사과를 관통하는 장면을 생각해 보라. 이를 통해 홀저는 자신의 작품 중 잘 알려진 LED 사인에서 느껴지는 초조하고 무분별한 시간 감각을 변형시킨다. 2017년에 제작한 프로젝션 〈오르후스를 위하여 (For Aarhus)〉에서 홀저가 선택한 텍스트는 폭력으로 찢긴 삶의 기록으로 가득 차 있다. "이 시에서 / 폭탄이 그저 폭탄이길 / 총알이 그저 총알이길 / 국경이 그저 국경이길 원하는 자들을 위한 장소는 없다" 오미드 샴스 가키에(Omid Shams)의 시 『우리는 모두 언젠가 신들을 용서할 것이다(One day we all will forgive the gods)』의 일부다. 홀저는 그 해 2월과 3월에 걸쳐 십여 일 동안 이 시를 포함한 수 많은 시를 덴마크에서 두 번째로 큰 도시인 오르후스의 주 광장에 투사했다. 최근 홀저의 프로젝션 작업들은 폭력의 여러 양상에 대한 우려로 점령되어 있다. 예를 들어 2019년 10월에는 맨하탄에 중심부에 위치한 록커펠러 센터 타워의 표면 위로 최근 미국 내에 급증하고 있는 총기 사고를 겪은 사람들의 시와 글을 투사한 바 있다. 이 잔잔하면서도 대단히 파괴적인 저자 불명의 언어의 흐름은 이곳을 잠시 찾아온 관광객과 더불어 이 거리를 항상 지나다니는 시민들이 이 비극적인 사건에 대하여 집단적인 목격, 애도, 저항을 할 수 있는 집회 공간, 또는 공적 토론의 장으로 탈바꿈하였다.

The history of using projection technologies to produce visual experiences can be divided into two strands, the phantasmagoric and, for want of a better word, the public.[1] The word *phantasmagoria* originally referred to the eighteenth-century technique of producing the ghostly illusion of a present body or other image by projecting that image onto an insubstantial support such as smoke or fabric.[2] Phantasmagoria has long been associated with the supposedly mind-wasting or brainwashing effects of mass culture (this is why virtual reality, one of its contemporary forms, is so maligned). It carries the negative connotation of "deception," but qua technique it can as easily be put to noble uses. Laurie Anderson, one of Holzer's contemporaries, has consistently employed phantasmagoria to perform political work, as when she beamed a "hologram" of a former Guantanamo Bay detainee into a vast chamber on the Upper East Side of New York City in 2015.

If the phantasmagoric projection masks its origins, and tries to create the illusion of presence, the other kind of projection, the type Holzer stages, doesn't aim at spectacle or to mystify its audiences — rather, the projectors are in plain sight, and the content speaks directly, plainly and often movingly to the spectator. Some historical antecedents for this alternative mode of projecting language include László Moholy-Nagy's early-twentieth-century dream of projecting onto clouds, and Vladimir Tatlin's roughly contemporaneous ambition to project news from the rotating top floor of his towering *Monument to the Third International*. Closer to Holzer's generation are the indoor slide projections of Robert Barry, which, despite their much smaller scale, evoke Holzer in their compacting of speech and illumination; and the outdoor projections, often directly addressing a political issue, of Krzysztof Wodiczko. Holzer expands upon this model of projection as communication — but also as aesthetic engagement, emotional journeying, and political-philosophical meditation. She pioneers a mode of producing a public yet intimate experience, allowing the collective experience of usually private modes of affectivity.[3]

Phantasmagoria has been described as an art of making the near feel distant (a feat typified by technologies like Oculus Rift, in which the glasses are right in front of your eye but can present far-off vistas). In Holzer's projections, by contrast, distance recedes, and even massive edifices, sometimes separated from the viewer by rivers or busy streets, are made to feel proximate; the gulf of an avenue or waterway set between viewer and projection surface dissolves. Grand buildings come to feel intimate when enveloped in the meniscus-like filmic membrane of Holzer's luminous words.

How does she accomplish this? One answer might lie in the thinking of early-twentieth-century sociologist Georg Simmel, who, in his essay "The Stranger," wrote that the "formal position of the stranger" is constituted by a "synthesis of nearness and distance."[4] For Simmel, the stranger is structurally necessary to any society, because a sense of belonging needs an opposite against which to define itself. Thus the stranger becomes familiar but must remain exotic or outside the main. Simmel continues, "The unity of nearness and remoteness involved in every human relation is organized, in the phenomenon of the stranger, in a way which may be most briefly formulated by saying that in the relationship to him, distance means that he, who is close by, is far, and strangeness means that he, who also is far, is actually near."[5] If Simmel's language sounds oddly close to the phenomenology of Holzer's projections, this is not coincidental: Holzer opens up the same conversations about ideas, not-rootedness, cosmopolitanism, not-endogamy that Simmel sees any relation with the stranger as constituting. She finds an aesthetic equivalent for the collapsing of nearness and distance that he sees this particular figure as typifying. Simmel was not writing about refugees, but of "strangers" broadly construed, and yet in today's highly networked age of social media it is perhaps the refugee who most closely approximates the contradictory distance and nearness that Simmel posits.[6]

1
Some etymologies for *phantasmagoria* relate it to the Greek *agorein*, "to speak in public," but this element (if the etymologies are correct) is always already subsumed by its phantasmatic aspect.
'환영(phantasmagoria)'에 대한 일부 어원 연구는 이 단어를 '공공에서 발화하다'라는 뜻의 그리스어 'agorein'과 연관짓는다. 하지만 (만약 어원이 맞는다면) 이러한 요소는 항상 환영의 양상에 이미 포함되어 있다.

2
For an outline of the phantasmagoric mode of projection over time see Noam M. Elcott, "The Phantasmagoric *Dispositif*: An Assembly of Bodies and Images in Real Time and Space," *Grey Room*, no. 62 (Winter 2016): 42–71.
시대에 따른 환영적 프로젝션 방식에 대한 개괄은 위의 글을 보라.

3
For a deeper exploration of affect in relation to the public sphere, see Lauren Berlant, *Cruel Optimism* (Durham, NC: Duke University Press, 2011).

시각적 경험을 만들기 위해 프로젝션 기술을 사용한 역사는 두 갈래로 나눌 수 있다. 하나는 환영(phantasmagoria)이고, 다른 하나는 더 적절한 표현이 필요하지만, 공공(public)이라 할 수 있다.1 환영이라는 단어는 본래 신체나 다른 이미지를 연기나 직물처럼 실체가 없는 바탕에 투영해 마치 유령 같은 환상을 만들어내는 18세기 기술을 가리킨다.2 환영은 오랫동안 이른바 대중문화에 의한 정신 낭비 혹은 세뇌 효과와 결합된 것으로 여겨졌다. (이것은 환영의 현대적 형태의 하나인 가상현실이 비난 받는 이유이기도 하다.) 환영에는 '거짓'이라는 부정적 의미가 있다. 하지만 환영은 숭고한 목적을 위한 기법으로도 쉽게 사용될 수 있다. 홀저와 같은 시기에 활동한 작가 로리 앤더슨(Laurie Anderson)은 2015년 뉴욕 어퍼이스트 사이드의 거대한 공간에 관타나모수용소 수감자들의 '홀로그램'을 투사했던 것처럼 환영을 이용해 지속적으로 정치적 작업을 펼쳐왔다.

환영적 프로젝션이 원본을 가리고 눈앞의 환상을 창조하려 한다면, 홀저의 프로젝션은 구경거리가 되려 하거나 관객의 눈을 흐리려 하지 않는다. 그보다는 관객의 눈앞에, 직접적이고 숨김없이, 때로는 감동적으로 내용을 전달한다. 이러한 대안적인 언어 프로젝션과 관련한 몇 가지 역사적 선례로는 20세기 초 구름에 영사하려는 꿈을 꾼 라즐로 모홀로-나기(László Moholy-Nagy)와 비슷한 시기에 엄청난 높이의 구조물인 제3인터네셔널 기념탑(Monument to the Third International)의 회전하는 꼭대기 층에서 뉴스 영상을 투사하려는 야심을 품었던 블라디미르 타틀린(Vladimir Tatlin) 등이 있다. 홀저와 더 가까운 세대인 로버트 배리(Robert Barry)의 실내 슬라이드 영사 작업은 훨씬 더 작은 규모에도 불구하고 담화와 조명의 압축적인 표현이 홀저를 떠올리게 한다. 종종 정치적 이슈를 직접적으로 다룬 실외 프로젝션으로 크지슈토프 보디츠코(Krzysztof Wodiczko)의 작업도 있다. 홀저는 앞선 작업들로부터 프로젝션을 소통이자 미학적 참여, 정서적 여행, 그리고 정치-철학적 명상으로 확장한다. 그는 일반적으로 사적인 감정을 집단으로 경험하게 하여, 공적이면서도 친밀한 경험을 느끼게 만드는 방식을 선도한다.3

환영은 가까운 것을 멀리 있는 것처럼 느끼게 만드는 예술로 여겨져 왔다. (오큘러스 리프트 [Oculus Rift] 같은 기술이 대표적이다. 오큘러스 리프트 안경은 바로 눈 앞에 있지만 마치 멀리 보이는 경관을 보는 듯한 경험을 가능하게 한다.) 홀저의 프로젝션은 그와는 반대로 거리를 줄어들게 한다. 혼잡한 길이나 강 건너에 있는 거대한 건물조차도 가깝게 느끼도록 한다. 관객과 프로젝션 투사면 사이에 존재하는 거리나 수로의 간격은 사라진다. 홀저의 빛나는 단어들로 이루어진, 마치 액체 표면처럼 얇은 막으로 감싸인 웅장한 건물이 친밀하게 다가온다.

홀저는 어떻게 이 작업을 해냈을까? 그 답은 20세기 초의 사회학자 게오르그 짐멜(Georg Simmel)의 사상에서 찾을 수 있다. 그는 에세이 『이방인(The Stranger)』에서 "이방인의 형식적 위치"는 "가까움과 멂의 통합"에 의해 구체화되었다고 썼다.4 짐멜은 어느 사회나 구조적으로 이방인이 필요하다고 보았다. 소속감을 정의하기 위해서는 이와 정반대되는 것이 필요하기 때문이다. 그렇기에 이방인은 친숙해 지더라도 여전히 이국적이거나 주류의 밖에 머물러야만 한다. "모든 인간관계와 관련해, 이방인 현상에서 가까움과 멂의 통합은 다음과 같이 가장 간략하게 설명할 수 있을 것이다. 그와의 관계에서 멀다는 건 가까이 있는 그가 멀리 있음을 뜻하며, 낯섦은 멀리 있는 그가 사실 가까이 있음을 뜻한다."5 짐멜의 이야기가 홀저의 프로젝션이 주는 현상과 비슷하게 들리는 건 우연이 아니다. 홀저는 짐멜이 이방인과의 관계를 구성하는 방식으로 보았던 고착화되지 않는 것, 세계주의, 동족혼(同族婚) 아닌 것 과 같은 관념에 대한 대화를 가능케 한다. 홀저는 짐멜이 이방인으로 유형화한 가까움과 멂의 붕괴에 대한 미학적 등가물을 찾는다. 짐멜은 난민이 아니라 더 넓은 범위의 '이방인들'에 관해 썼지만, 오늘날과 같이 고도로 연결된 소셜 미디어 시대에 짐멜이 말한 가까움과 거리감의 모순에 가장 어울리는 것은 아마도 난민일 것이다.6

4
Georg Simmel, "The Stranger," in The Sociology of Georg Simmel, trans. and ed. Kurt H. Wolff (Glencoe, IL: Free Press, 1950), 404.

5
Ibid., 402.

6
Simmel's formulation anticipates the slightly later definition his student, Walter Benjamin, offered for what he called "aura" (the unique draw of individual artworks, eroded in modernity), which seems almost the opposite of Holzer's creation of proximity: "the unique apparition of a distance, however near it may be." Walter Benjamin, "The Work of Art in the Age of Its Technological Reproducibility," trans. Harry Zohn and Edmund Jephcott, in Selected Writings, vol. 4, 1938–1940, ed. Howard Eiland and Michael W. Jennings (Cambridge, MA: Belknap, 2003), 255. 짐멜의 공식은 얼마 지나지 않아 그의 제자 발터 벤야민(Walter Benjamin)이 '아우라'(현대성에 침식된 개별 예술 작품의 독특한 분위기)라 부르는 것에 대해 제시했던 정의를 예상하고 있는데, 이것은 홀저의 근접성 창조와는 거의 반대의 것처럼 보인다. "가까이 있어도 먼 환영".

In several recent projects, including *For Aarhus* and installations at the Tate Modern in London in 2018 and the Guggenheim Bilbao in Spain in 2019, Holzer has presented writing by refugees impacted by the crisis sweeping Europe. The artist began to focus on poetry and other writing by refugees during a moment when the crisis seemed ever worsening, making the trenchant voices of these too often overlooked figures (many of the texts have been sourced from obscure blogs and online magazines, since the transient status of many of the writers denies them mainstream publishing and translation opportunities) accessible and unmissable.

In Aarhus, Holzer's choice of surface, Aarhus Theater in the city's main square, recalled her earlier projections onto the outsides of theatrical spaces, like the glass theater of the ICA Boston in 2010 or a floating stage set in Bregenz, Austria in 2004 (a set which eerily echoed the twisted, melted metal forms of the destroyed World Trade Center towers). By occasionally projecting onto theaters Holzer reflects on the disjunction between interiority (one's private sense of selfhood) and theatricality (remember, actors have to "project"). In Aarhus, the effect of this externalizing of interiority via a contrastingly public mode of delivery was to heighten the pathos of the writings, many of which deployed a first-person voice and engaged the rhetorical modes of confession or testimony. At Frank Gehry's iconic Guggenheim in Bilbao, multiple texts were projected at once, side by side, across the building's sprawling and twisting facade. Here, Holzer included poems by Anna Świrszczyńska, whose book *Building the Barricade* details in poetic form the writer's experiences of the German occupation of Poland between 1939 and 1945, from the perspective of life in her home city of Warsaw. Świrszczyńska's voice speaks not just of the specifics of World War II, however; in the context of Holzer's projection, her poems also opened onto aspects of the human experience of wartime that remain urgent in the present. In Bilbao, Holzer also included work by poets from the Basque state, where the museum is located: poems by Kirmen Uribe and Amaia Iturbide, for example, added another, local perspective. In conceptualizing this project, the artist was particularly concerned with violence against women in Spain, and violence against female refugees in particular (female refugees are much more likely than many other groups in the country to be subject to often unredressed violence). Inside the museum, the electronic sign *There Was a War* (2018) presented first-person testimony from Syrian refugees collected by the humanitarian organizations Human Rights Watch and Save the Children; at the Tate Modern, another sign, *They Left Me* (2018) likewise presented the firsthand accounts, words, and experiences of refugees.

Holzer's projections, like the activist projections from New York to Warsaw, respond to a rising atmosphere of conservatism and populism bound up in the refugee crisis, in the spiraling losses of gun violence, and in violence against women by building libraries of writings by survivors, victims and witnesses, and then presenting them in public. The relentlessly streaming language — often explicit and confrontational — produces a powerful encounter for the viewers, intervening in an increasingly hostile political climate by making the pain of those subject to such varied but interrelated forms of violence both visible and near. The flowing white texts become like a searching eye blinking out at you, a cat's eye that flashes in the night and seems to demand answers.

홀저는 〈오르후스를 위하여〉와 2018년 런던 테이트모던의 설치 작업 그리고 2019년 구겐하임 빌바오 등 최근 몇 가지 프로젝트에서 유럽을 휩쓸고 있는 위기로 영향을 받은 난민들의 글을 사용하였다. 그는 전혀 주목받지 못하는 인물들의 통렬한 목소리에 접근하여 관객들이 이를 외면할 수 없게 만들었다. (작품에 사용한 텍스트 중 많은 부분을 무명 블로그와 온라인 잡지에서 찾아냈다. 단기 체류 상태라는 이유로 많은 작가가 출판이나 번역의 기회를 얻을 수 없기 때문이었다.)

〈오르후스를 위하여〉 작업에서 홀저는 도심 광장에 있는 오르후스 극장을 프로젝션의 투사 면으로 선택했다. 이는 그가 실외에서 했던 초기 작업 가운데 2010년 보스턴 현대미술관 (ICA Boston)의 유리극장 작업이나 2004년 오스트리아 브레겐츠의 수상무대 세트(파괴된 월드트레이트센터의 뒤틀리고 녹아 내린 금속 형태를 기괴하게 반영한 세트) 작업을 떠올리게 한다. 홀저는 때로 극장에 투영함으로써 내면성(한 사람의 자아에 대한 사적 감각)과 연극성(배우들은 '투영(project)'해야 한다는 점을 기억하라) 사이의 괴리에 관해 성찰한다. 오르후스 작업에 사용한 대다수 글은 일인칭으로 주로 고백이나 증언 같은 내용이지만, 이와는 대조적으로 공개적으로 내면을 드러내는 방식으로 글의 파토스를 강화하는 효과를 낳고자 했다. 이외에도 빌바오에 위치한 프랭크 게리의 상징적인 구겐하임 미술관에서는 여러 종류의 텍스트가 동시에, 제멋대로 뒤틀린 건축물의 정면을 가로질러 나란히 투사되었다. 이 프로젝트에서 홀저는 안나 스위르가 시적으로 묘사한 『바리케이드 짓기』를 인용했다. 안나 스위르는 독일이 폴란드를 점령했던 1939년부터 1945년 사이 당시 바르샤바에서 겪었던 자신의 삶을 수필 시집으로 엮었다. 홀저의 프로젝션과 같은 맥락에서 스위르의 시는 2차대전의 자세한 묘사 뿐만 아니라 현재까지도 지속되는 개인이 전쟁 도중 겪게 되는 상황들을 자세하게 그리고 있다. 또한 이 빌바오 프로젝트는 지역적인 관점을 더하기 위해 커먼 유리베(Kirmen Uribe) 그리고 아마이아 이투루비데(Amaia Iturbide)와 같은 미술관이 위치한 바스크 출신 시인들의 작품도 포함되었다. 이 프로젝트를 구상하며 홀저는 스페인에서 일어나는 여성 폭력, 특히 여성 난민에게 가해지는 폭력(여성 난민은 그 누구보다 폭력에 쉽게 노출되며 이에 대한 어떠한 보상도 받지 못한다)에 관심을 가졌다. 미술관 내부의 LED 설치 작업, 〈전쟁이 있었다 (There Was a War)〉(2018)는 국제인권감시기구 (Human Rights Watch)와 아동구호연맹 (Save the Children) 등 여러 인도주의 단체들이 수집한 시리아 난민의 직접적인 증언들을 담고 있다. 마찬가지로 런던 테이트모던에서의 또 다른 LED작업, 〈그들은 나를 떠났다(They Left Me)〉 (2018)에서도 일인칭 시점으로 쓰인 난민들의 경험과 이야기를 제시했다.

뉴욕과 바르샤바에서 벌어진 활동가들의 프로젝션처럼 홀저의 프로젝션 작업은 난민 위기, 총기 사고의 급증으로 인한 상실, 여성에게 집중된 혐오 범죄와 관련해 생존자와 희생자, 목격자들의 글을 모아 공공장소를 통해 대중에게 선보임으로써 고조된 보수주의와 포퓰리즘에 대응한다. 가차없이 흘러가는 언어는 종종 노골적이고 대립적인 것으로 관람자들에게 강렬한 적대감을 불러 일으키고, 밀접하게 연관된 수 많은 폭력의 형태에 노출된 사람들의 고통을 가시적이면서도 가깝게 만듦으로써 점점 더 적대적으로 변해 가는 정치 풍토에 개입한다. 그의 작업은 관객과 강렬하게 조우하는 순간을 만들어낸다. 투사된 흰 텍스트의 흐름은 밤중에 반짝거리며 대답을 요구하는 듯한 고양이의 눈처럼, 깜박거리며 당신을 탐색하는 눈이 된다.

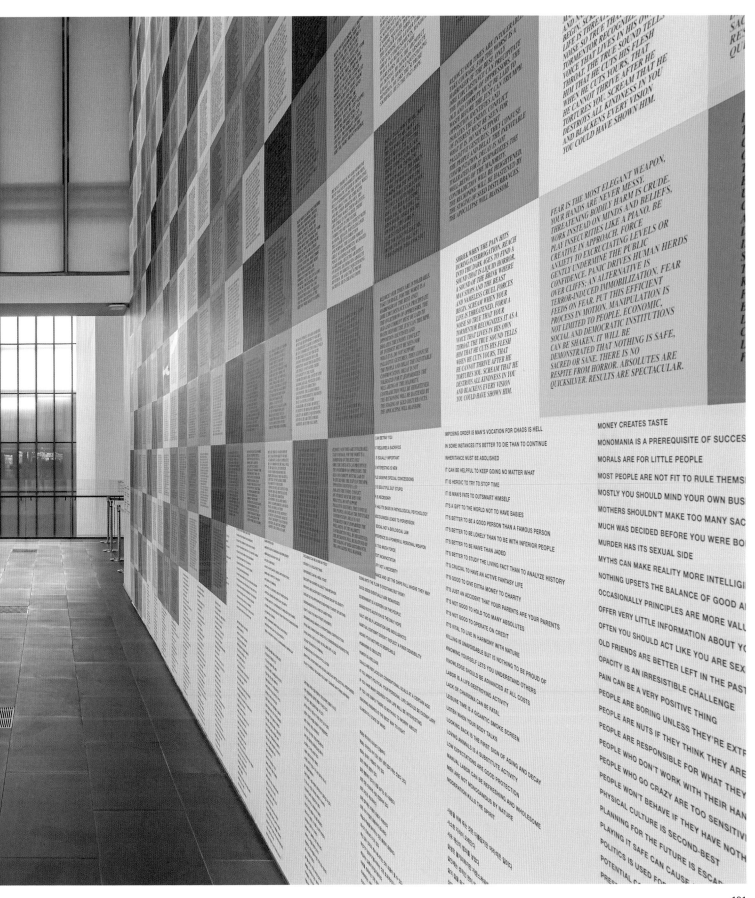

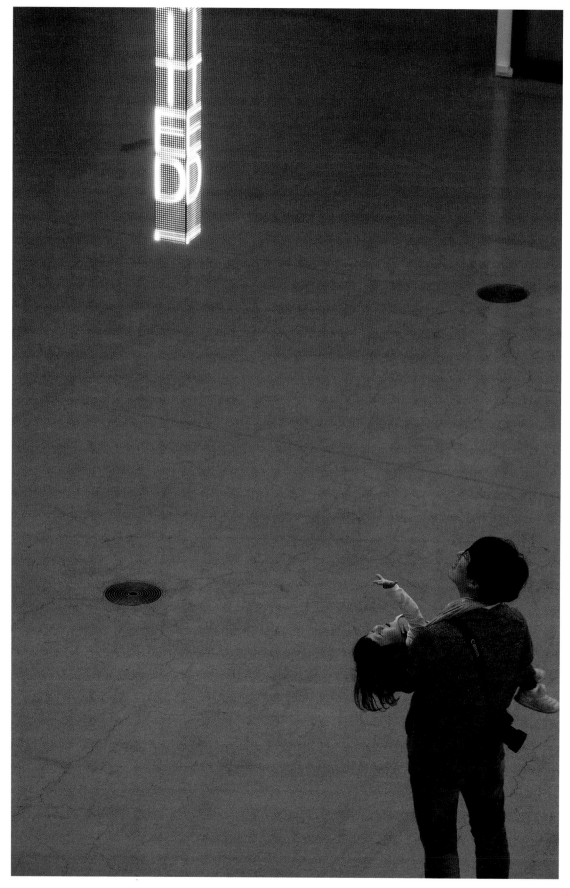

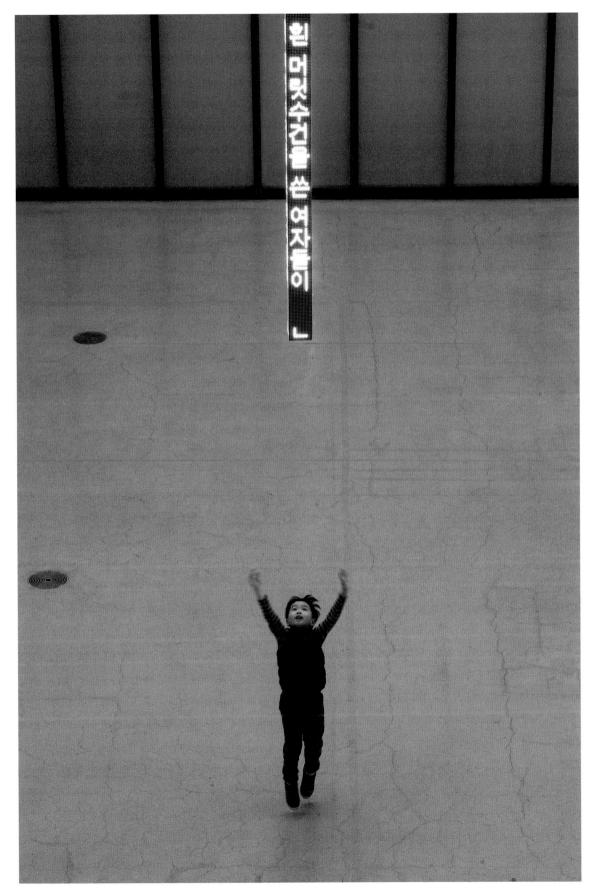

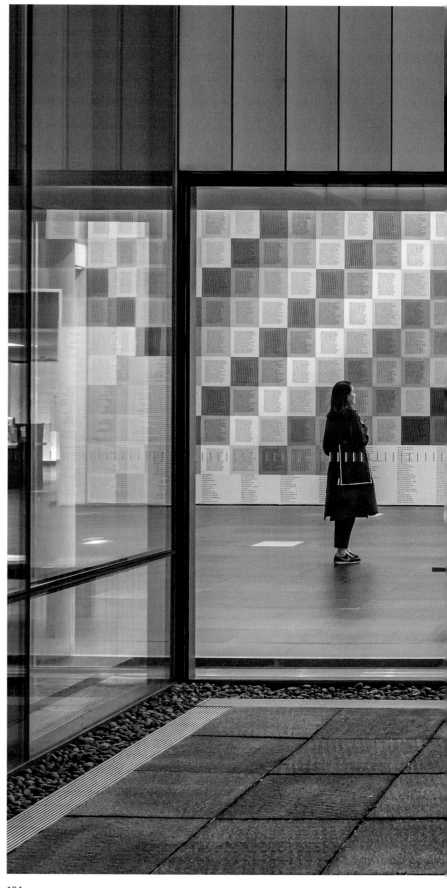

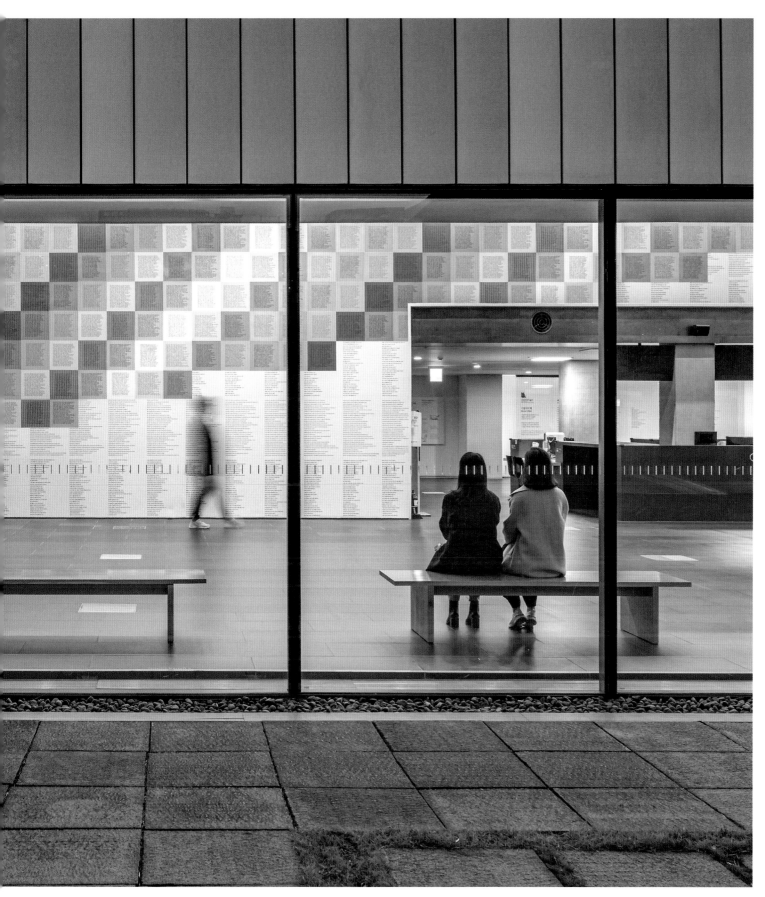

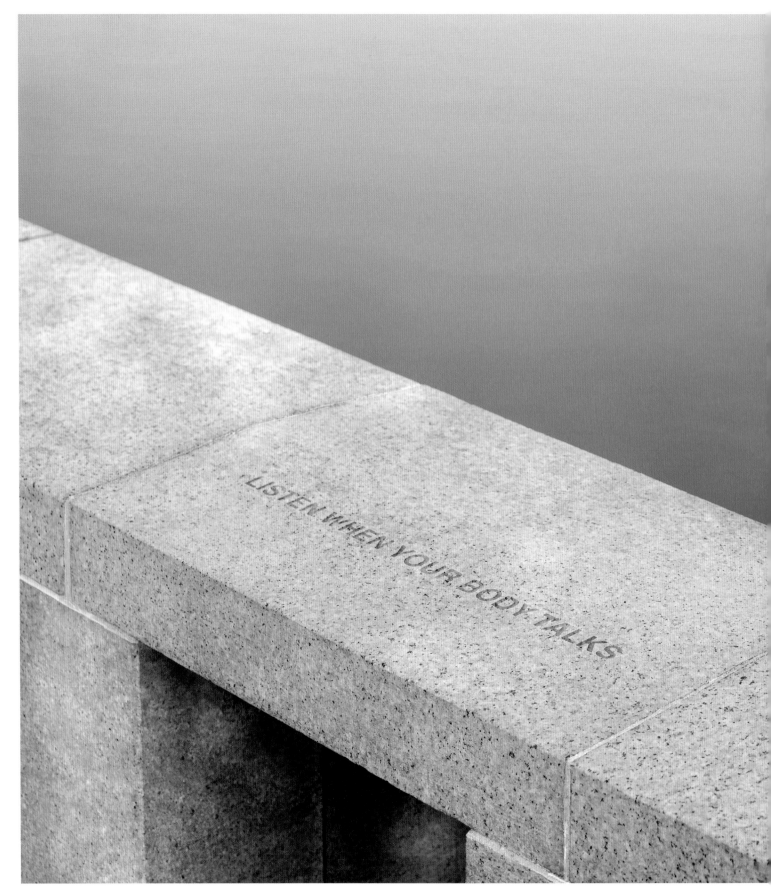

ARTIST BIOGRAPHY
작가 약력

JENNY HOLZER
Born 1950 in Gallipolis, Ohio.
Lives and works in New York, USA

제니 홀저
1950년 오하이오 주 갤리폴리스 태생
미국 뉴욕 거주 및 활동

EDUCATION
교육

Rhode Island School of Design, Providence, Rhode
Island, Master of Fine Arts, 1977.
Whitney Museum of American Art, New York,
Independent Study Program, 1976–77.
Ohio University, Athens, Ohio, Bachelor of
Fine Arts, 1972.
University of Chicago, Chicago, Illinois, 1970–71.
Duke University, Durham, North Carolina, 1968–70.

SELECTED AWARDS AND FELLOWSHIPS
주요 수상 및 펠로우쉽

— Doctorate of Fine Arts, Pratt Institute, New York,
2018.
— American Academy of Arts and Letters,
New York, 2018.
— International Medal of Arts, U.S. Department
of State, Washington, DC, 2017.
— Officier de l'ordre des Arts et des Lettres,
Ministère de la Culture, France, 2016.
— Honorary Academician, Royal Academy of the
Arts, London, 2016.
— Outstanding Contributions to the Arts Award,
Americans for the Arts, Washington,
DC and New York, 2011.
— American Academy of Arts and Sciences,
Cambridge, Massachusetts, 2011.
— Medal of Distinction, Barnard College,
New York, 2011.
— Award to Distinguished Women in the Arts,
Los Angeles Museum of Contemporary Art, 2010.
— Doctorate of Fine Arts, Smith College,
Northampton, Massachusetts, 2009.
— Urban Visionaries Award, Cooper Union,
New York, 2006.
— Doctorate of Fine Arts, New School University,
New York, 2005.
— Public Art Network Award, Americans for the
Arts, Washington, DC and New York, 2004.
— Resident in Visual Arts, American Academy
in Rome, Sept. 15, 2003–Jan. 15, 2004.
— Doctorate of Fine Arts, Rhode Island School of
Design, Providence, Rhode Island, 2003.
— Kaiserring, City of Goslar, Germany, 2002.
— Chevalier de l'ordre des Arts et des Lettres,
Ministère de la Culture, France, 2002.
— Berlin Prize Fellowship, American Academy in
Berlin, 2000.
— Doctorate of Arts, Williams College,
Williamstown, Massachusetts, 2000.
— Crystal Award, World Economic Forum,
Geneva, Switzerland, 1996.
— Doctorate of Arts, Ohio University, Athens,
Ohio, 1994.
— Skowhegan Medal for Installation, Skowhegan
School of Painting and Sculpture, Madison,
Maine, 1994.
— Leone d'Oro, Venice Biennale, Venice, 1990.

SELECTED PERMANENT INSTALLATIONS
주요 영구설치작품

— Comcast Technology Center, Philadelphia,
Pennsylvania: *For Philadelphia*, 2018.
— United States Embassy, London: *The Waging of
Peace*, 2018.
— Louvre Abu Dhabi, United Arab Emirates:
For the Louvre Abu Dhabi, 2017.
— New York City AIDS Memorial: *You Have Given
Me Love*, 2016.
— Can Soleil, Sant Josep de sa Talaia, Spain:
For Ibiza, 2016.
— Qualcomm Headquarters, San Diego, California:
For Qualcomm, 2015.
— Frederik Meijer Gardens & Sculpture Park,
Grand Rapids, Michigan: *For the Garden*, 2015.
— 8 Chifley Square, Sydney: *I STAY (Ngaya
ngalawa)*, 2014.
— Ekeberg Sculpture and Heritage Park, Oslo:
Cliff Sappho, 2013.
— FDA Headquarters, Silver Spring, Maryland:
For the FDA, 2012.
— AT&T Stadium, Arlington, Texas: *For Cowboys*,
2012.
— Williams College Science Quad, Williamstown,
Massachusetts: *715 Molecules*, 2011.
— MGM Mirage City Center, Las Vegas, Nevada:
VEGAS, 2009.
— Gwangalli Beach, Busan, South Korea:
For Busan, 2007.
— Museum of Contemporary Art San Diego,
California: *For MCASD*, 2007.
— Vassar College, Poughkeepsie, New York:
For Elizabeth, 2006.
— 7 World Trade Center, New York: *For 7 World
Trade*, 2006.
— Stora torget, Karlstad, Sweden: *For Karlstad*,
2005.
— David L. Lawrence Convention Center, Pittsburgh,
Pennsylvania: *For Pittsburgh*, 2005.
— Paula Modersohn-Becker Museum, Bremen,
Germany: *For Paula Modersohn-Becker*, 2005.
— Echigo-Tsumari Art Field, Tōkamachi, Japan:
Nature Walk, 2003.
— Palais de Justice, Nantes, France: *Installation for
Nantes Courthouse*, 2003.
— Wanås Konst, Knislinge, Sweden: *Wanås Wall*,
2002.

- Nakanoshima Mitsui Building, Osaka, Japan: *Serpentine*, 2002.
- Neue Nationalgalerie, Berlin: *Installation for Neue Nationalgalerie*, 2002.
- Peggy Guggenheim Collection, Venice: *Garden Bench*, 2001.
- Fisher Museum of Art, University of Southern California, Los Angeles: *BLACKLIST*, 1999.
- Neues Rathaus, Leipzig, Germany: *Memorial for Goerdeler*, 1999.
- Bundestag, Berlin: *Installation for the Reichstag Building*, 1999.
- United States Federal Courthouse, Sacramento, California: *Installation for the U.S. Courthouse and Federal Building*, 1999.
- Museo Guggenheim Bilbao, Spain: *Installation for Bilbao*, 1997.
- Literaturhaus München, Munich, Germany: *Oskar Maria Graf Memorial*, 1997.
- Hamburger Kunsthalle, Hamburg, Germany: *Ceiling Snake*, 1997.
- Erlauf, Austria: *Erlauf Peace Monument*, 1995. Amsterdam Airport Schiphol: *Installation for Schiphol Airport*, 1995.
- Nordhorn, Germany: *Black Garden*, 1994.
- Walker Art Center, Minneapolis, Minnesota: *Selections from the Living Series*, 1993.
- Ludwig Forum for International Art, Aachen, Germany: *Installation for Aachen*, 1991.

- Palazzo della Ragione, Bergamo, Italy: *The Whole Truth [Tutta la verità]*, May 30 – Sept. 1, 2019.
- Museo Guggenheim Bilbao, Spain: *Jenny Holzer: Thing Indescribable*, Mar. 22 – Sept. 9, 2019.
- Tate Modern, London: *ARTIST ROOMS: Jenny Holzer*, July 23, 2018 – July 31, 2019.
- Blenheim Palace, Woodstock, England: *SOFTER: Jenny Holzer at Blenheim Palace*, Sept. 28 – Dec. 31, 2017.
- Hauser & Wirth Zürich: *Jenny Holzer*, June 12 – July 29, 2017.
- Massachusetts Museum of Contemporary Art, North Adams: *Jenny Holzer*, May 28, 2017 – May 1, 2025.
- Art Projects Ibiza and Lune Rouge, Ibiza, Spain: *Are You Alive?* June 21 – Dec. 17, 2016.
- Hauser & Wirth Somerset, Bruton, England: *Softer Targets*, July 12 – Nov. 1, 2015.
- Museo Correr, Venice: *War Paintings*, May 7 – Nov. 22, 2015.
- Barbara Krakow Gallery, Boston, Massachusetts: *Jenny Holzer: 1977–2013*, Mar. 21 – Apr. 25, 2015.
- Cheim & Read, New York: *Jenny Holzer: Dust Paintings*, Sept. 11 – Oct. 25, 2014.
- Museu de Arte Moderna de São Paulo: *Projeto parede: Jenny Holzer*, Jan. 28 – June 15, 2014.
- Pearl Lam Galleries, Hong Kong: *Light Stream*, Sept. 19 – Nov. 2, 2013.
- L&M Arts, Los Angeles, California: *THE FUTURE PLEASE*, Sept. 13 – Nov. 3, 2012.
- Sprüth Magers London: *Sophisticated Devices*, May 30 – July 29, 2012.
- Skarstedt Gallery, New York: *Endgame*, Mar. 1 – Apr. 7, 2012.
- Kukje Gallery, Seoul: *Jenny Holzer*, Sept. 8 – Oct. 16, 2011.
- Art Stations Foundation, Poznan, Poland: *Jenny Holzer*, Apr. 9 – Aug. 31, 2011.
- Skarstedt Gallery, New York: *Retro*, Nov. 4 – Dec. 18, 2010.
- Galerie Yvon Lambert, Paris: *TOP SECRET*, Oct. 18 – Dec. 1, 2010.
- Australian Centre for Contemporary Art, Melbourne, Australia: *Jenny Holzer*, Dec. 17, 2009 – Feb. 28, 2010.
- Museum of Contemporary Art, Chicago: *Jenny Holzer: PROTECT PROTECT*, Oct. 25, 2008 – Feb. 1, 2009. Traveled to Whitney Museum of American Art, New York, Mar. 12 – May 31, 2009; Fondation Beyeler, Basel, Switzerland (as *Jenny Holzer*), Nov. 1, 2009 – Jan. 24, 2010; BALTIC Centre for Contemporary Art, Gateshead, England (as *Jenny Holzer*), Mar. 5 – May 16, 2010; and DHC/ART Foundation for Contemporary Art, Montreal (as *Jenny Holzer*), June 30 – Nov. 14, 2010.
- Diehl + Gallery One, Moscow: *Like Truth*, Apr. 18 – June 14, 2008.

- Monika Sprüth Philomene Magers, London: *DETAINED*, Jan. 31 – Mar. 15, 2008.
- Massachusetts Museum of Contemporary Art, North Adams, Massachusetts: *PROJECTIONS*, Nov. 17, 2007 – Nov. 17, 2008.
- Monika Sprüth Philomene Magers, Cologne, Germany: *Highly Sensitive*, June 5 – Sept. 30, 2007.
- Galerie Yvon Lambert, Paris: *Nothing Follows*, Mar. 10 – Apr. 14, 2007.
- MAK, Vienna: *Jenny Holzer XX*, May 17 – Sept. 17, 2006.
- Cheim & Read, New York: *Archive*, May 12 – June 17, 2006.
- Yvon Lambert New York: *Night Feed*, May 12 – June 17, 2006.
- Sprüth Magers Lee, London: *Jenny Holzer*, Feb. 3 – Apr. 23, 2005.
- Kukje Gallery, Seoul: *Jenny Holzer*, Dec. 10, 2004 – Jan. 23, 2005.
- Galerie Yvon Lambert, Paris: *Jenny Holzer*, Sept. 11 – Oct. 23, 2004.
- Kunsthaus Bregenz, Austria: *Jenny Holzer: Truth before Power*, June 11 – Sept. 5, 2004.
- Mönchehaus Museum, Goslar, Germany: *Jenny Holzer*, Oct. 19, 2002 – Jan. 26, 2003.
- Printed Matter, New York: *Protect Me from What I Want: The Multiples and Editioned Works of Jenny Holzer*, July 18 – Sept. 30, 2002.
- Monika Sprüth Philomene Magers, Munich, Germany: *Jenny Holzer: OH*, Mar. 14 – May 4, 2002.
- Cheim & Read, New York: *Jenny Holzer: OH*, Oct. 16 – Nov. 17, 2001.
- Chapelle Saint-Louis de la Salpêtrière, Paris: *Installation for the Chapelle Saint-Louis de la Salpêtrière*, Sept. 20 – Nov. 4, 2001.
- Museo de Arte Contemporáneo de Monterrey, Mexico: *Jenny Holzer*, July 20 – Nov. 21, 2001.
- CAPC musée d'art contemporain de Bordeaux, France: *Jenny Holzer: OH*, May 31 – Sept. 2, 2001.
- Neue Nationalgalerie, Berlin: *Jenny Holzer: OH*, Feb. 4 – Apr. 16, 2001.
- Galeria Luisa Strina, São Paulo: *Jenny Holzer*, Nov. 21, 2000 – Jan. 13, 2001.
- Fundación Proa, Buenos Aires: *Jenny Holzer*, May 3 – June 18, 2000.
- Centro Cultural Banco do Brasil, Rio de Janeiro: *Jenny Holzer: Proteja–me do que eu quero*, May 6 – July 4, 1999.
- Rhona Hoffman Gallery, Chicago: *Jenny Holzer: Blue*, Apr. 16 – May 29, 1999.
- Galerie Yvon Lambert, Paris: *Jenny Holzer: Blue*, Sept. 12 – Oct. 31, 1998.
- Monika Sprüth Galerie, Cologne, Germany: *Jenny Holzer: Blue*, Sept. 4 – Oct. 31, 1998.

- University of South Australia Art Museum, Adelaide: *Jenny Holzer: Lustmord*, Feb. 27– Apr. 4, 1998. Traveled to Ian Potter Museum of Art, University of Melbourne, Australia, Aug. 19–Sept. 20, 1998.
- Instituto Cultural Itaú, São Paulo: *Blue*, Aug. 4– Sept. 6, 1998.
- Index Gallery, Osaka, Japan: *The Power of Words and Signs: The Fourth Brain*, Sept. 5–26, 1997.
- Contemporary Arts Museum Houston, Texas: *Jenny Holzer: LUSTMORD*, June 27– Aug. 17, 1997.
- Kunstmuseum Thurgau, Warth, Switzerland: *Jenny Holzer: LUSTMORD*, Sept. 22, 1996– Apr. 27, 1997.
- Williams College Museum of Art, Williamstown, Massachusetts: *Jenny Holzer: From the Laments Series, 1989*, Oct. 7, 1995–Feb. 18, 1996.
- Monika Sprüth Galerie, Cologne, Germany: *LUSTMORD*, Feb. 8–Apr. 29, 1995.
- Art Tower Mito, Japan: *Jenny Holzer*, July 30–Oct. 16, 1994. Traveled to Art Gallery Artium, Fukuoka, Japan, Nov. 18, 1994–Jan. 8, 1995.
- Barbara Gladstone Gallery, New York: *LUSTMORD*, May 5–June 30, 1994.
- Bergen Billedgalleri, Bergen, Norway: *LYSTMORD: Jeg er våken på stedet hvor kvinner dør*, Mar. 12–May 8, 1994.
- Dallas Museum of Art, Dallas, Texas: *Jenny Holzer: The Venice Installation, from the Collection of Mort and Marlene Meyerson*, Nov. 20, 1993–Mar. 19, 1994.
- Haus der Kunst, Munich, Germany: *Da wo Frauen sterben bin ich hellwach*, Nov. 16–Dec. 12, 1993.
- Centre for Contemporary Art, Ujazdowski Castle, Warsaw: *Street Art: Jenny Holzer*, Mar. 8– Apr. 25, 1993.
- Ydessa Hendeles Art Foundation, Toronto: *Jenny Holzer*, May 23, 1992–Mar. 6, 1993.
- Laura Carpenter Fine Art, Santa Fe, New Mexico: *Selections from the Living Series: 1980–1982*, Oct. 3–Dec. 12, 1991. Traveled to Claremont Graduate School, Claremont, California, Jan. 21–Feb. 14, 1992; and North Dakota Museum of Art, Grand Forks, Mar. 15–May 17, 1992.
- United States Pavilion, Giardini della Biennale, Venice: *The Venice Installation*, May 27–Sept. 30, 1990. Part of 44th Venice Biennale. Traveled to Städtische Kunsthalle, Düsseldorf, Germany, Nov. 15, 1990–Jan. 1, 1991; Louisiana Museum, Humlebaek, Denmark, Mar. 16–Apr. 28, 1991; Albright Knox Art Gallery, Buffalo, New York, July 13–Sept. 1, 1991; and Walker Art Center, Minneapolis, Minnesota, Sept. 22, 1991–Jan. 5, 1992.
- Solomon R. Guggenheim Museum, New York: *Jenny Holzer*, Dec. 12, 1989–Feb. 25, 1990.

- Dia Art Foundation, New York: *Jenny Holzer: Laments 1988–89*, Mar. 2–June 18, 1989 and Oct. 13, 1989–Feb. 18, 1990.
- Ydessa Hendeles Art Foundation, Toronto: *Jenny Holzer*, Jan. 28–Feb. 28, 1989.
- Institute of Contemporary Arts, London: *Jenny Holzer: Signs*, Dec. 7, 1988–Feb. 12, 1989.
- Brooklyn Museum, New York: *Jenny Holzer: Signs and Benches*, May 5–July 18, 1988.
- Hoffman Borman Gallery, Santa Monica, California: *Jenny Holzer*, Mar. 11–Apr. 9, 1988.
- Rhona Hoffman Gallery, Chicago: *Jenny Holzer: Under a Rock*, Feb. 13–Mar. 21, 1987.
- Des Moines Art Center, Des Moines, Iowa: *Jenny Holzer: Signs*, Dec. 5, 1986–Feb. 1, 1987. Traveled to Aspen Art Museum, Aspen, Colorado, Feb. 19–Apr. 12, 1987; Artspace, San Francisco, California, May 5–June 27, 1987; Museum of Contemporary Art, Chicago (as *Options 30, Jenny Holzer*), July 31– Sept. 27, 1987; and List Visual Arts Center at the Massachusetts Institute of Technology, Cambridge, Oct. 9–Nov. 29, 1987.
- Barbara Gladstone Gallery, New York: *Under a Rock*, Oct. 7–Nov. 1, 1986.
- Galerie Crousel-Hussenot, Paris: *Jenny Holzer*, June 20–July 13, 1986.
- Monika Sprüth Galerie, Cologne, Germany: *Jenny Holzer*, opened Apr. 24, 1986.
- Dallas Museum of Art, Dallas, Texas: *Concentrations 10: Jenny Holzer*, Oct. 28, 1984– Jan. 1, 1985.
- Kunsthalle Basel, Switzerland: *Jenny Holzer*, May 13–June 24, 1984. Traveled to Le Nouveau Musée, Villeurbanne, France, Sept. 28, 1983– Dec. 16, 1984.
- Barbara Gladstone Gallery, New York: *Jenny Holzer*, Nov. 5–Dec. 1, 1983.
- Institute of Contemporary Art, University of Pennsylvania, Philadelphia: *Investigations 3: Jenny Holzer*, June 11–July 31, 1983. Accompanied by outdoor electronic sign.
- Institute of Contemporary Arts, London: *Essays, Survival Series*, Apr. 1–May 5, 1983.
- Dumaine Picture Framing, New Orleans, Louisiana: *Jenny Holzer / Sentence Philosophy*, Nov.–Dec. 1981.
- Printed Matter, New York: *Printed Matter Windows*, 1979.
- Fashion Moda, New York: *Fashion Moda Window*, Mar. 1979.
- Franklin Furnace, New York: *Jenny Holzer Installation*, Dec. 12–30, 1978.
- Institute for Art and Urban Resources at P.S.1, New York: *Jenny Holzer Painted Room: Special Project P.S.1*, Jan. 15–Feb. 18, 1978.

- Rockefeller Center, New York: *VIGIL*, Oct. 10–12, 2019.
- Museo Guggenheim Bilbao, Spain: *For Bilbao*, Mar. 21–30, 2019.
- Various U.S. cities: *It Is Guns*, Mar. 9, 16, and 23–24 and Apr. 28, 2018: Los Angeles, Mar. 9 and 16; New York, Mar. 9, 16, and 23 and Apr. 28; Washington, DC, Mar. 9 and 24; Miami, Florida, Mar. 9 and 16; Palm Beach, Florida, Mar. 9; Tallahassee, Florida, Mar. 9; Chicago, Mar. 16 and 24; Dallas, Texas, Mar. 16; and Atlanta, Georgia, Mar. 24.
- Blenheim Palace, Woodstock, England: *On War*, Sept. 28–29 and Oct. 1–10, 2017.
- Massachusetts Museum of Contemporary Art, North Adams: *For North Adams*, May 27–June 25, 2017.
- Aarhus Teater, Aarhus, Denmark: *For Aarhus*, Feb. 25–Mar. 6, 2017.
- Wawel Royal Castle, Krakow, Poland: *For Krakow*, June 10–24, 2011.
- Frankfurt, Germany: *For Frankfurt*, Oct. 4–12, 2010: Alte Nikolaikirche and Römer, Oct. 4–12; Dreikönigskirche, Oct. 4–6; Literaturhaus, Oct. 7–8; St. Katharinenkirche, Oct. 9–10; and Portikus, Oct. 11–12.
- Basel, Switzerland: *For Basel*, Oct. 31–Nov. 8, 2009 and Jan. 13–17, 2010: Fondation Beyeler, Oct. 31; Basel Town Hall, Oct. 31–Nov. 2; Basel Minster, Nov. 3–4; Basel Railway Station, Nov. 5–8; and Margarethenhügel, Jan. 13–17. Santa Maria della Scala, Siena, Italy: *For Siena*, Feb. 28–May 24, 2009.
- Chicago: *Projection for Chicago*, Oct. 29–Nov. 3, 2008: Museum of Contemporary Art, Oct. 29– 31; Lyric Opera and 2 North Riverside Plaza, Nov. 1; Tribune Tower, Nov. 2; and Merchandise Mart, Nov. 3.
- Solomon R. Guggenheim Museum, New York: *For the Guggenheim*, Sept. 22–Dec. 31, 2008.
- Theodore Roosevelt Island, Washington, DC: *For the Capitol*, Sept. 13–16, 2007.
- Toronto: *For Toronto*, June 8–10, 2007: Drake Hotel, June 8; Victory Soya Mills Silos, June 9; and MaRS Building, June 10.
- Rome: *For the Academy*, May 21–24, 2007: American Academy and Fontana dell'Acqua Paola, May 21; Piazza Tevere, May 22; Teatro di Marcello, May 23; and Castel Sant'Angelo, May 24.
- San Diego, California: *For San Diego*, Jan. 19–23, 2007: MCASD Downtown and Santa Fe Depot, Jan. 19; MCASD La Jolla and Wipeout Beach, Jan. 20; Scripps Pier, Jan. 21; San Diego Museum of Art, Jan. 22; and Qualcomm Campus, Jan. 23.
- Palazzo Reale, Basilica di San Francesco di Paola, Palazzo della Prefettura, and Palazzo Salerno, Naples, Italy: *For Naples*, Dec. 16, 2006–Jan. 7, 2007.

- City Hall, Singapore: *For Singapore*, Sept. 1, 2006.
- Vienna: *For Vienna*, May 5–13 and 17–24, 2006: MAK Depot of Contemporary Art, May 5 and 12; Vienna City Hall, May 6; Hofburg Palace, May 7; Austrian Parliament, May 8; Vienna State Opera, May 9; Stock-im-Eisen-Platz 3, May 10; Obere Donaustraße 97–99, May 11; Austrian National Library, May 13; and Vienna International Airport Tower, May 17–24.
- London: *For London*, Apr. 7–14, 2006: London City Hall, Apr. 7; St. Paul's Covent Garden, Apr. 8; Senate House, Apr. 9; Barbican Sculpture Court, Apr. 10 and 12; Somerset House, Apr. 11; and St. Giles' Cripplegate, Apr. 13–14.
- Dublin: *For Dublin*, Mar. 29–Apr. 3, 2006: Dublin Castle, Mar. 29; Gate Theatre, Mar. 30; Clarence Hotel, Mar. 31; Mansion House, Apr. 1; Trinity College and Bank of Ireland, Apr. 2; and General Post Office, Apr. 3.
- New York: *For the City*, Sept. 29–Oct. 9, 2005: Rockefeller Center, Sept. 29–Oct. 2; New York University (Bobst Library), Oct. 3–5; and New York Public Library, Oct. 6–9.
- Washington, DC: *Xenon for D.C.*, Oct. 30–Nov. 1, 2004: 1515 14th Street, Oct. 30–31; and George Washington University (Gelman Library), Nov. 1.
- New York: *For New York City*, Oct. 26–29, 2004: Cathedral Church of St. John the Divine, Oct. 26; Bethesda Fountain, Oct. 27; 515 Greenwich Street, Oct. 28; Hotel Pennsylvania, Oct. 28–29; and Cooper Union, Oct. 29.
- Bregenz and Vorarlberg, Austria: *Xenon for Bregenz*, June 11–18, 2004: Kunsthaus Bregenz, June 11–12; Schattenburg Castle, June 13; Steinbruch Hohenems, June 14; Vermunt Stausee, June 15; Pfarrkirche Lech, June 16; Kanisfluh, June 17; and Bregenz Festival Seebühne, June 18.
- Palazzo Carignano, Turin, Italy: *Xenon for Torino*, Nov. 8, 2003–Jan. 11, 2004. Repeated at Palazzo Madama, Nov. 6, 2004–Jan. 16, 2005 and Nov. 11, 2005–Mar. 19, 2006.
- Peggy Guggenheim Collection and Palazzo Corner, Venice: *Xenon for the Peggy Guggenheim*, Sept. 2–6, 2003.
- Palais du Festival and Old Harbor / Le Suquet, Cannes, France: *Xenon for Cannes*, May 14–25, 2003.
- Tate Liverpool, Liverpool, England: *Xenon for Liverpool*, Mar. 19–23, 2003.
- Monterrey, Mexico: *Xenon for Monterrey*, July 15–22, 2001: Museo de Arte Contemporáneo de Monterrey, July 15 and 19–20; Oficinas en el Parque, July 16; Biblioteca Magna Raúl Rangel Frias, July 17; La Huasteca, July 18 and 22; and Loma Larga, July 21.

- Paris, Bordeaux and Pyla-sur-Mer, France: *Xenon for Bordeaux and Paris*, May 26–June 2 and Nov. 1–4, 2001: Dune du Pyla, May 26 and June 2; Porte Cailhau, May 28; Place du Parlement, May 29; Cinéma Utopia, May 29 and June 1; Basilique Saint-Saint Michel and Opéra National de Bordeaux, May 30; Place de la Victoire and Quai des Chartrons, May 31; Louvre Pyramid, Nov. 1; Louvre Colonnade, Nov. 2; Square du Vert-Galant, Pont-Neuf, and Église Saint-Eustache, Nov. 3; and Panthéon, Nov. 4. Repeated at Louvre Pyramid, Apr. 7–10, 2009.
- Berlin: *Xenon for Berlin*, Jan. 27–Feb. 8, 2001: Neue Nationalgalerie, Jan. 27 and Feb. 1–3; St. Matthäus-Kirche, Staatsbibliothek and Philharmonie, Feb. 1–3; Federal Chancellery and Museumshöfe, Feb. 4; Berlin City Hall and Altes Museum, Feb. 5; Grand Hyatt and Humboldt-Universität, Feb. 6; Pergamon Museum and Bode Museum, Feb. 7; and DG Bank, DaimlerChrysler Services and Jewish Museum, Feb. 8.
- Newcastle and Gateshead, England: *Xenon for BALTIC*, Oct. 25–28, 2000: BALTIC Centre for Contemporary Art, Oct. 25 and 28; Castle Keep, Oct. 26; and Tuxedo Princess, Oct. 27.
- Buenos Aires: *Xenon for Buenos Aires*, Apr. 30–May 4, 2000: Planetario Galileo-Galilei and Bosques de Palermo, Apr. 30; Centro Cultural Recoleta, May 1; Universidad de Buenos Aires (Facultad de Derecho), May 2; Riachuelo and Fundación Proa, May 3; and Teatro Colón, May 4.
- Oslo and Lillehammer, Norway: *Xenon for Oslo and Lillehammer*, Jan. 22–Feb. 13, 2000: Museet for Samtidskunst, Jan. 22–27, Jan. 31–Feb. 3, and Feb. 7–10; Oslo City Hall, Jan. 28–30 and Feb. 11–13; University of Oslo, Feb. 4–6; and Lysgårdsbakkene, Feb. 5.
- Fondazione Giorgio Cini, Venice: *Xenon for Venice*, June 9–13, 1999.
- Rio de Janeiro: *Xenon for Rio de Janeiro*, May 5–9, 1999: Centro Cultural Banco de Brasil, May 5; Urca Hill and Sugarloaf Mountain, May 8; and Arpoador Beach, Leme Beach and Leme Hill, May 9.
- Vienna: *Xenon for Vienna*, Oct. 8–11, 1998: Kunsthalle Wien, Oct. 8–9; Museumsquartier, Oct. 10; and Ringturm, Oct. 11.
- Spanish Steps, Rome: *Xenon for Rome*, July 16, 1998.
- Arno River at Palazzo Tempi, Florence, Italy: *Xenon for Florence*, Sept. 20–22, 1996.

SELECTED PUBLICATIONS
주요 출판물

Catalogs

- *Jenny Holzer: War Paintings*. Cologne: Walther König, 2015. Text by Joshua Craze.
- *Jenny Holzer: Dust Paintings*. New York: Cheim & Read, 2014. Text by Henri Cole.
- *For Frankfurt: Jenny Holzer*. Bielefeld: Kerber, 2011. Text by Henri Cole, Rose-Maria Gropp, Peter Weibel, and Jürgen Werner.
- *Jenny Holzer: PROTECT PROTECT*. Ostfildern: Hatje Cantz, 2008. Text by Benjamin H. D. Buchloh, Joan Simon, and Elizabeth Smith.
- *Jenny Holzer: Redaction Paintings*. New York: Cheim & Read, 2006. Text by Robert Storr.
- *Jenny Holzer: Truth before Power*. Bregenz: Kunsthaus Bregenz, 2004. Text by Maurice Berger, Thomas Blanton, and Eckhard Schneider.
- *Jenny Holzer*. Bordeaux: CAPC, 2001. Text by Marie-Laure Bernadac.
- *Jenny Holzer: Monterrey 2001*. Monterrey: MARCO, 2001. Text by Michael Auping, Vanesa Fernández, and Marco Granados.
- *Jenny Holzer. Neue Nationalgalerie*. Berlin: American Academy in Berlin and Nationalgalerie Berlin, 2001. Text by Henri Cole and Angela Schneider.
- *Jenny Holzer, Lustmord*. Ostfildern: Cantz, 1996. Text by Markus Landert, Beatrix Ruf, Noemi Smolik, and Yvonne Volkart.
- *Jenny Holzer: The Venice Installation*. Buffalo: Albright-Knox Gallery, 1991. Text by Michael Auping.
- *Jenny Holzer*. New York: Guggenheim Museum, 1989. Text by Diane Waldman. Second edition: New York: Guggenheim Museum, 1997. German edition: Ostfildern: Cantz, 1997.

Monographs

- *Jenny Holzer: Xenon*. Küsnacht: Ink Tree, 2001. Text by Beatrix Ruf, Peter Schjeldahl, and Joan Simon.
- *Jenny Holzer*. London: Phaidon, 1998. Text by David Joselit, Renata Salecl, and Joan Simon.
- *Jenny Holzer: Writing / Schriften*. Ostfildern: Cantz, 1996. Text by Noemi Smolik.
- *Jenny Holzer im Gespräch mit Noemi Smolik*. Cologne: Kiepenheuer und Witsch, 1993. Text by Noemi Smolik.
- *Jenny Holzer*. New York: Universe, 1992. Text by Michael Auping.

Artist's Contributions to Periodicals

- Gun Safety series. *Vogue*, May 23–June 2, 2016. http://www.vogue.com/tag/misc/gun-control.
- "After the Towers." *New Yorker*, July 15, 2002: 59–67.
- *Lustmord. Süddeutsche Zeitung Magazin* (Munich), Nov. 19, 1993: 1–31.